An Ontology of Multiple Artworks

An Ontology of Multiple Artworks

DAVID DAVIES

OXFORD
UNIVERSITY PRESS

Great Clarendon Street, Oxford, OX2 6DP,
United Kingdom

Oxford University Press is a department of the University of Oxford.
It furthers the University's objective of excellence in research, scholarship,
and education by publishing worldwide. Oxford is a registered trade mark of
Oxford University Press in the UK and in certain other countries

© David Davies 2024

The moral rights of the author have been asserted

All rights reserved. No part of this publication may be reproduced, stored in
a retrieval system, or transmitted, in any form or by any means, without the
prior permission in writing of Oxford University Press, or as expressly permitted
by law, by licence or under terms agreed with the appropriate reprographics
rights organization. Enquiries concerning reproduction outside the scope of the
above should be sent to the Rights Department, Oxford University Press, at the
address above

You must not circulate this work in any other form
and you must impose this same condition on any acquirer

Published in the United States of America by Oxford University Press
198 Madison Avenue, New York, NY 10016, United States of America

British Library Cataloguing in Publication Data
Data available

Library of Congress Control Number: 2023945238

ISBN 978–0–19–284886–4

DOI: 10.1093/oso/9780192848864.001.0001

Printed and bound by
CPI Group (UK) Ltd, Croydon, CR0 4YY

Links to third party websites are provided by Oxford in good faith and
for information only. Oxford disclaims any responsibility for the materials
contained in any third party website referenced in this work.

Contents

Preface	vii
Acknowledgements	ix
Introduction	1
I.1 Berthold and Magda Talk about Art	1
I.2 Some Preliminary Methodological Reflections	2
I.3 Nine Explananda in Search of an Explanans	7
1. What Is a Multiple Artwork?	12
1.1 Multiple Instances and Multiple 'Instances'	12
1.2 Currie's 'Instance Multiplicity Hypothesis'	18
1.3 Challenges to the IMH	25
1.4 Conclusion	31
2. Multiple Artworks as Abstract Entities: An Introductory Overview	33
2.1 The Origins of Contemporary 'Type' Theories of Multiple Artworks	33
2.2 Julian Dodd's 'Simple View'	44
3. Two Explananda for a Theory of Multiples: Perceivability and Creatability	52
3.1 The Audibility of Musical Works	52
3.2 The Creatability of Multiples	62
4. Two Further Explananda: Fine Individuation and Performance Means	70
4.1 Contextualist Views of Art	70
4.2 Levinson's Contextualist Explanandum for the Ontology of Musical Works: 'Fine Individuation'	74
4.3 Levinson's Third Explanandum for Musical Ontology: 'Performance Means'	79
4.4 Dodd on Contextualism and Instrumentalism as Explananda for Musical Ontology	82
5. Methodological Interlude: The Primacy of Practice in the Ontology of Art	91
5.1 Introduction	91
5.2 The Dialectical Structure of *Works of Music* and the 'Pragmatic Constraint'	92
5.3 Individuating *Works*, Identifying *Instances of Works*, and the 'Appreciation Constraint'	97

5.4	Dodd's 'Meta-ontological' Argument	102
5.5	The Place of Artistic Practice in the Ontology of Art: the 'Pragmatic Constraint' Revisited	106
5.6	Meta-ontological Postscript	115

6. Further Explananda: Flexibility and Variability ... 116
 6.1 Berthold and Magda Debate the Modal and Temporal Flexibility of Artworks ... 116
 6.2 Rohrbaugh's Challenge to Platonist Views of Multiple Artworks ... 117
 6.3 Problems for Platonist Theories of Multiples Initiated via a Production Artefact ... 126
 6.4 Enigmatic Variations: Variability as an Explanandum ... 127
 6.5 A Few Words about Literary Artworks ... 140

7. The Nine Explananda Revisited ... 143
 7.1 Repeatability ... 143
 7.2 The Possibility of Unexemplified Works ... 145
 7.3 Perceivability ... 146
 7.4 Creatability ... 147
 7.5 'Fine Individuation' and Contextualism ... 148
 7.6 Instrumentalism ... 149
 7.7 Modal Flexibility ... 150
 7.8 Temporal Flexibility ... 152
 7.9 Variability ... 152

8. Non-Platonist Ontologies of Multiples ... 154
 8.1 Three Non-Platonist 'Materialist' Ontologies of Multiples ... 154
 8.2 'Sophisticated Idealism' ... 164

9. Multiple Artworks as Wollheimian Types ... 172
 9.1 Introduction ... 172
 9.2 The Nature of Wollheimian Types ... 173
 9.3 Artworks as Performances—a Brief Overview ... 184
 9.4 Multiple Artworks as Wollheimian Types and the Explananda for an Ontology of Multiples ... 189

10. Can Non-Platonists Be Realists about Multiple Artworks? ... 193
 10.1 Introduction ... 193
 10.2 Mag Uidhir, Hazlett, and Moruzzi: 'Multiples' as 'Relevantly Similar' Concreta ... 194
 10.3 Kania: Fictionalism about Multiples ... 202
 10.4 Azzouni: Multiples and the 'External Discourse Demand' ... 205
 10.5 Nominalist Realism about Multiples: a Provisional Defence ... 210

Bibliography ... 215
Index ... 221

Preface

My interest in the philosophical issues concerning the ontological status of multiple artworks was first piqued in a discussion with Jerry Levinson in the early 2000s. Julian Dodd's paper 'Musical works as eternal types' had recently appeared, and Dodd had claimed that Levinson's argument for the creatability of works of music, construed as initiated types, rested on a misunderstanding of the existence conditions for types. I shared with Levinson the belief that musical artworks, and indeed artworks more generally, were individuated in part by reference to their contexts of creation, but it was clear that, if Dodd's arguments were correct, this idea might be problematic if musical works were types of any kind. I assumed, however, that if musical works were thought of as *initiatings* involving types, as I suggested in my 2004 *Art as Performance*, my own contextualist sympathies were not threatened. This complacency was shaken, however, when Dodd's more developed version of the view bruited in his 2000 paper appeared in his 2007 *Works of Music*. One lasting virtue of this book is that it clarified what was at stake in such debates. This initiated an extended exchange of views between Dodd and myself, later reflected in increasingly methodological publications on both of our parts. At the same time, I became interested more generally in the problems posed by multiple artworks of different kinds—literary, cinematic, photographic, and print—an interest furthered by consideration of Gregory Currie's 'Instance Multiplicity Hypothesis' defended in his 1989 *An Ontology of Art*. Over the past dozen years, these issues have been addressed in a number of publications upon which I critically draw in this book (see the acknowledgements below). Of particular importance in the development of my thinking were two papers: a 2010 paper, 'Multiple Instances and Multiple "Instances"', and a 2012 paper, 'Enigmatic Variations'.

Given the 'history of making' of this book, it will not surprise the reader to find that the argument in the first six chapters takes the form of an extended dialogue with Dodd and Levinson about the merits of traditional 'type' theories of multiple artworks, whether those types be 'pure' or 'initiated'. In the remaining chapters, I look at alternative ontological accounts of multiple artworks, drawing in particular upon a rereading of what Wollheim was doing in introducing 'type' terminology into these debates in the first place. In the final chapter, I consider scepticism about the very idea that there can be multiple artworks.

This book has obviously been a long time in the making, and during that time I have benefited from input by many people apart from the figures mentioned above. While deficiencies of memory and limitations of space prevent me from

acknowledging here all those to whom I am indebted, I would like to thank in particular the following individuals for their substantial assistance in the evolution of the view defended in this book: Greg Currie, Julian Dodd, John Hyman, Andrew Kania, Jerry Levinson, Peter Momtchiloff, Anna Pakes, Guy Rohrbaugh, Bob Stecker, and Amie Thomasson. I would like to thank three anonymous reviewers for the Press for their extensive and immensely helpful suggestions on an initial draft of this book. I would also like to thank graduate students at McGill and elsewhere who have participated in seminars where we worked through a number of incarnations of this project—in particular (in chronological order) Matthieu Olivier, Yvan Tetrault, Michel Xignesse, David Collins, Eric Wilkinson, Axel Rudolphi, Alex Carty, Alper Gungor, Aditya Guntoori, and Beattie Bernfield-Millman. I would also like to thank Elisabeth Schellekens for providing me with the opportunity to refine and revise this manuscript during visits to the idyllic confines of Uppsala University. Finally, I would like to thank my partner, Ann Elsdon: her practical perspective on artistic matters has always helped to ground my metaphysical flights of fancy, and her love and support (and patience!) have been invaluable throughout my engagement in this project.

Acknowledgements

I would like to thank the Social Sciences and Humanities Research Council of Canada, a grant from whom helped to fund my initial research on these issues.

Chapter 6 reproduces material from David Davies, 'Enigmatic variations', *The Monist* 95.4 (2012), 644–63, by permission of Oxford University Press.

I would also like to acknowledge the following sources in which some of the ideas developed in this monograph first appeared and upon which I have drawn, in modified and sometimes corrected form, in specific chapters of this book.

Introduction: 'Nine explananda in search of an explanans', *Journal of Aesthetics and Art Criticism* 81.4, 1–10.

Chapter 1: 'Multiple Instances and Multiple "Instances"', *British Journal of Aesthetics* 50.4 (2010), 411–26; 'Varying impressions', *Journal of Aesthetics and Art Criticism* 73.1 (2015), 81–92.

Chapter 3: 'Dodd on the "audibility" of musical works', *British Journal of Aesthetics* 49.2 (April 2009), 99–108.

Chapter 5: 'The primacy of practice in the ontology of art', *Journal of Aesthetics and Art Criticism* 67.2 (Spring 2009), 159–71; 'Descriptivism and its discontents', *Journal of Aesthetics and Art Criticism* 75.2 (2017), 117–29.

Chapter 6: 'What Type of "Type" is a Film?', in Christy Mag Uidhir, ed., *Art and Abstract Objects* (Oxford: Oxford University Press, 2013), 263–83.

Chapter 8: 'Locating the musical work in practice', in *Virtual Works—Actual Things*, part of the *Orpheus Institute Series* (Leuven: Leuven University Press, 2018), 45–64.

Chapter 10: 'Mag Uidhir on what is "minimally viable" in "art-theoretic space"', *Journal of Aesthetic Education* 52.2 (Summer 2018), 8–22; 'What should a nominalist say about multiple artworks?', forthcoming in Joshua Brown and Otávio Bueno, eds., *The Philosophy of Jody Azzouni* (Dordrecht: Springer).

Introduction

I.1 Berthold and Magda Talk about Art

Few things are more enjoyable for Magda than discussing art with Berthold. Since they share interests in a broad range of arts—they pride themselves on the catholicity of their tastes—and are enthusiastic patrons of anything brought to their attention by trusted friends or selected critics in the cultural press, Magda has many opportunities to enjoy this particular pleasure, and their lively or even heated conversations are frequently overheard in galleries, concert intermissions, and the restaurants and bohemian haunts where they repair after viewing the latest cinematic or performative *cause célèbre*. They are also avid readers, and Magda encourages Berthold to read books she has enjoyed for the pleasure of discussing them with him (and probably disagreeing with him!) afterwards. In fact, because of the different rhythms of their lives, the works of art that they discuss are often ones they have each experienced separately, not only in the case of works of literature but also in the case of paintings, musical works, films, and performances. This fact does not trouble them, except on those occasions when aspects of the experienced works they are discussing prove to differ—two distinct performances of a play during a run in the West End, for example, or performances of a given musical work under different conductors. Only in these cases do they sometimes conclude that they are not able to intelligently disagree because they are not in fact able to talk about the same artistic entity.

Fortunately for Magda, perhaps, the pleasure of discussing artworks with Berthold is rarely punctuated by the kinds of questions that will occupy us in the following pages. She takes it for granted that, despite viewing Piero's *Baptism of Christ* at the National Gallery on different days, seeing different screenings of *The Usual Suspects*, reading different copies of *Riddley Walker*, and attending different performances of *The Lark Ascending*, they are in each case able to disagree passionately *about the same work* (or at least the same *performed* work in the latter case). And if someone were to question what that work was in each case, Magda would have little time for such idle reflection—for surely we have already identified each of these works by name, and what more is there to add? In each of the cases described, she might say, the work is there to be appreciated and she and Berthold take advantage of this, albeit on distinct occasions. So where is the problem?

If we are to interest Magda—or indeed the reader!—in the issues that have worried philosophers who have considered these kinds of cases, we might begin by asking *where* in each case the work is awaiting our individual or collective appreciation. A natural answer in the case of the Piero is that the work awaits us on a wall in one of the rooms of the National Gallery in London, although perhaps to actually encounter the work when standing before this painted surface our looking needs to be informed by the kinds of understandings provided by the audio guide or the panel beside the painting. But in the other cases, it seems that what engages us when we sit in the cinema or concert hall or open the pages of a book cannot be the work itself, however much understanding we bring to our encounter with it. For the cancellation of a screening of a film or performance of a musical work, or the loss in a fire of a given copy of a book, will, except in exceptional circumstances (for example, where this is the only copy of the book), in no way imperil the work itself. Thus, whereas in the case of the work by Piero it seems plausible to identify the work with the very thing we directly experientially encounter in our appreciative endeavours, in the other three cases the work seems to somehow exist apart from the things with which we so engage. The work, it seems, is something to which we get access *through* a screening, a copy of a text, or a performance, but which cannot be identified with any of these things. So, to repeat our question, *where is the work* in such cases? Or, since this seems integral to answering that question, what *kind* of thing is the work?

As we shall see in Chapter 1, formulating these questions fruitfully calls for the drawing of certain distinctions. The kinds of stimulating discussions of particular works of art in which Magda loves to engage with Berthold clearly require that each party has had the relevant kind of experiential engagement with the work discussed: such engagement is necessary to ground the kinds of aesthetic judgments about which it is worth disagreeing! But, clearly, in some cases only one thing seems qualified to provide such an experiential engagement—only the pigmented surface generated by the actions of Piero will do! In other cases, however, different things can play what we might term the 'experiential role' in the appreciation of a work, although none of these things themselves seems to be identifiable with the work. Suppose we tentatively term something that can play this experiential role for a given work an 'instance' of that work. Then it seems that some works have only a single instance—paintings, for example—while others allow of multiple instances—cinematic and literary works, for example. Our task in this book is to arrive at the most plausible account of what multiply instantiable artworks are.

I.2 Some Preliminary Methodological Reflections

As I have just characterized the aim of this book, it is natural to assume that the 'plausibility' of a proposed philosophical account of multiply instantiable artworks

depends upon how well it makes sense of the relevant features of our artistic practices. And this is indeed how I and the other authors I shall discuss in the succeeding chapters understand their task. In the third section of this Introduction I shall offer a preliminary list of putative 'explananda' for an account of multiply instantiable artworks—things that, according to those who have written on these issues, should be accounted for by a plausible account of such works. And it is concerns about the status of these putative explananda and the capacity of different accounts to accommodate them that will structure the overall argument of this book. In so proceeding, I conform to what I have elsewhere termed the 'pragmatic constraint' on inquiries into the ontology of art. According to the 'pragmatic constraint',

> Artworks must be entities that can bear the sorts of properties rightly ascribed to what are termed 'works' in our reflective critical and appreciative practice; that are individuated in the way such 'works' are or would be individuated, and that have the modal properties that are reasonably ascribed to 'works,' in that practice. (Davies 2004, 18)

Julian Dodd has also taken ontology of art to have an essential explanatory dimension. According to what he terms the 'discovery model' (2012), theories of philosophical ontology have a 'quasi-scientific' standing because their adoption reflects the balancing of a number of theoretical virtues. These include not only 'coherence with folk belief, but also norms such as explanatory power, simplicity, and integration with the findings of other domains' (2013, 1051).

How Dodd and I differ in our understanding of the explanatory nature of inquiries into the ontology of art is the central issue in Chapter 5 below. But before proceeding further, it is necessary to briefly distinguish, and I hope defend, this methodological approach in light of a different conception of the philosopher's task defended by Amie Thomasson. Both the 'pragmatic constraint' and Dodd's 'discovery model' take philosophical reflection on the nature of artworks to stand in a *reflective* relation of accountability to our actual artistic practices and beliefs about those practices, and therefore to be potentially *revisionary* of those practices and beliefs. It is this claim that Thomasson rejects.

Thomasson's anti-revisionary stance in the ontology of art (2005) is based upon her more general views in the philosophy of language. She holds that nominative expressions, singular or general, obtain determinate referential purchase on the world only through the categorial intentions, explicit or implicit, of the competent users of those expressions who ground that reference. She claims that this bears crucially on metaphysical questions about the nature of different kinds of entities—the conditions under which there exist entities that fall under a given concept—and their identity and persistence conditions:

The most basic, frame-level identity and persistence conditions for the objects we refer to are fixed analytically in fixing the reference of the very terms we must use in asking the metaphysical question. As a result, answering questions about the most basic identity and persistence conditions for entities of various kinds must take off from a kind of conceptual analysis, analyzing the proper use of the relevant terms, their application and coapplication conditions.

(Thomasson 2007, 189–90)

To clarify some of the technical terms in this passage, the 'application conditions' for a given nominative term—for example 'kangaroo'—determine the situations in which an attempted referential use of that term can succeed—the situations in which the thing indicated is indeed a kangaroo. The co-application conditions specify the circumstances in which the term can be successfully applied to one and the same entity on different occasions—this is the same kangaroo that I saw earlier. The persistence conditions are the conditions under which a given entity—this kangaroo—continues to exist. In each case, the most general such conditions are what Thomasson terms 'frame-level' (Thomasson 2007, 39–41). In claiming that the 'frame-level' application and co-application conditions for a nominative term are determined by the referential intentions of those who fix the reference of the term, Thomasson endorses a 'hybrid view' of reference fixing. The latter steers a path between two alternative 'purer' views of how reference is fixed. According to different versions of one of these views—the *'descriptions'* theory— the referent of a given term is determined by all, or some weighted subset of, the descriptions that a user, or a community of users, associates with that term. On this view, the name 'Aristotle' picks out the individual who did all or most of the things that users of the term associate with that name in their individual or collective idiolects. Similarly, the term 'gold' picks out a natural kind whose referents have the properties that a user, or a community of users, associates with that term. As contrasted with various forms of the 'descriptions' theory, *'causal-historical'* theories of reference fixing hold that the referent of a term may not in fact satisfy such associated descriptions (see, e.g., Kripke 1980, Putnam 1975). Proponents of causal-historical theories claim that it makes perfectly good sense to suppose that 'Aristotle' in fact refers to someone who did none of the things we normally associate with that name, and that much of what we think of as gold is not in fact gold. Causal-historical theorists maintain that the reference, for a community of users, of proper names and natural kind terms, and by extension of other terms, is fixed by the community's collective picking out, through their use of the term, of some thing or some things in the world and by the nature of the things that they thereby pick out. Since their shared beliefs about what they are picking out might be false, the things to which they refer may not satisfy the descriptions collectively associated with a given term.

The 'hybrid' theory endorsed by Thomasson is a response to the so-called 'qua' problem for 'pure' causal-historical theories of reference fixing (see Devitt and Sterelny 1999). Suppose it is claimed that the reference of the term 'kangaroo' for a linguistic community is determined by the nature of the things picked out by an act of ostension of the form—by 'kangaroo' I mean *that* kind of thing. The problem is that this act of ostension will pick out not just a kangaroo but also other kinds of entities: a unified collection of kangaroo parts, for example, or an individual time slice of a kangaroo, or the kangaroo's tail. Of course, it might be said, what I intend to pick out in my use of the term 'kangaroo' is a kind of animal, and the intention to so refer informs my act of ostension. But this is taken by the 'hybrid' theorist to show that the causal-historical theory must be supplemented by elements from the 'descriptions' theory in order to establish at the most general level the kind of thing to which the term must refer, if indeed it refers at all.

This, then, is the sense in which the most general referential intentions of those who fix the reference of a term—their 'frame-level' intentions for Thomasson—determine the application and co-application conditions for the term. But since, in pursuing ontological questions, philosophers are indeed interested in determining the general categories to which things belong, it is *conceptual analysis* that is required to answer these questions, she maintains. And this lesson applies to the ontology of art just as much as it applies elsewhere. When we ask, for example, whether works of art 'should be understood as concrete artifacts, action types, abstract objects, or entities of some other sort' (Thomasson 2007, 189), the answers to our questions cannot conflict with the 'frame-level' intentions of those whose intentions fix the reference of the very terms that we have to use to pose our ontological questions.

This view about how such metaphysical questions are to be answered entails that metaphysical inquiry into the nature of artworks of different kinds cannot be revisionary of the conceptual content conferred upon the relevant art-kind terms by ordinary users of those terms, since it is such content that determines the kind of thing to which the term refers. Only in this way can the very act of reference be disambiguated, given the 'qua' problem for pure causal-historical theories of reference. In setting out her view in her *Ordinary Objects* (2007), Thomasson argues that, where philosophers of art *do* make revisionary proposals, these only make sense if they are taken to be proposals to *revise the meanings of our terms*, in the interests of rendering our usage more consistent, or more useful. Such projects are 'pragmatic'. but they do not enlighten us about the referents of our existing art-kind terms: 'ontologists engaged in this project must be clear that they are not discovering surprising facts' (Thomasson 2007, 200) about these referents, although their activities may be prompted by the realization that our current art-kind terms are internally inconsistent and thus associated with application conditions that cannot in fact be satisfied. We may discover, through conceptual analysis, that there are and can be no things corresponding to our concept of

'musical work', for example, but metaphysical inquiry cannot reveal that the things we call 'musical works' are different from how we ordinarily take them to be. As is clear in later papers by Thomasson, a principal target here is Julian Dodd's 'discovery model' of work in the metaphysics of art, something we shall consider in greater detail in Chapter 5.

I shall not address here Thomasson's more general claims about the manner in which reference is fixed for terms that refer to ordinary objects, or her proposed solution to the qua problem. What I do want to question are the conclusions she draws from these more general views for work in the ontology of art. Consider, for example, her response to Gregory Currie's claim that paintings are action types. The views of the grounders of a term like 'painting', she maintains, cannot turn out to be wrong, and they show Currie's claim to be false:

> Given, for example, the customary use of the term 'painting' and associated painting names ("The Mona Lisa," "Broadway Boogie-Woogie," "Guernica"), it just could not turn out (as Gregory Currie, 1989, alleges) that these names in fact refer to types of action that can survive the burning of any canvas.... If our painting names refer at all, they must refer to things with the basic, frame-level identity conditions competent users of the painting names would associate with them, and these seem to allow for survival through minor restoration, but not through a complete destruction of the canvas. In general, on this view, answering questions about the identity conditions for entities of various kinds is not a matter of looking deep into the world, but rather must be based on a form of conceptual analysis. (Thomasson 2007, 191)

I think this response to Currie misrepresents what he and many other ontologists of art are about. The task they set themselves is not answerable to the ways in which the folk fix the reference of art-kind sortals like 'painting', nor are they proposing that we revise the meaning of such sortal terms. Rather, what Currie is attempting to illuminate in the cited passage is the nature of the *object of critical and appreciative attention* in a practice in which a central role is played by the things that satisfy the application and co-application conditions of the folk term 'painting'. The term 'painting' (or, better, 'visual artwork'), as used by ontologists of art, is a theoretical term that is intended to refer to whatever kind of entity enters into the best *reflective explanation* of what serves as the appreciative focus of our 'painting practice'. There is no interest on the part of such ontologists in *either analysing or revising the core folk concept* of a painting according to which an artefact such as the *View of Delft* is a physical object that may be seen in different places at different times, that might suffer damage if a fire broke out in the Mauritshuis, that can be an object of attention for restorers, and that was painted by Vermeer in 1662. There is nothing in this concept for the ontologist of art to correct. But it is the way in which the referent of this folk concept enters into

our appreciation of Vermeer's work *View of Delft* that occupies philosophers who take themselves to be inquiring into the ontological status of the visual artwork.

When Currie claims that the painting qua artwork is the type of performance enacted by the painter, he grounds this claim in the essentially explanatory nature of the ontology of art (Currie 1989, 11–12). His project is neither the conceptual analysis of the folk concept of 'painting' nor a proposal that *that* concept be revised. As noted above, the project is to better understand where, in a set of practices that revolve around the referent of that folk concept, the painting qua artwork—qua proper object of criticism and appreciation—resides. On this way of thinking about things, as I shall argue in Chapter 5, ontology of art is by its very nature reflective and potentially revisionary of certain aspects of our folk beliefs and artistic practice, where what is revised is our *folk theory* of what the artwork, qua object of criticism and appreciation, is. This folk theory reflects the fact that our artistic discourse—and indeed our artistic practice at any time—is inflected by the largely unexamined ideas of earlier and contemporary ontologists of art—for example, the aestheticist ideas that permeate without our general awareness what I have elsewhere termed our 'common-sense' theory of art.[1] But while adherents of the common-sense theory of art also employ the folk concept of painting, it is not this concept itself that is called into question by the ontologist of art but the folk theories that are, as Dodd puts it, implicit in our artistic practices. Ontology of art involves not conceptual analysis but the codification of a practice in a way that clarifies the role that certain things play within it.

In her more recent work, Thomasson has in fact acknowledged the legitimacy of the kind of philosophical project that I have just ascribed to Currie and other ontologists of art, granting that this project may advance our understanding of the arts in important ways. Such projects are not rightly viewed as exercises in conceptual analysis or conceptual revision, but as exercises in 'conceptual engineering' in one sense of that term—filling important lacunae in our current conceptual framework rather than recrafting problematic parts of that framework.[2]

I.3 Nine Explananda in Search of an Explanans

If the aim in this book is explanatory in the sense just described—something to be spelled out much more fully in Chapter 5—what should we take to be our explananda? In the following chapters, we shall examine a range of different explananda for an ontology of multiple artworks that have been proposed in the literature. To give some idea of the nature and range of these putative explananda,

[1] Davies (2004, ch. 1).
[2] Personal communication. For some of Thomasson's recent work on conceptual engineering, see her 2020 and 2021.

it will be helpful to provide a brief introductory overview of the considerations that will frame our explanatory endeavours in the following chapters. I shall also illustrate how these considerations have entered into the literature, although this again is merely a propaedeutic to future discussion.

As we shall see, much of the literature on the nature of multiple artworks has focussed on works of music. This fact admits of both conceptual and more broadly sociological explanations. On the one hand, understanding the nature of multiple musical artworks presents some challenges that do not attend an understanding of many other kinds of multiples. On the other hand, philosophy of music has been one of the most active areas in analytic aesthetics, and has attracted some of the most talented philosophers working in the field. As a consequence, since it has been assumed that the defining philosophical issue about multiples is their multiplicity, it has also been assumed that an ontological account that accommodates the multiplicity of musical works—standardly, by viewing them as abstract entities of some sort—can perform the same task in the case of other kinds of multiples. This assumption is directly contested by Guy Rohrbaugh (see Chapter 6), who argues, conversely, that our ability to explain some multiples—for example, photographs—in purely material terms undermines that idea that musical works must be abstract entities.

Bearing these things in mind, we can identify nine features of our practices that have been prioritized by different theorists as explananda for an ontology of multiple artworks:

[E1] *Repeatability*—the capacity of a work to have more than one instance. This is generally taken to be the defining feature of multiple artworks, but, as we shall see in Chapter 1, the notion of instance is open to different readings, and only one of these readings can give us a serviceable notion of repeatability if the latter is to fund the standard distinction between multiple and singular artworks.

[E2] The possibility of *unexemplified* works, works that as a matter of fact never have *any* instances of the relevant sort. This explanandum is little discussed in the literature, but can be brought as an objection against some accounts of multiples that seem unable to account for this phenomenon.

[E3] The *perceivability* of a work through our engagement with its instances. This idea is built into the notion of an 'instance' of a work as introduced above, and has played a key role in some of the literature.

[E4] The *creatability* of a work—its being brought into existence through the activity of one or more artists. While it might be thought to be partly definitive of what it is to be an artist that she brings artworks into existence, this idea seems unsustainable on some of the most widely espoused views of the nature of multiples.

[E5] The *'fine individuation'* of artworks—some have held that the identification of particular works proceeds by reference not merely to their structural or perceptually manifest properties but also to the art-historical contexts in which they were initiated.

[E6] A work's being partly constituted by *a given material means of instantiation*—in the case of at least some musical works, for example, it may be claimed that it is part of their nature that their instances involve the production of a given sound sequence on specific instruments.

[E7] A work's being *modally* flexible—a given work, it may be claimed, could have differed in some of its intrinsic properties, given that—it is assumed—the artist could have conferred upon a given work different properties from the ones it actually possesses.

[E8] A work's being *temporally* flexible—the intrinsic properties of a work that enter into its proper appreciation, it may be said, can themselves change over time. And finally:

[E9] *Variability*—some multiple works—for example, musical works—admit at a given time of a determinate range of instances that *differ* in those properties that, in bearing on their appreciation, thereby bear upon the appreciation of the work of which they are instances.

The competing accounts of the nature of multiple artworks that we shall examine in the following pages all work within an explanatory space definable in terms of these nine explananda, but they differ as to the significance and proper weighting that they accord to individual elements in that space. Assessing in detail the arguments given in support of these accounts will occupy us for much of this book, but it may be helpful, as a preliminary 'reader's guide', to map out schematically how different types of accounts orient themselves within the explanatory space just described. We shall return to this 'reader's guide', hopefully informed by our more detailed reflections, in Chapter 7, and in Chapters 8 and 9, where we assess how different accounts measure up against the explananda when the latter themselves have been more carefully assessed.

In Chapters 2, 3, and 4, one of our tasks will be to consider arguments given against broadly Platonist accounts of multiple artworks that take such works to be pure abstract entities of some sort. The most recent version of such an account is Julian Dodd's 'simple view'. Dodd claims that two of our explananda, repeatability [E1] and audibility/experienceability [E3], are central and that the 'default explanation' of these two explananda is that musical works are *types* and their instances are tokens. More precisely, they are what he terms 'norm-types', individuated by reference to an associated property that specifies the requirements for a correct instance of the work. This, he maintains, also explains audibility since we can hear the work indirectly in hearing its performances. On the considered version of his view, this allows for unperformed works [E2]. Dodd, however,

rejects many of the other explananda. Musical works, he maintains, cannot be created [E4], nor can they be either modally or temporally flexible [E7, E8], since abstract entities cannot have these properties. He also rejects both 'fine individuation' [E5] and 'instrumental means' [E6] for two reasons: (a) they are difficult to reconcile with the eternal nature of norm-types, and (b) they fail to fit with what he takes to be the proper account of musical appreciation. E5 and E6, he argues, pertain not to the appreciation of musical works but to the appreciation of other things (e.g. composers and musicians). Dodd, like most of the other theorists we shall look at, doesn't address variability [E9], but it might be thought that this can be easily explained by his account: the performances that meet the requirements of the norm-type can have different appreciable qualities bearing on the appreciation of the work.

The most influential challenge to a purely Platonic view of musical works in particular, and of multiple works in general, has been the 'indicated structure' theory developed and defended by Jerrold Levinson (see Chapters 3 and 4). Levinson argues, against the Platonist account, that it cannot account for the creatability [E4] and fine individuation [E5] of musical works in the common practice period and the significance of instrumental means [E6] for their instances. Works as 'initiated types', Levinson maintains, not only explain all three of these things, but also account for the explananda [E1, E3] prioritized by Dodd. Dodd's response to Levinson's account questions whether indicated structures are ontologically kosher, and, if they are, whether they in fact satisfy creatability [E4].

While Dodd's and Levinson's accounts take musical works, and by implication multiple works more generally, to be abstract entities of some kind, a number of authors have offered sophisticated materialist theories such as perdurantism (Caplan and Matheson) and endurantism (Rohrbaugh). Rohrbaugh (see Chapters 6 and 8 below) takes the key explananda to be creatability [E4], and modal and temporal flexibility [E5 and E6]. He agrees with Dodd that entities having these properties cannot be types. Rather, Rohrbaugh maintains, they are 'historical individuals'. Since works, so conceived, either incorporate as parts (perdurantism) or are ontologically dependent upon (endurantism) their instances, works, like their instances, are perceivable [E3]. Furthermore, since works are temporally flexible, they are variable [E9]. On some versions of perdurantism, however, it is not clear how there can be unperformed works [E2]. In contrast, a recent proposal, a sophisticated idealist account of musical works proposed by Cray and Matheson (Chapter 8), explicitly argues that it measures up better against at least some of the foregoing explananda than competitors.

Finally, the argument for a fictionalist view of musical works defended by Andrew Kania (Chapter 10) rests on the assumption that, if there are to be multiple musical works, they would have to be both repeatable [E1] and creatable [E4]. To be repeatable, Kania maintains, they would have to be types, but types

cannot be created. So there can be no multiple musical works, although it is useful to continue talking as if there were (fictionalism).

As is clear from this very brief overview, while the authors whose views we have canvassed move in the same explanatory space, they disagree over the valence of different elements in that space, and this means that one of our principal tasks is to see how much weight should be assigned to each explanandum if we are to arrive at the account that makes best sense of our artistic practices. In fact, as we shall see, while Magda and Berthold may display a refined indifference to the kinds of philosophical questions that concern us, it is to aspects of their appreciative practices that our own deliberations must be reflectively accountable. For, as we shall see, each of our explananda is in fact grounded in specific ways in which we engage with, talk about, and think about works of art. And the weight properly given to those explananda can be assessed only by looking at the proper understanding of our practices. In the final chapters of this book, I shall argue that the account that makes best sense of our practices—that fits best with our explananda once suitably assessed and weighted by reference to those practices—has its roots in the very reflections that have grounded Platonist theories, but is not itself a kind of Platonism: multiple works, I shall suggest, are what we may term 'Wollheimian types', but Wollheimian types are grounded in our practices, rather than being entities that by their very nature transcend those practices. But, before looking at this and other proposed accounts of multiply instantiable artworks, it is crucial that we clarify the very nature of multiple instantiability. This is a central task in Chapters 1 and 2.

1
What Is a Multiple Artwork?

1.1 Multiple Instances and Multiple 'Instances'

As illustrated in the Introduction, philosophers generally introduce the idea of multiple artworks by observing that to properly appreciate most if not all artworks requires an experiential engagement of some kind with an entity that makes manifest to a receiver at least some of the properties that bear upon the work's appreciation. In the case of a painting—for example, Vermeer's *View of Delft*—it is assumed that we require an experiential encounter with a particular physical object, the object whose pictorial properties are the unmediated result of the agency of the artist(s) to whom the work is properly attributed. In the case of Vermeer's painting, the object in question can normally be found in the Mauritshuis in The Hague, and admirers of Vermeer's work often travel considerable distances to see it there. If the focus of a viewer's perceptual attention is another object that looks just like *View of Delft* but is a reproduction or a copy thereof, then, even if that viewer is unable to perceive any difference between the two pictures, it is assumed that her ability to properly appreciate the artwork is compromised.

With musical, literary, and cinematic works, on the other hand, there seem to be many different locations where, at a given time, we might experientially encounter a work in the manner necessary for its appreciation. You may be watching *Casablanca* in Casablanca, or looking at Stieglitz's *The Steerage* in the Metropolitan Museum of Art in New York. I, at the same time, might be watching *Casablanca* in London or viewing *The Steerage* in the Museum of Modern Art in San Francisco. Assuming that the prints in both cases are not flawed, we would be equally capable, in each case, of having the kind of experience taken to be necessary for the proper appreciation of the artwork. In this respect, films and photographs resemble musical and literary works. It is generally agreed that to properly appreciate a musical work one must hear a performance of it, and that to properly appreciate a literary work one must have read it. It is also assumed that people in different locations engaging with different objects or events can have the kind of experiential encounter with a given musical or literary work deemed necessary for its proper appreciation.

Philosophers point to these kinds of facts about our artistic practices to motivate the idea that some art forms are 'multiple'. In so doing, they often

speak—as we spoke in the Introduction—of the latter as art forms in which artworks are capable of having more than one 'instance'. The latter term rarely, if ever, features in our ordinary talk about artworks. If you ask an assistant in a bookstore if they have an instance of *Bleak House*, or ask one of the staff in a gallery where you might find instances of paintings by Turner, you will be greeted with puzzlement unless you fortuitously happen upon someone who has encountered the relevant philosophical literature. The term 'instance' often functions in this literature as a philosophical term of art applicable to entities taken to have the capacity to make manifest to a receiver some or all of the experienceable properties bearing upon the appreciation of a given artwork. Instances, so conceived, are defined by the particular role that they play in appreciation. In the Introduction, we termed this the 'experiential' role. Suppose we take as a working hypothesis that multiple artworks are artworks that can have multiple instances in this sense, multiple entities that can play the experiential role in their appreciation.

But entities can be more or less well fitted to play this role. It is usually assumed that some performances of a musical work may depart unintentionally (or even intentionally!) from what is mandated by the score, some copies of a novel may contain typographical errors, and a given screening of a film may fail to provide the audience with certain of its manifest features because the print of the film is damaged.[1] This suggests that we should talk not merely of entities 'qualified' to play the experiential role for a work but also of those entities that are 'fully qualified' in virtue of not being flawed in these ways. The following characterization might render the latter notion more precise. An entity, we might say, is *fully qualified* to play the experiential role in the appreciation of a given artwork X at a time t just in case it possesses at t *all* those experienceable properties that are *necessary*, according to the practices of the art form in question, to fully play this role.[2] Where an entity fully qualifies in this sense to play the experiential role for a work W at a time t, we may term it a *strict instance* of X at t. To say, then, that *different* events or objects may fully qualify at specific times to play the experiential role for a given artwork is to say that the work admits of a plurality of strict instances.

It is crucial to note, however, that in those art forms that admit of variability (see the Introduction), something that possesses the properties necessary to *fully play the experiential role* for a given work will not thereby be able to provide a *full appreciation* of the work. In the case of such artworks, it is acknowledged that full appreciation of the work requires experiencing the range of artistic properties that different legitimate instances of the work can possess. What is required of a 'strict'

[1] For a dissenting view, see Goodman (1976, 187).
[2] The temporal variable is necessary because the properties that an instance of a work possesses can change over time, at least in the case of instances that are material objects rather than events. As a result, a given object may be 'fully qualified' to play the experiential role for a given work at one time but not 'fully qualified' at another time due to suffering material damage.

instance in such cases is that it possess all those properties required in *each* of the things that can fully play the experiential role. In the case of a musical work, these will be structural features (including perhaps timbral features produced by particular instrumental means). But none of the things that are strict instances in this sense is independently capable of providing a *full appreciation* of the work. So, for example, two different performances of a musical work can have all the structural and sonic features necessary to qualify as strict instances of the work but can reveal different appreciable qualities of the work performed. This contrasts with multiple art forms that do not admit of variability, such as literary works. Any strict instance of a literary work can provide everything experientially necessary for a full appreciation of the work. But no individual strict instance of a multiple work admitting of variability can do this.

The observations in the penultimate paragraph call for a modification in our 'working hypothesis'. It is in allowing for a plurality of *strict* instances so understood that so-called 'multiple' artworks or art forms might be thought to differ from so-called 'singular' works or art forms. As we just observed, classical music and literature are treated as multiple in this sense. Painting, on the other hand, is not treated as multiple but as singular because, even though prints and copies might to some extent play the experiential role in the appreciation of a painting, we take only one entity to be a strict instance of the work. Only the original canvas, it is assumed, can possess (or at least be known to possess) all of the properties that our artistic practice deems necessary to fully play the experiential role in the appreciation of the work. It is such an assumption that grounds Nelson Goodman's answer to the question, what is the *aesthetic* difference between a painting and a perceptually indistinguishable forgery of that painting?[3] A work's aesthetic properties, Goodman insists, comprise not only those features that we can discriminate at a given time but also those that we can learn to discriminate through honing our perceptual skills. Since we might *learn* to perceive an aesthetically relevant difference to which we are currently blind between the original painting and the forgery, we are justified in according to the original a status we do not accord to the forgery. In terms of our current vocabulary, we can say that only the original painting counts as a strict instance of the work. Of course, even the original *in its present state* may not count as a strict instance, for its perceivable properties may no longer match those it had when painted due to damage or chemical changes in the pigments.

But, although imperfect performances of musical works and flawed screenings of films are not strict instances of those works, they are nonetheless usually treated as being intimately related to the works in question, as no less instances *of* these works than their strict counterparts. On the other hand, we customarily treat even

[3] Goodman (1976, ch. III, sec. 2).

the most faithful copy of a painting or a work of carved sculpture as extrinsic to the work. Such a copy is not taken to be 'of' the work in the sense that flawed performances or screenings are taken to be 'of' given musical or cinematic works. This asymmetry in treatment prescinds from the purely epistemological considerations in terms of which we have introduced the notions of 'instance' and 'strict instance'. A flawed print of a film may be less well suited than a very good period copy of a painting to play the experiential role for their respective works, for example. Yet the former is usually treated as being 'of' the work in the same sense as its strict instances, while the latter is not.

It is arguably because such flawed performances and screenings stand in a particular kind of relationship to the *provenance* of a work that they are treated as being performances and screenings 'of' that work in an intimate sense that is denied to copies of paintings. For the latter do *not* stand in this relation to provenance. A flawed performance of a musical work will usually involve the use, by performers, of a copy of the same score-type, originating in the same compositional activity of a composer, as is used by those performers whose activity results in strict instances of the work. Similarly, a copy of a literary work containing typographical errors will usually result from an attempt to reproduce the same textual features as are reproduced in strict instances of the work, features that derive from the compositional activity of the author. And flawed copies of works of cast sculpture treated as being 'of' the work will have been cast from the same mould as strict instances of that work. Copies or reproductions of paintings, however, stand in a more mediated relation to the activity of the painter than the original painting which we treat as the work's only instance. Entities possessing some or all of the properties required to fully play the experiential role for a given work that do so in virtue of standing in this kind of intimate relation to the provenance of a work may be termed its 'provenential instances', or 'p-instances'. What distinguishes the p-instances of a work from other elements entering into the provenance of the work is that they are the first (kind of) artefact issuing from the creative activity generative of an artwork that, when completed, bears a sufficient number of the manifest properties required to play the experiential role in the appreciation of the work. The p-instance of a painting is the finished canvas, while the p-instances of a work for performance are its performances, not its score or script.[4] But all those things that are fully or partly qualified to play the experiential role in the appreciation of a work can be characterized as 'instances' of the work on the purely epistemic grounds described earlier. To reflect this difference, we may talk of these as a work's 'epistemic instances', or 'e-instances'.

[4] The p-instances of a literary work are those texts that stand in a conventionally appropriate relation to a certification of the verbal structure of the work. An author's manuscript will count as a p-instance, although it will rarely be a strict instance given the corrections and modifications usually made in the process of certification. For more on this, see the discussion of literary works as multiples in Chapter 6.

Corresponding to this distinction between two kinds of instances, we can define two kinds of multiplicity: a work is p-multiple if it is capable of having multiple p-instances that are strict e-instances of the work, and, as already stated, it can be e-multiple if it can have multiple strict e-instances.

In the case of e-multiplicity, the reason for defining multiplicity in terms of *strict* e-instances should be obvious. Trivially, any work allows of multiple things that can in a more limited way play the experiential role for that artwork. The high quality mounted reproduction of *View of Delft* that hangs in my study can certainly provide considerable insight into the perceptually appreciable properties of the painting, but this fact would not trouble those who wish to insist on the e-singularity of paintings. But what is the reason for defining p-multiplicity in terms of the possibility of having multiple p-instances that are *strict e-instances*?

Consider photographic and print works. While photographic works generally admit of a multiplicity of p-instances in virtue of the physical processes whereby they are produced—the use of what Nicholas Wolterstorff (1980) terms a 'production artifact' that allows multiple prints to be generated—some photographic artworks—daguerreotypes—are treated as p-singular.[5] The manner in which a daguerreotype is initiated results directly in an instance of the work, with no mediating role being played by a production artefact such as a negative or bitmap. But some print artworks that do involve the use of a production artefact—a 'matrix'—and that do allow for a multiplicity of p-instances do not seem, by their very nature, to allow for a multiplicity of p-instances that are strict e-instances. Consider, here, monotypes. In producing a monotype, an artist applies either oil paint or printer's ink to a flat unmarked surface—traditionally copper, zinc, or glass. The matrix is then covered with a sheet of paper and passed through a printing press. Clearly, it is possible to repeat this process, thereby producing multiple p-instances of the work. But monotypes are generally regarded as e-singular artworks—only the initial pressing from the matrix is regarded as a strict e-instance of the work. The reason for this is easily seen. Suppose that there were a practice in which a second (less detailed and colourful) impression taken from the matrix of a monotype also counts as a strict e-instance. This would be a very puzzling practice. For, on any standard understanding of how a print work's artistic vehicle articulates the work's artistic content, the properties distinguishing the first and second impressions drawn from the matrix of a monotype will be artistically relevant. Thus, even if both impressions are p-instances of the work,[6] one impression—the second—will presumably not fully qualify to play the experiential role and will thereby fail to be a

[5] This claim about daguerreotypes is not undermined by the historical process of 'redaguerreotyping'. See D. Davies (2015).
[6] This might in fact be questioned. If a p-instance of a multiple work initiated by means of a production artefact is the result of using that production artefact in the ways sanctioned by the relevant artistic practices, it might be argued that someone who produced a second print from the matrix used

p-instance that is a strict e-instance. If we want a notion of p-multiplicity that motivates the distinction drawn in our practices between monotypes and other kinds of print artworks, therefore, we must define p-multiplicity in terms of the possibility for multiple p-instances that are strict e-instances, and not merely the possibility for multiple p-instances per se.

Let me here briefly remark on a point of terminology for the remainder of this book. As we have seen, the distinction between strict and flawed instances is an epistemic one, measuring the extent to which something is fully qualified to play the experiential role in the appreciation of a work. It is, in other words, a way of classifying a work's e-instances. A work's p-instances may themselves be strict e-instances of the work, or they may be in some ways flawed e-instances (or, as in the example of a heavily eroded work of sculpture [see below], they may fail to be e-instances at all). For convenience, I shall henceforth talk of 'strict' or 'flawed' p-instances of a work, but this must always be understood as shorthand for talk of those p-instances of a work that are strict or flawed *e-instances* of the work. A strict p-instance, in other words, is (1) a p-instance that (2) meets the epistemic conditions to qualify as a strict e-instance of the work.

A work's p-instances will normally be among its e-instances, strict or flawed. I say 'normally' because a p-instance of a work *W* may over time lose so many of the properties bearing upon its playing the experiential role in the appreciation of *W* that it no longer makes sense to think of it as capable of playing that role. Consider, for example, some of the gargoyles on the exterior of Gothic churches that have been so weathered with the passage of time that none of their distinguishing features are now visible.[7] But, more significantly, given how the two notions have been defined, there is no principled reason why a work cannot have e-instances—and indeed strict e-instances—that lack the necessary causal history to be among its p-instances. A p-instance of a literary work *W1* that is also a strict e-instance of that work (that is, the text contains no typographical or other errors) may also be a strict e-instance of another work *W2*, generated in a very different art-historical context, with which it shares its text. This scenario is (imperfectly) exemplified in Jorge Luis Borges's short story *Pierre Menard, Author of the*

to produce a monotype is *not* using the matrix in ways sanctioned by the artistic practices applicable to monotypes. In that case, the resulting print would not be a second p-instance of the monotypes and, a fortiori, would not be a second *strict* p-instance of the work.

[7] It might be thought, however, that it is definitional of a p-instance of a work that it also be an e-instance. For, as just noted, what distinguishes a work's p-instance(s) from other elements entering into its provenance is that a p-instance is the first (kind of) artefact issuing from the creative activity generative of an artwork that, when completed, bears a sufficient number of the manifest properties required to play the experiential role in the appreciation of the work. But if, as in the case of our gargoyles, one of a work's p-instances—which by definition starts out life as an e-instance—loses its capacity to serve as an e-instance of the work, does it thereby also lose, from that time on, its status as a p-instance? I take it that it does not. Something is a p-instance of a work in virtue of its history of making, and this includes its capacity, at birth, to serve as an e-instance of the work. But this historically grounded status is unaffected by the kind of damage I describe.

Quixote (Borges 1970), where we are invited to imagine that, in France in the early twentieth century, one Pierre Menard contrives, without mere copying, to pen a text that is word-for-word identical to a *fragment* of Cervantes's *Don Quixote*. The scenario is better exemplified in Gregory Currie's thought experiment (Currie 1991) where we imagine discovering a previously unknown text by Ann Radcliffe that is word-for-word identical with Jane Austen's *Northanger Abbey*, but written, unknown to Austen, ten years earlier. These examples are normally put to philosophical use in arguing that the resulting texts will differ in both aesthetic and artistic properties, and that literary works therefore cannot be identified with their texts (see the later discussion of these issues and examples in Chapter 4). But in the present context the examples can be put to a different use. For it seems that in both cases the provenance of the particular text that I am reading will not affect my ability to fully experientially appreciate the works in question. This is obviously the case if we *do* identify a literary work with its text, since we will say that Radcliffe and Austen have independently authored *the same work*. But it will also arguably be the case if, as the above example assumes, we think that the individuation of literary works must take account not just of their texts but also of the literary-historical contexts in which those texts were authored. If I read what is in fact a text provenentially related to Ann Radcliffe's act of authorship while interpreting it in relation to the history of making of Jane Austen's work, my ability to fully experientially engage with Austen's work will in no way be compromised. Thus the text that is a p-instance (and a strict e-instance) of Radcliffe's work can also be a strict e-instance (but not a p-instance) of Austen's work.

1.2 Currie's 'Instance Multiplicity Hypothesis'

Since we have already granted that literary works are e-multiple, this result, while perhaps slightly counter-intuitive, will not call into question our working hypothesis that the distinction between 'singular' and 'multiple' artworks is to be drawn in terms of the e-multiplicity of the latter, but not of the former. What *would* call this into question would be a parallel argument applicable to our paradigm examples of artistic singularity, artworks in the visual arts. Just such an argument has been advanced by Gregory Currie (1989) in defence of what he termed the 'Instance Multiplicity Hypothesis' (IMH). All artworks, Currie claimed, can be multiply instantiated, the only obstacles to this being practical rather than theoretical.[8] Currie's arguments, to which we shall turn in a minute, clearly relate to e-multiplicity. If he is right, then no serviceable distinction between 'singular'

[8] A similar conclusion, albeit one drawn on different grounds, can be found in Strawson (1974).

and 'multiple' artworks can be drawn in terms of e-multiplicity. If, as I believe, Currie's argument—with some minor modifications—succeeds, this will require that we seek an elucidation of what it is to be a multiple artwork in terms of p-multiplicity rather than e-multiplicity. Such an elucidation will be one of the tasks of Chapter 2. First, however, I shall sketch and defend Currie's argument and try to answer the objections brought against it by his philosophical critics.

In arguing that all artworks can have multiple instances, Currie defines an 'instance' of a work in purely epistemic terms, as something that plays a particular role in our experiential engagement with that work. Instances are 'all those concrete things that we come into contact with when we experience a work of art' (Currie 1989, 5). I take the claim that all artworks are multiple, then, to be the claim that all works admit of multiple strict e-instances. In defence of this claim, Currie notes that, in the case of a supposedly e-singular art form such as painting, we can imagine a 'super-copier' that would produce a molecule-for-molecule duplicate of an original painting. This duplicate, *ex hypothesi*, will provide a perceptual experience in principle indistinguishable from that produced by the original, at least at the time the duplicate is generated (1989, 110–11). In this case, it is claimed, the super-copy and the original would be equally qualified to play the 'experiential' role in appreciation. Thus paintings can have multiple strict e-instances. It is only for technological reasons that this possibility cannot be realized at the present time. This result generalizes to other kinds of artworks ordinarily treated as being e-singular—for example, works of carved sculpture. Thus all artworks are in principle e-multiple.

In defending the standard understanding of the singular/multiple distinction against Currie, Stephen Davies (2003) acknowledges that Currie is not assuming, as an empiricist might do, that the identity of a work depends only upon its appearance. Currie is well aware that empiricism, were it correct, would entail the IMH. His view, however, defended in the earlier chapters of his 1989 book and elsewhere, is that provenance is partly constitutive of the identity of an artwork. But he also takes this to be compatible with the e-multiplicity of all artworks. Davies puts Currie's point this way: 'What is needed for aesthetic identification and appreciation is not information regarding the origin of the copy, but knowledge of the original's causal origin coupled with a guarantee that the copy is qualitatively identical at the physical level' (2003, 157). Davies grants that the super-copy of a painting might be 'an invaluable substitute' if one were for some reason unable to see the original, but insists that we would not thereby concede 'that the super-copy is an *instance* of the work that the painter painted. 'One might learn a great deal about the appearance of a work from something that looks like it, but similarity in appearance does not entail that the two are instances of the same thing.'[9]

[9] Davies, S. (2003, 158). See also Shields (1995).

Armed with our distinction between e-instances and p-instances, however, we can see that this final claim holds unproblematically only if we are talking about *p-instances* of works. In the case of e-instances, on the other hand, the kind of similarity in appearance canvassed in Currie's thought experiment *does* entail that we have two strict instances of the same work, and this is precisely the distinction upon which Currie wishes to insist in holding that the IMH is compatible with the view that works are partly individuated in terms of their provenance. As Davies's gloss on Currie's argument acknowledges, for the epistemic contextualist p-instances of a work bear upon its appreciation primarily because it is the history of making of a work's p-instances that directly or indirectly provides the context in which its strict e-instances have to be located if the work is to be properly appreciated. It is, then, the notion of p-instance that, for the contextualist, bears directly upon the *individuation* of works. In claiming that all works are e-multiple, Currie need not deny that some works—such as paintings and works of carved sculpture—are p-singular. If the IMH is a claim about strict e-instances, then Currie can freely grant Davies's claim as a claim about p-instances. Since Davies grants that the super-copy can play the same *purely epistemic* role as the original, he seems to agree that even paintings are e-multiple. But then he leaves Currie's IMH unimpugned, if Currie's point is that p-multiplicity/singularity and e-multiplicity/singularity can come apart.

It might be thought, however, that this response misses Davies's point. The objection against Currie, it might be said, is that he is wrong to talk, in the case of paintings, about multiple instances rather than multiple *copies*, given the 'real differences' in the way we talk in our ordinary artistic practice. But even if there were a firm difference between 'copies' and 'instances' (or, perhaps more charitably to Davies given my earlier remarks about the term 'instance', between 'copies' and 'originals') in our ordinary talk about paintings, this would not count against Currie. For the 'super-copier' thought experiment is intended to test our intuitions on a case where the practical equivalence between p-instances and e-instances of purportedly singular artworks comes apart. In practice, the only things we treat as e-instances of paintings are their p-instances. But this may be because, as Goodman (1976) suggests, we have no way of identifying a work's e-instances save in terms of their being p-instances. Currie's 'super-copier' thought experiment presents us with a situation in which we have something that we know is capable of doing what a work's (strict) e-instances do. So why should we refuse in this case to view it *as* a (strict) e-instance, given the purely epistemic nature of the latter?

But is Currie right in insisting that all works are e-multiple? I sketched above what is essentially a modified Currian account of literature which I believe to be strongly intuitive. *Ex hypothesi*, Jane Austen's *Northanger Abbey* and Ann Radcliffe's *Northanger Abbey* in Currie's thought experiment have identical texts. Thus it surely does not matter if, in trying to appreciate Austen's work by

reading a given text, the text I am reading stands in a historical relationship to the writing activity of Radcliffe or to that of Austen. In other words, it does not matter whether the text is a p-instance of Radcliffe's work or a p-instance of Austen's work. All that is necessary, for the contextualist, is that I locate the textual properties of what I am reading, whatever its own history of making, in the context of Austen's act of authorship. It is knowledge of the provenance of p-instances of Austen's work that must be brought to bear on the text in front of me if I am to appreciate Austen's work in reading that text. All that is required of the text itself, however, is that it be a strict e-instance of the work, and this is guaranteed in the hypothetical situation we are considering since the works by Radcliffe and Austen have identical texts.

It is important to be clear what the foregoing argument purports to establish. It is *not* supposed to show that literature is e-multiple, since this is not something that could plausibly be disputed. As we saw in the Introduction, Magda and Berthold's heated discussions about literature can proceed untroubled by the fact that they read different (strict) copies of a given novel. What is being claimed, rather, is that a literary work can have strict e-instances *that are not among its p-instances*. This bears upon the IMH because the latter requires that this also apply to an art form like painting where a work has only a single p-instance. It may be helpful, here, to consider whether other indisputably e-multiple art forms are like literature in this respect, and whether this then provides a general strategy for defending the IMH. Let us consider, in this respect, performable works of music.

It might be tempting to offer an argument regarding performable musical works that closely mirrors the one just offered for literary works. Suppose that we have two scored works, *MW1* and *MW2*, with *identical* scores composed in very different musico-historical contexts. For a contextualist like Jerrold Levinson, the scores will be scores for *different* musical works, as his examples in support of the 'fine individuation' of musical works (1980) are intended to show.[10] Suppose the works in question are both string quartets, and suppose that a group of musicians G intends to play *MW1* but that, unbeknownst to them, the score used in their performance is historically related to the composition of *MW2*, not to that of *MW1*. The scores for the two works are, of course, not themselves p-instances of the works since they do not possess the relevant experienceable properties bearing on the works' appreciation. But the status of a performance as a p-instance of a given musical work might be thought to depend upon the provenance of the score that guides the performers, since the score mediates between the compositional activity of the composer and the performance. In that case, G's performance would be a p-instance of *MW2* and not, as they

[10] I discuss these examples in Chapter 4.

intended, a p-instance of *MW1*. But, by analogy with the literary case, it might be said that the performance, if it is not flawed, can serve as a strict e-instance of *MW1* that, if heard in light of the provenance of *MW1*, might enable the listener to fully appreciate that work.

But there are at least two problems with this argument. First, why should we say that it is the provenance of the score rather than the performative intentions of the performers that determines the work of which their performance is a p-instance? The performance will be guided by the intention to perform the work having the provenance of *MW1*, and this seems to provide a stronger grounding for being a p-instance of that work than the grounding provided by facts about the actual score used. Second, and closely related, the audible qualities required in a strict e-instance of a musical work are determined, for the contextualist, not merely by the score but also by the interpretative and performative norms in place in the musical community assumed by the composer. As Wolterstorff (1975, 332) notes—a point to which we shall return later—many of the defining features of a classical musical work are not to be found in the score. So, if G are intending to perform *MW1*, which differs from *MW2* in terms of the norms operative in the performing community intended by its composer, their performance may very well *not* qualify as a strict e-instance of *MW2*. For, given G's intention to perform *MW1*, the directions in the score may not be interpreted in the manner necessary if their performance is to qualify as such an instance.

But suppose, like Levinson (see Chapter 4), one takes the performance means specified by a composer to be partly constitutive of a musical work. Then we might give another argument for the possibility of strict e-instances of musical works that are not p-instances of those works. A performance of a performable musical work makes available to members of the audience certain audible qualities bearing upon the appreciation of the work performed. Suppose, as Levinson maintains, that these qualities include the timbral properties that would be generated if an occurrence of the prescribed sound sequence were generated on the instruments specified by the composer. A performance of a given work on these instruments might, *ex hypothesi, sound* the same as a contextually sensitive performance of the work's score on a perfect timbral synthesizer (PTS) able to exactly replicate the sonic output of any particular instrument. In such a case, the same merely audible properties bearing upon the proper appreciation of the musical work will be present in both performances.[11] So, in this respect at least, it will not matter which kind of instrumentation has been used in generating the performance to which we listen. The contextualist may insist that it matters for the appreciation of the musical work what instrumentation was intended, and in

[11] Note that I have not ruled upon whether the execution of the work's score on a perfect timbral synthesizer counts as a performance *of the work*. Musical theorists disagree about this, but we do not need to take a stand on this issue.

what musico-historical context the prescriptions with which the performance complies were laid down. Appreciation of the musical work, then, may require that we *hear* the audible properties common to the two performances *as* played on the prescribed instruments and *as* composed in a particular musico-historical context. But it seems that the performance employing the PTS can serve equally well as a source of the timbral sonic qualities required in strict e-instances of the work. This performance will not count as a p-instance of the work if we hold, plausibly, that where performers knowingly disregard a composer's instructions to perform the work on specified instruments, then, rather than being a *flawed* p-instance of the work, the performance is not a p-instance at all. But, given that we have defined e-instances purely in terms of the distinctive experiential role that they play in appreciation, both performances will count as strict e-instances unless there is some other salient difference between them bearing on their possession of this status.

Levinson, however, might insist that there *is* such a salient difference.[12] He has argued that the expressive qualities that we ascribe to a piece of music may depend in part upon the physical nature of the activities that we take to be involved in producing the sounds we hear. Suppose that *MW1*, composed for performance by a string quartet, is properly taken to possess such expressive properties. These properties, however, might not be graspable by the audience attending a performance which makes manifest the timbral sonic qualities of the work but overtly does so by means of a perfect timbral synthesizer. If we seek to grasp the expressive properties of the work through our experiential engagement with an event that exhibits the manifest properties bearing experientially on its proper appreciation, then the work will not be properly appreciable by those who attend the performance on the PTS. The latter, then, will not be a strict e-instance of the work since audience members will fail to accurately grasp at least some of the work's expressive properties. Suppose, for the sake of argument, that we grant this.[13] The proponent of the IMH can still make her point in the following way. Unless we hold that only a live performance of a musical work can serve as a strict e-instance of that work, we can run the above argument for those strict e-instances that are *recordings* of performances. As long as I hear the timbral sonic sequence in such a recording *as* produced on the intended instruments, I can grasp the work's expressive properties even if the sounds I hear were actually produced by a PTS. Thus the work can have strict e-instances that are not p-instances.

If we acknowledge the different contributions made by p-instances and e-instances to the individuation and appreciation of musical works, the following

[12] Levinson (1990b).
[13] There is at least one reason why we might *not* wish to grant this. It might be argued that in the described situation we have a genuine strict e-instance of the work but that those whose appreciation is affected by seeing the performers using the PTS stand in an imperfect epistemic relationship to that strict e-instance. For the significance of this distinction in other contexts, see Davies, D. (2019).

picture recommends itself. Performances of a work are to be identified in terms of the intentional-causal relation in which the performers stand to the composer's act of initiating the work, taken together with the requirement that they recognizably realize the work's prescribed sonic sequence. A performable work's performances and those recordings of these performances that present the same array of acoustic properties to the receiver are the work's p-instances, whether or not they contain some flaws. Given that we require that a strict e-instance of a performable work contains no such flaws, a work can have performances (p-instances) that are not among its strict e-instances. But a musical work can also have strict e-instances that are not among its performances (p-instances). For a performance, or a recording of a performance, that does not qualify as a p-instance of a particular performable musical work can nonetheless serve as a strict e-instance of that work, just as a p-instance of Radcliffe's *Northanger Abbey*—defined in term of its history of production—can serve as a strict e-instance of Austen's work.

This should not surprise us. It is a possibility that arises because the notions of performance (p-instance) and strict e-instance are doing different kinds of jobs. The notion of performance (p-instance) helps us to keep track of which playings/recordings are playings/recordings *of* a given work in a way that does not invest all authority in the score but accords a role to history of production. It allows us to evade the radically revisionary implications for our ways of classifying performances if we accept the infamous 'Goodman argument' in *Languages of Art* (Goodman 1976, 187).[14] The notion of strict e-instance, on the other hand, picks out a particular role that something can play in the appreciation of an artwork in virtue of its manifest properties alone. It is possible for a performable work to have strict e-instances that are not performances because an event can play the relevant role in appreciation without standing in the relevant causal-intentional relation to the composition of the work.

Once we grasp the importance of this distinction, it seems that it can obtain, at least in principle, in any art form. The Currian super-copy can indeed be a strict e-instance of a painting, without standing in the right causal-historical relation to the painter's activity to be the sole p-instance of the work. But it is the causal-historical relation in which the painter stands to the original, *qua* sole p-instance, that determines, at least for contextualists, many of the kinds of considerations that need to be brought to bear in properly appreciating the artwork on the basis of the manifest properties that, *ex hypothesi*, the original and the super-copy share. Forgery matters, in the case of paintings, for the reasons Goodman cites (1976, ch. 3). We are unable, in practice, to know whether a given entity *is* a strict e-instance of a work without referring to its history of making. Only because such

[14] For an extended critical discussion of this argument, see Davies (2011, 58–65).

knowledge is guaranteed in Currie's super-copier example is the copy an indisputable strict e-instance of the work, at least at the time when the copy is made and assuming that the original at that time is itself a strict e-instance of the work.

1.3 Challenges to the IMH

The foregoing reasoning presents a defender of the e-singularity of at least some kinds of artworks with the following options: either (1) dispute the proposed account of literary works whereby their e-multiplicity can include strict e-instances that are not p-instances, or (2) challenge the extension of this account to other art forms. If the first option is unpromising, the defender of e-singularity must argue for the second. I shall consider two ways in which such an argument might go, the first by Jerrold Levinson and the second by Noël Carroll. I shall argue that in neither case is the foregoing argument for the e-multiplicity of painting undermined. However, Carroll's discussion allows us to clarify the conditions under which a work *might* be e-singular, and to see how at least some artworks might meet those conditions. Thus the IMH fails as a claim about the e-multiplicity of *all* artworks, even if it succeeds for those works traditionally taken to be paradigms of singularity.

1.3.1 Levinson

Levinson offers two reasons for denying that the Currrean super-copy of a painting can serve as a strict e-instance of the work. First, he argues that an original canvas, unlike its super-copy, puts us in direct connection with the creative activity of the artist.[15] The brushstrokes on the original painting issue from the artist's hand, whereas the 'brushstrokes' on the molecule-for-molecule copy do not. But, granting this to be true, how does it bear on the status of the super-copy as a strict e-instance of the work? A strict e-instance of a work, we may recall, is something that has all those perceptible properties necessary to provide us with the kinds of experiences required for the proper appreciation of the work. Is a sense of being in direct connection with the artist's creative activity a necessary element in this experiential dimension of appreciation? If we answer this question positively for painting, why shouldn't we (implausibly) hold literature accountable to the same standards? If the sense of being in direct experiential contact with the artist's creative activity is a necessary element in the experiential engagement required to properly appreciate a painting, why do we not require, for the proper

[15] Levinson (1996, 141–4).

appreciation of a literary work, an experiential engagement with the original manuscript? For the original manuscript is the only manifestation of the textual properties necessary in anything that is to play the experiential role for the appreciation of the work that issues *directly* from the creative activity of the artist.

Levinson counters this response by suggesting two kinds of disanalogies between painting and literature. First (1996, 141–4), he maintains that the expressiveness of a painting derives in part from gestural qualities of the actions whereby the painter marked the canvas, whereas none of the expressiveness of a literary work depends upon similar qualities of the actions whereby the author inscribes the manuscript. Furthermore, he claims, 'we can more transparently and vividly imagine the artist's gestural action in creating the painting...when we know the object in front of us was actually and directly the result of such action'. This seems to give insufficient credit to our imaginative powers, however. If I know that the original bears exactly the same types of markings as the super-copy, it is surely no more difficult to imagine the kinds of gestural actions that would be required to produce such markings if I know I am looking at the super-copy than it would be if I knew I was looking at the original.

Levinson's second kind of disanalogy between painting and literature might not only bolster his first argument against the IMH but might also serve as a separate such argument.[16] If we attempt to appreciate a painting through an experiential engagement with its super-copy, Levinson maintains, we fail to honour and acknowledge the artist's intentions as to the nature of the work. For the artist intended the work to be a physically incarnate unique image. The painter's intentions here contrast with those of the novelist. Even if only one manifestation of the textual properties of a literary work stands in an unmediated relation to the creative activity of the author, we assume the author intended her work to be appreciable through the multiple copies generated from this manifestation, all of which thereby function as p-instances of the work. So, while we can honour the author's intentions as to the nature of her work by reading copies generated from the original manuscript, we cannot honour the painter's parallel intentions by experientially engaging with the super-copy.

Perhaps some painters would happily embrace the possibility that their works be more widely appreciated by means of super-copies. But let us grant, for the sake of argument, Levinson's claims about the different intentions of the author and the painter. The salient question is how this difference calls into question the status of 'copies' of their strict p-instances as strict e-instances of those works. We have not rehabilitated the idea that experiential engagement with the work

[16] Levinson suggested such a disanalogy in a commentary on an earlier version of this argument presented at a symposium on 'Multiple Artworks' at the 2009 meetings of the American Society for Aesthetics in Denver, Colorado.

requires the sense of engaging directly with the artist's creative activity. For if this feeling is relevant for the appreciation of the painting, then it should be relevant for the appreciation of the novel, whatever the author's intentions. And, even if the painter intended that the work be appreciated through engagement with the original, it is not clear why this prevents the super-copy from furnishing the receiver with the necessary experiential engagement with the work. For the super-copy possesses all the properties required in a strict e-instance save the capacity to generate the 'sense of being in touch with the creator'. More significantly, the difference in intentions to which Levinson alludes can indeed enter into our appreciation of the painting and the novel, even if we count the super-copy of the painting as a strict e-instance of the work. For knowledge of the respective intentions of author and painter concerning the p-instances of their works will be part of the knowledge of provenance that we bring to our engagement with the super-copy and the copy of the novel, and thus part of our sense of what the work is, if contextualism is correct. It is unclear why the bearing of these intentions on the proper appreciation of the work requires that the intentions constrain what counts as a strict e-instance of the work, rather than supplementing the knowledge of provenance that we bring to our engagement with the work's strict e-instances.

1.3.2 Carroll

Noël Carroll argues that the Curriean account cannot accommodate the manner in which visual artworks change over time.[17] Nor can it accommodate works that may be *intended* to change over time, such as the 'earthworks' of artists such as Robert Smithson. I shall consider each kind of case in turn and argue that the works in question are indeed e-multiple, as the IMH requires. I shall then turn to another related kind of case that proves more problematic.

Consider the ways in which a visual artwork such as *View of Delft* can change over time through the working of natural forces on the physical elements of which its vehicle is composed. Carroll claims that the original painting and its Curriean super-copy will almost certainly undergo *different* such changes and thereby come to have different manifest properties. The assumption is that, for this reason, the super-copy cannot be a strict e-instance of the work and the work must be taken to be e-singular. We can meet this objection, however, if we attend to the role that the original painting, as p-instance, plays in determining the properties required in strict e-instances of the work. There are, I think, two possibilities, each of which might, but need not, be grounded in intentions of the artist.

[17] Carroll (1998, 219–22).

(I) It might be held that, barring intentions by the artist to the contrary, strict e-instances of a visual artwork must possess the manifest properties of the original at the time when it was completed. In this case, as the original painting changes over time, it will itself cease to be a strict e-instance of the work, although, as the unique p-instance, it provides us with evidence that bears upon the properties a strict instance of the work would have to possess. We might view in this way some of Turner's watercolours which were deliberately painted using 'fugitive' pigments. The latter offer much richer and brighter visual properties when a work is painted, but the cost of these heightened visual properties is that the colours fade more quickly. To appreciate such works properly, it might be argued, we must experientially engage with something possessing the same manifest features as the original did at the time it was painted. But then the work will be e-multiple in virtue of the possibility of making a super-copy of the original at the time of its creation. The original or the super-copy (or both) may alter over time and cease to be strict e-instances. This does not affect the e-multiplicity of the work, however, given the modal nature of the multiple/singular distinction.

(II) Alternatively, we might hold that the standard against which strict e-instances of a painting are to be measured itself changes over time in tandem with changes in the manifest properties of the sole p-instance of the work. In this case, a super-copy of the work made at t may no longer be a strict e-instance of the work at $t+1$. But at $t+1$ we can make another super-copy of the painting which *will* be a strict e-instance of the work at $t+1$, again demonstrating the e-multiplicity of the work.

Works that are *intended* to change over time present a more interesting challenge to the idea that all works are e-multiple. Carroll begins with examples of 'site-specific' art, where works owe at least part of their artistic character to their environments. This in itself does not pose a problem for the proponent of the e-multiplicity of all artworks. Consider, for example, certain Renaissance religious images that depend for some of their formal and expressive qualities on architectural features and ambient lighting in the locations where they were intended to be viewed. Works such as Piero's *The Legend of the True Cross* cycle, for example, can arguably only be properly appreciated if viewed under the conditions that obtain when they are viewed *in situ*, in the basilica of San Francesco in Arezzo. But while the original location is singular, the conditions that obtain in that location are at least in principle replicable elsewhere. Thus 'site-specific' works can have multiple strict e-instances as long as the conditions under which the works are presented for appreciation *in situ* can themselves be duplicated and super-copies of the painting can be viewed in these duplicated conditions.

Some site-specific works, however, depend not upon the conditions in place at a particular site, abstractly conceived, but upon the site's history. Helen Chadwick's *Blood Hyphen* (1988), for example, was created for the Woodbridge Chapel in Clerkenwell, and its content draws in a number of ways upon the history of the chapel (which served as a medical mission after the Second World War) and its unique architecture (a false ceiling installed in the 1970s, which created the hidden upper chamber in which Chadwick staged her work).[18]

The more interesting cases, however, are ones where the intended site of the work plays a more dynamic role, so that elements in the original constitution of the piece 'are altered over time by the conditions of the surrounding environment in ways that are intended to constitute parts of what viewers are to take as their objects of appreciation'. Carroll cites as an example Robert Smithson's *Spiral Jetty*. This was constructed on a site notable for its unique possession of a certain strain of algae that guaranteed the reddish hue that he was after, and the shape of the jetty was a response to the formation of the surrounding site. Moreover, part of what was to be appreciated in the work was the differing appearance of the jetty as the water levels altered.[19]

The significance of such works, according to Carroll, lies in the fact that 'the very vicissitudes these works undergo as they interact with their actual environments are part of what these works are about. These works are involved with processes, not merely with products.' Such works, he maintains, cannot plausibly be dealt with by the 'super-copier' strategy, because 'it is hard to imagine that, in the known physical universe, one could regularly replicate the exact processes undergone by the original site-specific works by means of Currie's super-Xerox machine'. Even if we could replicate the initial site-specific situation, it is difficult to imagine that we could also replicate the transformative events in the subsequent history of the piece. But, in the absence of such replication, Carroll claims, the works will be different.

Let us grant that we cannot replicate the temporal evolution of a work such as *Spiral Jetty*. How does this bear upon whether the work is e-singular or e-multiple? To answer this question we must ask what conditions must be met by a strict e-instance of such a work, and whether more than one entity can meet these conditions. What kind of experiential engagement is required if we are to properly appreciate Smithson's work? For example, does one have to observe the actual site from time to time through its changes, or even observe it continuously throughout its entire evolution? If so, then it might indeed be said that the work is e-singular, but as a consequence few, if any, people—Smithson included!—can claim to have

[18] I am grateful to Robert Hopkins for raising this kind of general possibility. If it be granted that works like Chadwick's *are* e-singular, this would require minor modification of the conclusion drawn in Section 1.4 below about the scope of the IMH, but would preserve the idea that p-multiplicity is what is at issue in philosophical inquiry about multiple artworks.

[19] Carroll (1998, 220).

had the experience necessary to properly appreciate the work.[20] But suppose Smithson did not intend that his work only be appreciable by receivers who spent a large portion of their lives camped out in the proximity of the site. Suppose, rather, that his intention was that we have access to the relevant processes and changes through the *documentation* to be found in galleries that present the work—documentation comprising texts, photographs, and videos. Insofar as the work is about the processes that occur, our experiential engagement with these processes is mediated by such documentation. But the documentation itself is multiply reproducible—we can have the necessary experiential engagement with such a work wherever a copy of the relevant documentation is provided. We then appreciate the work by relating the experiences elicited in us by the documentation to our knowledge of its provenance, the events documented that took place at the site selected by the artist. The work in this case has a single strict p-instance—the documented unfolding of events at the site of the work in Utah *insofar as these events exemplify certain more general operations and forces operative in nature*—and multiple e-instances—namely, all those copies of the relevant texts, photographs, and videos that one finds in different galleries that allow us to have experiential access to the way in which these natural forces governed the development of *Spiral Jetty* over time. In this case, the work is unproblematically e-multiple without any need to appeal to super-copiers.

In the case of 'earthworks', I have argued, it might be claimed that our experiential appreciation of the element of process in the work does not call for a direct experiential engagement with that process as it unfolds, and thus is compatible with the claim that such works are e-multiple once we clarify what is required in strict e-instances. But other artworks that comprise an essential element of process arguably *do* call for such a direct experiential engagement with that process as it unfolds. Where these works are p-multiple, as in the case of multiply performable works of music, this fits easily with the e-multiplicity of the works. But what if, in such a case, the work is p-singular?

The relevant cases here will be individual events, either performances of performable works or improvised performances, that we wish to classify as artworks. Take, for example, Keith Jarrett's *Köln Concert*. We have here a wholly improvised performance that is widely regarded as being a work of art. There is no

[20] Suppose it were said that proper appreciation of the work required that one visit the site at least once. The problem is that, if the changes undergone over time by the installation are central to the work, these changes would not be apparent on a single visit. In fact, the underlying question with respect to Smithson's work is the nature of its p-instance. Is the work's p-instance the entire unfolding natural process in all its detail—in which case no one can claim to have more than a rudimentary appreciation of the work? Or is it, as I go on to suggest, the more general operations and forces exemplified in that natural process, in which case its e-instances will be the relevant documentation? We might compare this to a work of performance art such as Vito Acconci's *Following Piece*. Here we have no photographic documentation of his enactment of the prescribed performance, but take the proper focus of our appreciative attention to be the *type* of thing done, as illustrated in four photographs staged after the event.

pre-existing *performable work* of which the *Köln Concert* is a performance, nor a performable work brought into existence by the performance.[21] The work then is presumably p-singular. But what should we say about its strict e-instances? Again, we must ask what conditions must be met by its strict e-instances, and whether more than one entity can meet these conditions. With what entities might we experientially engage in order to meet the experiential requirement for the proper appreciation of the *Köln Concert*? One option would be to say that one can meet this requirement only if one was present at the Opera House in Cologne on 24 January 1975. 'You had to be there', it might be said, to fully appreciate such a work: only someone present at the concert could properly appreciate the spontaneous nature of the composition, and this is an essential experiential dimension of the piece. If we take this option, it will turn out that there are indeed some works that are e-singular: the sole strict e-instance of the work is the event that took place at the foregoing time and place. The full appreciation of these works, it will be claimed, requires that we experientially engage with the very history of making that confers upon a particular event the status of sole p-instance, and that we do so in an unmediated way.

However, we might resist such an austere view. Why can't Jarrett's work be properly appreciated through an experiential engagement with a *recording* of the performance, either audiovisual or audio, as long as this engagement is suitably informed by knowledge of the performance's history? Such an engagement, it might be argued, will allow the listener to hear the recorded sounds *as* a spontaneously generated sound sequence, and thus to appreciate the work as an improvisation, even though there is no direct engagement with the work's singular p-instance. At least on the first occasion of hearing such a recording, the listener can share with those present at the recorded event a sense of the adventurous and exploratory nature of the performance. This approach mirrors our earlier treatment of literary and classical musical works in holding that what matters is the knowledge that informs our experiential engagement with something fully qualified to play the experiential role for a work rather than the provenance of that entity, and it would make even a work such as the *Köln Concert* e-multiple. It might even be argued that an authorized (or even an unauthorized?) recording of Jarrett's performance is itself a p-instance of the work, but we need not pursue this point here.

1.4 Conclusion

In light of these reflections, we can now propose the following modified version of Currie's 'Instance Multiplicity Hypothesis'. A work is e-multiple unless (a) it is

[21] See my discussion of this work in Davies (2011, 135–43, 158–60).

p-singular, and (b) a strict e-instance of the work requires direct experiential engagement with the provenance of its singular p-instance. If, therefore, the multiple–singular distinction is to mark a genuine difference between art forms such as music and literature, on the one hand, and painting and carved sculpture, on the other, it must be defined not in terms of the capacity for multiple strict e-instances but, plausibly, in terms of the number of *p-instances* that a work can have. For reasons noted in the earlier discussion of monotypes, however, what matters is the capacity to have more than one p-instance that is also a *strict e-instance*. The claim then, expressed in the terms introduced in Section 1.2, is that the multiple–singular distinction must be drawn in terms of whether a work admits of a multiplicity of strict p-instances if it is to mark a salient difference between artworks or art forms. The distinction is between artworks or art forms that are 'p-multiple' and those that are 'p-singular'. A work that allows for a multiplicity of strict p-instances ipso facto allows for a multiplicity of strict e-instances, although, as we have seen, the converse does not hold. If we were able to guarantee a process that reproduced every perceptible property of a painting, painting might allow for a multiplicity of strict e-instances while remaining p-singular in virtue of the role that an original canvas plays in determining just which features must be possessed by a strict e-instance of the work.

Thus, if we accept Currie's argument for the IMH—and thus for the e-multiplicity of nearly all of those artworks normally regarded as singular—then it would seem that a serviceable conception of multiple artworks must rest upon their being p-multiple rather than e-multiple. But, while we have an intuitive sense of what makes a work e-multiple—albeit a sense that may misrepresent the extent of the phenomenon—it is less clear why certain works should be p-multiple while others should not. Until we have thrown some light on this, we might wonder whether p-multiplicity will be found to be as indiscriminating as e-multiplicity. To clarify these matters, and to calm such worries, we shall turn in the next chapter to another influential thread in the literature on multiple artworks. Indeed, as we shall see in the following chapters, this thread has motivated the dominant approach to the ontological nature of such works.

2
Multiple Artworks as Abstract Entities
An Introductory Overview

2.1 The Origins of Contemporary 'Type' Theories of Multiple Artworks

2.1.1 Richard Wollheim on Multiple Artworks as 'Types'

At the end of the previous chapter I suggested that, to calm any concern that p-multiplicity might turn out to be as unpromising as e-multiplicity for elucidating the intuitive distinction between singular and multiple artworks, we might turn to another influential thread in the literature. The thread in question originates in Richard Wollheim's *Art and its Objects*.[1] Wollheim begins by rejecting one kind of general question about art in favour of another. The question rejected is 'What is art?', taken as a request for a definition of the term 'art' or the term 'artwork': such a definition would provide necessary and sufficient conditions for something to be art, or to be an artwork. Wollheim's proposal is that we should not assume that there is something that distinguishes all artworks from all other things, but we should ask whether, in the diversity of things that we treat as artworks, there may at least be some common features. He suggests that we might make more progress if we ask as to the *general kind* of entity to which artworks belong. This will give us a *necessary* condition for something's being an artwork, but it will not give us a *sufficient* condition. By analogy, it is a necessary condition for something to be a sparrow that it be a bird, but clearly not all birds are sparrows.

Wollheim's provisional answer to this question is that all artworks are *physical objects*. He terms this the 'Physical Object' (PO) hypothesis. The PO hypothesis is open to two kinds of challenge, which correspond, he observes, to 'a division within the arts themselves' (Wollheim 1980, 4). The first challenge is that in certain arts, such as classical music and literature, there is no physical object or event plausibly identifiable as the work of art. The second challenge is that, in those arts such as painting and sculpture where there *is* a physical object with which one might identify a work, there are compelling reasons to reject such an identification.

[1] Wollheim (1980).

It is obviously the first challenge, and the suggested 'division within the arts themselves', that bears upon our current concerns. Wollheim maintains that in art forms like literature and music there is no physical object or event plausibly identifiable with the work. Physical objects, and other concrete particulars such as events, exist at determinate times and, at those times, occupy determinate regions of space.[2] But nothing enjoying determinate spatio-temporal existence can plausibly be identified with a literary or a musical work.[3] The only candidates might be *copies* of books, or *scores* of musical works, or (if we allow not merely physical objects but spatio-temporally locatable events) *performances* of musical works or plays. But the works themselves cannot be identified with such entities for a number of related reasons. First, the existence of a literary work is usually unaffected by the destruction of individual copies of that work. Second, performances of a musical work often possess properties that differ from those rightly ascribable to the work: there can be limp performances of a stirring work and vice versa, for example. For similar reasons, Wollheim rejects the suggestion that we identify a literary or classical musical work with the *author's manuscript* or the *original score*. In the literary case, the manuscript may have properties that the work doesn't possess, and the work can (and very frequently does) survive the loss of the original manuscript. Parallel considerations apply in the musical case. Nor can we preserve something like the PO hypothesis by identifying works with *classes* of objects—whether classes of copies of texts or classes of performances. If the literary work is a *class of copies*, then the work *Ulysses* is not complete as long as further copies are being produced. Similarly, if the *Enigma Variations* is the class made up of its performances, the work remains incomplete as long as it is still being performed. Second, all unperformed musical works will be identified with the empty set. And third, we cannot explain why we group texts or performances in the way that we do, since, on this view, it is *only in virtue of being so grouped* that something counts as a copy of *Ulysses* qua work. But we would normally say that we group certain texts or performances together *because* they are copies or performances of the same work rather than vice versa.

Given such considerations, Wollheim suggests that we should identify literary and classical musical works with whatever guides us in classifying instances as instances of a particular work. He therefore proposes (Wollheim 1980, 74) that we identify literary and musical works with *types*, where the physical objects or events that are central to our appreciation of such works are *tokens* of those types. He draws a distinction here between particular things and what he terms *generic*

[2] I bracket here concerns about the determinacy of such matters at the quantum level.
[3] As we shall see, this will be disputed by those seeking to offer sophisticated materialist accounts of multiple artworks—see Chapter 8 below).

entities—entities that by their very nature have, or could have, other entities as *elements*. Our interest in generic entities is largely an interest in the groupings of elements that fall under them.

Wollheim maintains that we can distinguish between kinds of generic entities according to the relationships that obtain between them and their elements. He compares and contrasts the relationships between (1) *types* (e.g. the word 'red') and their *tokens*, (2) *classes* (e.g. the class of red things) and their *members*, and (3) *universals* or properties (e.g. redness) and their *instances*, with reference to how the generic entity can share properties with its elements. The crucial distinction, he maintains, is between *shared* and *transmitted* properties. Two entities A and B share a property if they both possess the property. For a property *f* to be *transmitted* between A and B, on the other hand, it must be the case that A has *f because* B has it, or vice versa. Classes only contingently share properties with their members—for example, the class of slowly growing things may as a matter of fact be slowly growing—so no properties are transmitted. Universals, by contrast, may not only share properties with their instances but also transmit some of these properties. For example, redness is exhilarating *because* red things are exhilarating. Properties can also be transmitted between types and their tokens. For example, the property of being blue and yellow is transmitted between the Swedish flag, qua type, and individual Swedish flags, qua tokens.

But, Wollheim argues, there is a crucial difference between universals and types. Instances of universals cannot transmit any properties they have *necessarily*. An instance of redness *must be* both red and coloured, for example, but redness itself is neither red nor coloured. But, if we exclude properties that a token has purely in virtue of being a *token*—for example, having a determinate spatio-temporal location (Wollheim 1980, 76)—*all and only* those properties a token has necessarily in virtue of being a token of a given type are transmitted between the tokens and the type. Furthermore, such transmitted properties include not only those properties *required* (in some sense) to be a token of the type, but also other properties that are in some sense *entailed by* those properties. For example, individual red flags transmit to the Red Flag the property of inspiring revolutionary fervour in the heart of any true socialist!

We might note here that this explains why Wollheim takes the *second* kind of challenge to the PO hypothesis to be the crucial one. The second kind of challenge, we may recall, maintains that if we identify paintings with marked canvases, and works of sculpture with blocks of marble or other materials, such physical objects could not possess the sorts of representational and expressive properties that we ascribe to these works. First, it is claimed, *as a matter of fact*, artwork and physical object can have incompatible representational properties. Donatello's *San Giorgio* can be said to 'move with life', whereas the block of marble with which we might try to identify it is motionless and inanimate. Second, it is claimed, artworks have expressive properties that *no mere physical object* could possibly have. For

example, critics have said that *La Donna Velata* by Raphael is dignified, but this is surely not a property that a mere physical object like a canvas could have.

Wollheim thinks the proponent of the PO hypothesis can accommodate the representational properties of artworks by taking them to be properties that we can *see in* a physical object (or, in his earlier formulation, that we can see it *as*).[4] The expressive properties of artworks, on the other hand, can be accommodated if we take them to be determined by the kinds of emotional states that might be thought to have entered into the *production of,* or to be *produced by*, a physical object. We need not consider the merits of these proposals here. What we can note is that, if they were accepted, then we could explain the representational and expressive properties of artworks that are not *themselves* physical objects if they are types whose *tokens* are physical objects. For such *tokens* can presumably *transmit* their *representational and expressive properties* to the types of which they are tokens so that the works themselves are correctly said to have those properties.

Returning to our immediate concerns, Wollheim claims that we generally postulate *types* when we can correlate a class of particulars—whether objects or events—with a piece of human invention (1980, 78). The particulars may then be viewed as *tokens* of the type established by that piece of invention. He then considers a number of ways in which types can result from a piece of human invention. First, someone may produce a particular object or event and then others may copy it. The 'goth look' would be an example of this. Second, someone may draw up a set of instructions for generating an indefinite number of particulars. For example, a chef may produce a recipe for a signature creation and others may produce particular dishes that are tokens of that creation. Third, a particular object or event may be produced with the intention that it be copied. The object then serves as a model or prototype of the resulting type. Wollheim offers the Boeing 747 as a non-artistic example. Finally, a type may be initiated through the production of an artefact that, when used appropriately, generates those particulars that are tokens of the relevant type. This would apply to postage stamps and coins, for example.

Wollheim argues that those artworks properly regarded as types originate in a piece of human invention in one of these ways, and his proposal has been echoed in writings by other authors (e.g. Wolterstorff 1980, 90 ff.; S. Davies 2003, 159–63). Suppose we use 'initiate' as a neutral term for the artistic activity that brings it about that a new artwork becomes available for appreciation through its instance(s). This term can be applied across the arts and carries no commitment as to whether initiation is creation or discovery. Echoing Wollheim and the other authors just listed, we can identify three ways in which multiple artworks can be

[4] See 'Seeing-as, seeing-in, and pictorial representation', in Wollheim (1980, 205–26).

initiated. First, as in the case of literary works, an artist's activity may bring into existence an exemplar which, when certified in accordance with relevant artistic conventions in place, furnishes the conditions that must be met by strict p-instances of the resulting work. Second, as in the case of standard analogue photography and cast sculpture, an artist may produce an artefact that, when employed in prescribed ways, generates p-instances of the work. This may be termed a 'production-artefact' (Wolterstorff 1980, 91–2). As in the case of exemplars, further conventions in place in the relevant art form determine how this artefact must be used if a *strict* p-instance is to be produced. Third, as in the case of classical musical works, an artist may provide instructions that, if properly followed by those aware of the relevant conventions and practices, result in strict p-instances of the work. In such cases, compliance with the instructions also calls for performative interpretation, and the resulting instances of the work (strict or flawed) are performances of it.

In each of these cases, p-multiplicity is built into the very manner in which a work is initiated: the methods of initiation are methods whereby, given relevant artistic practices and conventions in place, (a) a plurality of strict p-instances might be generated, and (b) the production of such a plurality is both intended by those responsible for initiating the work and internal to the very process of initiation. In the case of what are traditionally regarded as singular art forms, on the other hand, the method of initiation brings into existence a singular p-instance of a work, with neither the intention nor the means, internal to that process, to produce a plurality of such instances, or at least (recall the monotype) a plurality of strict p-instances. We thereby arrive at a conception of multiplicity that both is capable of making the distinctions we intuitively make and can do so in terms of facts about the practices whereby artworks are brought into existence.

It should be noted that neither of the notions of 'instance' in play in the literature on multiple artworks that were distinguished in Chapter 1 are themselves metaphysical. Neither notion can be directly identified with the metaphysical notion of standing in a designated relation to an 'instantiable' such as a universal. The notion of an 'e-instance' is purely epistemological, defined in terms of the capacity to play a particular experiential role in the appreciation of a work. The notion of a 'p-instance', on the other hand, groups entities in terms of the relation in which they stand to a generative process involving an artist. While both notions relate instances to works, they immediately entail nothing about what those works themselves are, ontologically speaking.[5] In particular, a work's having instances in either sense does not immediately entail that it is an 'instantiable' in the metaphysical sense—a universal or a type, for example—rather than a particular. Thus paintings, even if particulars, are correctly ascribed instances.

[5] The 'provenential' element in a p-instance relates it to an act of initiation, not directly to the work thereby initiated, so can hold even if the latter is an abstract entity.

Of course, one appealing explanation of the (p-)multiplicity of an artwork is that the work is indeed an instantiable. But this substantive metaphysical claim should not be confused with the phenomenon it is intended to explain.[6] How this phenomenon *is* best explained is the subject that will concern us in the remainder of this book.

2.1.2 Nicholas Wolterstorff on Multiple Works as 'Norm-Kinds'

As just suggested, a natural response to Wollheim's claim that multiple artworks are not physical objects but types that have physical objects or events as their tokens is to identify such types with *non*-physical entities that, like properties understood Platonistically, can have physical entities that somehow fall under them. Such entities, as instantiables, will then be abstract objects of some kind. It is not surprising, therefore, that, when Nicholas Wolterstorff takes up Wollheim's invitation to think more deeply about multiple artworks, he interprets Wollheim's talk of types ontologically and takes his task to be to correct certain details of the Wollheimian account so construed. Wolterstorff's views were first presented in his 1975 paper 'Toward an ontology of art works' and were further developed in his 1980 book *Works and Worlds of Art*. While these titles might suggest that Wolterstorff's interest is in the ontology of art more generally, it is clear from the 1975 paper that, like Wollheim, he thinks that the ontologically puzzling questions are the ones that concern multiples. Since these issues are explored more succinctly in the 1975 paper, I shall focus my attention here on their presentation in the latter.

Wolterstorff begins his 1975 paper by offering a general overview of the sorts of things that are correctly termed 'works of art' in the different art forms. But his aim is to distinguish, amongst such works of art, those belonging to the subset which he terms 'art works'. He begins with what we may term the 'performance arts'—primarily music, theatre, and dance. Here, he argues, we need to distinguish between two different kinds of 'works of art': (a) a performance of something and (b) that of which it is a performance. Setting aside pure improvisations, where such a distinction clearly has no purchase, he maintains that, for reasons similar to those offered by Wollheim, we cannot identify what is performed on a given occasion—(b)—with the performance itself—(a). There is, he argues, always a divergence in 'ontological properties' between these entities: only the thing performed possesses a property of the form 'was composed by x', and only

[6] A possible source of confusion here is the use of the term 'repeatability' to characterize the distinctive feature of multiple artworks. This is naturally taken as an ontological characterization of multiple works themselves, as 'instantiables' in the metaphysical sense.

the performance possesses a property of the form 'takes place at location L at time t'. There is also often a difference in 'aesthetic properties'. Schoenberg's *Pierrot Lunaire*, for example, possesses the property of 'having the voice part begin on A natural', whereas a (flawed) performance may lack this property. Furthermore, there can be two distinct performances of a single musical work. Thus, Wolterstorff maintains, we need to distinguish between that which can be performed—what he terms *'performance-works'*—and performances of those works, the latter being occurrences or events that may also indeed be 'works of art'. The puzzling question, however, is the ontological status of performance-works.

In certain of the non-performance arts, he argues, we have an analogous distinction. In the case of prints, cast sculptures, and works of architecture we have a distinction between works and the *objects* which instantiate those works—impressions of a print, castings of a sculpture, and examples of an architectural work. In such cases we can talk of *object-works* and their corresponding objects. For reasons analogous to those that obtain in the case of performance-works, we cannot *identify* an object-work with its corresponding objects. First the object-work and its objects may differ in properties. An instance of a print, such as Rouault's aquatint dry-point work *Obedient unto Death*, may possess properties that the work itself does not, or cannot, possess—for example, the properties of 'being a physical object', 'having a small tear at the bottom left hand corner', and 'having faded due to exposure to sunlight'. Furthermore, there can be distinct examples of an object-work, and any one of the several objects of an object-work can be destroyed without the work thereby being destroyed. In the case of literature, Wolterstorff suggests that works might be thought to be *both* performance-works and object-works: they are entities of which there can be both performances (utterances) and objects (copies). By contrast, in the case of paintings and works of non-cast sculpture Wolterstorff agrees with Wollheim that the work is to be identified with a particular physical object. While we can have *reproductions* of this object, these are not analogous to the objects of object-works (Wolterstorff 1975, 120). Finally, if there are *pure improvisations* in music, the work will be a particular event, not a performance-work. In this case, what we have is a 'work of art', but neither a 'performance-work' nor a 'performance' in Wolterstorff's sense (1975, 121).

Wolterstorff takes the ontological status of those works of art that are performances and objects to be unproblematic. The philosophical challenge is to clarify the ontological status of performance-works and object-works—'art works' in Wolterstorff's terminology. He agrees with Wollheim that the key to such a clarification lies in the manner in which the properties of such works relate to the properties of their instances. But, unlike Wollheim, he takes it to be crucial that we distinguish between the sharing of *predicates* and the sharing of *properties*. Two entities A and B share a predicate 'p' iff 'p' is truly predicated of both A and B.

They *share a property p* iff both *A* and *B* have *p*. But *A* and *B* can share a predicate '*p*' without sharing a property if '*p*', as predicated of *A* and *B*, stands for two different properties. Wolterstorff distinguishes three kinds of case here:

1) When the *same* property is predicated of *A* and *B*, the predicate is *used univocally*. For example, if the predicate 'is a vegetarian' is truly predicable of both *A* and *B*, then they also share the property of being a vegetarian.
2) When different properties are predicated of *A* and *B* and there is *no* systematic relation between these properties, the predicate is used equivocally. For example, the predicate 'lives close to a bank' may be truly predicable of both *A* and *B*, but this may be because *A* lives on a river and *B* lives next to a financial institution.
3) When different properties are predicated of *A* and *B*, but where there is some *systematic relation* between these properties, then the predicate is used *analogically*.

This third kind of use may strike us as puzzling. But, Wolterstorff maintains, it is what is actually going on in those cases cited by Wollheim as evidence of the sharing and transmission of *properties* between generic entities and their elements. Wolterstorff agrees with Wollheim that there is a pervasive sharing of *predicates* in such cases. This sharing is the thing upon which Wollheim relies in his claim that properties are transmitted between works, as types of structures, and examples of those works, as tokens of those types. Rather than engage directly with this idea of transmitted properties, Wolterstorff attempts to give a more precise account of the circumstances under which a predicate ascribable to an element that falls under a generic entity such as a musical work can be truly ascribed to the generic entity itself. We obviously need to exclude predicates that, while truly ascribable to a particular performance of a work *W*, are ascribable for reasons that have nothing to do with its being a performance *of W*—for example, the property of 'starting thirty minutes late because of a power failure'. We also want to exclude predicates that, while they are truly ascribable to most or even all performances of a given work, are so ascribable because of *failings* in those performances to deliver what the work requires. For example, we don't want to deny that 'having a voice part beginning on A natural' is truly predicable of Schoenberg's *Pierrot Lunaire* even if none of the work's actual performances have that feature. To exclude these kinds of examples we need to restrict our attention to those predicates that ascribe to performances of a work properties that they must have in order to be *correct* performances of that work. After some further precisification to exclude 'unacceptable' predicates like 'is a performance', which obviously cannot be truly predicated of works, Wolterstorff proposes the following formula:

For any predicate P which is acceptable with respect to W, if there is some property *being P* which P expresses in normal usage and is such that it is impossible that something should be a correctly formed example of W and lack *being P*, then P is true of W. (1975, 125)

This formula provides the basis for two proposed modifications of the Wollheimian account. First, Wolterstorff maintains, the shared predicates in the cases described by Wollheim do not function univocally, but rather *analogically*. Suppose, for example, I predicate 'begins with "April is the cruellest month"' of both Eliot's *The Waste Land* and of my copy of *The Waste Land*, or predicate 'has a G-sharp in its seventh measure' of both Bartók's First Quartet and a performance of Bartók's First Quartet. The properties that we predicate of the *instances* of works in such cases are properties that relate to word-*occurrences* or sound-*occurrences*. But the works themselves do not consist of such occurrences. Thus the properties we predicate of the works in those cases to which the above formula applies must be different from the properties we predicate of the instances. But the two properties are systematically related: '"P" when truthfully predicated of W stands for the property of *being such that something cannot be a correct example of it without having the property of being P*' (Wolterstorff 1975, 126).

The second modification of Wollheim's account relates to the kind of thing that art works, in Wolterstorff's sense, should be taken to be. The formula for shared predication suggests how this question should be answered. If, as the formula proposes, 'what is true of correctly formed examples of an art work plays a decisive role in determining what can be predicated truly of the work', this suggests that 'the concept of an art work is intimately connected with the concept of a correctly formed example of a work' (1975, 125). Like Wollheim, Wolterstorff takes this intimate relationship between art works and their examples to require that we think of performance-works and object-works as '*kinds* (or "types" or "sorts")' (1975, 126). Kinds possess certain distinctive features that we have already identified as features of such works: a kind might have had more or different members/examples than it actually has, and there can be two distinct unexemplified kinds.

But Wolterstorff parts from Wollheim in drawing an analogy between art works, construed as kinds, and *natural kinds* such as the Grizzly Bear. In the case of the latter, we find the same pattern of analogical predication characteristic of art works: while 'growls' can be truly predicated of both an individual grizzly and the kind Grizzly Bear, it is used analogically in the latter case. To truly predicate 'growls' of the Grizzly Bear is to say that something cannot be a *properly formed* example of the natural kind unless it growls. While not all kinds admit of both correct and incorrect examples—the kind 'red thing' does not, for example—those that do can be termed *norm-kinds*. Those works of art that are *art works*, then, are norm-kinds.

What *are* norm-kinds, however, and under what conditions does a norm-kind exist? And is there a serviceable notion of norm-kind applicable to both natural kinds, like the Grizzly Bear, and individual artworks, like Elgar's *Enigma Variations* and Eliot's *The Waste Land*? These are questions that will concern us both later in the current chapter, when we examine Dodd's analysis of the nature of what he terms 'norm-types', and in Chapter 6, where we will problematize the proposed analogy between artworks and natural kinds and ask about the nature of norms more generally. They are not, however, questions addressed by Wolterstorff in his paper. Taking the notion of a norm-kind as sufficiently clear, his concern is with how art works, construed as norm-kinds, are individuated. Given the intimate predicative relationship between art works and their examples, the individuation of art works qua norm-kinds is taken to depend upon the things that, for a given work, can serve as such examples. Focussing on musical performance-works, Wolterstorff first asserts that examples of a given musical work, qua norm-kind, are occurrences of sound sequences. But to clarify the nature of the *work*, construed as a norm determining what is required in its correct or well-formed examples, we need to clarify how the examples subject to this norm are themselves to be understood.

Wolterstorff first rejects two possible answers to this question. First, the examples cannot be all and only those sonic events that are occurrences of a *particular* sound sequence required for *correct* performance of W, since our standards of correctness allow for differences between those sound sequences that are correct performances.[7] Second, we don't want to restrict the examples of a work to its *correct* performances. While Nelson Goodman, for reasons stemming from more general features of his philosophical project, did maintain that only sound sequences complying with the notational parts of the score of a musical work could count as examples of the work (1976, 184–7), Wolterstorff rejects this idea: it both conflicts with our artistic practice and goes against the idea of works as norm-kinds. The latter, as we saw, are defined precisely in terms of the ability to have both correct and incorrect examples: a grizzly bear that lost its growl would not thereby cease to be a grizzly bear, after all.

Suppose, however, that we can agree on a set of sound-sequence-type *occurrences* which we would count as performances of W if produced by a performer.[8] We must still choose between two possible principles, definitive of two different conceptions of musical works as norm-kinds, for determining which occurrences that belong to this set are examples of the work. The two principles, which Wolterstorff labels '3' and '4', are as follows:

[7] This *variability* of correct performances of a performable musical work is central to the 'argument from variability' developed against Platonist theories of multiples in Chapter 6 below.

[8] See again Chapter 6 for reflection upon what such agreement would involve.

3: A musical work *W* is identical with that kind whose examples are occurrences of members of that set of sound sequences which performances of *W* are occurrences of. (1975, 130)

4: A musical work *W* is identical with that kind whose examples are performances of *W* (or, more simply stated, with the kind: Performance of *W*).
(1975, 131)

'3' and '4' differ over whether examples of a musical work should be restricted to those qualified sound sequences that are *produced by performers*. Wolterstorff counsels an openness to both options, which, he maintains, correspond to different ways we sometimes think about such matters. But his examination of the two alternatives is of independent interest given our inquiries in this and the following chapter, and I shall briefly survey what Wolterstorff says.

He begins by trying to clarify just what it is to *perform* a musical work. Rejecting Goodman's claim that the performances of a musical work are those intentionally produced sound sequences that comply with the explicit directions in the score for the work, he maintains (1975, 131) that composers seldom make explicit in a score all matters pertaining to correct performance of their works. In part this is because they assume that much does not need to be made so explicit given shared understandings in the performing community that they target. What is required if something is to count as a performance of a musical work is, rather, that the performers know *what is required for correct performance*, are guided in their playing by this knowledge, and are reasonably successful in their attempts at correctness. This account of what counts as a performance of a musical work bears not only upon our understanding of '4' but also upon our understanding of '3'. For we determine the set of sound occurrences that are examples of *W*, on '3', by reference to the set of performances of *W*, but allow anything that *sounds like* those performances to count as an example of the work.[9]

Wolterstorff notes two related issues that turn upon whether our conception of the musical work, as norm-kind, embraces option 3 or option 4. First (1975, 134), most obviously, if we allow non-performed occurrences of sound sequences that sufficiently comply with the requirements for correct performances of a work *W* to count as examples of that work, then one can hear an example of *W* without anyone performing it, or by hearing a performance of a distinct work *W**. Second, Wolterstorff takes the choice between '3' and '4' to bear upon whether composers of performable musical works, construed as norm-kinds, are rightly viewed as the

[9] Note also that, in working with the undifferentiated notion of an 'example' of a musical work, Wolterstorff lacks the linguistic resources to distinguish, amongst a work's 'examples' so construed, between those that, in the terminology introduced in Chapter 1, are p-instances and those that are e-instances.

creators of those works. Composition, so Wolterstorff maintains (1975, 136–9), normally involves two activities. First, the composer determines what will be required for correctness of performance, and second, the composer makes a record of that determination, usually via the production of a score. It follows from this, according to Wolterstorff, that two people can compose the same work, since it is surely possible 'for two people to determine and record the same correctness conditions' (1975, 137).[10] But, Wolterstorff maintains, it also follows from '4' that composition can be viewed as creation. For '4' holds that a work is a performance kind, and something counts as a performance of a work W only if it is informed by knowledge of the correctness conditions for W. Since a performance cannot be so informed prior to the composer's determination of W's correctness conditions, the composer's act of determination is what makes it possible for the work to have examples (performances, according to '4'), and thus, in this sense, brings the work into existence.

If '3' is right, on the other hand, composition is not creation since the work can have examples prior to the composer's act of determination. That act merely establishes the conditions that earlier sonic events would have had to satisfy to now have the status of being examples of the work. What should we say, on '3', about the conditions under which works, as norm-kinds, exist? Wolterstorff suggests the following alternatives: (1) If we say that W exists when it is actually being exemplified, then works go into and out of existence; (2) If we say works exist when they are or have been exemplified, then there can be no unperformed works; (3) If we say that W exists if it is *possible* for it to be exemplified, then musical works exist everlastingly. Given the counter-intuitive nature of (1) and (2), (3) seems to be the right ontological view if we accept '3'. As we shall see in Chapter 3, similar reasoning underlies Jerrold Levinson's argument for a contextualist form of musical structuralism.

2.2 Julian Dodd's 'Simple View'

The most developed and most discussed account of musical works as pure abstract entities—Julian Dodd's 'simple view'—explicitly takes Wolterstorff's account of art works as norm-kinds as its model and further refines, elucidates, and develops that model. The 'simple view', Dodd claims, provides answers to two questions with respect to 'all works of pure instrumental music' (Dodd 2007, 2):

[10] But this possibility is much more difficult to realize in practice than might be initially thought, for Wolterstorff. For, as we just saw, he takes the requirements for correct performance to include not only what is explicit in the score but also what would have been taken as 'understood' conditions for properly interpreting that score in the relevant performative community.

1) The *categorial question*: to which ontological category do works of music belong? (By 'works of music', Dodd refers to what Wolterstorff terms musical art works.)
2) The *individuation question*: what are the identity conditions of musical works—that is, under what conditions are W and W^* the same musical work?

Dodd's answer to the categorial question preserves the central features of Wolterstorff's account. According to what he terms the 'type-token theory', musical works are *norm-types* whose tokens are sound-sequence events. As 'norm-types', works admit of properly and improperly formed tokens. The identity of a norm-type is determined by the condition something must satisfy to be a *correctly formed* token. Dodd endorses Wolterstorff's '3' in allowing, as instances of a musical work, not only performances, and 'playings' of recordings of performances, but also sound-sequence events produced naturally without the activity of human performers that meet the work's sonic requirements for correct performance. Dodd defends this preference for Wolterstorff's '3' over his '4' on the grounds that nothing is to be gained by *excluding* naturally produced sound sequences. For, Dodd argues contrary to Wolterstorff, we don't preserve the creative role of the composer by restricting instances to performances and playings. We shall look further at this argument in Chapter 3.

In answering the *individuation question*, Dodd proposes and defends 'timbral sonicism', the second component of the 'simple view'. Given his answer to the categorial question, he takes the individuation question to be answerable by further clarifying the constraint that the work, conceived as a norm-type, imposes on its correct performances:

> A musical work is individuated according to the condition a sound-event must meet to be one of its *properly formed* tokens... The sonicist's distinctive claim can be put thus: whether a sound-event counts as a properly formed token of W is determined purely by its acoustic qualitative appearance. The properties comprising the set E of properties normative within any work W are all wholly acoustic in character: properties such as *being in 4/4 time, ending with a c-minor chord*, and so on. (Dodd 2007, 201)

Unlike 'pure' sonicists such as Peter Kivy (1988), the timbral sonicist holds that musical works are types of sound sequences individuated by reference to 'how they sound' in a rich sense that includes not only such properties as pitch, duration, rhythm, and accent but also the timbral qualities that result from the use of particular instrumental means to produce the pitches etc. But, while timbral properties of sound sequences are partly individuative of musical works, the timbral sonicist holds that the use of particular instruments to *realize* those

timbral properties in correct occurrences of those works is not. Nor do features of the musico-historical context in which a particular work was composed by a composer play any role in the individuation of musical works. Again echoing Wolterstorff, Dodd holds that if two composers initiate works that require, for correct performance, the same sound sequences in this rich sense, they compose the same work.

Dodd claims that the 'simple view' is the 'default view' in musical ontology, the most natural account that should be renounced only if its opponents can provide strong reasons in favour of their alternatives. Its 'default' status, Dodd maintains, stems from the fact that it provides a straightforward explanation of two basic 'facts' about musical works, facts enshrined in our ordinary ways of talking. The first fact is that musical works are *multiple* or, as Dodd puts it, *'repeatable'*, in that 'they are items that can have multiple sound-sequence events as occurrences' (2007, 3). The second fact is that musical works are *audible* in the sense that 'it is possible to listen to a work *by* listening to a performance of it' (2007, 3), and, relatedly, that it is possible to listen to the whole of a work by listening to a whole performance of it. Making what he takes to be the 'plausible assumption' that the repeatability of a musical work 'is explicable in terms of the ontological category to which such works belong', Dodd maintains that the best explanation of such repeatability is one that takes the work to be 'a generic entity, that is, something whose ontological category supports instantiation' (2007, 10–11).[11] The type-token theory, it is claimed, can explain repeatability in terms of the basic relation between a type and its tokens, and can account for audibility by appealing to a kind of 'indirect reference' of the sort that permits us to refer more generally to types by means of their tokens. Dodd further claims that alternative answers to the categorial question cannot account for one or both of these basic features of musical works in any straightforward manner, and require that we offer some kind of philosophical reconstruction of such ordinary talk.

After establishing in this manner the default status of the type-token theory, Dodd spells out the consequences of accepting that theory once we clarify the metaphysical status of types. But, so he then argues, any such consequences that might initially strike us as counter-intuitive—for example, the *uncreatability* of musical works—can be accommodated by reflective revisions of our practice, and are a small price to pay for a theory that so fully conforms with our basic intuitions

[11] Note that Dodd's assumptions here are substantial ones if, as I suggested above, the notions of e-instance and p-instance do not in themselves commit us to the view that whatever has such instances is an 'instantiable' in the sense in which Dodd is using that term here. Note also that the 'plausible' assumption that the 'repeatability' of a work is to be explained in terms of the ontological category to which it belongs is also a substantial one. It might be disputed, for example, on the grounds that, as we have seen, the very means by which different kinds of multiples are initiated have built into them the possibility of multiple strict p-instances, quite independently of any conclusions we might draw about the ontological category to which the works themselves belong. I return to this point in Chapters 7 and 9 below.

about the repeatability and audibility of musical works. We shall look at these arguments in detail in the following three chapters. Our task in the remainder of this chapter is to clarify Dodd's positive view and, in particular, what he takes the consequences of that view to be. As noted above, Wolterstorff says relatively little about the ontological properties of the norm-kinds with which he proposes to identify art works. Dodd, however, spends chapters 2 and 3 of his book spelling out exactly what he takes to be the implications of the kind of Platonism that he defends. He takes his task in chapters 4 and 5 to be to defend the claim that musical works are types so construed. Further implications of the type-token theory that go against widely endorsed views in the contemporary philosophical literature are then addressed in the final two chapters, where Dodd defends timbral sonicism as an answer to the individuation question.

Dodd argues for four distinct claims about types in general, and norm-types in particular: (1) they are abstract entities; (2) they are unstructured; (3) they are modally and temporally inflexible; and (4) they are eternal existents. Let me spell out each of these claims, and the reasons given for them, in greater detail.

2.2.1 Types Are Abstract Entities

Dodd defines an abstract entity as 'an entity that is not located in space'. In arguing that types must be taken to be abstract entities so conceived, he first rejects nominalist attempts to exclude types from our ontology. Such attempts, he maintains, involve an unacceptable diversity of paraphrases of our ordinary talk. He then rejects nominalist attempts to construe types as concreta. His principal target here (Dodd 2007, 48) is Eddy Zemach's 'Aristotelian' conception of types as 'continuants' that are wholly present in each of their tokens (Zemach 1970). Dodd rejects the idea that only such a view can explain how types can have properties that only concrete entities can have, such as a weight, as in the claim that 'the polar bear has four legs and weighs about 500 lbs'. He appeals here (Dodd 2007, 46-7) to Wolterstorff's doctrine of analogical predication: works, as types, can satisfy analogically the same predicates that their concrete tokens satisfy. Dodd also argues that types, if taken to be wholly present in each of their tokens, violate the 'axiom of localization' (2007, 43-4) once we allow for more than one token of a type to exist in different places at the same time, as is obviously the case with instances of multiple artworks such as photographs, films, and literary and musical works.

2.2.2 Types Are Unstructured

If types, as abstracta, lack spatial locations, they must also lack spatial parts. Furthermore, Dodd claims, since they are not perduring entities like events,

they also lack temporal parts. Rather, they endure through time. Dodd further argues that, just as it doesn't follow, from the fact that a type's tokens have spatial parts, that the type has spatial parts, so it wouldn't follow, from the fact that a type's tokens are perdurants, that the types are themselves perdurants.[12] Types, as abstracta, should not be understood as structured in any way. A type is simply a 'binder' of tokens, tokens being those entities that satisfy the property-associate of the type—the property of 'being an x' associated with the type x (Dodd 2007, 49). A type can be complex in requiring that its *tokens* be structured in a certain way, but the type itself is not, and cannot be, structured. The temptation to think otherwise results from a failure to read structural predications of types analogically (2007, 53).

2.2.3 Types Are Modally and Temporally Inflexible

As noted in the Introduction, Guy Rohrbaugh (2003), arguing against the idea of multiple works as abstract entities, draws a distinction between a thing's nature being *fixed*—what he terms its *modal* inflexibility—and its nature being *unchanging*—what he terms its *temporal* inflexibility. An entity X is *modally* inflexible just in case there cannot be a possible world in which it differs in its intrinsic properties. X is *temporally* inflexible just in case, in a given world, it cannot change in its intrinsic properties over time. If, as Dodd maintains, types are individuated in terms of the conditions they lay down for their tokens, only these conditions are intrinsic properties of a type. In that case, a type could be modally or temporally flexible only if the same type could be associated with properties requiring that different conditions be satisfied by its tokens. But in either case, this is ruled out by the individuation conditions on types: a difference in property-associates entails a difference in types. We can accommodate those cases where we might be tempted to think of a given type—for example the Ford Thunderbird—as flexible by either viewing the property associated with the type as itself somewhat indeterminate or unspecific, or by describing the situation as involving a succession of different, but very similar, types.

2.2.4 Types Are Eternal Existents

If types are abstracta, under what conditions does a type exist? We may recall that, in his 1975 paper, Wolterstorff considers two answers to this question in the case of musical works construed as norm-kinds. Each answer relies upon a more

[12] On *works of art* as perdurants, see Chapter 8 below.

general assumption about the conditions under which such a kind exists: a kind exists when it is possible for it to have examples. The difference between Wolterstorff's '3' and '4' is that, according to '3', the examples of a musical work are sound sequences that meet the sonic conditions for being performances of the work, but these sound sequences need not themselves be performances. In this case, since a sound sequence meeting these conditions can temporally precede the composition of the musical work in question, works construed as norm-kinds also precede the compositional activity of the composer. A musical work can in principle have instances at any time in the history of the universe when a sound sequence having the relevant sonic properties can occur. The composer's act of composition therefore does not bring the work into existence. On '4', on the other hand, only performances count as examples of the norm-kind that is a musical work. If, as Wolterstorff argues, a performance of a work needs to be guided by a knowledge of the work's correctness conditions, and if these conditions only exist as a result of a composer's act of determining these conditions, then a musical work, qua norm-kind, cannot have examples prior to its composition, and composers can be thought of as bringing their works into existence.

Dodd believes that the assumption underlying Wolterstorff's reasoning is incorrect. He also thinks that the same assumption underlies Jerrold Levinson's arguments (1980) for the creatability of musical works conceived as what Levinson terms 'indicated structures'. We shall look at this debate in detail in the discussion of the creatability objection to Platonism in the next chapter. In the present context, however, I shall restrict my attention to Dodd's positive proposal concerning the existence conditions for types in general, and for musical works as norm-types in particular. According to Dodd, types exist eternally if they exist at all. To say that types exist eternally is not to say that they are timeless in the sense of existing outside of time, but to say that, for all times, t, they exist at t. To view types as timeless renders problematic our ability to epistemically interact with them. The argument for the eternal existence of types has two premises (Dodd 2007, 60): (P1) a norm-type T exists just in case its associated property specifying the features required in its correct examples exists, and (P2) properties exist eternally if they exist at all. P1 is taken to be plausible because, as long as the property-associate of T exists at t, there exists at t the condition that must be met to be a token of T. The existence of T at t doesn't depend upon its actually having instances at t. The argument for P2 is more complex, as we shall see in Chapter 3, but rests on the assumption that an account of properties should avoid making them *transcendent*—raising the question how particulars can come to have such properties—and should also avoid having them *go into and out of existence*, only existing at times when they are instantiated (2007, 61). While, as we shall see in Chapter 3, there are a number of different accounts of the existence conditions for properties that meet these two desiderata, Dodd argues that we should prefer an account where a property exists at a time t just in case there is some time t^* such

that it is possible for the property to be instantiated at t^*. On this account of property existence, a type K will exist at a time t just in case there is some time t^* at which it is possible for its property-associate to be instantiated. Types, then, exist at all times if they exist at any time, and this will hold for musical works if they are indeed norm-types.

Dodd's detailed and carefully reasoned spelling out of the implications of taking at least some multiple artworks—performable musical works—to be 'types' in a metaphysically charged sense performs an invaluable service for those who seek to better understand the nature of multiples. Furthermore, there is nothing in Dodd's more general claims for the 'default' status of the type-token theory of musical works—its capacity to explain what are taken to be the principal desiderata in an ontology of such works, their 'repeatability' and 'audibility'—that seems to stand in the way of a generalization of his account to the other kinds of multiples identified in Chapter 1. For 'repeatability', if understood in terms of a work's p-multiplicity, seems to be a defining feature of any multiple artwork, and 'audibility' seems to exemplify for a specific perceptual modality the more general requirement that a work, whether singular or multiple, be experienceable through our engagement with its instances. As we shall note in Chapter 6, however, Dodd himself expresses some doubts as to whether his ontological account of musical works would extend to at least one other kind of multiple artwork, photographs. These doubts, I think, are well founded, but, once we consider how we might account for the repeatability and perceptibility of photographs in non-Platonistic terms, this raises the possibility of doing something analogous in the case of musical works.

As Dodd is well aware, if musical works are norm-kinds having the properties he ascribes to types, this entails a number of consequences that might seem to conflict with our ordinary ways of thinking about such works. Most obviously, if musical works are eternal existents, then they cannot be brought into existence by their composers, but are better thought of as *discovered* rather than created. Jerrold Levinson, however, in a highly influential paper published in 1980, argued that the creatability of musical works is one of the desiderata that must be met by an ontological account of such works. Indeed, Levinson's target in his paper was precisely the kind of musical Platonism defended by Dodd, albeit in an earlier incarnation in the work of Peter Kivy. A second issue relates to the individuation of musical works construed as norm-types. As noted above, the second element in Dodd's simple view—timbral sonicism—maintains that only a work's timbral sonic properties play a role in the individuation of musical works. But this would seem to entail that the individuation of musical works prescinds from contextual variables that relate to the musico-historical context in which a composer initiates a given musical work by identifying a set of timbral sonic properties required in correct performances of that work. Wolterstorff, we may recall, holds that composers who lay down the same set of requirements for correct

performance of a work will compose *the same work*. But, as we saw, Wolterstorff thinks that various kinds of contextual variables enter into the determination of what is required for correct performance. As we shall see, Dodd's conception of musical works as norm-types is less open to this kind of contextual element in work individuation: he takes it to be excluded by the nature of the eternally existing property-associates of the norm-types with which works are rightly identified. This again brings him into conflict with Levinson, who takes it to be a further desideratum for the ontology of musical works that it reflects the ways in which the musico-historical context of a work's initiation enters into the individuation of such works.

In subsequent chapters of his book, Dodd argues that we should not be troubled by these kinds of consequences of the simple view. I shall consider whether this is correct in the following three chapters. In Chapter 3 I consider two challenges to the simple view of musical works—and of multiples more generally—as norm-kinds: first, a challenge to Dodd's claim that the simple view enjoys default status in part because it can account for the 'audibility' of musical works without the need for philosophical reinterpretation; and, second, Levinson's claim that musical works must be creatable, and his further claim that this condition, while not met by the kind of Platonist view endorsed by Dodd, is met by his own alternative account of musical works as 'indicated structures'. In Chapter 4 I shall look at Dodd's response to the Levinsonian claims that the individuation of musical works must respect their contexts of initiation, and must also incorporate a composer's selection of particular instrumental means for the acoustic realization of her musical ideas. This will provide the basis for reflection, in Chapter 5, on the methodological constraints that should govern us in our inquiries concerning the ontological status of multiples, and on ways in which Dodd's defence of the 'simple' view might be taken to violate such constraints. In Chapter 6 I shall consider further arguments against the idea that multiple artworks can be viewed as abstracta, thereby setting the stage for the consideration of non-Platonist theories of multiples in Chapters 8, 9, and 10.

3
Two Explananda for a Theory of Multiples
Perceivability and Creatability

3.1 The Audibility of Musical Works

As we noted in Chapter 2, the purported 'default' status of Dodd's 'simple view' of musical works rests upon its ability to account, without the need for philosophical reinterpretation, for two central facts concerning our treatment of such works. The first of these facts is their 'repeatability', something that, according to Dodd, is most naturally explained by taking works to be norm-types whose tokens are the instances of those works. In the previous chapter, I raised some concerns as to whether this argument is compelling once we clarify that (a) repeatability is a matter of being p-multiple, and that (b) being p-multiple is in a sense built into the manner in which such works are initiated. What, however, should we say about the capacity of the 'simple view' to account for the second of these explananda: the *audibility* of musical works, our ability to hear such works, and to hear them in their entirety, in listening to their correct performances?

If musical works are norm-types, and if norm-types are to be understood in the way defended by Dodd, we might wonder as to the perceptual mechanisms required for such audibility. Performances of musical works are temporally structured events that occur at a given spatio-temporal location, and to appreciate what is presented to us in a musical performance is to appreciate a range of aesthetic (and artistic) properties articulated through the non-aesthetic sonic properties of the performance. Musical works for the Doddian Platonist, on the other hand, are unstructured entities lacking both temporal parts and spatial location, and possessing the aesthetic and artistic properties ascribable to their performances only analogically. Musical works, it would seem, are not the kinds of things that can be audible in the sense in which their performances are. Rather, if we predicate audibility of musical works, it seems that we must be doing so analogically. But, if this is the case, why is Platonism better placed to account for the audibility of musical works than alternative ontological accounts? For, if we predicate audibility *analogically* of a musical work, and thereby predicate audibility—in the standard sense—only of its performances, then surely a range of different ontological accounts will be able to offer such an explanation of the

audibility of musical works. As long as an account can explain how musical works can have performances, the audibility—in the standard sense—of those performances will entail the audibility—in the analogical sense—of the work itself. If we describe such a move as a matter of 'philosophical reinterpretation' of our ordinary talk, then everyone—including the Platonist—will be guilty of such reinterpretation. And we thereby lose one of Dodd's two arguments for the 'default' status of the type-token theory. Dodd goes to considerable lengths to deflect this kind of critical response, but, as we shall see, there are strong reasons to doubt whether he succeeds. If so then, while this doesn't constitute an argument *against* a Platonist understanding of musical multiples, it undermines one of the principal arguments offered in its favour. And it seems that, *mutatis mutandis*, similar considerations will apply to the perceivability of other kinds of multiple artworks.

Dodd's initial claim is that the type-token theorist can account for the audibility of musical works by drawing upon Quine's explanation (1969) of how it is possible for us to refer to types by demonstrating their tokens. Quine argued that I can refer to a particular letter-type, for example the letter 'e', by demonstrating a token of that type on a blackboard, even though the letter-type is, by its very nature, abstract rather than concrete. (This would explain how you could understand what I am saying if I say that the distinctive feature of Georges Perec's novel *La disparition* is that the letter 'e' does not occur anywhere in the novel!) Then, Dodd argues, by similar reasoning,

> the type/token theorist in the ontology of music can use the conceptual apparatus of the type-token distinction ... to explain how it is possible to listen to a work of music by listening to one of its performances. Just as the demonstration of a letter-type is secured by one of its tokens being present in space before one, so one may listen to a type of sound event by virtue of listening to one of its token performances or playings.... Hearing a performance of a work just *is* to hear the work *in* performance, and the reason for this is that the work stands behind a performance of it in exactly the way that a letter-type stands behind its concrete tokens. (2007, 12)

Dodd dismisses, here, the concern that, given the abstract nature of types, they cannot meet the requirement that there be some kind of causal interaction with anything that is an object of perception. For, he maintains, there is no good reason to deny that abstract objects like types can enter into causal relations. We might note that Dodd's view on this question differs from the view espoused in the 2000 paper where he first defends a form of the 'simple view'.[1] But, rather than pursue

[1] In the 2000 paper he agrees with Stefano Predelli (1995, 340) that the reason why abstract objects cannot be created is that 'the creation of an abstract object would have to be a kind of causal interaction between a person and an abstract object, or objects; and abstracta cannot enter into such interactions.'

this point, we might note another obvious difficulty, apart from possible causal inertness, with the idea that we hear works of music in hearing their performances. For, it might seem, the problem with the claim that we 'indirectly hear' the abstract musical type (the work) when we listen to a token of that type (a performance of the work) is not primarily that types lack the relevant causal or spatial properties to produce an auditory experience, but that they lack properties that any object of audition must possess—duration, temporal boundaries, and acoustic/sonic properties. Given Dodd's account of types, musical works, if they are types, lack temporal parts, do not occur in time, and do not begin or end in time. Furthermore, as noted in the previous chapter, Dodd follows Wolterstorff in holding that all predications of *particular* audible properties of musical works, as types, have to be understood analogically.

But then, we may wonder, how can something that possesses particular acoustic/sonic properties only analogically, and that lacks temporal extension, possess the property of audibility in the *same sense* (i.e. *non*-analogically) as its performances and playings? If the principle of analogical predication applies to those properties of a work's tokens that they possess in virtue of being tokens of a given work, why does it not apply to audibility in general as much as it applies to the particular audible properties that are required in correct performances of a given work? Why, to rehearse the reasoning sketched above, does the type-token theory not commit us to a 'revisionist' reading of our ordinary talk about 'listening to musical works', in that what we are ascribing to works can only be the property of being such that all of their *tokens* are audible?

Dodd responds to these concerns by granting that we can only hear a musical work in a 'derivative sense', as contrasted with the direct sense in which we can hear a performance of a musical work. But, he maintains, we still hear a musical work *in the same sense* in which we can hear material objects such as bells and whistles:

> we must not forget that this derivative sense in which a type of sound-event can be heard is the same sense in which *any* entity other than an event can be causally responsible for an auditory experience. Even material objects such as sticks, stones, and people can be counted as causes only by virtue of being related appropriately to the events that actually *do* the causing. This is not to deny, of course, that there exists an important disanalogy between works of music, *qua* types, and sticks, stones, and people: works of music, unlike these other paradigms of causally efficacious entities, are *abstracta*. But... there is no convincing rationale for denying that abstract types can similarly participate causally in

That this is so is reflected in the fact that statements seemingly reporting causal relations between abstracta can always be paraphrased in such a way as to reveal that the relata of the causal relation are really concrete' (Dodd 2000, 431).

events. Indeed, the idea that a type may so participate in an event by virtue of the said event's being one of the type's tokens has an intuitive ring to it. So, since there is no good reason to deny that types may be causally active within events, there is, similarly, no good reason to deny that the causal chain leading to an auditory experience may begin with an event in which a type participates causally. And what this means is that a type/token theorist need not deny that works of music are audible in the same sense in which other objects are. When a type/token theorist applies 'is audible' to a work of music, the predicate expresses the same sense as it does when it is applied to material objects.

(Dodd 2007, 94)

Dodd does not directly address the original charge, that musical works cannot be audible in the same sense that their performances are. The charge, recall, was as follows: given that all particular audible properties truly predicated of musical works are to be understood analogically, the predication of audibility of musical works must also be analogical. There are two senses of 'audibility' at issue here: literal and analogical. Dodd's response is to draw a different distinction, between 'direct' and 'derivative' senses in which something can be heard. Only token events can be heard directly. But things that enter causally into those token events can be heard derivatively. So, when I hear directly a car backfiring, I can be said to hear the car derivatively. Similarly, Dodd claims, when I hear a performance of a musical work directly, I can be said to hear the work itself derivatively. So, to the extent that we have no problems with the idea that cars are objects of perception in virtue of the causal roles they play in audible events, we should have no problem with the idea that musical works are objects of perception in virtue of the causal roles they play in the directly audible events that are their performances. In this case, the only possible point of contention is whether musical works, as norm-types and hence as abstract entities, can enter causally into the events that directly cause perceptual experience, and Dodd, as we have noted, cites philosophical support for the view that they can.

I take it that Dodd's response rests on the assumption that to be audible in the sense in which musical works are audible does not require that musical works possess literally the acoustic properties of their performances. Cars, after all, can be correctly classified as objects of audition even though they do not themselves possess the particular audible properties that we hear directly. When I hear a squealing of tyres in the street outside, there are various acoustic qualities that are directly heard. These qualities are properties of the event and not non-relational properties of the car, but it is correct to say that I hear the car because of its causal role in the event having those acoustic properties. By parity of reasoning, while the musical work does not literally, but only analogically, possess the acoustic properties of which I am aware in listening to the performance, the causal role of the work in the performance event allows me to say that I hear (derivatively) the work.

But this response by Dodd faces a number of problems. First, the reason why the audibility of musical works might be thought to bear crucially on musical ontology is that this is supposedly essential to our *appreciation* of musical works: it is only through hearing the appreciable acoustic qualities of those works that we are in a position to appreciate them. But what is distinctive of the 'hear x' idiom where x is an object is that x doesn't possess the acoustic qualities characteristic of what we hear. It is the car accelerating, as event, that possesses the acoustic qualities that we directly hear. In the musical case, it is the performance of the work that literally possesses those qualities: the work, if we follow Wolterstorff, possesses these qualities only analogically. So the sense proposed by Dodd in which I can be said to hear a musical work is not the sense that matters to us. If our talk of 'hearing musical works in hearing performances' is to bear the significance Dodd desires in settling matters of musical ontology, hearing a musical work must amount to more than hearing a representative performance of the work.

Second, if all that is required for a musical work to be audible in the 'derivative' sense is that it can be said to enter causally into those performances of the work that are themselves directly audible, then it is unclear why this cannot be accommodated by alternative ontologies of the musical work, contrary to what Dodd claims. What are the constraints on saying that something X can be heard or seen in the derivative sense? What is not required, obviously, is that X itself possess any properties perceivable via the appropriate sense organ. Dodd suggests that what is required is some kind of causal connection between the entity that is sensed in the 'derivative sense' and the event that is the cause and direct object of the sensing. He bases the link between (a) a type's being causally active in the chain of events leading to an auditory experience and (b) its being audible in the derivative sense, upon the following chain of reasoning:

> A work of music, thus construed, can enter into causal relations derivatively by virtue of being a type of sound-event: a type whose token events can feature as relata of causal relations. Hence, given that the objects of perception are just those things that causally affect how things perceptually seem to us, this means that the type/token theory is not precluded from saying that works of music, in addition to their tokens, may be heard. Far from it. In fact, a work of music, though abstract, can be heard precisely *because* it is a type whose tokens are performances, playings, and other sound-events that can cause us to have certain auditory experiences. The work itself counts as a *bona fide* object of hearing because the event that initiates the causal chain leading to an auditory experience—a sound-event—is one of its tokens. (Dodd 2007, 16)

Note first that the principle to which appeal is made here—that the objects of perception are just those things that causally affect how things perceptually seem to us—is obviously false as it stands. The bulb in the projector in a cinema meets

this condition but is not thereby an object of perception. More saliently, if a musical work is a norm-kind—a set of constraints upon the correctness of its examples—it is prima facie the wrong kind of abstract object to be causally efficacious in the way that Dodd requires. For works, as norm-kinds, do not in any obvious sense enter causally into their tokens—indeed, their tokens need not be correct and therefore need not satisfy all of the requirements of the norm-kind. Perhaps it might be said that they enter causally by guiding the activity of the performers. But why isn't a similar account open to proponents of alternative views?

Third, it is tempting to say that such locutions as 'I heard the bell' are abbreviations for 'I heard the ringing of the bell', where the ringing of the bell is the event that has the relevant acoustic properties that are directly heard. Talk about the audibility 'in the derivative sense' of objects such as bells and whistles would then be shorthand for talk about the audibility, in the direct sense, of the events in which those objects partake. In the case of musical works, this would mean that talk about the audibility of musical works is merely shorthand for talk about the audibility of their performances, exactly what we would expect if, in line with our understanding of the ascription of particular acoustic qualities to works, we took such talk analogically. And it is worth noting that the usual contexts in which we talk about having heard musical works are precisely contexts in which we are reporting our participation at performances of those works. In fact, this diagnosis is borne out by other cases where we predicate perceptibility of a norm-type. For norm-types with literally perceptible examples are not in general themselves perceptible in the same sense, either directly or derivatively. The Polar Bear, to use Wolterstorff's example, is not, qua norm-kind, perceptible, in the literal sense in which individual polar bears are perceptible. If I say that the Polar Bear is visible with the naked eye, whereas the Amoeba isn't, I am not saying that I can see (even indirectly) one norm-kind but not the other. Rather, I am presumably saying that examples of the one norm-kind are so visible while examples of the other norm-kind are not. Similarly, when I say that the Stars and Stripes is a visible symbol of American presence in the world, it is not the type that is visible but its tokens. In each of these cases, it seems plausible to say that the perceptibility-related predicates truly and literally predicable of the tokens are, when predicated of the type, related to how such tokens causally affect us in virtue of being tokens of that type. I find this diagnosis more satisfactory than Dodd's appeal to a derivative sense of perceivability that relies on a far from transparent notion of causal roles for abstract and atemporal types. And, as I have argued, even if we can make sense of the idea that musical works can be heard 'in the derivative sense', it doesn't give us the kind of audibility that matters in the ontology of music.

There is, however, another strategy open to Dodd in defending the supposed default status of the type-token theory in explaining the audibility of musical works. In setting out my challenge to Dodd, I have been assuming that, if musical

works are only *analogically* audible, and their audibility consists in the audibility of their performances, this is something to which all theorists, whether or not they take musical works to be abstracta, are entitled. Dodd's actual strategy, as we have seen, does not directly address this claim but appeals—unsuccessfully, I have argued—to a 'derivative' sense in which musical works, understood as abstracta, are audible when we listen to their tokens. But certain remarks by Dodd in the opening chapter of *Works of Music* suggest a more direct response to my claims about analogical predication. This response would *grant* that musical works, as types, are only analogically audible, but *deny* that this kind of explanation of audibility is open to those who reject the type-token theory.

To see how such a response would work, we need to return to Dodd's initial claims about the default status of the type-token theory. He appeals to two general theses. First, he argues that the type-token theory has a default status in explaining *repeatability*. He begins with the 'plausible' assumption (Dodd 2007, 10–11) that the 'repeatability' of a musical work is to be explained in terms of the ontological category to which it belongs. He then argues that only something that can have *examples* can be repeatable and that only generic entities can have examples. Rehearsing Wollheim's and Wolterstorff's discussion of such matters, he distinguishes between three different kinds of generic entities: types, sets, and properties. He then argues that, given these alternatives for 'generic' accounts of musical works, only the type-token theory can explain the repeatability of musical works because types are the only kind of generic entity that exhibit a distinctive feature of works of music—analogical predication. Echoing Wollheim's claim that only in the case of types is there a transmission of essential properties between a generic entity and its elements, Dodd draws on Wolterstorff's amendments of Wollheim in claiming that the only generic entities featuring analogical predication are types. In light of this, however, it seems open to Dodd to *grant* that musical works are only analogically audible, but to further maintain that only types—taken to be abstract entities—exhibit analogical predication. If so, then those who reject the idea of musical works as types *cannot* hold that musical works are *analogically* audible. Only the type-token theorist can explain the audibility of musical works in this way. Thus, it might be claimed, the default status of the type-token theory can be upheld.

A full response to this line of reasoning must await lines of inquiry to be pursued in Chapters 7 and 9 below. But, to very briefly suggest how such a response would go, there are arguably two problems with the foregoing argument. First, as we shall see, the assumption that we need an ontological theory to explain repeatability is open to challenge. As already noted in Chapter 2, in an important sense we can account for the repeatability of some but not of other artworks purely in terms of the different ways in which artworks are initiated. The possibility of multiple strict p-instances of a work—and thus the work's p-multiplicity—is intrinsic to the very processes whereby p-multiple ('repeatable') artworks are

initiated. Second, as we shall see when we return to Wollheim in Chapter 9, the sharing of predicates between type-expressions and token-expressions is a grammatical (or, as Wollheim puts it, 'logical') feature of the roles that those expressions play in a language. As such, its Wolterstorffian heir, analogical predication, will be a feature of any expressions having this grammatical property. But it is a further claim that the referents of any expressions having this grammatical property must be metaphysical 'instantiables' having the kinds of features described by Dodd in chapters 2 and 3 of his book. In brief, it can be argued that an account of audibility in terms of analogical predication is available to anyone who takes the terms that refer to musical works to have the kinds of grammatical properties described by Wollheim and Wolterstorff. As we shall see in Chapter 9, it is not only types in Dodd's sense that can have these features.

As noted earlier, Dodd bases the so-called 'default' or 'prima facie' status of the type-token theory on its making straightforward sense, without philosophical reinterpretation, of our talk of musical works as repeatable and as audible through their individual performances, where, so it is claimed, other ontologies of music require that we reinterpret our 'ordinary talk'. (As we shall see in Chapter 8, this is one of the reasons why Dodd rejects certain 'materialist' views of musical works.) But, if Dodd is only entitled to claim that musical works are audible in an analogical sense, then he can at best argue that the philosophical reformulations required by his theory are less drastic than those required by other theories. However, as I have just suggested, it is unclear why this should be the case. To draw a general lesson here, if everyone has to offer some kind of revisionist reading of our ordinary talk about a musical work's being 'audible',[2] then complying with our ordinary way of talking literally construed can hardly be an appropriate criterion to decide what is the 'default' option in musical ontology.

We have, thus far, followed Wolterstorff (and Dodd) in thinking that when we predicate audible properties of a performable musical *work*, the predication is *analogical*: while 'beginning on A natural' ascribes to a *performance* of Schoenberg's *Pierrot Lunaire* a particular sonic property, the same predicate applied to the *work* ascribes the systematically related property of having such a sonic property in all of its well-formed instances. The Platonist appeals to this strategy to explain how such predications of works can be reconciled with the idea that works, as abstract entities, cannot themselves possess sonic properties. I have argued, contra Dodd, that (1) if this is the right account of predications of particular audible properties to musical works, then it should also apply to

[2] At least one proposed ontology of musical works—the 'stage theory' defended by Caterina Moruzzi—avoids this consequence by taking the musical work proper to be the individual performance—the 'stage'—which clearly *can* be heard in a literal sense. Where our talk seems to commit us to there being a work distinct from its individual performances, Moruzzi holds that such discourse relates to what she terms the 'work as construct', something that is merely an artefact of our critical practices. For further discussion of this view, see Chapter 10.

audibility itself, as a property of such works, and (2) this strategy requires a *linguistic* distinction between works (as types) and performances of works (as tokens), but does not commit us to a Platonistic conception of works as types. But while analysing sentences such as '*Pierrot Lunaire* begins on A natural' in this way is necessary for the Platonist, such an analysis is not forced upon us. In fact, it might be claimed, if we consider the linguistic evidence, that such an analysis seems to be false. We find just such a challenge to the Wolterstorffian doctrine of 'analogical predication' in work by Stefano Predelli (2011). I shall first sketch Predelli's argument and then consider how it bears on our discussion of audibility as an explanandum for the ontology of musical works.

Predelli's argument is simple but powerful. He first points out that, if there is indeed an ambiguity in the use of predicates such as 'begins on A natural' in our talk about musical works and performances, then, even if this ambiguity is *systematic* rather than accidental, it must be apparent in the logical forms of sentences: the two distinct meanings will require separate lexical entries. There are, however, standard linguistic tests for ambiguous terms and distinctive features of the sentences that contain them. One important test looks at the behaviour of terms in elliptical contexts. Predelli offers the following example:

Focusing on a case of accidental lexical ambiguity, the sentence

(5) Bill has a bat, and so does Mary

can only be read as attributing to Bill and Mary either the possession of a wooden club or the ownership of a certain flying mammal: there is no reading for (5) according to which this sentence is true on a circumstance in which Bill owns a device for hitting balls and Mary a member of the order *Chiroptera*. (2011, 275)

If we try to mix different uses of an ambiguous term in an elliptical context, the resulting sentence, while it can be understood, is linguistically malformed and exemplifies the figure of speech zeugma, as with 'she arrived in a flood of tears and a sedan chair'. But, Predelli maintains, there are no zeugmatic effects when we combine the two supposedly systematically different meanings of a term like 'begins on A natural', as in '*Pierrot Lunaire* begins on A natural but tonight's performance didn't'.

Predelli suggests that we follow Wolterstorff in linking predications of musical works to predications of generic entities. Wolterstorff's example, we may recall, is the Grizzly Bear. 'The Grizzly Bear growls', he maintains, predicates a property of a kind of animal, whereas 'the grizzly bear was growling' predicates a different but systematically related property of a particular beast. Wolterstorff takes this to be an example of analogical predication, where the property being ascribed to the kind 'Grizzly Bear' is that its well-formed examples can produce such noises. But

we can run the same sort of linguistic argument here: there is nothing malformed in the sentence 'The Grizzly Bear growls, but this grizzly bear doesn't'. Drawing on work in linguistics on generic terms, Predelli claims that, rather than there being a systematic or accidental ambiguity in the *predicate* applied to both the generic entity and its examples, it is the *subject term* that is ambiguous in admitting of both a generic use and a use in respect of particular examples of a kind, something that is revealed in the logical form of sentences that contain it. Take our example from above: '*Pierrot Lunaire* begins on A natural, but tonight's performance of *Pierrot Lunaire* didn't'. This sentence, Predelli maintains, has the following logical form:

[G] GEN(x) [R(Pierrot, x) & begins-on-A-natural (x)] & not-begins-on-A-natural (tonight's performance),

GEN here relates to how things stand in the case of 'well-formed' examples of *Pierrot Lunaire*, while 'R' is roughly the relationship 'being-a-performance-of'. Thus [G] says that well-formed instances of *Pierrot Lunaire* begin on A natural but tonight's performance did not do so. We thus predicate one and the same property of *Pierrot Lunaire* and a performance of *Pierrot Lunaire*, but in both cases the things of which the property is being predicated are performances: we commit ourselves only to performances and certain norms whereby some performances count as well formed. These norms, Predelli suggests, will depend upon the context in which a sentence is uttered or properly assessed. This is to be contrasted with the Wolterstorffian view according to which the relevant norms are given by the property associate of the relevant norm-kind.

Predelli's proposals will resonate with our discussion of the practice-based nature of norms in Chapter 6. For the present, however, we may note two things. First, while the two accounts differ in their analysis of the logical form of sentences like '*Pierrot Lunaire* begins on A natural', they ascribe essentially the same semantic content to that sentence. Wolterstorff analyses the sentence as saying that (W) PL has the property 'all of its correct instances have p', where this follows from a norm which individuates PL qua work. Predelli, on the other hand, analyses the sentence as saying that (P) All correct instances of PL have p, where this follows from a norm in practice. Second, if we agree with Predelli that linguistic evidence supports an analysis of sentences ascribing audible properties to musical works in terms of generics rather than analogical predication, this further weakens Dodd's claim that only a type-ontology can explain such audibility. As Predelli stresses, the analysis of the logical form of sentences whose subjects are generics does not commit us to an identification of the referents of generics with abstract entities.

3.2 The Creatability of Multiples

When we first encountered Berthold and Magda in the Introduction, I remarked that their lively disputations about artworks of various kinds were rarely troubled by concerns of the sort that have occupied us thus far. However, this is not to say that we cannot find, in their activities, a tacit endorsement of the two explananda for an ontology of multiple artworks upon which Dodd bases his claim that musical works are rightly thought of as norm-types. As we saw, their debates about particular artworks are normally predicated on the assumption that they can discourse about the *same* artwork even when their experiential engagement with that work is mediated by what we are terming different p-instances of the work. So such works must be repeatable. And they would also take it to be unquestionable that this experiential engagement allows them to perceptually engage with the work. When Berthold enters a state of aesthetic rapture in listening to a performance of Sibelius's Second Symphony, for example, he speaks afterwards of what he heard as an exemplary performance of an exemplary work. So such works must be audible.

Our reflections in the last chapter suggested that, whether this concerns them or not, Dodd's view of musical works would provide conceptual underpinnings for these aspects of Berthold and Magda's appreciative practice. But our further reflections suggest that other ontological accounts might also provide such underpinnings. It seems, then, that neither Berthold not Magda has anything invested in these aspects of the philosophical debates between Dodd and his critics. But Berthold, at least, might be more concerned about a further implication of the kind of ontological view of musical works—and plausibly of other kinds of multiple works—to which Dodd subscribes. For, while Magda is less taken by such thoughts—disagreeing with Berthold is pleasure enough—Berthold admires nothing more than the creative powers of composers such as Sibelius, novelists such as Dostoevsky, playwrights such as Shakespeare, and painters such as Vermeer. He marvels at the abilities of such artists to bring into existence intellectually and spiritually inspiring works that can elevate us above the mundane plane of our ordinary existence. Were it to be suggested to Berthold that, according to some philosophical views, while Vermeer is the creator of his works, Sibelius is not (nor, perhaps, are Shakespeare and Dostoevsky), even he might be roused from his dogmatic slumbers and wonder how such a scandalous view could be defended. He would perhaps find some consolation in knowing that other philosophers have held that creatability is one of the principal explananda for an ontology of musical works, and, by implication, of other multiples. Foremost among such philosophers is Jerrold Levinson, who makes this claim central to his attack on the kind of pure structuralist view of musical works endorsed by Peter Kivy and then later by Dodd. We need to look first at Levinson's argument, and then at how pure structuralists might respond.

In 'What a Musical Work Is', Levinson begins by expressing agreement with the idea that 'a musical work is... a variety of abstract object—to wit, a structural type or kind'.[3] He takes this to be Wollheim's view, and agrees that a musical work is *some* kind of structural type which, as such, is non-physical and publicly available. His target, however, is what he takes to be the most common view as to the *sort* of structural type with which musical works are to be identified. This view identifies a musical work with 'a *sound* structure – a structure, sequence, or pattern of sounds, pure and simple', comprising 'all purely audible properties of sound' including 'not only pitches and rhythms, but also timbres, dynamics, accents' (Levinson 1980, 64). Such a structuralist account is 'pure' in denying non-sonic aspects of a musical work—such as the musico-historical context in which a composer arrived at a sound structure—any role in constituting or individuating the work.

Levinson raises three objections to pure structuralist accounts and, in so doing, proposes three explananda for any satisfactory account of the nature of musical works. In this section we shall look at the first of these, and in the next chapter we shall consider the other two. In raising the first objection, Levinson picks up on the discussion at the end of Wolterstorff's paper—sketched in Chapter 2—about whether musical 'composition' brings the musical work into existence. He insists that musical composition is properly regarded as *creation*. He initially offers two reasons why we should think this. First, this is one of our most firmly entrenched beliefs about *artworks in general*; second, some of the value that we ascribe to the act of musical composition derives from our belief that the composer is the creator of the work. In a later paper (Levinson 1990a), where he defends this view against critics like Peter Kivy, Levinson adds two further reasons: we describe composers as *adding* to the world, or as bringing their works into being, and we take the artist to stand in a relation of 'unique possession' to her works. This motivates the following constraint on the adequacy of an ontology of performable musical works:

Cre: Works must be such that they do not pre-exist the composer's compositional activity, but are *brought into existence* by that activity.

(Levinson 1980, 68)

Levinson claims that the pure structuralist view of musical works fails to satisfy **Cre**. He argues that since 'pure' sound structures could always have had instances, they must exist at all times. The assumption underlying this inference (1980, 65)—that a sound structure exists if it is capable of being instantiated—is, we may recall, the same assumption that underlies Wolterstorff's claim that, if we

[3] Levinson (1980, 64). He states at the beginning of his paper that he is confining his inquiry to 'that paradigm of a musical work, the fully notated "classical" composition of Western culture, for example, Beethoven's Quintet for piano and winds in E-flat, op. 16' (64–5).

adopt his option '4' rather than his option '3', composers can be seen as bringing their works into existence. Levinson further claims that **Cre** can be satisfied by an 'impure' structuralism that—like Wolterstorff's '4'—makes the compositional activity of the composer a precondition for a work to have examples. We can satisfy **Cre** if we identify works not with 'pure' structures but with what he terms *indicated structures*. He offers two ways in which such structures might be understood. Suppose we call a structure of sounds, in the above sense, that is to be produced on particular specified instruments a *sound-performance means structure* (an S/PM structure), Suppose also that we use '*A*' as a variable that refers to individuals, *t* as a variable that refers to particular times, and '*MHC*' as an expression ranging over musico-historical contexts understood as containing various kinds of elements. Levinson's two proposals are then as follows (1980, 79):

1) (MW): A musical work *W* is an *S/PM*-structure-as-indicated-by-*A*-at-*t*

2) (MW*): A musical work *W* is an *S/PM*-structure-as-indicated-in-*MHC*n.

Indicated structures so understood, he claims, *are* brought into being through the activity of the composer. Ontologically speaking, indicated structures are what Levinson terms *initiated types*, to be contrasted with the *implicit types* with which 'pure' structuralists wish to identify musical works. An implicit type exists if it is among the things permitted by a general framework of possibilities. For example, all the kinds of chess games that are possible given the rules of chess are implicit types. Even though, as in the case of chess, the framework might itself be the result of human invention (Levinson 1990a, 258), the implicit types licensed by the framework pre-exist their discovery by particular players. Both pure sound structures and *PM* structures are implicit types. *Initiated* types, on the other hand, come into existence only when initiated by an intentional human act of some kind that 'indicates' a pure structure (an implicit type).[4] Only once such an act of indication has taken place can there be tokens/instances of that *initiated type*— tokens/instances of that pure-structure-as-indicated. It is necessary but not sufficient for being an instance of an initiated type that something be an instance of the selected *implicit-type*. Levinson says little in his original paper about what is involved in 'indicating' a pure structure in the musical case. In a later paper (Levinson 1990a, 260), however, he tentatively endorses the idea that to *indicate* a pure structure is not just to provide an instance of it, as the earlier paper suggests, but to do so as a way of prescribing conditions for proper examples of the type. In the musical case, such examples are properly formed performances. As may be apparent, this view resembles Wolterstorff's '4' when taken together with

[4] A related view is proposed by Robert Stecker (in his 2003, 88–90). Stecker, who also takes himself to be following Wollheim, uses the term 'structures in use'.

Wolterstorff's account of composition as requiring the determining by a composer of the correctness conditions for her work.

We may break down Levinson's argument concerning the creatability of works of musical art into three claims:

(L1) we are committed in our thinking about such works to their being the creations of their composers;

(L2) traditional ways of understanding the idea of musical works as 'pure' sound structures cannot accommodate this commitment; and

(L3) musical artworks, if viewed as 'indicated structures', can accommodate this commitment and thus, for this reason among others, the 'indicated structure' view should be preferred to the 'pure' structuralist view.

If, as proponents of the idea of musical works as pure sound structures maintain (e.g. Dodd 2000, 426), the latter exist at all times, then it is not open to such proponents to dispute L2. The natural response, therefore, is to dispute L1. We find this strategy in Peter Kivy's responses to Levinson and also in Dodd's 'Musical works as eternal types', a 2000 paper in which his 'simple view' made its first appearance, albeit in a slightly different form.[5] In this paper, Dodd introduces the 'simple view' as an example of the kind of 'pure' structuralism targeted by Levinson: works are types of *sound-structures* individuated without reference to the musico-historical context of the composer (Dodd 2000, 425). Echoing arguments presented by Kivy (1983) in a paper defending what he termed musical 'Platonism', Dodd rejects L1, He claims that those features of our musical practice that Levinson seeks to explain in terms of creatability are better explained in terms of the *creativity* exercised by the composer in *discovering* that work, qua type. He draws an analogy with thoughts (Dodd 2000, 428): to be intellectually creative is to think in a fruitful way, not to somehow bring into existence the very content of one's thoughts. Dodd then argues that none of Levinson's arguments for **Cre** make a case for musical works being created rather than creatively discovered. Responding to the claim that we describe composers as *adding* to the world, or as bringing their works into being, Dodd questions whether we can make any sense of the idea that *types* can be created—a point to which he returns

[5] It may be helpful to list here the principal changes in Dodd's position in the 2007 book compared to his position in the 2000 article: 1) In Dodd (2007), he adopts from Wolterstorff the idea of works as *norm*-types, rather than (in 2000) as simple types, as claimed by Wollheim. This means that the property-associate of a musical work changes: it now concerns the condition for being a *correct* instance. 2) He also adopts Wolterstorff's account of analogical predication. 3) He changes his view as to whether abstract objects can enter into causal interactions. We may contrast his negative answer to this question in his 2000 (431) with his positive answer in his 2007 (12 ff.). 4) He changes his view of the existence conditions for properties (see below). 5) He characterizes the 'simple view' as affirming that musical works are types of sound *sequences*, not sound-*structures*. This entails that, as argued in his 2007, musical works are unstructured.

in questioning whether, contra (L3), 'indicated' structures fare any better than 'pure' structures in meeting the requirements of **Cre**. Dodd suggests that we can paraphrase those other claims about works cited by Levinson in ways that avoid any commitment to creatability. Responding to the idea that we take the artist to stand in a relation of 'unique possession' to her works, Dodd claims that we say similar things in cases where we have creative *discovery* of, for example, a mathematical theorem. The same holds for the status that we attach to compositional activity, which, like the status we ascribe to those who make major scientific discoveries, can be explained in terms of creativity in discovery rather than creation. Finally, Dodd argues that Levinson's claim that theoretical unity with the other arts requires creatability ignores the ontological differences between the arts. If we take paintings to be concrete particulars, why think there should be such unity? Or, indeed, if we stress the similarities between paintings and musical works, why shouldn't we think of *paintings* as creatively discovered rather than created?

As noted above, Dodd's arguments here echo those offered earlier by Kivy. It is not clear that either side in this debate over the status of **Cre** has a conclusive argument against the other, something that Levinson (1980) himself seems to acknowledge in according a lesser role to **Cre** than to two other desiderata (see next chapter) in presenting the case against the 'pure' structuralist view. But Dodd, unlike Kivy, further argues that Levinson's use of **Cre** in arguing against 'pure' structuralism and in favour of 'indicated structuralism' is flawed. He challenges not only L1 but also L3 in Levinson's argument. This is significant in the present context since, if correct, it shows that both 'pure' and 'indicated' structuralist accounts are committed to the idea that musical works are discovered and not created. This conclusion will be significant when, in Chapter 6 below, we ask about the scope of structuralism in accounting not merely for musical multiples but also for multiples initiated in other ways.

As we saw above, Levinson claims that musical works are 'indicated structures', that indicated structures are 'initiated types', and that initiated types, unlike implicit types, are creatable. Dodd argues, however, that Levinson misconstrues what a *type* is, and that, on a correct construal of the latter, types, *whether implicit or initiated*, are Platonic entities that cannot be created. Levinson's misunderstanding of the nature of types, Dodd argues, is apparent in the reasoning offered for thinking that if works are *pure* structures, then they are eternal. Levinson, as we have seen, argues that pure sound structures exist at all times because they can have instances at all times. The claim, more generally, is that a type K exists at t only if K can have instances at t. Given this principle, it seems that we can think of musical works as created if we identify them with types that *cannot* have instances prior to the compositional act on the part of the composer. This is supposed to be the case for *indicated* structures. As noted earlier, Levinson is here mirroring Wolterstorff's reasoning concerning the existence conditions for *norm-kinds*.

Dodd argues (2000, 435) that this misconceives the identity and existence conditions for types. The identity of a type is fixed by the condition that a token must meet to be a token of that type. This condition can *obtain* at a time *t* whether or not it can be *satisfied* at *t*, and the type exists just as long as the relevant condition obtains. For example, the identity of the type 'student graduating from McGill in 2050' is fixed by the condition that must be satisfied to be a token of that type, and this condition must exist now. This is because we now know what this condition is, although we also know that nothing can satisfy it at the present time, or now be known to satisfy it at some future time. The relevant condition, Dodd argues, is a *property*: the identity of a type *k* is determined by the property of which it is the *type-associate*: being a *k*. The type exists just in case its *property-associate* exists.

As in *Works of Music*, Dodd argues that an account of the existence conditions for *properties* must avoid two unacceptable alternatives: (i) a 'Platonism' that has properties existing independently of their ever being instantiated, leaving it unclear how things come to have properties at all; and (ii) the view that properties exist only when they are actually instantiated, so that properties come into and go out of existence. He suggests that we accept the 'intuitive theory' (2000, 436) that a *property* exists eternally iff there is some time—now, in the past, or in the future—at which it is instantiated. Given the relation between properties and types, if properties exist eternally as long as they have instances at some time, then so do types. The reason pure sound structures exist eternally, therefore, is that they are types.

However, as Dodd acknowledges in *Works of Music*, there is an obvious problem with this account if it is to apply to musical works. For consider an occasional composer Schmozart, one of whose compositions, with sound structure Sn, is never actually performed in the history of the universe, purely as a matter of contingent fact. Then, supposing there is no 'natural' occurrence of the specified sound structure, the property 'being an instance of Sn' is never instantiated. But, on the foregoing 'intuitive theory' of property existence, it follows that the property doesn't exist. So, if the work is a type, and if a type exists just in case its property-associate exists, then Schmozart's composition does not exist as a work. In other words, the 'intuitive' view proposed in Dodd (2000) entails that there can be no unperformed works! But, in footnote 5 of Dodd (2000), he seems to take it to be a constraint on musical ontology that it must account for unperformed works. Indeed, he also takes it to be a conclusive argument against a set-theoretic treatment of musical works that it fails to account for this.

In *Works of Music* (59–69), therefore, the 'intuitive theory' of property existence is replaced by another 'intuitive theory', according to which a property exists just in case it is *possible* for it to have instances at some time in the past, present, or future. Dodd distinguishes four different accounts of the existence conditions for types/kinds: the account (W/L) assumed by Wolterstorff and Levinson; the

account (Dodd I) offered in his 2000 paper (and now credited to David Armstrong); the account (Dodd II) offered in *Works of Music*; and a modified version of the Wolterstorff/Levinson account (W/L*) that reformulates the latter in line with the idea that a type exists just in case its property-associate exists. Taking '*K(n)*' to designate a kind '*n*', '*k(n)*' to designate an instance of a kind '*n*', and PA(*K(n)*) to designate the property-associate of a kind (*n*), we may characterize these four accounts as follows:

W/L: *K(n)* exists at *t* iff <> [*k(n)* exists at *t*]

Dodd I: *K(n)* exists at *t* iff PA(*K(n)*) exists at *t*
 & PA(*K(n)*) exists at *t* iff (E*t**) [PA(*K(n)*) is instantiated at *t**]

Dodd II: *K(n)* exists at *t* iff PA(*K(n)*) exists at *t*
 & PA(*K(n)*) exists at *t* iff (E*t**) [<>(PA(*K(n)*) is instantiated at *t**)]

W/L*: *K(n)* exists at *t* iff PA(*K(n)*) exists at *t*
 & PA(*K(n)*) exists at *t* iff (E*t**)[{*t** < or = *t*} & {<>(PA(*K(n)*) is instantiated at *t**)}]

Dodd argues that both W/L and W/L* wrongly assume that a type, or the property-associate of a type, can exist at *t* only if it can have examples at *t*. Echoing an example used in the 2000 article, he considers the type 'child born in 2050' and argues that the property-associate of that type must exist now in order for it to be false that a child born in 2022 has that property. While he takes Dodd II, rather than Dodd I, to incorporate the correct view about property-existence, each of these accounts is taken to entail that Levinson's indicated structures are no more creatable than pure structures. Suppose, with Levinson, that a musical work is an initiated type—say, something having the schematic form [S/PM-as-indicated-in-MHCx]. As a type, its identity is given by the corresponding property-associate, and its existence conditions are the existence condition of the latter. If the property associate of an implicit norm-type—say 'S/PM'—is 'being a correct instance of SP/M', then the property-associate of the initiated norm-type will be 'being a correct instance of S/PM-as-indicated-in-MHCx'.[6] In both cases, the corresponding property exists eternally as long as that property has at some time (Dodd I), or could have at some time (Dodd II), an instance. Thus the initiated type, like the implicit type, exists eternally as long as its property-associate does so. So a musical work, if it is indeed an initiated type,

[6] I here follow Dodd's own formulation on p. 49 of his 2007, where he states that the property associate of a norm-type *K* is '*being a properly-formed k*'. But this needs more careful formulation if norm-kinds are to admit of both correct and flawed examples. More carefully formulated to allow for flawed instances of a norm-type, the property-associate must be of the form 'being properly formed if p, q, and r', a property that both correct and incorrect instances can possess.

exists eternally, even if it could not have had instances before a certain time. This is why, as noted briefly in Chapter 2, Dodd holds that there is nothing to be gained by opting for Wolterstorff's '4' over Wolterstorff's '3'. For in neither case does the composer's activity bring the work into existence.[7]

If we accept Dodd's account of the nature of types, it seems that neither a pure nor an indicated structuralist account of the musical work can assuage Berthold's anguish at the thought that Sibelius did not in fact create his Second Symphony. Perhaps further reflection on his part about what is actually lost if we move from talk of creation to talk of creative discovery might provide some comfort. But it seems that, at least in the case of performable musical works, there are no compelling reasons to think that composers must be viewed as creators, something, as we noted, that Levinson himself grants in according less weight to **Cre** than to two other putative explananda to be examined in the next chapter. However, as we shall see in Chapter 6, creatability seems less negotiable in the case of some other multiple art forms where the process of initiation seems more closely tied to the creative activity of the artist. One lesson to carry forward from our discussions in this section is that, if Dodd is right in claiming that identifying a multiple work with an abstract entity of some kind—whether pure or indicated—precludes the creatability of that work, then, if there are multiple works whose creatability seems non-negotiable, at least some multiples cannot be abstract entities—in which case, it seems, being an abstract entity cannot, as Dodd claims, be a precondition of repeatability. But, before pursuing this line of investigation further, we need to consider some other putative explananda that present problems for a pure structuralist like Dodd.

[7] In a more recent paper (2012), Levinson has considered whether the idea of musical works as indicated structures requires that the latter be conceived of as types in anything like Dodd's sense, and, if not, whether this would enable them to be creatable. Since assessment of this issue requires resources to be set out in later chapters, I defer further consideration until Chapter 9.

4
Two Further Explananda
Fine Individuation and Performance Means

4.1 Contextualist Views of Art

Perhaps unsurprisingly, Berthold's admiration for the creative powers of the artists he loves inflects his appreciative attention to their works. He is fascinated by the ways in which an artist can bring her mastery of an artistic medium or technique to bear on particular themes or subjects that interest her, and the process whereby the finished work is formed through her creative activity. He is also an avid consumer of the information provided in gallery catalogues, concert programmes, and the cultural press about the ways in which individual artists both draw upon and inform the ongoing artistic activities of others. While Magda is not immune to an interest in such matters, her attention, when exploring a gallery or attending a concert, is focussed upon perceptible features of the fascinating objects on the wall or the sounds produced by the musicians. The accompanying texts serve at best to clarify things that puzzle her in her exploration of the sensible manifolds instantiated by the works she admires. But she always feels a certain annoyance at having to concern herself with such things. Art, as she often tells Berthold, should be able to speak for itself.

As we have already noted, it is such features of our appreciative practices that fund the kinds of explananda adduced by philosophers who argue for particular views about the ontological status of artworks in general, and of multiple artworks in particular. In this case, the philosophical issue is in the first place an epistemological one: what kinds of things should enter into the proper appreciation of a given artwork, over and above an experiential engagement with one or more of its strict instances? But how we answer this question is taken to bear upon the kinds of ontological questions that concern us here. For, given an answer to the epistemological question, we may ask: what kind of thing must the work be if an understanding of such things must enter into its proper appreciation?

While some views fit less easily into these categories than others, two broad approaches to the epistemological question have been defended in the literature. 'Empiricists' speak for Magda, albeit in a more theoretical voice: to properly appreciate an artwork, we need only to engage tastefully with its experienceable artistic manifold, a manifold through which the work is able to 'speak for itself'. 'Contextualists', on the other hand, provide conceptual foundations for Berthold's

appreciative practices. To engage with the artistic manifold of an artwork in abstraction from its place in 'the artworld'—its art-historical location and the properties it possesses in virtue of that location—is, according to the contextualist, to fail to engage with it as the particular work that it is. A contextualist epistemology so conceived has obvious implications for a pure structuralist ontology of artworks. The contextualist will deny that we can individuate artworks purely in terms of their structural properties. Rather, we must build into their identity conditions some reference to the art-historical context in which they were initiated.

Before looking at Levinson's contextualist challenge to pure structuralist accounts of musical works, it will be helpful to look at similar challenges to structuralist or formalist views of works in other art forms, both p-singular and p-multiple. Consider first works of visual art. In the opening chapters of his 1981 book *Transfiguration of the Commonplace*, Arthur Danto argued that the sorts of appreciable properties that distinguish artworks from non-artworks, and artworks from one another, are not merely properties of their perceptible manifolds per se but also properties that depend essentially on an entity's history of making and features of the art-historical context in which that making occurred. To cite Danto's maxim in his earlier presentation of his view, 'to see something as art requires something the eye cannot descry—an atmosphere of artistic theory, a knowledge of the history of art: an artworld' (Danto 1964, 580). In arguing for this conclusion in *Transfiguration*, Danto presents hypothetical cases where, *ex hypothesi*, we have perceptually indistinguishable objects that differ dramatically in their artistic properties and their artistic status. In his most famous example (Danto 1981, 1–3), we are asked to imagine eight perceptually indistinguishable painted red squares, six of which are works of art and two of which are mere 'real things'. The artworks, he maintains, also differ from one another in many artistically significant respects in virtue of the ways in which the initiating acts performed by their creators conferred upon them various properties that, while embodied in the manifest properties that they share, also depend upon their creators' acting with reference to a developing artistic tradition. These non-manifest differences pertain to genre, expressive properties, representational properties, and formal properties.

In Chapter 1 I drew, for other reasons, upon Gregory Currie's use of a similar strategy in arguing against pure structuralist, or 'textualist', ontologies of the literary artwork. In chapter III of their 1988 book *Reconceptions in Philosophy & Other Arts & Sciences*, Nelson Goodman and Catherine Z. Elgin argued that a literary artwork is a type of verbal structure or text, individuated purely in terms of those features it possesses as a character-type in a symbol system. In the case of those symbol systems that are natural languages, characters are individuated by reference to the way they are spelled and the language to which they belong. A symbol system, for Goodman (1976, ch. IV), is a symbol scheme—something

that has a certain syntax defined in terms of permissible ways of conjoining atomic characters—correlated with a field of reference.

An obvious objection to the idea that literary artworks are text-types, so construed, is that it seems easy to imagine cases where distinct literary works have identical texts as their vehicles. An example often cited, and alluded to in Chapter 1, is taken from 'Pierre Menard, Author of the *Quixote*', a short story by Jorge Luis Borges (1970). In Borges's story, Pierre Menard is an early twentieth-century French author whose 'admirable ambition was to produce pages which would coincide – word for word and line for line – with those of Miguel de Cervantes' (Borges 1970, 66). The narrator of Borges's story proceeds to *contrast* Menard's *Quixote* with Cervantes's *Quixote* by citing features of, or passages in, the text that they have in common, and by taking those features or passages to have a radically different import in the two cases. The differences relate to properties that are ascribable to these features or passages in virtue of the literary-historical contexts in which tokens of their common text-type were inscribed. To cite one example, Borges's narrator writes that

> Menard's *Quixote* is more subtle than Cervantes'. The latter, in a clumsy fashion, opposes to the fictions of chivalry the tawdry provincial reality of his country. Menard selects as his 'reality' the land of Carmen during the century of Lepanto and Lope de Vega. What a series of *espagnolades* that selection would have suggested to Maurice Barres or Dr. Rodriguez Larreta! Menard eludes them with complete naturalness. In his work there are no gypsy flourishes or conquistadors or mystics or Philip the Seconds or *autos da fe*. He neglects or eliminates local colour. This disdain points to a new conception of the historical novel.
>
> (Borges 1970, 68)

Such differences in the sorts of aesthetic and artistic properties that would seem to bear on the appreciation of literary artworks might be thought to entail that, in spite of the textual identity, Cervantes and Menard are authors of distinct literary works. Critics of textualism have claimed that this demonstrates that the generation of distinct tokens of a given text-type in different art-historical contexts results in different literary *works*, and supports a *contextualist* ontology of literature. The contextualist ontologist identifies a literary work with a text-type as tokened by an author in a particular art-historical context, or offers another account of the literary work that makes both text-type and generative context constitutive elements of a work.[1]

As Currie and others have noted, there are certain objections to the Borges example if it is presented as an argument against textualism. First, the text-type

[1] For an alternative anti-textualist response to Goodman and Elgin that identifies literary works with *inscribings* of texts, see D. Davies (1991).

tokened by Menard is identical, as text, with a *fragment* of the text-type that serves as the vehicle for Cervantes's work. Second, it is questionable whether the seventeenth-century Spanish in which Cervantes wrote and the early twentieth-century Spanish in which Menard hypothetically wrote are indeed the same language. The archaism of Menard's text, for example, to which Borges's narrator also refers, is presumably a matter, inter alia, of its using linguistic constructions not current in the Spanish of Menard's day, while failing to employ functionally similar linguistic constructions that were so current. This seems to demonstrate that the linguistic resources of Cervantes's Spanish and Menard's Spanish are significantly different. If so, the textualist might argue, they are different languages for the purpose of individuating texts.

Currie therefore offers a different example that we briefly discussed in Chapter 1. In Currie's thought experiment, we are to imagine that we discover a previously unknown manuscript by Ann Radcliffe, the famous author of Gothic fictions. This manuscript is textually identical to Jane Austen's *Northanger Abbey* but written some ten years earlier. Assuming that Austen had no knowledge of Radcliffe's manuscript, we have tokenings of identical 'texts' by two authors who are presumably employing the same language. But, as Currie persuasively argues, the resulting works possess strikingly different and apparently incompatible properties. Austen's novel, for example, is valued for the ways in which it satirizes the Gothic tradition, upon which it comments and to elements of which it frequently refers. Radcliffe's hypothetical text, however, seems incapable of serving as the vehicle for a work having these kinds of properties. Indeed, it would be anachronistic to see it as ironically commenting upon other texts that had not been written at the time when Radcliffe hypothetically composed her text. If, then, we think that these kinds of differences in artistic content are relevant to the individuation of literary works, we must resist the identification of such works with their texts. Rather, we must identify them with entities that somehow incorporate both a text, as artistic vehicle, and a context of making, in virtue of which the vehicle serves to articulate its particular artistic content.

Currie considers a number of textualist responses to this argument. First, the textualist might reject the crucial assumption that the works resulting from the text-generative activities of Radcliffe and Austen differ in their artistic content—Austen's work being ironic and alluding to other works by Radcliffe, for example, when Radcliffe's work has neither of these properties. The textualist can do this by finding other ways to represent properties that depend upon the context of generation of a token of a text-type. The preferred strategy is to *relativize* these properties in some way so that there are no properties that one work possesses and the other lacks. One option is to relativize contextually based properties to an *interpretation* of a work. There is a single literary work, *Northanger Abbey*, it might be said, that has the property of being interpretable-as-a-satirical-comment-on-Radcliffe's-Gothic-novels. But, given the existence of

other equally acceptable interpretations that treat the work as non-satirical, it also possesses the property of being interpretable-as-a-'straight'-Gothic-novel. The work, if identified with the text-type, can possess both of these properties without contradiction. So Radcliffe and Austen, in independently tokening the same text-type, author the same work.

Currie responds that this would entail that Radcliffe's work possesses both of these properties, even though it seems anachronistic, not to say bizarre, to see her work as interpretable in the first way, as a satirical comment on works she has not yet written. An anachronistic interpretation of this kind, he maintains, is unacceptable because it would entail an anachronistic *evaluation* of Radcliffe's work in crediting it with possessing this property. But, he argues, our sense of a work's value should reflect our sense of what the artist achieved. Textualists, of course, might reject such a conception of artistic value, in which case there is nothing inconsistent in their position. But, Currie suggests, it may be difficult to reconcile that position with central features of our critical and interpretive practice.

Another option would be to relativize contextually based properties that we ascribe to works to particular acts of *generating* a token of a text-type. *Northanger Abbey*, which (for the textualist) is to be identified with a particular text-type, is then satirical-or-ironic-as-generated-by-Austen, but a-ripping-Gothic-yarn-as-generated-by-Radcliffe. There is nothing inconsistent in ascribing both of these properties to a given text, but, once again, it is difficult to reconcile this idea with our ordinary practices of ascribing properties to works as part of their appreciation. *Animal Farm*, we want to say, is a biting commentary on the development of Russian socialism, not merely such-a-thing-as-composed-by-Orwell. A similar difficulty attends a different textualist strategy. The textualist might deny that any of the contextually grounded properties to which the argument appeals are genuine properties of literary works at all. Rather, it might be said, they are properly viewed as properties either of authors or of the activities of authors. But to hold such a view seems to radically impoverish works by denying them any properties that relate them to other works or current events in the artist's milieu. *Animal Farm* becomes a tale about life in the farmyard, while we cannot view Austen's work, or indeed any work, as a satire on other contemporary literary developments.

4.2 Levinson's Contextualist Explanandum for the Ontology of Musical Works: 'Fine Individuation'

A similar dialectic was engendered by Levinson's appeal, some ten years earlier, to contextually grounded differences between structurally identical *musical* works in arguing for his second explanandum for an ontology of such works. Levinson

offers five musical thought experiments. In each case, we are asked to imagine that two composers, on separate occasions in a given world, determine the same structural correctness conditions for performances of their works. Levinson claims that, on each occasion, the pairs of composers produce works that have very different, and indeed incompatible, aesthetic and/or artistic properties bearing on their correct regard. This difference, it is claimed, derives from differences in the musico-historical contexts in which these acts of composition take place. He glosses the idea of a composer P's 'total musical-historical context' at a time t in terms of the following list of at least necessary components:

> a) the whole of cultural, social, and political history prior to t; b) the whole of musical development up to t; c) musical styles prevalent at t; d) dominant musical influences at t; e) musical activities of P's contemporaries at t; f) P's apparent style at t; g) P's musical repertoire at t; h) P's oeuvre at t; i) musical influences operating on P at t. (Levinson 1980, 69)

The first four factors make up the *general* musico-historical context, and the rest are *individual* factors that bear upon P's compositional activity at t. Levinson cites the work of others in support of a principle upon which his argument relies: 'Works of art *truly have* those attributes which they *appear* to have when *correctly* perceived or regarded' (1980, 69, n. 15).

Levinson's pairs of structurally identical compositions differ from one another in the kinds of properties that are claimed to bear upon the appreciation (and hence the individuation) of works. In a later paper, Levinson draws the following distinction between the aesthetic and the artistic attributes of works:

> *Artistic* attributes are attributes of artworks *directly descriptive or reflective* of their place in art history, their situation in the field of artworks as a whole; this includes the influences they undergo or exert and their various relations – referential, imitative, allusive, parodistic, denunciatory – to other works of art. *Aesthetic* attributes are a species of perceptual attribute, which although complexly *dependent* on a work's art-historical context, do not have as their *content* (some aspect of) that contextual embeddedness. (1990a, 239, n. 56)

Two of Levinson's hypothetical examples involve differences in the expressive or affective properties ascribable to a work—properties that relate to how it should affect a receiver who properly grasps the work. In the first of these examples, we are asked to imagine a work identical in sound structure to Schoenberg's *Pierrot Lunaire* (1912) but composed by Richard Strauss in 1897. The Strauss work, Levinson claims, would be 'more *bizarre*, more *upsetting*, more *anguished*, more *eerie*' when perceived against the different musico-historical setting in which Strauss would have been working. The second example is of a modern work

identical in sound structure to one of the symphonies by Johann Stamitz (1717–57). While the use of Mannheim rockets in Stamitz's piece makes it exciting, the same features in a contemporary piece would just make it funny, Levinson claims.

The remaining three examples concern differences in artistic properties. First, we are asked to imagine a score written in 1900 and identical in sound structure to Mendelssohn's *A Midsummer Night's Dream* Overture (1826). The former work, Levinson claims, would lack the *originality* of the latter, something residing in part in its feel for tone colour. Second, a salient quality of Brahms's early Piano Sonata (Op. 2) (1852) is its being *influenced by the work of Liszt*, something a schooled listener can hear in the work. But a work identical in sound structure written by Beethoven could not have this quality but *would* have a visionary quality that Brahms's work lacks. Finally, a passage in a 1943 piece by Bartók *satirizes* Shostakovich's *Seventh Symphony* (1941), but the very same score written by Bartók in 1939 could obviously not have had this satirical property.

To bring out more clearly how each of the thought experiments is supposed to tell against the pure structuralist, it may be helpful to present one of them—the Brahms/Beethoven example—more formally. We are asked to imagine that a given type of sound structure—the sound structure of Brahms's Piano Sonata Opus 2 [$SS(BPS\ op2)$]—is tokened in different musico-historical contexts by Brahms and Beethoven. Let us term the resulting works $W(Br)$ and $W(B)$. For the pure structuralist, who identifies the work with the sound structure, we have two generations of a single work: $W(Br) = SS(PS\ op2) = W(B)$. But $W(Br)$ and $W(B)$ have different properties. $W(Br)$ has the property of being strongly Liszt-influenced and lacks the property of being visionary. $W(B)$, by contrast, has the property of being visionary and lacks the property of being strongly Liszt-influenced. So, by Leibniz's Law of the Indiscernibility of Identicals, it cannot be the case that $W(Br) = W(B)$. Thus pure structuralism must be wrong.

On the basis of these hypothetical examples, Levinson formulates his second desideratum for an ontology of musical works—the requirement of 'fine individuation'—as follows:

> (**Ind**): Musical works must be such that composers composing in different musical-historical contexts who determine identical sound structures compose distinct works. (1980, 73)

In his original 1980 paper and in a response to his critics written some ten years later, Levinson tries to answer two kinds of structuralist arguments against **Ind**. The first argument insists on a distinction between a work's 'aesthetic' properties—which count towards the individuation of works of art, qua art— and its 'art-historical' properties—which don't so count. In the kinds of cases cited by Levinson, the structuralist claims, the pairs of compositional actions may

indeed produce works that differ in their art-historical properties, but they do not produce works that differ in their aesthetic properties. Thus what we actually have in such a case is only a *single* work which can be discovered in different contexts. It is the acts of discovery themselves, or the individuals who carry out these acts, that may differ in properties. Only if we speak elliptically can we ascribe such differences to the works themselves. Thus we may describe the musical work having the sonic conditions for correct performance of Brahms's Piano Sonata Op. 2 as being Liszt-influenced-as-composed-by-Brahms and as not being Liszt-influenced-as-composed-by-Beethoven. Both of these relativized properties can obviously be possessed by a single work. Levinson is no more sympathetic to this talk of relativized properties than was Currie to the same suggestion concerning the contextually based properties of literary works. Like Currie, he appeals to our artistic practice, which, he claims, treats such aesthetic and artistic properties as *determinate* and *non-relativized* properties of works that have contextual variables as essential constituents.

More generally, the structuralist's appeal, here, to the distinction between 'aesthetic' and 'art-historical' properties echoes earlier appeals to this distinction in support of other broadly structuralist or formalist views of art. For example, the distinction is central to Alfred Lessing's argument (1965) that it makes no genuine difference to the artistic value of a painting if it turns out to be a forgery. Critics, Lessing argues, were wrong in changing their assessment of *The Disciples at Emmaus* when it was discovered to have been painted by Van Meegeren in the twentieth century rather than by Vermeer in the seventeenth century. He writes that

> the fact that a work of art is a forgery is an item of information about it on a level with such information as the age of the artist when he created it, the political situation at the time and place of its creation, the price it originally fetched, the kinds of materials used in it, the stylistic influences discerned in it, the psychological state of the artist, his purpose in painting it, and so on. All such information belongs to areas of interest peripheral at best to the work of art as aesthetic object, areas such as biography, history of art, sociology, and psychology. (Lessing 1965, 464)

But neither Lessing's argument nor an appeal to a parallel strategy by the structuralist seeking to undermine **Ind** is convincing as it stands. For in each case the argument rests crucially on an appeal to an unexplicated—and dangerously ambiguous—notion of the 'aesthetic'. In Lessing's case, that a work's being a forgery is irrelevant to its *value as art* follows from the claim that this doesn't make an *aesthetic* difference only if we are using 'aesthetic' as synonymous with 'artistic'. But, if that is how Lessing is using the term, the argument seems to beg the question as it stands, since his opponent is someone who holds that artistic value

comprises much more than 'aesthetic value' in the traditional empiricist sense.[2] In the case of Levinson's opponent, we have the same kind of problem with the proposed distinction between 'aesthetic' and 'art-historical' value. Is the former to be equated with 'aesthetic value' in the empiricist sense, or with 'artistic value' in a sense that might include elements other than aesthetic value so construed? If the former, then Levinson can respond that the kinds of differences highlighted in his five examples are indeed not aesthetic, but they are not of merely art-historical value either: they are non-aesthetic components of a work's artistic value, involving differences in *artistic* properties, and therefore bear upon the individuation of works. If, on the other hand, Levinson's opponent is using 'aesthetic' as synonymous with 'artistic', then the claim that the differences in the hypothetical examples are not 'aesthetic' simply begs the question.

A further problem with this kind of response to Levinson's use of his five thought experiments in support of **Ind** is that, as we noted above, some of the differences in properties identified in the examples seem obviously aesthetic. It can hardly be said that a work's being exciting, or funny, or anguished is an art-historical property of the work. Such properties, according to Levinson, are aesthetic properties, in the narrow sense, that we experientially ascribe to a work when we hear it as a work having a certain provenance. But if this is what the structuralist is objecting to, her position is much less plausible, at least in the absence of further argument, and would render mistaken many of our ordinary judgments as to the aesthetic and expressive properties of artworks. If our ordinary critical and appreciative practice is so mistaken, we seem in need of an error theory. (As we will see, Dodd's account speaks implicitly to exactly these kinds of concerns.)

Peter Kivy (1983) offered a different kind of response to **Ind**. Kivy described his own structuralist view as a form of musical Platonism: musical works are Platonic universals that exist as pure, eternally existing sound structures. Kivy asks (1987, 246, cited in Levinson 1990a, 227) how we should describe a situation in which we change our views about the nature of the act whereby a work with a given sound structure was initiated. Suppose that we thought the composer was X but we now think that it was Y, where X and Y worked in different musico-historical contexts. Platonism, Kivy maintains, is supported by our intuition that, in such a case, the work itself doesn't change when we change our minds about the composer. We should conclude that it is *the same work* but with a different history of making. Levinson, responding to Kivy, thinks no such conclusion follows. It is true that the work itself doesn't change, but this is because what changes is our epistemic relationship to it—the 'history' is an integral part of the unchanging work.

[2] For a fuller account of this distinction between two uses of the term 'aesthetic', see the critical discussion in Chapter 5 below of Dodd's appeal (2007) to 'aesthetic' value in his defence of 'moderate musical empiricism'.

4.3 Levinson's Third Explanandum for Musical Ontology: 'Performance Means'

As we have seen, Levinson's 'non-negotiable'[3] requirement that the individuation of musical works respect their 'fine individuation' is an application to one of the more discussed p-multiple art forms of more general concerns relating to the individuation of artworks, whether they belong to singular or multiple art forms. The same cannot be said for Levinson's second 'non-negotiable' requirement for an adequate musical ontology. This requirement, which he terms 'performance means', is characterized as follows:

> **Per**: Musical works must be such that the specific means of performance or sound production are integral to them. (Levinson 1980, 78)

Obviously, as stated,[4] this explanandum for musical ontology will generalize at best to the other performing arts. Levinson's claim is that the specification of a particular 'performance means' whereby a sound structure is to be realized is itself integral to, and partly individuative of, the kinds of musical works whose ontological nature he is seeking to clarify. He offers a number of reasons for thinking this to be the case:

(1) Composers who provide a score for the works they compose specify in that score not only pure sound patterns but also specific instrumental means whereby performers can produce such patterns.

(2) Such scores, specifying not merely the elements making up a sound structure but also instrumental means for realizing that structure, are standardly taken to be definitive of such musical works. If, Levinson argues, we are to preserve 'the principle that properly understood scores have a central role in determining the identity of musical works' (1980, 75), and if we also wish to preserve the idea that it is compliance with the score that plays a central role in determining the class of performances of musical works, then we cannot allow that a performance that disregards the specified performance means is a performance of a given work.

[3] See Levinson (1980, 68, n. 11).
[4] However, we might formulate a more generalized version of **Per**—term it **Prod**—as follows: artworks must be such that the specific means of production of their instances are integral to them. **Prod** might be taken to hold for works of visual art, for example, so that differences in the specific kinds of materials and techniques used in generating a given perceptual manifold would entail that the distinct manifolds are instances of distinct works. For example, a canvas perceptually identical to Vermeer's *Young Woman Standing at a Virginal* whose production did not involve use of a camera obscura would be a different visual artwork (see Steadman 2001 on Vermeer's presumed use of the camera obscura).

(3) The *aesthetic content* of a musical work is determined not only by its sound structure and its musico-historical context but also by the actual means of production chosen. Levinson offers a number of examples in support of this claim, the most cited of which is Beethoven's 'Hammerklavier' Sonata, which he describes as 'a sublime, craggy, and heaven-storming piece of music'. But, he maintains, these aesthetic qualities of the work 'depend in part on the strain that its sound structure imposes on the sonic capabilities of the piano; if we are not hearing its sound structure *as* produced by a piano, then we are not sensing this strain, and thus our assessment of aesthetic content is altered'. Generalizing from this example, Levinson maintains that the aesthetic attributes of paradigm works of classical music 'always depend, if not so dramatically, in part on the performing forces understood to belong to them' (1980, 76–7).

(4) The *artistic properties* of a work often depend crucially on performance means. A work is 'virtuosic' because of the demands it makes on a performer who performs it on a specified kind of instrument, and it may be 'original' in virtue of the ways in which it prescribes that particular instruments be used. Furthermore, part of the artistic value of a work may lie in the way in which it brings into productive dialogue the particular instruments involved, and thereby 'solves the problem of balancing piano and winds' (1980, 78), for example.

In his 1990 response to his critics, Levinson (1990a) addresses two arguments offered by Peter Kivy (1988) against **Per**. First, Kivy claims that there can be perfectly recognizable performances of a piece of music on very non-standard instruments—for example, a performance of the Brandenberg Concertos on kazoos. Levinson responds that there can also be recognizable performances that fail to comply with a work's sonic structure, but it doesn't follow that the sonic structure isn't constitutive of the work. Kivy's second argument, which Levinson takes to be more interesting, is a historical claim about *why*, at a given time in the history of composition, composers began to specify performance means. Kivy claims that this was motivated by purely practical considerations: given the increasingly complex and ambitious tonal structures devised by composers, the specified performance means were the only available instruments for realizing those structures. He further claims that, if the composer's motives were not colouristic or expressive, it is perfectly acceptable to employ modern instruments like synthesizers which are capable of realizing the tonal structures identified in terms of the use of particular instruments.

Levinson responds (1990a, 242 ff.) by citing a range of works of nineteenth- and twentieth-century classical music that, so he claims, cannot be viewed in 'aninstrumentalist' terms. He maintains that Ravel's *Boléro*, which consists of 'nine repetitions of the same sinuous melody and countermelody, varied almost

exclusively through changes in instrumentation' is a *reductio ad absurdum* of Kivy's view. Both central aesthetic and important artistic properties of this work depend essentially on the particular choice of instrumental means, Levinson maintains, and this example differs from other works only in being extreme. He further argues that proper appreciation and evaluation of such musical works require that one hear them played on the particular instruments specified by the composer, and questions whether 'aspects of musical compositions that absolutely *must* be considered in fairly evaluating them...[can]...be reasonably *excluded* from a notion...of what is integral to them as compositions'.

Levinson claims that his own proposal that musical works are indicated structures can satisfy all three of the desiderata for an ontology of musical works that he has identified. We have already seen, in the previous chapter, reasons to doubt that this applies to creatability. But the third desideratum, **Per**, is to be met by talking about S/PM structures rather than S structures. The second desideratum, **Ind**, is to be met by building into the identity of the work the indicating of a particular S/PM structure by an individual at a time (on *MW*), or in a particular musico-historical context (on *MW'*). Since works, as indicated structures, are distinct if they differ in any of their constitutive elements—S/PM structure, composing individual, and time (on *MW*), or S/PM structure and total musico-historical context (on *MW'*)—it follows that, as **Ind** requires, works composed in different musico-historical contexts will be different. For any difference in musico-historical context must involve a difference in the composing individual, or the time, or both.

We might note here the implications of opting for *MW* or *MW'* and Levinson's reasons for preferring on balance *MW*. One implication of *MW* that might worry us is that it not only, as one of the arguments for **Cre** requires, gives content to the idea that works are the possessions of their composers, but goes further in making this relationship of possession an *essential* property of a work. Since the composer is one of the constitutive elements in the work, it is metaphysically impossible that a given work could have been composed by anyone else. But the modal implications of *MW'* might be thought to be even more worrying. In both his original 1980 paper and in his 1990 response to his critics (1990a), Levinson rejects the charge that he makes all of the aesthetic/artistic properties cited in the thought experiments offered in support of **Ind** *necessary or essential* properties of works (see, e.g., 1990a, 221). **Ind**, he maintains, only requires that works genuinely possess certain properties that depend on musico-historical context of generation, not that those properties are essential (1980, 84, n. 29). But, if we were to opt for *MW'*, we would have to say that all of these aesthetic/artistic properties *are* essential properties of the work. For the properties in question are determined by the structural features of the work and the musico-historical context of composition, and on *MW'* both of these things are constitutive properties of the work, properties it must have in any possible world in which it exists. Thus, on

MW', in any possible world in which a work exists it must have the very same artistic and aesthetic properties that it has in the actual world.[5]

4.4 Dodd on Contextualism and Instrumentalism as Explananda for Musical Ontology

Dodd's defence of the pure structuralist 'simple view' against the challenges posed by Levinson's arguments for **Ind** and **Per** relies upon many of the same strategies already rehearsed that have been used by literary and musical structuralists to counter contextualist arguments. However, as will soon become clear, Dodd's approach differs in one very significant respect. In virtue of that difference, he seems to have a way of defusing the resource upon which contextualists usually rely in parrying those structuralist strategies. As we have seen, when structuralists appeal to distinctions between 'art-historical' and 'aesthetic' properties, or to relativized variants of context-dependent properties that render such properties acceptable to the structuralist, contextualists argue that these strategies conflict with the ways in which such things are dealt with or understood in our artistic and critical practice. Dodd's strategy, however, is designed to render such appeals to practice invalid when brought before a higher court of appeal—the constraints that mature philosophical theory imposes upon our ordinary ways of thinking.

We saw in Chapter 2 Dodd's claim that the 'simple view' provides answers to two questions relating to 'all works of pure instrumental music' (2007, 2). The *categorial* question asks about the ontological category to which such works belong, and the *individuation* question asks about the identity conditions of such works, the conditions under which W and W^* are the same musical work. Dodd takes himself to have answered the categorial question in chapters 1–7 of *Works of Music*. By the 'type-token theory', musical works are *norm-types* whose tokens are sound-sequence events. The 'type-token' theory is claimed to be the default ontological theory because it offers an unproblematic explanation of the two relevant explananda in the field, the 'repeatability' and the 'audibility' of musical works. Dodd takes himself to have shown (2007, chs. 4–5) that the implications of the type-token theory, as spelled out in his 2007, chapters 2 and 3, are acceptable given the other virtues of that theory. He has also argued (2007,

[5] As Guy Rohrbaugh (2005) notes in his insightful paper on the general issues surrounding the idea that artworks are necessarily by their actual authors, *MW* and *MW'* are *ontological* proposals stemming from the consideration of *Ind* and *Per*, which are themselves claims about how musical works are rightly *individuated*. Rohrbaugh clearly distinguishes between individuative questions as to how things should be individuated in a world and modal questions about the properties that a given entity must have in all possible worlds in which it exists. The point here is that neither *MW* nor *MW'* itself follows from the acceptance of *Ind* and *Per* as constraints on work individuation. Rohrbaugh also notes that Levinson's reasons for preferring *MW* assume, for independent reasons, that having a particular author is a necessary property of an artwork.

chs. 6–7) that it offers a better explanation of the relevant explananda than competing contemporary ontological theories of musical works.

In chapters 8 and 9, Dodd asks how we should answer the individuation question if, as he takes himself to have shown, 'musical works are norm-types whose tokens are sound-sequence-events' (2007, 201). Here he defends *timbral sonicism*, the second component of the 'simple view'. The individuation question—when do we have one and the same work of music and when do we have distinct works—is presented as requiring an answer that further elucidates the answer already given to the categorial question: 'Factoring in the thesis that musical works are norm-types, a musical work is individuated according to the condition a sound-event must meet to be one of its *properly formed* tokens.' The sonicist understands this condition in the following way:

> Whether a sound-event counts as a properly formed token of W is determined purely by its acoustic qualitative appearance. The properties comprising the set *E* of properties normative within any work W are all wholly acoustic in character: properties such as *being in 4/4 time, ending with a c-minor chord*, and so on A work of music W and a work of music W* are numerically identical if and only if W and W* are acoustically indistinguishable: just in case, that is, they have exactly the same acoustic properties normative within them.
> (Dodd 2007, 201–2)

Unlike 'pure' sonicists such as Kivy, however, the *timbral* sonicist holds that musical works are types of sound sequences individuated by reference to 'how they sound' in a rich sense that includes not only properties such as pitch, duration, rhythm, and accent but also the timbral qualities that result from the use of particular instrumental means to produce these pitches, etc. But, while timbral properties of *sound sequences* are partly individuative of musical works, the timbral sonicist holds that the use of particular instruments to *realize* those timbral properties is not, nor are features of the musico-historical context in which a particular work was composed by a composer.

It is only now that Dodd introduces the kinds of considerations raised by Levinson in his arguments for **Ind** and **Per**. What he terms 'contextualism' and 'instrumentalism' are, he maintains, properly understood as alternative proposals for answering the individuation question as just characterized. In other words, they offer alternative accounts of 'the condition a sound-event must meet to be one of [a work's] *properly formed* tokens'. *Instrumentalism* (Levinson's **Per**) amounts to the following claim: 'works of music written for different instruments cannot be identical because they lay down distinct conditions for the production of properly formed tokens' (Dodd 2007, 202). The instrumentalist takes the set of properties normative within a work to include properties relating to how token sounds are to be produced. *Contextualism* (Levinson's **Ind**) is the claim that 'any

differences between the settings in which compositional acts take place will automatically bring about differences in the works composed, even if those works sound alike' (2007, 203). These 'differences' relate to what it is for a sound-sequence event to be a token of a work. For a sound-sequence event to count as a token of *W*, 'it must not merely have a certain acoustic character, but must bear a certain (presumably causal-intentional) relation to the *actual process of EW's composition that took place*' (2007, 203). For, as just noted, Dodd identifies the question 'How are musical works to be individuated?' with the question 'What properties are normative within the work, as type, *in the sense that they are properties required in any correct performance of the work*?' Thus, in an important sense that will be clearer below, Dodd's defence of a 'pure' structuralist ontology for musical works against Levinson's arguments for **Ind** and **Per** as desiderata for musical ontology *just is* his defence of 'timbral sonicism', as the preferred answer to the individuation question so construed, against the alternative answers to this question presented by contextualism and instrumentalism as glossed above. For, as we shall see, Dodd's case for timbral sonicism rests upon denying that contextualism and instrumentalism are legitimate explananda for an ontology of musical works.

In arguing for 'timbral sonicism', Dodd again begins by claiming 'default' status for this view. This status, it is claimed, is acknowledged even by sonicism's opponents, and would be endorsed by anyone 'unencumbered by developments in analytic aesthetics' (Dodd 2007, 204). The 'default' status of timbral sonicism 'follows from a highly natural account of musical appreciation'. This account, which he terms *musical empiricism*, is initially characterized as 'the view that to appreciate a piece of music, we need only use our ears' (2007, 205):

> The limits of musical appreciation, the empiricist claims, are what can be heard in the work, or derived from listening to it (Beardsley 1958: 31–2). Facts concerning the context in which the piece was composed are of art-historical interest, and perhaps shed light on the extent of the composer's achievement; and facts concerning how the sounds are actually produced enable us to determine the nature of the performer's achievement; but such facts play no role in determining a musical work's aesthetic value.

This view, Dodd claims (2007, 205–6), is

> enshrined in some of the responses typically made by ordinary listeners in a variety of situations. For example, a modern jazz *aficionado*, unimpressed by what seem to her to be the gauche and corny mannerisms of the New Orleans jazz of the 1920s, will not in the least be swayed on being told how contemporary jazz evolved from such music and how original and ground-breaking this earlier music was at the time. Such considerations, though they might make our modern

jazz lover better disposed towards the *achievements* of the New Orleans jazz men, will be regarded by her as irrelevant to the question of its worth as *music*. What matters, she will argue, is how the music *sounds*; and to her it sounds crude and lacking in sophistication. Our modern jazz lover, then, will not be swayed by appeals to matters art-historical.

Furthermore, Dodd argues, she is right not to be so swayed:

> In our ordinary discourse about music, we regard with suspicion those who change their opinion of a piece's aesthetic value after finding out who composed it and when. For example, as Kivy has mentioned (1987: 246), there is a prelude and chromatic fugue in E flat that was thought to be an early work of J. S. Bach, but was later discovered to have been a mature work of his cousin, J. C. Bach. Now, someone who changed her mind about the work's aesthetic value upon finding out the true history of its composition would, I think, be regarded—by ordinary listeners, at least—as something of a cheat. To claim subsequently to discovering its true origin, and in contrast to one's earlier opinion, that the piece is powerful and complex would be to reveal oneself to have failed to examine the work on its own merits. (Dodd 2007, 205–6)

In so arguing,

> the empiricist insists upon a distinction between the aesthetic and the art-historical, so her point is that such contextual factors are of interest, if we are to tell the story of how a composer came to compose works with the character that they have, or to evaluate her achievement in doing so. But the empiricist nonetheless insists that to tell this story is to change the subject from giving an account of the aesthetic value of a composer's works. (Dodd 2007, 207)

I shall look at these claims in more detail in Chapter 5. What we should note here is Dodd's response to the standard instrumentalist and contextualist claim that musical empiricism goes against our critical practice as evidenced in the writings of musical critics, composers, and performers: 'The concept of music—which includes within it the concept of a musical work—is not owned by professional musical critics; it belongs to all of us. And what this means is that the theoretical beliefs of music critics—a small minority of the concept's constituency—can be trumped by the practices of ordinary consumers of music' (Dodd 2007, 207). Music critics, he maintains, are concerned with art-historical matters, not with 'the music as music'. He later remarks upon the 'culturally mongrel' nature of musical criticism.

Dodd grants, however, that we do need to modify 'naive' empiricism so that what counts is what can be heard in the music by one with (a) a musical

background, and (b) suitable discriminative abilities. We also need to be aware of the *category of art* to which a piece of music belongs. Taking these things into account, we arrive at what Dodd terms *moderate musical empiricism*: musical appreciation is restricted to 'what can be heard in the work' by someone who is suitably familiar with the style of music in question and knowledgeable as to the 'category of art' to which the work belongs.

Given that Dodd subscribes to *timbral* rather than *pure* sonicism, his disagreement with the *instrumentalist* is over whether performance means properties, as opposed to timbral properties, are normative within the types that are works. The question is whether works require of their correct performances not only that they *sound as if* they have been produced on particular instruments but that they *are* produced on those instruments. He considers two of the arguments that Levinson offers for instrumentalism. The first of these—the *argument from scores*—points to the fact that the scores for musical works standardly prescribe the use of particular instruments. Dodd, echoing claims by Peter Kivy examined earlier in this chapter, argues that instruments were specified in scores only because those instruments were the sole means available at the time of composition capable of producing the sound sequence intended by the composer: the composer's governing concern was only with the prescribed sound sequence. But, Dodd further argues, if this conflicts with what composers take themselves to be doing, then they are simply mistaken (2007, 219). More generally, he dismisses (2007, 222) appeals, in arguing for instrumentalism, to either musical practice or established conventions operative in that practice: these, he claims, should be trumped by philosophical argument of the sort that has already established the type-token theory as the preferred answer to the categorial question and sophisticated musical empiricism as the preferred account of what matters for the appreciation of music *as music*. He also claims that, where composers do specify particular instruments, this is only because they are interested in issuing challenges to performers and bears only on the assessment of *performances*, not on the value of *the works performed*.

The second Levinsonian argument for **Per** considered by Dodd maintains that a performance can transmit certain aspects of a work's aesthetic content and artistic import only if the sounds are produced in a certain way. Dodd responds that in some cases the artistic properties in question are not genuine properties of musical works, but pertain only to our assessment of performers and performances. This applies, for example, to one of Levinson's examples—the 'virtuosity' of one of Paganini's *Caprice* in virtue of what it requires of the performer when played on the specified instrumentation. It also applies to the 'originality' of a piece scored for violin but with the intention that the sound sequence thereby produced should sound as if it was produced by a flute.

However, Dodd recognizes that this strategy will not be plausible when the properties in question pertain to a work's aesthetic or expressive properties. One

of Levinson's examples, as we saw, points to aesthetic qualities of the 'Hammerklavier' Sonata that are grounded in ways in which it strains the capacities of the instrument upon which it is to be played. More generally, Levinson talks of certain expressive qualities that depend upon our hearing in the music the *gestures* that would be involved in producing a sound sequence on certain instruments (Levinson 1990b). Dodd grants that such properties must be taken to be genuine properties of musical works: 'works certainly *can* be sublime, craggy, and assertive, so a timbral sonicist cannot reply by denying this' (2007, 230). But, he maintains, 'while it is true that we must hear a performance of the piece *as* played on the piano if we are to grasp the full gamut of its aesthetic qualities, it does not follow that a properly performed performance must *actually* make use of the piano' (2007, 230). If so, this might allow Dodd to uphold timbral sonicism against the challenge of instrumentalism. For, as we have seen, the operative assumption is that only those properties that are *normative within the work for its correct performances* enter into the individuation of works.

In chapter 9, Dodd turns to the kinds of hypothetical examples offered by Levinson in arguing for the 'fine individuation' of musical works. He takes the general thrust of the contextualist challenge, as represented by Levinson's doppelgänger thought experiments, to be that a musical work's aesthetic and artistic qualities supervene not merely on its acoustic character but also on the total musico-historical context in which the composer is working (2007, 241). Unlike Kivy (1987), he grants the legitimacy of Levinson's appeals to Leibniz's Law in the thought experiments offered in support of **Ind**. If it can be shown that, in the case of musical artworks having exactly the same timbral sonic properties normative for their correct performance, there are indeed contextually based differences in the properties bearing on the aesthetic appreciation of these works, then timbral sonicism cannot be correct. And he does not think that, in such cases, we can take contextually based properties to be relativized to an act of composition. As in the case of the arguments for instrumentalism, Dodd adopts a 'mixed' strategy (2007, 253). What he argues is that:

(1) in the case of artistic, representational, or object-directed expressive properties dependent upon contextualist considerations, these are *not* properties bearing on the aesthetic appreciation of works, but are ascribable to artists, or are art-historical properties of the work, and
(2) in the case of aesthetic and other expressive properties *rightly* taken to bear upon the aesthetic appreciation of musical works, these are genuine properties of the work but they do *not* vary with context.

Dodd's strategy in respect of (1) is exemplified by his treatment of such properties as being 'original' or being 'Liszt-influenced'—which we will recall are among those ascribed to works by Mendelssohn and Brahms in Levinson's

thought experiments. Such properties, he claims, are rightly ascribable to the artists rather than to the musical works. This as it stands is a familiar structuralist response, but Dodd deflects contextualist appeals to our artistic practice by claiming that such properties *can't* be properties of works, given that works are types:

> If the moral of this book's first seven chapters is correct—and we should regard works of music as abstract, structureless, eternally existent types—then there would seem to be a serious question as to the intelligibility of attributing properties such as *being Liszt influenced* and *being original* to works of music. To be sure, a composer can be influenced by Liszt, or be highly original, in his composing of a certain piece of music; but it is not clear what it would be for an *abstract, eternally existent entity* to be *itself* original or influenced by Liszt. Here, perhaps, we have a case in which philosophical theory should prompt us to revisit assumptions that have we have hitherto accepted unreflectively. (2007, 257–8)

He then argues that those expressive and aesthetic properties that *are* rightly ascribed to musical works and that bear upon their appreciation and aesthetic value do not depend on context. He claims that the kinds of differences in properties cited in Levinson's thought experiments are either disguised artistic differences or not differences at all (2007, 270). However, he acknowledges that this claim requires further argument:

> It is undeniable that works of music can genuinely be *coherent, flamboyant, upsetting, anguished,* and the like. Given that this is so, what can stop the contextualist from describing a possible world in which a pair of works are acoustically indistinguishable but in which, due to differences in the musico-historical matrices in which their respective composers were situated, the pair fail to share the same aesthetic properties? Such cases, we have noted, are easy to construct, and all seemingly point in the same direction: towards the thesis that acoustic indistinguishability is insufficient for work-identity. (2007, 266)

In responding to this challenge, he appeals once again to the 'moderate empiricist' account of musical understanding for which he argued in the previous chapter:

> The thesis that understanding a work of music *as music* requires the listener to hear it against a background of knowledge of the musico-historical context in which it was composed conflicts head-on with the doctrine of moderate empiricism that we found so plausible in §8.2. There, to recap, it was argued that the aesthetic appraisal of a work requires us merely to use our ears (and be cognizant of the category of artwork it falls under). The work's aesthetic properties are there to be heard in it; and in order to get our minds round these features, we do not

need to bring to bear a raft of information concerning the composer's *oeuvre* and influences, or the point in musical, social, and cultural history in which the work was composed. (2007, 267)

He offers in support of this claim Miles Davis's *Kind of Blue*:

In order to appreciate *Kind of Blue* as a work of music, one need not have internalized information concerning musical, cultural, and political history up to 1959, and one does not even *need* to know anything about the development of Davis's *oeuvre* or the musical influences upon him. Rather, one must be sufficiently familiar with, and sensitive to, the music itself: *how it sounds*....

This is not to deny that such contextual matters are of concern to the music scholar; it is to insist that such questions are of art-historical interest and do not touch upon the work's aesthetic qualities. (2007, 268)

As in the case of the putative *artistic* differences considered above, Dodd's appeal to the traditional empiricist distinction between the 'aesthetic' and the 'art-historical' interest and value of a musical work is bolstered by the claim that the contextualist's claims go against already established philosophical wisdom. In this case, this 'wisdom' is not the argument in chapters 1–7 of *Works of Music* for the type-token theory but the argument in chapter 8 for musical empiricism as the preferred view of musical understanding and appreciation:

Given the intuitive force behind moderate empiricism, [the sonicist] should insist that genuinely *aesthetic* properties (i.e. those *heard* in the work) *cannot* vary in the cases imagined by Levinson. Works of music (i.e. works of the same artistic category) cannot differ aesthetically without sounding different. So, when it comes to the imagined possible world containing *Pierrot Lunaire* and *Pierrot Lunaire**, for example, we should insist that Schoenberg's work and Strauss's work are equally upsetting, anguished, and eerie. And the same goes for *bizarreness*, if this property is understood aesthetically rather than artistically. If Schoenberg's piece is bizarre, and bizarreness is a property that is genuinely heard in the music, then Strauss's piece cannot have this quality to any greater or lesser degree than Schoenberg's....

My point is this: *either* the putative aesthetic differences highlighted by Levinson are disguised artistic differences, and thus differences in the composers' respective compositional acts, and not their works; or else the properties he focuses on are *shared* by the sonically indistinguishable works, and hence do not undermine the thesis that these works are numerically identical. (2007, 268–70)

Dodd's response to Levinson therefore takes the following form: 'Since a work of music's aesthetic properties are heard in it, and since Levinson's "sonic

doppelgängers" sound exactly alike, such sound-alikes cannot vary with respect to their aesthetic properties, and hence should be treated as numerically identical.' Levinson, however, had earlier responded to this kind of claim (1990b) by presenting a challenge to the kind of construal proposed by Dodd of when there can be a difference in 'how a work sounds'. Dodd sets out this response as follows: 'There is a broader understanding of "how a sound sounds" such that two aurally indistinguishable sounds might nonetheless sound different. The crucial idea in this latter notion is that two aurally indistinguishable sounds might in this second sense sound different to a hearer if they are heard against different backgrounds of information.' This will explain how musical works that 'sound alike' in the narrow sense can have different aesthetic properties. Furthermore, Dodd notes, it might be thought that he is in fact committed to granting this point to Levinson. For, in response to instrumentalist arguments, he has maintained that we can hear a piece of music *as played on a piano* whether or not it is actually so played:

> Once I have granted that an audience may hear a performance *as* a piano performance, it is inconsistent of me then to deny (as I have) that there is a sense in which *Pierrot Lunaire* and *Pierrot Lunaire** may yet sound different. For if an audience can hear a passage *as* produced by a piano, it can surely hear two qualitatively identical works as, respectively, *composed by Schoenberg* and *composed by Strauss*; and if this is possible, then, as Levinson suggests, it follows that the audience may hear differing aesthetic qualities in exact sonic duplicates.
>
> (Dodd 2007, 272)

Dodd, however, denies that the differences between composers are *genuinely heard*. They are, rather, interpretations of what is heard, whereas in the case of hearing something *as* played on a piano, this is how we hear sounds.

In this and the previous chapter, we have looked at some challenges to the idea that multiple artworks, and more particularly performable musical works, are 'pure' structures that are eternally existing types. We have noted on a number of occasions that, while Dodd's response to these challenges echoes earlier defences of structuralism in appealing to a distinction between the 'aesthetic' and 'art-historical' properties of a musical work, where only the former play a part in the individuation of the work, he seeks to counter instrumentalist and contextualist appeals to aspects of our artistic and critical practice by holding such appeals accountable to the deliverances of metaphysical and more generally philosophical reflection. To assess the success of this strategy, we will need to address more fundamental questions about methodology in the ontology of art. These questions will be our focus in Chapter 5.

5
Methodological Interlude
The Primacy of Practice in the Ontology of Art

5.1 Introduction

In the previous two chapters I have looked at some challenges to the idea that multiple artworks, and more particularly performable musical works, are 'pure' structures that are eternally existing abstract entities. I have noted on several occasions that Dodd's response to these challenges echoes earlier defences of structuralism (e.g. by Kivy) in appealing to a distinction between the 'aesthetic' and the 'art-historical' properties of a musical work, where only the former play a part in the individuation of the work. The standard instrumentalist and contextualist counter to such appeals holds that the distinction to which the structuralist points conflicts with central aspects of our artistic and critical practice. Dodd, however, rejects this instrumentalist and contextualist stratagem, maintaining that such features of our practice must be held accountable to the deliverances of mature metaphysical and more general philosophical thinking.

In this chapter I shall present two methodological challenges to Dodd's dialectical strategy in *Works of Music*. I shall then consider his more recent attempts to defend this strategy by invoking certain general meta-ontological principles. In countering these attempts, I shall offer a more general defence of the 'primacy of practice' in the ontology of art as expressed in my understanding of the 'pragmatic constraint'. The structure of this chapter will therefore be as follows. First (Section 5.2), I shall argue that Dodd's strategy in *Works of Music* fails to respect an important methodological constraint on philosophical understanding in the ontology of art, something that I have termed (D. Davies, 2004) the 'pragmatic constraint' (see Introduction). This is apparent in Dodd's assumption that the 'categorial question'—what kind of thing is a (musical) work of art?—can be satisfactorily answered before 'epistemological' questions about what enters into the proper appreciation and evaluation of works are addressed. As we shall see, this assumption contrasts strikingly with the methodological assumptions of those who serve as the principal targets of Dodd's argument. Dodd's failure to respect the pragmatic constraint is, ironically, clearly evident in those passages where he appeals to the constraint to *justify* his own way of proceeding. I also consider whether Dodd's way of proceeding might nonetheless be regarded as acceptable, given that he explicitly deals with the relevant 'epistemological' issues in his

defence of 'moderate empiricism' in chapter 8, and in his discussion of instrumentalism and contextualism in chapters 8 and 9, of his book. In fact, I maintain, this merely compounds the problem because (1) the ontological conclusions of the first seven chapters of his book are used to discount claims about 'proper appreciation', and (2) the defence of 'moderate empiricism' is question-begging.

Second (Section 5.3), as we saw in the previous chapters, Dodd's dialectical strategy leads him to identify the question 'how do we *individuate musical works?*' with the question 'how do we *identify instances of musical works?*' I argue that we shouldn't equate these questions, and indicate why Dodd's type-token theory entails such an equation. In so doing, I provide a hypothetical example where we have the same conditions for identifying instances of works but different requirements for their proper appreciation. My claim is that the individuation of works must satisfy the following requirement: if W and W^* require different things for their proper appreciation, then W and W^* are distinct works. The hypothetical example that I use to show that we can have different works that share the conditions they impose on their well-formed instances is a variant on a case that Dodd himself considers in countering instrumentalism.

Third (Sections 5.4–5.5), I consider Dodd's claim that such an appeal to practice in defence of instrumentalist and contextualist views of musical works goes against a meta-ontological principle that governs work in applied ontology more generally, and fails to take seriously the properly explanatory goals of the ontology of art. In countering this claim, I consider the more general constraints on exercises in applied ontology and argue that, once these constraints are properly understood, artistic practice must be accorded the role in the ontology of art that is assigned to it by the pragmatic constraint.

5.2 The Dialectical Structure of *Works of Music* and the 'Pragmatic Constraint'

Dodd's overall strategy in the ontology of art differs strikingly in one respect from the strategies manifest in the writings of those whom he numbers among his principal opponents—Gregory Currie (1989), Jerrold Levinson (1980), and myself (2004). Each of these authors, taking as their goal the development and defence of an ontological thesis about artworks of certain kinds, attempts to draw ontological conclusions only after a detailed examination of appreciative and critical practices relating to the kinds of artworks in question. It is assumed that ontological conclusions in this domain must be grounded in, and answerable to, what we might term 'epistemological' premises. Such premises draw upon our practices in characterizing the kinds of features of artworks that are taken to bear upon their appreciation and value as art, and the kinds of perceptual and conceptual resources that are taken to be necessary if, in our encounter with an artistic

vehicle, we are to properly gauge the artistic content that it articulates. Furthermore, in providing such epistemological foundations for ontological reflection, a principal target is the kind of 'empiricist' view of artistic appreciation that Dodd defends in chapter 8 of *Works of Music*—the view he terms 'moderate musical empiricism'.

Currie, for example in his 1989 book *An Ontology of Art*, devotes chapter 2 to an extended argument against more or less sophisticated forms of what he terms 'aesthetic empiricism', the latter being the kind of empiricist view of the appreciation and evaluation of musical artworks that Dodd defends in chapter 8 of his book. Only after setting out what he takes to be a view of artistic appreciation and evaluation consistent with our artistic practice does Currie turn, in chapter 3, to ontological matters. The question, he there argues, is how artworks should be understood ontologically if their appreciation and evaluation are to have the features critically presented in his previous chapter. Levinson, as we have seen, adopts the same kind of strategy in defending his account of musical ontology. He begins by appealing to features of our critical and performative practice in establishing three conditions that must be met by any adequate musical ontology: creatability, fine individuation, and performance means. He then defends his account of musical works as 'indicated structures' on the grounds that this is the ontological theory that best satisfies those conditions. And my argument for the 'performance theory' in *Art as Performance* also adopts this strategy. It is only after offering, in chapters 2 and 3, a range of actual examples from our critical and evaluative practices in defence of a contextualist model of artistic appreciation and artistic value that I turn, in chapter 4, to ontological matters. There, like Currie and Levinson, I ask which kind of ontological account can best do justice to those features of our artistic practices that seem, on reflection, to play essential roles in those practices, given their more general aims.

This methodological assumption that we need to ground ontological conclusions about artworks in premises relating to actual artistic practices is what, in the opening chapter of *Art as Performance*, I termed the 'pragmatic constraint' (PC):

> Artworks must be entities that can bear the sorts of properties rightly ascribed to what are termed 'works' in our reflective critical and appreciative practice; that are individuated in the way such 'works' are or would be individuated, and that have the modal properties that are reasonably ascribed to 'works', in that practice. (Davies 2004, 18, cited in the Introduction)

PC has an ineliminable *normative* dimension, in that it does not require that ontology conform to our existing practice, or to the ways in which we talk about that practice, per se, but to those features of our practice, and our ways of talking about it, that we deem acceptable upon reflection. In engaging in such reflection upon a practice, we need to take account of the goals it is reasonable to ascribe to

it, the values reasonably posited as sought within it, and the values reasonably ascribable to the entities that enter into it.

To endorse PC, I have claimed, is to make ontology of art answerable to epistemology of art, as is done in the works just cited by Currie, Levinson, and myself. But, as we have seen, Dodd only addresses such epistemological matters in the final chapters of his book, after arguing that his preferred ontology, the type-token theory, is the correct answer to the categorial question because it can explain repeatability and audibility. An evaluation of the more specific judgments that we make about particular works is postponed until the basic ontology is already in place. It is introduced only in response to the question how musical works, viewed as eternally existing norm-types, should be individuated. It is clear that Dodd assumes that the categorial question can be answered before issues about instrumentalism and contextualism are addressed.

Surprisingly, in spite of this, Dodd claims that his methodology fully accords with the PC. This, however, reflects an understanding of the PC very different from that of its proponent, and, I shall now suggest, incompatible with the latter. Dodd appeals to the PC in defending his 'moderate empiricist' view of the appreciation of musical works. As we saw in the previous chapter, Dodd's empiricist proposes that any property ascribed to a musical work in our critical and appreciative practice that depends upon the art-historical context in which the work was composed has no bearing on the proper appreciation of the work *qua work of music*. Rather, it is properly viewed as 'either an *art-historical* property or an *achievement* property... possessed by *composers* and *their actions*, rather than by their works' (Dodd 2007, 185–6). He offers the following argument in support of this claim:

> If (PC) has the normative, rather than purely descriptive, character Davies presents it as having, then what is to stop the type/token theorist from... claiming that such [provenance-based] properties are not 'rightly' ascribed to works? A holder of the simple view will insist that... the type/token theory can provide a principled rationale for denying that musical works genuinely bear art-historical and achievement properties. How, she will ask, can an abstract object really be, for example, *influenced by Ellington* or *visionary*? Strictly speaking, the only things that can have such properties are people and their actions. Once one appreciates that works of music are abstract objects, ascribing such properties to them becomes a strange business indeed. (2007, 186)

Dodd assumes that, given the arguments for the type-token theory, one can defend aesthetic empiricism by rationally revising those critical judgments to which writers like Currie, Levinson, and myself appeal in arguing against it. In so reasoning, Dodd reads the PC as a 'holistic' methodological principle, one that rules that we cannot evaluate any individual component in a philosophical theory

of art—ontological, epistemological, or axiological—without locating it in a total theory of art. But, as we saw above, PC claims not that epistemology of art and ontology of art mutually constrain one another, but that it is our creative and appreciative practice that has primacy, and that must be foundational for our ontological endeavours. For it is our practice that determines what kinds of properties, in general, artworks must have, and thus what properties must be accounted for by an acceptable ontology. The reason why this is so might be put as follows: our philosophical interest in artworks arises out of, and is an attempt to better understand, that practice. Artworks are whatever plays the central role in a range of practices that comprise artistic production and artistic appreciation. The problem with aesthetic empiricism is that it cannot make sense of the kinds of values we seek in our engagement with artworks, and the kinds of properties that bear upon our appreciation and evaluation of those works. Something that only admitted of the sort of appreciation and evaluation permitted by the empiricist would not *be* a work of art in the sense that interests us as philosophers. This is why we cannot postpone the epistemological and axiological questions until after we have done our basic ontology.

In a more recent paper, Dodd has defended his methodological strategy in *Works of Music* against this kind of objection. I shall come back to this and provide a more developed understanding and defence of the PC in the later sections of this chapter. First, however, I want to bring out in more detail the ways in which Dodd's defence of structuralism in *Works of Music* fails to meet the requirements of the PC. Only if Dodd is able to show that artistic practice does not in fact have primacy in the ontology of art will his defence of the simple view against its contextualist and instrumentalist critics hold up.

It might be said that Dodd's way of proceeding is harmless. For, even if he claims to have answered the categorial question before turning to epistemological questions about the kinds of properties rightly ascribed to artworks in our appreciative practice, he certainly addresses these kinds of issues in the final two chapters of his book. Furthermore, he there offers a detailed defence of the kind of 'moderate empiricism' rejected by his opponents, and he also offers detailed arguments against the claims of instrumentalists and contextualists. But, as may have been clear from our discussion in the previous chapter, far from bringing the overall argument of *Works of Music* into closer alignment with the demands of the PC, the treatment of these issues in chapters 8 and 9 only serves to compound the problem. There are two reasons why this is so:

(1) As exemplified in Dodd's appeal to the PC cited above, the ontological conclusions drawn without a grounding in relevant details of our appreciative practice in chapters 1 to 7 are, in the last two chapters of the book, used to discount instrumentalist and contextualist claims about elements that enter into that practice.

(2) The defence of 'moderate musical empiricism' against its critics only works if we equivocate on the two central notions: that of the 'aesthetic' and that of what it is to appreciate a musical work 'as music'.

Let me take these points in turn.

5.2.1 The Appeal to 'Mature Philosophical Theory' in Dodd's Arguments

Consider here the following examples, most of which are familiar from Chapter 4:

a) We are encouraged to override composers' own understandings of what they are doing when they specify particular performance means for their works, given sonicism's 'status as the default position', and its being a claim about how such understandings 'should be *interpreted* in light of mature philosophical theory concerning both the individuation of works of music and the nature of our musical experience' (Dodd 2007, 219). If a composer takes his specification of particular musical instruments for the performance of his piece as laying down a condition for its correct performance, 'he would be wrong about this' (2007, 229, n. 16).

b) In response to Levinson's examples of artistic properties of musical works that depend upon the history of making of those works—for example, being Liszt-influenced, or being original—Dodd argues that 'if the moral of this book's first seven chapters is correct—and we should regard works of music as abstract, structureless, eternally existent types—then there would seem to be a serious question as to the intelligibility of attributing properties such as *Liszt-influenced* and *original* to works of music ... Here, perhaps, we have a case in which mature philosophical theory should prompt us to revisit assumptions that we have hitherto accepted unreflectively.' The sentences in which we seem to commit ourselves to such properties being genuine properties of works must be seen as really about the acts of composers, not about their works, since 'works of music are types, and types, we have noted, are modally inflexible.... Consequently ... it follows that their natures cannot be influenced by the actions of composers. It was *Brahms* who was so influenced in his composition of his Second Piano Sonata, not the sonata itself' (2007, 257–8).

c) Dodd affirms that 'the thesis that understanding a work of music *as music* requires the listener to hear it against a background of knowledge of the musico-historical context in which it was composed conflicts head on with the doctrine of moderate empiricism that we found so plausible.... Given the intuitive force behind moderate empiricism, [the sonicist] should insist that genuinely *aesthetic* properties ... cannot vary [as a function of context]' (2007, 267–8).

5.2.2 Equivocation on the Concepts of 'Aesthetic Worth' and 'Worth as Music'

Dodd's appeal to a distinction between a musical work's 'aesthetic' worth, or worth 'as music', and the work's merely 'art-historical' merit seems to rely on an equivocal appeal to the notions of 'the aesthetic' and of 'music'. If talk of the worth of a musical work 'as music', or of its 'aesthetic worth', is talk of *what can be heard in a sound sequence without reference to instrumentation or context*, then we will indeed rightly resist any appeal to the latter considerations in our judgments of 'aesthetic worth' or 'worth as music'. But the assumption that any properties that fail to qualify as aspects of 'the music', or as 'aesthetic', so construed are merely 'art-historical' and of no relevance to the appreciation of the musical work *as art* simply begs the question against the non-empiricist. The plausibility of this inference rests upon an ambiguity in talk of 'aesthetic worth'. On the one hand, such talk can refer to what can be heard in a sound sequence without attention to matters of context or instrumentation. On the other hand, some philosophers who talk of a work's 'aesthetic worth' or 'aesthetic value' use these terms as synonymous with *artistic* worth or value. The same applies to Dodd's talk about our interest in a musical work 'as music'. On the one hand, there is an 'aesthetic' reading where such talk concerns our interest in the mere sound sequence of (a performance of) the work. On the other hand, there is a reading where what is at issue is our interest in the work *as a musical artwork*. To assume that a judgment about what is 'of aesthetic interest', or what 'concerns the music', in the first sense supports sonicism in that it relegates all other judgments to the domain of art history etc. is simply to assume that there is no legitimate 'aesthetic' and 'musical' interest, in the second sense, in the kinds of instrumentally and contextually based properties cited by writers like Levinson. But whether there *is* such a legitimate interest is precisely the point at issue in the debate between Dodd and his instrumentalist and contextualist opponents.

5.3 Individuating *Works*, Identifying *Instances of Works*, and the 'Appreciation Constraint'

In presenting Dodd's treatment of the individuation question in the previous chapter, we noted a further consequence of his methodological strategy. In seeking an answer to the categorial question prior to engaging with the kinds of appreciative and evaluative considerations that might be thought to bear crucially on the individuation of musical works, he equates the question 'How do we individuate *works*?' with the question 'How do we identify *instances of works*?' Such an equation follows directly from Dodd's proposed answer to the categorial question and his account of types. If musical works are indeed *norm-types*, then, according to Dodd's account of types, they must be individuated in terms of their property-

associates, where the latter specify the properties that are normative within the type—the properties that a correct token of the type must possess. In the case of musical works, the tokens are taken to be performances, playings, and other sound sequences having the relevant features, so the correctness conditions given by the property-associate of a musical work, qua norm-type, are the conditions for something to count as a correct performance or instance of the musical work in question. Thus the *individuation* question 'how do we individuate musical works?' is identified with the question 'how do we identify instances of works—performances—in terms of the conditions for them to be *correct performances*?'

But, if we take ontology to be accountable to practice in the way described in the PC, then it seems that the criterion for individuating works must take account of what bears upon their correct *appreciations*. Why, we might ask, is it reasonable to think that everything that bears upon a work's being the distinct appreciable entity that it is will be captured in the conditions for something to be a correct instance of that work, especially if this claim rests upon an understanding of 'normativity within a work' in non-contextualist and non-instrumentalist terms? Dodd's cause is helped, however, by the fact that Levinson, the principal proponent of an instrumentalist/contextualist conception of the musical work and thus Dodd's principal opponent in his arguments against instrumentalism and contextualism, seems to *agree* that all of a musical work's appreciable properties (at least as far as instrumental means is concerned) must be tied to the conditions to be satisfied by well-formed performances.[1]

It is this that allows Dodd to meet the instrumentalist's objection that some of the aesthetic properties of the 'Hammerklavier' Sonata require that the work be performed on the instruments specified by the composer. For Dodd can grant that to appreciate these aesthetic properties requires a sound-sequence event having the necessary timbral sonic properties that the listener can *hear as* produced on the particular instrument specified by the composer, but insist that there is no need for the sounds to *actually be* produced on that instrument. But then it follows, given the assumption (to which Levinson subscribes) that the individuation of works is a matter of which properties are *normative within the work for correct performance*, that the use of specified instrumentation is not individuative of the work, and that timbral sonicism is correct.

[1] See Levinson (1980). See in particular p. 85, where he makes the same claim for contextual properties: 'In order for a performance to be a performance of W, not only must it fit the S/PM structure of A's work W; there must also be some *connection*, more or less direct, between the sound event produced and A's creative activity. Whether this is primarily an intentional or causal connection is a difficult question, but, unless it is present, I think we are loath to say that A's work has been performed.' While Levinson, unlike Wolterstorff, holds that only correct instances of works count as performances, he places on incorrect instances the same requirement that they stand in the necessary causal and/or intentional relation to the composer's activity (86).

But Dodd's acknowledgement that some of a musical work's aesthetic properties require that it be *heard as* played on certain instruments seems to open the door to an instrumentalist and contextualist critique of sonicism and, as we shall now see, of the assumption that criteria for work-individuation and work-instance identity are equivalent. For it brings into play the very thing that the moderate musical empiricist cannot allow—something other than the general musical sophistication of the listener and her knowledge of the work's category of art that constrains the proper appreciation of a work, but that does not constrain its proper performance. This has the potential to fund a difference between works on the reasonable assumption that, if *W1* and *W2* differ in the properties that bear upon their proper appreciation as works, they must be different works. More formally:

Appreciation constraint (AC): If *W* and *W** are artworks and if different properties bear on the proper appreciation of *W* and *W**, then *W* and *W** are distinct artworks.

Dodd considers the following instrumentalist response to his claim that, to grasp those aesthetic properties of the 'Hammerklavier' Sonata that relate to the production of its particular timbral sound sequence on an instrument with the physical capacities of a piano, we only need to hear the sound sequence *as* played on a piano. W*hy*, it might be asked, is it right to hear the 'Hammerklavier' Sonata as played on a piano rather than as played on a PTS? For only if it is *right* to hear it in the former manner rather than in the latter will the aesthetic properties of sublimity and cragginess be objectively possessed. Surely, the instrumentalist might respond, the reason why the sound sequence has to be heard *as played on a piano* is that this is how the composer *intended* that it be played. If so, properly appreciating the aesthetic properties of the music requires that the receiver know of these intentions. But such knowledge is precisely the kind of contextual and instrumental knowledge that moderate musical empiricism says is *not* necessary to appreciate a musical work 'as music'. Dodd responds that what matters here is not the receiver's knowledge of the composer's specifications but 'our familiarity with the customary origins' of the sounds we hear in listening to a piece of music (Dodd 2007, 231). What count, he maintains, are 'the responses of a certain class of perceivers' (2007, 233), namely, those who not only possess a developed musical sensibility that allows them to discriminate the audible qualities of sound-sequence events but also 'share *our* way of conceptualising what is heard' and who will therefore 'think of certain sounds as *sounds typically made by a piano*' (2007, 234). This reflects the more general fact that 'we come to think of sounds' tone colours in terms of their characteristic causes' (2007, 233). And this, Dodd maintains, allows us to preserve the determinate nature of a work's aesthetic properties without making performance means partly individuative

of the work. For, even if the 'Hammerklavier' Sonata would *not* be sublime, craggy, or assertive if heard *as* played on a PTS, that is not the way it is properly heard by the relevant class of perceivers, whether or not it is actually played on a piano or a PTS.

Suppose we grant Dodd that Beethoven's 'Hammerklavier' Sonata (*HS*) does indeed genuinely have the properties of cragginess, sublimity, and assertiveness in virtue of the fact that the relevant class of perceivers will hear it as played on a piano because this is how such sounds are customarily produced. What, however, should we say about a musical work (*HS**) within which identical sonic properties are normative for correct performance, but which is composed in a temporal extension of our culture where pianos are no longer the customary means for producing what we would think of as piano-like sounds? Rather, let us suppose, such sounds are customarily produced on a PTS. What aesthetic properties would such a work have? Dodd's treatment of the 'Hammerklavier' Sonata example seems to commit him to saying that *HS** would possess different aesthetic properties. For the relevant class of informed perceivers for such a work will presumably be individuals who will think of the sound sequence constitutive of this hypothetical sonic *doppelgänger* of the 'Hammerklavier' Sonata as composed of sounds typically made by a PTS. They will therefore not hear the work as sublime, craggy, or assertive. But then, by appeal to AC as a specific application of Leibniz's Law of the Indiscernibility of Identicals, we have different works that are identical in the timbral sonic properties normative within them. More significantly, we have different works that have *the same properties* normative within them for correct *performance*—if we follow Dodd in holding that performance means are not so normative—but *different properties* normative for their correct *appreciation*.

It is important not to confuse the issue here with other related issues. The question is not whether we would be able to appreciate the aesthetic properties of the futuristic work, and whether contemporaries of the composer of that work would be able to appreciate the aesthetic properties of Beethoven's work. The issue, in other words, is not whether we can somehow hear the sounds that are normative within works as produced by means other than their customary means in our own experience. Nor is the issue whether the 'Hammerklavier' Sonata (that is, the work composed by Beethoven) would lose or lack its aesthetic properties when listened to in the futuristic setting—surely it would not. Presumably what we should say is that our community of future listeners might, sadly, not be able to appreciate the aesthetic qualities of Beethoven's work. Nor, even more emphatically, can the case be described, as Dodd seems to want to do (2007, 235, n. 19), as one in which the 'Hammerklavier' Sonata is composed by the futuristic composer. To so describe it is simply to beg the very question at issue, namely, whether something identical to the 'Hammerklavier' Sonata in terms of the sonic properties normative for correct performance, but which is composed for PTS, or in a

situation where what we would describe as piano-like sounds are customarily produced by a PTS, would have the same aesthetic properties as the 'Hammerklavier' Sonata, this, in turn, bearing—given AC—on the question whether it would indeed *be* the 'Hammerklavier' Sonata. Given that this is a proposed counter-example to sonicism, one cannot *assume* the truth of sonicism in describing the example!

In order to assess the force of this counter-example, it may be helpful to schematize the overall argument in which it is located. Dodd's 'simple view' involves a commitment to the following two claims concerning works of music:

(D1) W and W^* are distinct works if and only if W and W^* have different properties normative within them for their instances. This follows from the type-token theory, given Dodd's account of how types in general, and norm-types in particular, are individuated.

(D2) *Instances* of musical works are identified in accordance with timbral sonicism: 'Whether a sound event counts as a properly formed token of W is determined purely by its acoustic qualitative appearance' (2007, 201).

D1 and D2, taken together, entail the timbral sonicist account of work-individuation:

(TS) A work of music W and a work of music W^* are numerically identical if and only if W and W^* are acoustically indistinguishable: just in case, that is, they have exactly the same acoustic properties normative within them.

AC, however, imposes a different constraint from D1 on the individuation of *artworks*:

(AC) If W and W^* are artworks and if W and W^* have different properties that bear on their proper appreciation, then W and W^* are distinct artworks.

This allows for the possibility that D1 and AC differ on work-individuation for a given criterion of work-instance identification: this is what happens in the hypothetical example. *HS* and *HS** have exactly the same acoustic properties normative within them for their instances. So, by D1 and D2, *HS* and *HS** are the same work. But *HS* and *HS** have different properties bearing on their proper appreciation. So, by AC, *HS* and *HS** are distinct works.

To counter this challenge to timbral sonicism, Dodd must either challenge the claim that *HS* and *HS** have different properties bearing on their proper appreciation or challenge AC. I shall consider the latter response in the following section. If we focus here on the former response, one option would be to say

that musical works like the 'Hammerklavier' Sonata do not genuinely possess aesthetic properties such as cragginess, or only possess them in a relativized manner. But these responses are incompatible with Dodd's professed view that the 'Hammerklavier' Sonata *does* possess such determinate aesthetic properties. Another option, however, might seem more promising.[2] The foregoing argument assumes that talk of a 'customary way of producing certain kinds of sounds' is indexed to the context in which the work was composed, so that the aesthetic properties are those that the composer would have envisaged in selecting a particular set of requirements on right instantiation of his or her work. But Dodd might say that 'customary way of producing certain kinds of sounds' is indexed to *our* context for all actual and possible musical works. In that case HS^*, like HS, would be properly heard as performed on a piano, and HS and HS^* would have identical aesthetic properties bearing on their proper appreciation. Since the timbral sonicist repudiates the idea that contextual variables play a role in the individuation of musical works, she might also deny such variables any part in determining upon which instruments instances of musical works are properly heard as performed.

But this option comes at a heavy cost. We must say that neither the composer of HS^* nor his or her contemporaries are capable of fully appreciating the work. Or, by parallel reasoning, a work W^{**} composed in a musical community prior to our own whose members would have heard that sound sequence as played on a different instrument from us, where this would involve different aesthetic properties, could not have been properly appreciated by members of the community in which it was composed.

5.4 Dodd's 'Meta-ontological' Argument

The methodological arguments against Dodd's defence of the 'simple view' presented in the previous sections of this chapter rely upon two principles that I have taken to be normative for work in the ontology of art. The first principle, the 'pragmatic constraint' (PC), holds that ontological conclusions about the kinds of things that artworks are must be grounded in facts about our appreciative practices, and that artworks must be the kinds of things that can have the properties we would ascribe to them in those practices after rational reflection upon the latter. The second principle, the 'appreciation constraint' (AC), assigns a determinative role in the *individuation* of artworks to the particular properties rightly ascribable to artworks in our appreciative practices: If W and W^* are

[2] I am grateful to Yvan Tétreault for pointing out this possible response.

artworks and if different properties bear on the proper appreciation of W and W*, then W and W* are distinct artworks. The two principles provide the dialectical underpinnings for the kinds of arguments for ontological contextualism presented in the previous chapter. PC directs us to attend to differences in the properties ascribable to works in our appreciative practices that, it is claimed, reflect differences in the art-historical contexts in which those works were initiated, and AC licenses individuating works in light of these differences. This can be brought out in schematic presentations of the contextualist arguments offered by Levinson and Currie examined in the first part of Chapter 4. In the case of Levinson, the argument can be analysed as follows:

(L1) the same sound sequence prescribed in different musico-historical contexts would result in works having different properties bearing on their proper appreciation and thus (by AC) in different works, and

(L2) musical works must therefore (by PC) be taken to be initiated types, finely individuated by reference to their art-historical contexts of origin, rather than pure types.

In the case of Currie, we have a parallel dialectical structure:

(C1) Jane Austen's *Northanger Abbey* and an identical text authored by Ann Radcliffe a few years earlier would possess very different properties bearing on their proper appreciation as literary works and thus (by AC) be different works, and

(C2) literary works must therefore (by PC) be taken to be art-historically contextualized texts rather than pure texts.

In both cases, there is not only a general assumption (PC) that ontology of art is accountable to features of our reflective artistic practice but also a more specific assumption that *individuative* judgments about artworks can act as a constraint on *categorial* judgments as to the kinds of things that artworks are. But both of these assumptions might be questioned by one committed not only to the kind of ontological view championed by Dodd but also to the idea that one of the merits of this view is that it accords with more general meta-ontological principles. In the case of the second assumption (enshrined in AC), for example, it might be said that we cannot make authoritative judgments as to the kinds of appreciable properties artworks possess unless we know what kinds of things they are: until we answer the categorial question, our actual appreciative judgements reflect no more than our folk understandings of such things. Thus, as in Dodd's own reasoning, we must resolve the categorial question before asking how things belonging to the relevant ontological category are properly individuated. In a

more recent paper (Dodd 2013), Dodd raises exactly these kinds of concerns, partly in response to my claim, rehearsed above, that his defence of the simple view in *Works of Music* fails to observe the pragmatic constraint as properly interpreted. His ostensible target is what he terms 'local descriptivism' as a meta-ontological principle in the philosophy of art, but his paper raises more general questions that it will be fruitful to consider in detail.

Dodd distinguishes local descriptivism from two other meta-ontological views which he terms 'folk-theoretic modesty' and 'global descriptivism'. Local descriptivism and folk-theoretic modesty about art differ as to the relationship between the folk-theoretic beliefs about artworks implicit in our practices and the correct ontology of art for particular art forms. The local descriptivist thinks that the folk-theoretic beliefs in some way determine the ontological characters of artworks, whereas proponents of folk-theoretic modesty think that properly rigorous philosophical inquiry in accordance with the demands of 'mainstream metaphysics' can lead us to rightly conclude that our folk ontology of art is seriously in error. The local descriptivist differs from the *global* descriptivist in subscribing to folk-theoretic modesty for domains other than art. The global descriptivist rejects the more general meta-ontological thesis—which Dodd terms 'meta-ontological realism'—that provides the grounds for folk-theoretic modesty.

Dodd characterizes meta-ontological realism as it pertains to the ontology of art as the view that

> the correct answers to first-order art-ontological questions – questions concerning the respective ontological categories the various artwork kinds belong to, their identity conditions, their persistence conditions, and so on – are objective (i.e. mind-independent) in the following sense: their correctness is in no way determined by what we say or think about these questions. (2013, 1048–9)

Meta-ontological realism is taken to entail folk-theoretic modesty, characterized as the view that 'if the ontological nature of F's is fixed independently of what we think on the matter, then F's could turn out to be very different from how we folk presuppose them to be' (2013, 1049). Descriptivism in the ontology of art, on the other hand, is characterized as the view that 'the correct ontological theory of artworks of a given kind can only codify, not falsify, the nascent ontological conception of such works implicit in our critical and appreciative practice' (2013, 1049). As Dodd puts this, for the descriptivist 'there is no prospect of the ontological conception implicit in this practice being proved substantially false by the deliverances of the ontology room' (2013, 1050–1).

Dodd's argument against local descriptivism runs as follows:

(1) folk-theoretic modesty should be viewed as the default view in metaphysics in general, thus

(2) the local descriptivist owes us an argument as to why we should take a *descriptivist* view in the ontology of art, but

(3) no convincing argument of this sort has been offered, and

(4) more crucially, we have good reason to think that the descriptivist will not be able to come up with a convincing account of the kind of relationship that supposedly exists between the folk-theoretic beliefs implicit in our artistic practice and the ontological character of artworks.

The descriptivist, Dodd claims, is committed to what he terms 'the determination thesis', which maintains that 'the facts of the matter in the ontology of art are not objective, but determined by the folk-ontological beliefs implicit in our critical and appreciative practice' (2013, 1055). He takes 'determination' here to be some kind of *non-causal* determination, viewed as 'a thesis of metaphysical fundamentality... taking the form of a claim that things possess properties of one kind *in virtue of* possessing properties of another kind' (2013, 1056). However, he maintains, descriptivists have given us no good reason to think that our artistic practice can determine the art-ontological facts in this way. All our artistic practice can determine is the properties we *think* that works have. Nor, Dodd further maintains, is this worry in any way assuaged by the suggestion that our philosophical interest in artworks 'arises out of and is an attempt to better understand [the totality of] our practice'. He cites here the defence of PC in a 2009 paper (Davies 2009), where I criticize his methodology in *Works of Music*, and he claims that I both ignore the properly explanatory goals of the ontology of art and am guilty of a non sequitur: 'Since when were facts about the ontological nature of a type of entity determined by what our philosophical interests happen to be?' (2013, 1058).

Dodd's paper raises a number of questions. First, is local descriptivism, as characterized by Dodd, flawed in the ways that he claims? How we answer this question will depend upon how local descriptivism is to be understood, which will in turn determine to what extent those whom Dodd takes to be local descriptivists really do subscribe to such a view. At least the following aspects of 'local descriptivism' require clarification: [A] Is it (i) our artistic practice, (ii) an ontology of art supposedly *implicit* in our artistic practice, or (iii) our folk *beliefs* about our artistic practice that is taken by the descriptivist to play the supposedly determining role? [B] Is it (i) our *existing* artistic practice, or folk beliefs about this practice, that is supposed to play this determining role, for the descriptivist, or (ii) the practice or beliefs that would be *acceptable upon reflection*? Dodd's answer to 'A' seems to be that what counts, for the local descriptivist, are our folk beliefs about artworks, and his answer to 'B' seems to be that what counts, for the local descriptivist, is our actual practice rather than any rationally revised version of that practice. If so, it is obvious that to subscribe to PC is *not* to endorse local descriptivism. For, as we

have seen, PC holds that 'artworks must be entities that can bear the sorts of properties rightly ascribed to what are termed "works" in our reflective critical and appreciative practice'. 'Practice', for the PC, is not to be cashed out in terms of our *beliefs* about practice, let alone our *ontological* beliefs about our practice. And there is an ineliminable *reflective* dimension to the pragmatic constraint that allows for revisions not only in our beliefs about our practices and the things that enter into them but also in those practices themselves. Dodd seems to think (2013, 1050–1) that his critique of local descriptivism also applies to the PC since, for one who subscribes to the PC so construed, the beliefs (or, presumably, practices) that survive rational reflection are what determine the correct ontology of art. But, it may be countered, if the PC involves this reflective dimension, it seems it can satisfy the defining condition for folk-theoretic modesty if the latter is read as follows: if the ontological nature of F's is fixed independently of what we [in our ordinary folk practice] think on the matter, then F's could turn out to be very different from how we folk presuppose them to be [in that practice].

Dodd will presumably insist that even ascribing such a determining role to our *reflective* beliefs or *reflective* practice violates the requirements of meta-ontological realism. To answer this challenge, we shall have to say more about why artistic practice should be accorded some kind of determining role in the ontology of art. Our focus should be upon what I take to be the most important methodological questions raised by Dodd's criticism of local descriptivism:

a) How can our practice constrain the ontology of art in ways that seem to violate the principles of meta-ontological realism?
b) In virtue of what can it have such a constraining role, and to what extent is this compatible with revisionism concerning such practice?
c) How much revisionism is possible?
d) If the relationship between practice and ontology is not a 'determining' one in Dodd's sense, what is that relationship?

5.5 The Place of Artistic Practice in the Ontology of Art: the 'Pragmatic Constraint' Revisited

To answer these questions, we must ourselves engage in some meta-ontology and ask as to the constraints that govern exercises in applied metaphysics such as the one in which we engage when we ask about the ontological status of multiple artworks. Any applied ontological inquiry needs to start with a way of picking out the entity whose metaphysical status is to be investigated. To ask what kind of thing an event is, for example, we need some prior way of picking out events. Lacking this, it will be unclear why what we finish up with is an ontology of *events*. There are two kinds of constraints on a satisfying ontology of x's, for some x. First,

'*metaphysical*' constraints come from more fundamental metaphysical inquiry, which investigates, for various kinds of candidates *M1*, *M2*, etc. that might answer our question about the metaphysical status of *x*'s, what properties are distinctive of these *M*'s and in what ways they differ. Lacking an understanding of the nature of particular *M*'s, we have no basis for deciding to which ontological category *x*'s belong. I take the metaphysical constraints on an exercise in applied metaphysics to be what Dodd terms 'the deliverances of the ontology room'. Such deliverances may be clarificatory in nature. 'Mainstream metaphysics', in clarifying the nature of *M*'s, also clarifies what we are buying into if we say that *x*-works are *M*'s. Dodd's discussion in chapters 2 and 3 of *Works of Music* offers a clarification of the nature of types and of norm-types, and in so doing makes clearer the implications of saying that musical works are such things. But the deliverances of the ontology room may also be critical in their focus, calling into question the fruits of more general philosophical reflection. Philosophical reflection on the nature of *x*-works might suggest that *x*-works are *M**s, but it might be objected that mainstream metaphysics doesn't recognize *M**s as a legitimate ontological category. Dodd, in the final paragraph of his 2000 paper, raises exactly this kind of objection to Levinson's claim that musical works are 'indicated types', and her philosophical critics have brought the same charge against Amie Thomasson's claim (1999) that fictional characters are 'abstract artifacts'. Other critical deliverances from the ontology room include the claim that the 'continuants' with which Guy Rohrbaugh (2003) proposes to identify both musical works and paintings are 'mysterious' or conceptually confused (see, e.g., Cray and Matheson 2017, discussed in Chapter 8 below). Unsurprisingly, one finds two kinds of response to such critical deliverances from the ontology room. Those such as Dodd who argue for the primacy of 'pure' metaphysics over our practices conclude that we should reject the idea that artworks of a given kind belong to a category that fails to accord with the findings of mainstream metaphysics. Those who argue that mainstream metaphysics must provide us with the kinds of categories necessary to understand the things with which we engage in the world, on the other hand, place the burden on mainstream metaphysics to broaden its range of acceptable ontological categories (see, e.g., Thomasson 1999).

Second, and more importantly for our purposes, what we may term '*topic-specific*' constraints come from the fact that 'ontology of *x*' is *applied* metaphysics where we try to make sense of *x*'s in terms of the more general framework provided by fundamental metaphysics. Our question in the present context is how the topic-specific constraints are to be understood when the object of inquiry is artworks of various kinds, and how the former act as constraints on right ontological theory.

For a local descriptivist in Dodd's sense, the topic-specific constraints on ontological inquiry are presumably provided by the folk understandings implicit in our actual practice. This is why the ontological conclusions at which a local

descriptivist arrives cannot be revisionary of those understandings. But suppose that, for some *x*, we subscribe to folk-theoretic modesty about *x*'s: we think that the nature of *x*'s may differ from the ways we actually think about them. Suppose, indeed, that we further subscribe to what we may term 'folk-practice modesty': we think the nature of *x*'s can conflict with the ways we actually treat *x*'s in practice—for example, in not possessing some of the properties we treat them as having. Then acceptable topic-specific constraints on an ontology of *x*'s cannot presuppose the correctness of our ontologically oriented beliefs about what kinds of things *x*'s are, or the rightness of our practices in respect of *x*'s.

But insisting on topic-specific constraints that allow our ontological inquiries to be revisionary of our folk-theoretic practices does not rule out a crucial role for those practices in applied ontology, at least if our interest is in the ontology of art. This becomes clear if, following Dodd, we take ontology of art to have an essential explanatory dimension. Dodd maintains that the theories of philosophical ontology have a 'quasi-scientific' standing because their adoption reflects the balancing of a number of theoretical virtues, including not only 'coherence with folk belief, but also norms such as explanatory power, simplicity, and integration with the findings of other domains' (2013, 1051). In characterizing philosophical ontology as analogous to scientific theory in being an essentially explanatory endeavour, Dodd intends a contrast with descriptivist metaphysics as he understands it, according to which our ontological accounts simply mirror our existing beliefs or practices and have no explanatory dimension. But it is instructive to consider the parallel contrast, in the case of scientific theory, between descriptivist and nondescriptivist accounts of how the reference of terms entering into our theoretical discourse is fixed.

In scientific inquiries, the terms that enter into explanations of phenomena are lodged in theoretical frameworks that ascribe to the referents of these terms those properties that they are taken by the theory to possess. According to 'descriptivist' accounts of reference, the referent of such a 'theoretical' term just is the thing, if any, that possesses these ascribed properties. Two implications of such a view are that we cannot discover that our theories are wrong about the entities to which they refer, and that, if we are led to revise or replace our existing theories, we also change the things our theories are about—the new theory refers to things that possess the properties ascribed in *its* theoretical framework, not to the entities posited in the superseded theoretical framework. Thus, on such a descriptivist account of how the reference of our theoretical terms is fixed, science is not a practice whereby we arrive at progressively better understandings of the theory-independent entities to which our theories refer, but a practice where, even if we retain our theoretical terms, our successive theories are talking about different things.

We can contrast this 'descriptivist' view of reference fixing for theoretical terms in science with the causal/historical account of such reference fixing initially

developed independently by Saul Kripke (1980) and Hilary Putnam (e.g. in 1975). This account accords a reference-fixing role not to our beliefs about x's, but to our standing in the right kind of causal-historical relation to the referents of our terms. If our use of a scientific term stands in such a relation and thereby picks out an individual or property as our referent, then it can turn out that many or even all of our theoretical beliefs about that referent are false. For Putnam at least, one of the main incentives for developing such a theory of reference fixing was to defend a realist account of scientific kinds against those who thought that our theories at a given time played the central role in determining what those theories were about and that, as a result, successor theories were 'incommensurable' with their predecessors.[3] The Putnamian account allows us to say that caloric theory and statistical thermodynamics are alternative theories of the same natural phenomenon—temperature—even though proponents of one theory take themselves to be referring to a fluid whereas proponents of the other theory take themselves to be referring to a statistical property of collections of molecules.

The argument for a nondescriptivist account of the fixing of the reference of theoretical terms in science is not merely that we can thereby preserve the 'realist' idea of science as an enterprise that delivers increasingly accurate accounts of the natural world. It is also motivated by the consideration, adduced by Dodd, that theoretical terms in nontaxonomical branches of natural science are intended to play a central role in the explanation of phenomena. It is therefore not sufficient, in order to fix the reference of a theoretical term in a scientific theory, that *something* stands in an appropriate causal-historical relation to our introduction and use of the term. In addition, the thing standing in such a relation must be such that it allows the theoretical term to play an explanatory role in science by entering into powerful empirical generalizations. Since it is usually the case that what the referents of a term entering into such generalizations have in common are their causal powers, a putative theoretical term that turns out to stand in the right kind of causal-historical relation to entities that differ sharply in their causal powers will fail to refer or will refer to a nonexplanatory kind that is not suitable to be the referent of a *theoretical* term in science. Putnam (1975) is very clear on this feature of the causal-historical theory of reference fixing for theoretical terms. A term like 'jade' that is taken to refer to a natural kind but that turns out to stand in the appropriate causal-historical relation to a collection of different kinds of stuff with different causal powers fails to refer to a natural kind and only picks out at best a phenomenal kind. Such a term cannot serve as a theoretical term in science.

[3] As noted in the Introduction, Amie Thomasson, following critics of the causal theory, has argued (2005, 221-9) that we also require a solution here to the 'qua' problem to determine which of the myriad things that stand in the causal path count as the referents. The solution to the 'qua' problem, according to Thomasson, points to the user's intentions that the referent fall into a given kind-category—chemical, biological, chromatic, functional, and so on. On the 'qua' problem, see Devitt and Sterelny (1999).

The takeaway message from this digression into the philosophy of science is that, if we share with Dodd the intuition that ontology of art is an essentially explanatory endeavour, then we must take terms that refer to particular artwork kinds as terms whose reference is fixed not 'descriptively' by our 'folk' beliefs or our 'folk' practices but by the capacity of their referents to play a particular explanatory role. In science, as we have seen, that explanatory role might be cashed out in terms of the referent's possession of causal powers in virtue of which the referring predicate can enter into powerful empirical generalizations that explain natural phenomena. What, then, is the particular explanatory role that the referents of terms for artwork kinds are intended to play, and in terms of which competing ontologies of art can be assessed? What can play this reference-fixing role in—and thereby serve as the topic-specific constraint on—applied ontological inquiries where the things of interest are not natural kinds but kinds that enter in seemingly inextricable ways into human practices—what we may call 'cultural kinds'?

What is distinctive of ontological investigation into cultural kinds in this sense is that our philosophical interest is in determining the kind of thing that would be capable of playing certain kinds of roles in our practices.[4] An ontological account of a cultural kind x that failed to speak to this interest would thereby fail to satisfy the topic-specific constraints on such an account: something incapable of playing the x-role could not be an x. In the case of cultural kinds, therefore, acceptable topic-specific constraints on ontology impose the following condition:

Topic-specific constraint on cultural kinds: For any cultural kind, x, if y's cannot by their very nature play the kinds of roles that x's play in our x-practices, then, whatever other virtues the theory that x's are y's may have, it cannot be an acceptable account of the ontological character of x's.

Explaining our x-practices in this way plays the same 'grounding' role for terms that refer to cultural objects that occupying a place in a network of explanatory empirical generalizations plays for natural kind terms, on the Kripke–Putnam account. This, to return to an earlier theme, clarifies the sense in which our interest in artworks as things that enter into certain human practices 'determines' what the ontology of art is about. There is, *pace* Dodd, no non sequitur in the idea

[4] Of course, some natural kinds play a highly significant role in human practices—in particular, those natural kinds that are by their very nature suited to satisfying various human needs. But our interest in how these things can indeed enter into our practices in the way that they do is parasitic upon a prior interest in the practice-independent nature of these things. It is only by drawing upon our understanding of these things' natures, as natural kinds, that we can explain how they can enter into our practices in certain ways in virtue of the relations in which they stand to *our* natures. The claim is that cultural objects differ in that it makes no sense to try to begin by understanding what they are independent of our practices.

that our philosophical interests play a constraining role in ontological inquiry concerning the arts, simply a recognition of the need to particularize any ontological inquiry to the things about which we are inquiring and a further recognition that what particularizes our ontological inquiry into the nature of artwork kinds is the explanatory roles that such kinds are intended to serve. The interests, in other words, determine *what it is whose ontological status is at issue*, not *what that ontological status is.* Just as, on the causal-historical theory of reference, whatever turns out to be gold, if this is to be a natural kind, must be something that both stands in the right causal-historical relation to our use of the term 'gold' and can play the relevant roles in the right kinds of empirical generalizations (where 'the right kind' is something that science progressively uncovers), so a musical work, for example, must be something that stands in the right kind of causal-historical relation to our use of the term 'musical work' in our reflective musical practice and explains the salient features of that practice.

Indeed, Dodd himself, in another paper that criticizes Thomasson, ascribes just this kind of role to artistic practice:

> When it comes to the grounding and regrounding of the reference of 'work of music', it is the nature of our musical practices that is the key such factor. We have developed an aesthetic interest, not merely in datable, locatable musical events, but in items that are common across many such events—items of which many events can be instances. These repeatable items can be fully appreciated, and only fully appreciated, when performed or played; and the requirements for properly realising such an item in a sonic event are specified by means of instructions typically encoded in a score. The grounding and regrounding of 'work of music' marks an interest in such items—an interest manifest in facts such as the following: that a practice of using musical notation has developed, thereby enabling composers to provide clear instructions for the generation of multiple realizations of their ideas; that we evaluate certain performances as interpretations of what the composer has used this notation to represent; that we worry about whether a given performance authentically renders the score's instructions in sound; and that we concern ourselves with the question of whether such a performance succeeds in doing justice to the full aesthetic and expressive content of the thing the composer has characterized in her score. The *point* of the term 'work of music' is to pick out the things that are the locus of this aesthetic interest. (Dodd 2012, 78)

Nor is there any conflict here with folk-theoretic modesty. Folk-theoretic modesty requires that, just as our folk theories of gold can prove to be false of gold without thereby undermining our ability to be talking/thinking about gold, so our folk theories of musical works can prove to be false of musical works without thereby

undermining our ability to be talking/thinking about musical works. In both cases, what ground our inquiries into specific entities are the topic-specific constraints on those inquiries. In ontological inquiries into cultural kinds, we have no alternative but to start from topic-specific constraints that identify entities in terms of the roles they have in our practices.

But it is important to stress two things here. First, it is the totality of our *x*-practices that enter into these topic-specific constraints. We cannot privilege certain features of those practices prior to our attempts to philosophically comprehend those practices and the nature of the entities entering into them.[5] Second, while we cannot avoid starting in this way in fixing the topic of our inquiry, individual features of our *x*-practices are open to revision if such revisions better serve our overall account of *x*'s as things that play a spectrum of roles in those practices. Thus the topic-specific constraints that reflect our actual practices in respect of *x*'s do not 'determine' the ontological facts in Dodd's sense, for two reasons:

1. As noted earlier, the ontological facts must also respect the more general metaphysical constraints on ontology, and
2. we may have reason to revise some aspects of our practices in light of the reflections that lead to our ontological conclusions.

In this way, facts about actual practices *rationally constrain* our ontological inquiries. The idea that practice rationally constrains our ontological inquiries captures, as I have just argued, the explanatory dimension of meta-ontologically realist methodology upon which Dodd (2013, 1051) insists.

I have claimed that it must be the totality of our *x*-practices that enters into the topic-specific constraints on ontological inquiries into the natures of cultural objects such as particular artwork kinds. But, it might be objected, this is to assume that our *x*-practices are sufficiently unified to allow us to arrive at a

[5] It might be thought that, in claiming (see above) that 'a musical work must be something that stands in the right kind of causal-historical relation to our use of the term "musical work" in our artistic practice and explains how such things play the kinds of roles that they do', I am privileging at least one element in our artistic practices, namely, our referential practices. But all that is being claimed is that the term 'musical work' is used in relation to the things that enter into one collection of practices—musical practices—as opposed to the things that enter into another collection of practices—say our 'visual art' practices, where the relevance of this fact follows from a general theory about how we fix the reference of terms that are introduced to play an explanatory role. None of our particular referential practices are thereby privileged. It can turn out that among the features of our practice subject to revision are particular ascriptions of the term 'musical work' to some entities. Just as some of the examples to which we apply the term 'gold' in our ordinary linguistic practice may turn out, in light of mature scientific theory, to not be gold, so some of the examples to which we apply the term 'musical work' in our ordinary artistic discourse may turn out, in light of reflective ontological inquiry, to not be musical works.

univocal answer to questions about the kinds of things that *x*'s are. *Artistic practices*, however, exhibit considerable diversity both across cultures and within our own culture, even within a given genre. The framework of practices in our culture in which works and performances of classical music have their place is very different from the framework of practices surrounding jazz performance or rock music, for example. And, as Stephen Davies's (2007) illuminating discussion of Balinese aesthetics makes clear, the framework of practices in which musical performances take place in some other cultures bears little resemblance to any of the frameworks of practices characteristic of different genres of Western music.[6] The role ascribed to practices on the proposed account seems to lead to a radically pluralistic ontology. Is this perhaps an argument in favour of the kind of 'top-down' model in ontology of art endorsed by Dodd, which promises to impose some order on this threatened metaphysical anarchy?

On the contrary, I think the diversity of artistic practices is an argument *against* attempts to 'sanitize' ontology of art in such a manner. In musical ontology, for example, increasing attention to the different ways in which musicians, audiences, and commentators in different musical genres engage with and appreciate musical works and performances has led philosophers to embrace an ontological pluralism that reflects this diversity in practices.[7] If, as I have argued, the necessary topic-specific constraints upon ontology of art require that we hold the latter rationally accountable to artistic practices, then pluralism in the ontology of art of the sort just canvassed merely testifies to the complexity of the phenomena we are trying to better comprehend.[8]

I have suggested that features of our artistic practices constrain artistic ontology in a manner that allows for revision of those practices but only in ways compatible with the need to retain a grounding of our ontological inquiries in the subject that concerns us. Despite his professions of folk-theoretic modesty, Dodd is in fact just

[6] There are also considerations that arise from the plurality of critical practices surrounding what are intuitively the same works. For example, critical treatments of literary 'works' by those working in the tradition of E. D. Hirsch differ strikingly from critical treatments of the same 'works' by followers of Derrida. I shall not address these considerations here, although I have touched upon their ontological implications elsewhere—see D. Davies (2007). I take the issue here to be internal to the theory of criticism, turning on whether the proper object of critical and appreciative attention is partly constituted by an artefact's art-historical context of making. This is Wollheim's (1980) distinction between 'criticism as retrieval' and 'criticism as revision'. How we resolve this issue depends upon whether we want to distinguish between two senses in which we can talk of 'appreciating a work' (as I argue in D. Davies 2007) or whether we want to reject one of these concepts of criticism as invalid.

[7] See, for example, Stephen Davies (2001, ch. 1); Goehr (2007); Gracyk (1996); and Kania, (2006). See also D. Davies (2011, ch. 5). For critical responses to these authors on the grounds that their 'particularism' is not particular enough, see the following: (a) the exchange between Kania and Lee Brown over Kania (2006)—Brown (2011), Kania (2012b), and Brown (2012); (b) critical responses to Gracyk (1996)—Bruno (2013), Burkett (2015), and Bartel (2017).

[8] To anticipate what will be claimed in Chapter 9, ontological pluralism in this sense might be compatible with a higher-order unified account of what different artwork-kinds have in common.

as committed to this grounding role of practice as his supposedly 'descriptivist' opponents. This was clear in his response to Thomasson quoted above, but it is equally clear in the following passage which also brings out how Dodd fails to observe the foregoing requirement that we take as our initial explanandum the totality of our practices in respect of a given kind of artwork:

> Plausibly, musical works are in themselves both repeatable and audible: more precisely, such works can have multiple occurrences (e.g. performances), and we can listen to a work by listening to an occurrence of it. But, nonetheless, these properties are philosophically perplexing. What kind of entity must a work of music be, given that it can have multiple occurrences? And how, given that an occurrence of a work is distinct from the work itself, is it possible to listen to the work in listening to an occurrence of it? An ontological proposal for works of music should try to answer these questions (Dodd 2007, pp. 9–19). But if, as I have argued (Dodd 2007, Chaps. 1, 6, 7), the account of musical works as sound event-types is the theory with the greatest overall explanatory power, and if types, as I have claimed (Dodd 2007, Chaps. 2, 3), are eternally existent entities that are both temporally and modally inflexible, then it is compelling to think that we should adopt this theory even though it contradicts some of the central pillars of the nascent ontological conception of such items shared by the folk.
>
> (Dodd 2013, 1053–4)

What is it that justifies Dodd's claim here—indeed the claim upon which the entire argument of *Works of Music* rests—that the repeatability and audibility of musical works are not only 'plausible' but can be taken as the principal explananda for a properly modest ontology of musical works? The 'plausibility' of taking musical works to be repeatable and audible is obviously not a result of analysis of the concept 'musical work' but of the way such works are treated in our artistic practice. Furthermore, Dodd never subjects these practice-based claims about musical works to critical scrutiny: they are viewed as data, the ability to explain which can serve as the measure of competing ontological theories. The supposedly superior capacity of Dodd's own 'type-token' theory to explain *these* data then gives it the status of 'mature philosophical theory' that can be used to revise *other* features of our artistic practice—in particular, those features cited by creationists, contextualists, and instrumentalists like Levinson. But Dodd offers no defence of partitioning our practice and making ontology accountable to only part of it as a prelude to discounting the rest. Nor does he explain why his methodology holds immune from revision our practices of treating musical works as repeatable and audible. This is particularly worrying if, as I argued in Chapter 3 above, the latter feature of our practice stands in need of revision in light of the 'mature philosophical theory' that clarifies the role of analogical predication or of the semantics of generic expressions.

5.6 Meta-ontological Postscript

In agreeing with Dodd that the ontology of art may be *revisionary* of our artistic practices and our beliefs about those practices, I might seem to be disagreeing with Amie Thomasson. As noted in the Introduction, Thomasson holds that our broadly artistic practices play a necessary role in grounding a properly philosophical understanding of the nature of artworks, but maintains that, when that grounding role is properly understood, it will be clear that ontology of art *cannot* rightly claim to be revisionary of those practices. Ontology of art, she maintains, is *not* an explanatory endeavour but, rather, a form of conceptual analysis. As noted in the Introduction, however, the 'revisionary' nature of ontology of art I have defended in this chapter does not in fact conflict with Thomasson's position, since ontology of art so understood is supplementary to rather than revisionary of those features of our ordinary linguistic practice that ground the meaning of 'folk' terms like 'painting', 'sculpture', 'book', 'musical work', etc. As sketched in the Introduction, the view of ontology of art that I defend seeks to clarify the nature of *the proper objects of critical and appreciative attention* in those artistic practices where the referents of those folk terms play a central role. It is the folk theories relating to the latter, rather than the folk grounding of the reference of those terms, that is open to revision on the basis of a philosophical theory. Thus, as again noted in the Introduction, the ontology of multiple artworks as I understand it is a form of 'conceptual engineering', not a correction of the folk concepts of the entities that enter into our artistic practices. Does this differentiate my view from that of Dodd, who is Thomasson's principal target in her arguments against the 'discovery model'? Dodd certainly claims that 'mature philosophical theory' may show that the folk concept of 'musical work' is seriously flawed, and he does seem to think that this bears upon the very referent of the 'folk' term. So read, Dodd's view directly contradicts Thomasson's. On an alternative reading, however, Dodd might be taken to be disputing not the role of the folk in determining the referent of a term like 'musical work', but the 'folk theory' that the folk associate with the referent of that term. On this (less likely) understanding of what Dodd is claiming, he would also be engaged in conceptual engineering rather than the correction of folk semantics.

6
Further Explananda
Flexibility and Variability

6.1 Berthold and Magda Debate the Modal and Temporal Flexibility of Artworks

Berthold, as we know, is fascinated by the ways in which artworks are shaped by sometimes contingent aspects of the creative processes whereby they are initiated. He is therefore an enthusiastic consumer of the kinds of information about provenance delivered by scientific scans of pictures that reveal the overriding by the artist of earlier compositional decisions relating both to the elements to be included in the representational scene presented by figurative works and to the ways in which elements, figurative or not, are disposed in relation to one another within the picture plane. On the obligatory visit to MOMA on a cultural expedition to New York, as he and Magda stand before that herald of modernism, Picasso's *Les Demoiselles d'Avignon*, Berthold delights in telling Magda (and anyone else within earshot) that the work was originally conceived as having both male and female figures, making it more apparent that the scene is set in a brothel. While Picasso is to be praised for subsequently eliminating the male figures from the composition, opines Berthold, the painting would still 'have been better had it lacked certain stylistic inconsistencies' (Rohrbaugh 2003, 183). This interest in how the finished version of a work conceals, yet in some sense represents, such compositional decisions on the part of the artist, and how this bears upon the work's artistic value, also inflects Berthold's engagement with, and critical response to, works in other artistic media. After he and Magda attend a repertory screening of *Fatal Attraction*, Berthold remarks to Magda that the film would have been better if the original ending—where Alex commits suicide in an ultimately unsuccessful attempt to frame Dan for her murder—had not been changed—as a result of negative reviews by focus groups—to the familiar one where Alex gets killed by Dan's wife during a psychopathic attack on the family home.

Magda, however, can never understand why Berthold so concerns himself with such things. She wants to discuss the work we actually have, not some hypothetical situation in which the artist acted, or might have acted, in such a way that we would be presented with a different artistic manifold capable of eliciting in us different experiences. And, she adds, if the artist had acted differently in the

situations described, it wouldn't have been the same work! A more stylistically unified variant on *Les Demoiselles* would not convey the same sense of pictorial exploration; a film with the narrative of *Fatal Attraction* but culminating in Alex's suicide and the eventual proven innocence of Dan would have been a different (and in some ways more troubling) film.

A similar conversational impasse ensues when they visit an exhibition at Tate Britain of Turner's watercolours. Magda remarks that the colours lack vivacity and are disappointingly lifeless, not what one would have expected from Turner given the chromatic values in his oil paintings. Berthold, drawing as usual on scholarly research undertaken prior to visiting the exhibition, responds that this is certainly a feature of the works as we encounter them now, but was not a feature of the works at the time when Turner painted them. For, as we noted earlier, he chose to use 'fugitive pigments' that are much more chromatically vibrant when first applied but that lose this vibrancy over time. The works, laments Berthold, have changed and are much less artistically interesting than they were. Magda, however, protests that what has changed is surely not the works themselves but our ability to properly appreciate them. The vibrant colours intended by Turner are essential to the value of the watercolours as works of art, a value that partly resides in the striking visual experiences elicited in the viewer. Now that the colours are dulled and flat, the works are no longer available to us for proper appreciation as the works they are.

The issues that divide Berthold and Magda may remind us of two of the purported explananda for an account of multiple artworks sketched in the Introduction and briefly reprised in outlining Dodd's defence of the 'simple view' in Chapter 2. Expressed in the terminology introduced there, the disagreement is over whether the works in question are 'modally flexible' and 'temporally flexible' respectively. According to Guy Rohrbaugh, musical works, and works of art more generally, possess both of these features, but the kinds of abstract entities with which the Platonist wishes to identify musical artworks do not. If we side with Rohrbaugh (and Berthold) in these debates, this would provide a very serious challenge to Platonism. If we sympathize with Magda (and Dodd), on the other hand, Platonism is untroubled. Our task in the first part of this chapter is to balance the competing claims that are in play.

6.2 Rohrbaugh's Challenge to Platonist Views of Multiple Artworks

Dodd's strategy in *Works of Music*, as we have seen, is to argue that works of music (and presumably at least some other multiple artworks) must be *types* (to account for repeatability and perceptibility), and that, as a consequence, they are neither creatable nor capable of either modal or temporal change in their intrinsic

properties. Rohrbaugh argues in the opposite direction. Since, he maintains, at least some multiple artworks *can* be brought into and go out of existence, and *are* subject to change in their intrinsic properties, they *cannot be types*. Since these multiples are by definition repeatable, there must be some non-Platonist way of accounting for their repeatability. And, Rohrbaugh maintains, once we see how this is possible for certain multiples, we can offer the same kind of non-Platonist explanation of the repeatability of musical works.

Rohrbaugh begins his paper with an example from photography—Alfred Stieglitz's 1907 work *The Steerage*, of which there are a number of prints that count as strict p-instances. For reasons familiar from our earlier discussion of other multiple art forms, Rohrbaugh concludes that the photographic work cannot be identified with either an individual print or its prints taken collectively. What, then, is *The Steerage*? We should recall, here, the discussion in Chapter 2 of the three different ways in which multiple artworks—artworks capable of having multiple strict p-instances—can be initiated. First, as in the case of literary works, an artist may bring into existence an instance of the work which, once certified, serves as an exemplar. Further instances are then generated through emulating the exemplar in those respects required by relevant artistic conventions in place. Second, as in the case of cast sculpture, an artist may produce an artefact—what Wolterstorff (1980) terms a 'production artefact'—that, when employed in pre-scribed ways, generates instances of the work. Third, as in the case of classical musical works, an artist may provide prescriptions that, if properly followed by those aware of the relevant conventions and practices, result in strict instances of the work. In such cases, the instructions call for interpretation, and instances of the work (strict or flawed) are performances of it, or soundings that have the properties required in performances.

Most of our discussion thus far has focussed on multiples of the third type. This reflects the fact that most of the literature on multiples has concentrated on works of music. Photographs and films, however, clearly fall into the second category. An analogue camera registers light rays entering through its lens as photochemical changes on a strip of film, while a digital camera records, stores, and digitizes the values of the light levels. While the trace produced photochemically by a standard analogue camera is a negative, the trace produced by a digital camera is a bitmap. In each case this trace serves as, or is manipulated to produce, the production artefact. Appropriate employment of the latter then generates those prints or digital images that are p-instances of the work. Films, on the other hand, have as their production artefacts those entities used, in various cinematic media, to generate screenings of those films—film prints, videotapes, digital files, etc.—which either are or stand in a 'copy' relation to master encodings of the film.

We might wonder how far the kinds of considerations that have shaped arguments over the ontological status of musical works would also hold for photographs, or, indeed, for other multiples initiated through a production

artefact. Rohrbaugh, as we shall see, argues for a non-Platonistic account of photographs, but this might in fact be compatible with Dodd's view if it turns out that we need to tell *different* ontological stories for different kinds of multiples depending upon how such works are initiated. Indeed, Dodd himself seems open to this possibility. Critically discussing Rohrbaugh's arguments against the type-token theory of musical works, he first entertains the idea that 'the repeatability of photographs—that is, the fact that they admit of multiple copies (in the form of prints)...indicate[s] that photographs are types'. In a footnote, however, he comments as follows: 'This is a big supposition, of course, and one to which I do not wish to commit myself. After all, it is possible that the kinds of arguments that lead us to view works of music as types do not apply in the case of photographs, or that there are special reasons why the repeatability of photographs is best explained by a rival to the type-token theory' (Dodd 2007, 109, n. 12).

The problem with this ecumenical suggestion, however, is that both Dodd's and Rohrbaugh's arguments seem to invite generalization to all multiple artworks. Given the nature of the arguments, we would need to ask *why* they wouldn't generalize. Rohrbaugh, in any case, clearly thinks his argument does generalize to musical works. One of his goals, in beginning with photographs, is to draw conclusions about musical artworks and about multiple artworks more generally. Having posed the puzzle about the ontological status of photographic artworks, as distinct from their individual prints, he comments that

> this puzzle is not unique to photography. Similar reasoning generates an analogous puzzle for any repeatable work of art. Novels, poems, plays, symphonies, songs, and the rest share an ontological predicament and create a general puzzle concerning the ontological status of repeatable works of art. It is widely held that the puzzle has an equally general solution, one which I will argue fails for systematic reasons...I hope it is clear that the considerations I appeal to in photography are not idiosyncratic but shared by the wider class.
> (Rohrbaugh 2003, 177)

Rohrbaugh begins by acknowledging that photographic artworks are multiple, and that we can make use of the semantic distinction between types and tokens in order to describe this fact:

> As introduced by C. S. Peirce, the terms 'type' and 'token' refer to two senses in which a word such as 'word' or 'photograph' may be used. In its token sense, a word is used to refer to a particular occurrence, in its type sense, it is used to refer to that of which tokens are occurrences (Peirce 1933: 242). There is no doubt that 'photograph' and 'The Steerage' have this sort of ambiguity and that it is the type sense of these terms which picks out a work as opposed to its occurrences. We might describe this situation by saying that *The Steerage* is a type, but one should

not forget that Peirce's distinction is semantic and not metaphysical. Allowing that 'The Steerage' has a type-sense leaves open or merely constrains what metaphysical situation or object, if any, lies behind that usage. Further proposals regarding the underlying metaphysics must be evaluated on their own merits.

(2003, 179)

In addressing Platonist understandings of multiple works as 'types', Rohrbaugh identifies three fundamental features which, so he argues, are common to multiple artworks like photographs and non-multiple artworks like paintings: (a) modal flexibility—a work could have had different intrinsic properties; (b) temporal flexibility—a work's intrinsic properties can change over time; and (c) temporality—a work comes into and can go out of existence.[1] Since types, as characterized by Dodd, lack all three of these features, Rohrbaugh concludes that multiple photographic artworks cannot be types. If we ask what kind of entity *can* possess all three of these features and also be repeatable, Rohrbaugh answers that such an entity is properly conceived as a *continuant*—an essentially historical individual that depends for its existence on those concrete entities that are its *embodiments*. We should think of photographic artworks as objects that persist through time (2003, 178), rather than as things identifiable in terms of their formal or structural properties: 'Photographs are non-physical, historical individuals, continuants, which stand in a relation of ontological dependence to a causally-connected series of physical (sometimes mental) particulars' (2003, 198). Among a photograph's embodiments are its *occurrences*, which are distinguished from other embodiments, such as the negative, in the following respect: 'The "occurrence of" relation is...a more specific form of the embodiment relation, one conditioned by the needs of the practice of a particular art form and one which picks out those embodiments which display the qualities of the work of art and are relevant to appreciation and criticism' (2003, 198). In terms of the distinctions introduced in Chapter 1 of this book, a multiple artwork's occurrences are its p-instances, or perhaps its strict p-instances. It is in virtue of its capacity for multiple occurrences that the photograph is repeatable. Rohrbaugh proposes a similar account not only for films but also for musical works.

One critical response to Rohrbaugh (e.g. Dodd 2007, ch. 6) questions whether we have a firm grasp on the metaphysical idea of a 'continuant', and whether there is a serviceable sense in which continuants might meet our requirements for musical works, given the proposed generalization from the treatment of photographs. I shall look at Rohrbaugh's positive proposal in Chapter 8, where I also survey some other non-Platonist accounts of multiple artworks. What I want to

[1] Since the principal issues relating to the supposed temporality of multiple artworks have already been addressed in the discussion of the 'creatability' of such works in Chapter 3, I shall focus in this section on Rohrbaugh's first two explananda, modal and temporal flexibility.

examine here is the force of his argument against Platonism. The argument against a Platonist account of *photographs* rests upon two assumptions: (1) photographs are modally and temporally flexible and are temporal entities, and (2) these are properties that types, as eternal existents, cannot possess. Given (1) and (2), it follows that photographs cannot be types. But what is the argument for (1)?

We should begin by clarifying what modal and temporal flexibility require. Rohrbaugh offers the following account of modal flexibility: 'An object is modally flexible if and only if it could have had different qualities than it actually has.' He offers as examples himself—'I could have been taller or a better golfer'—and his dented car—'which could have remained pristine'. His claim is that the same applies to photographs and paintings. 'Possibility' here is not mere logical possibility: rather, 'the nature of the thing in question and its history' must contribute to what is and is not possible for it. He also restricts the class of relevant properties to 'intrinsic properties of objects', where the latter are to be contrasted with extrinsic—usually relational—properties. Temporal flexibility, on the other hand, is a matter of something's being subject in principle to changes in what we would regard as its intrinsic properties over time—'intrinsic' again being contrasted with 'extrinsic'. For example, Rohrbaugh may become a better golfer over time, while his once unmarked car may now sit dented in his garage.

Given this understanding of modal and temporal flexibility, we will surely grant that both Rohrbaugh and his car are flexible in both senses, for the modal and temporal differences in the kinds of intrinsic properties cited in no way call into question whether it is the same entity that possesses these different intrinsic properties. Having a certain level of ability at golf is in no way essential to being Rohrbaugh, we might say, and being undented is in no way essential to being Rohrbaugh's car. But what properties of photographs might, in the same way, be intrinsic but non-essential if photographs are also to be modally and temporally flexible in this way? Dodd's response to Rohrbaugh, sketched in Chapter 2 above, simply assumes that the intrinsic properties of a *musical* work must be those that bear upon its proper appreciation, and this leads him to deny that a given work can differ modally or temporally in such properties. Any locutions that might tempt us to think otherwise, Dodd claims, are more plausibly understood in terms of suitable paraphrases. Where a work W^* differs in its intrinsic properties, either modally or through time, from a work W, or from a work W at a time t, then we should view W^* and W as distinct works, albeit distinct works that closely resemble one another. Alternatively, we might take W and W^* to be interpretations of a single work whose invariant but partly underspecified timbral structure they share. Dodd's reasoning here has the following structure: (a) the intrinsic properties of a musical work are those that bear upon its proper appreciation; (b) the properties that bear upon the proper appreciation of a musical work are essential properties of the work; so (c) any change in a musical work's intrinsic properties results in a different work. Rohrbaugh, as we shall see

below, claims that (b) depends upon Dodd's own view of musical works as norm-types individuated by reference to the timbral properties that are required in their correct tokens and thus that bear upon their proper appreciation. But, we may note, (b) also seems to be a consequence of AC, the principle to which we appealed in the previous chapter in arguing *against* Dodd's 'simple theory'! Thus (b) is not so easily dismissed.

More significantly, Rohrbaugh's argument for the modal and temporal flexibility of photographs—and thus of musical works—is open to challenge on independent grounds. He argues first for the modal and temporal flexibility of paintings, then claims that similar reasoning will apply in the case of photographs and other multiple artworks. But obviously, if there are reasons to question the claim that paintings are flexible in one or both of these respects, then the attempt to generalize from paintings to multiple artworks cannot get off the ground. We must therefore examine the argument relating to paintings in closer detail.

Take first the claim that paintings are modally flexible. As Rohrbaugh makes clear, the issue here relates to *de re* rather than *de dicto* modality. Our interest is in the modal properties of the entities to which our terms for paintings refer, and relates, as we have seen, to the *intrinsic* rather than the *relational* properties of those entities.[2] Paintings, he maintains, are physical objects which are themselves continuants and remain the same, as physical objects, even when they vary in what are plausibly taken to be intrinsic properties of paintings. Picasso's *Guernica*, for example, could have had a different appearance had Picasso chosen to act differently when he painted the canvas now exhibited in the Reina Sofía in Madrid. He runs the same line of reasoning with respect to *The Steerage* (Rohrbaugh 2003, 182). The work could have looked different if Stieglitz had made some different decisions when capturing his subject.

He then presents a dilemma for anyone who attempts to deny the modal flexibility of artworks. If it is claimed that *all* artworks have their intrinsic features necessarily, one must hold that even works of visual art like *Guernica* are modally inflexible. But this seems absurd if, as suggested, we identify such works with modally flexible material objects. If, on the other hand, it is claimed that it is only repeatable works like *The Steerage* that are modally inflexible, one needs to explain why this is the case. Rohrbaugh grants that accepting the type-theory might motivate such a distinction, but argues that

> this gets the order of explanation exactly backwards. We are supposed to accept the type-theory because types have all the features we attribute to artworks. One

[2] The issue, in other words, is whether Picasso's *Guernica*, for example, which has pictorial properties $p(G)$, could have had pictorial properties $p(G^*)$, rather than whether the sentence 'Picasso's *Guernica* has pictorial properties $p(G^*)$' might have been true. This *de dicto* claim is unproblematically true—we need only imagine a situation in which we used the name *Guernica* to pick out a different painting.

can't then turn around and make substantial claims about how artworks are based on how types are. What is needed is a differential aesthetic motivation, and I don't see what it could be. If we accept a picture of the creative process which allows Picasso, while painting Guernica, to decide what it should look like and when it is finished, then we see precisely the same phenomenon in Proust's decisions [to include a particular wording in his novel] or in Stieglitz's [to capture his subject in particular lighting]. (Rohrbaugh 2003, 183)

Rohrbaugh also argues that paintings, as physical objects, are clearly *temporally flexible*. The colours on a canvas may fade over time, as with the 'fugitive pigments' used by Turner in his watercolours. Or a painting may be damaged, either accidentally, as during wartime bombing, or deliberately, as in the case of the damaging of over fifty paintings, including works by Rubens, Rembrandt, and Dürer, by Hans-Joachim Bohlmann between 1977 and 2006. Picasso's *Guernica*, for example, can change through time because the physical object identified with the painting can itself change through time as a result of both natural processes of change and damage or vandalism (it was deliberately damaged in 1974). Rohrbaugh considers the objection that we talk in such cases of our inability, after such change or damage, to properly appreciate the painting. Magda, we may recall, says just this about Turner's watercolours. This suggests that we view the properties of the original canvas affected by such changes as still essential to the work of art, the latter therefore no longer being fully present for appreciation when we perceptually engage with the canvas in its current state. The latter, we might say, is no longer a strict instance of the work. We might also ask as to the purpose of attempts to restore paintings if they are indeed temporally flexible entities. There are indeed some artworks that have a temporal dimension built into them—consider Smithson's *Spiral Jetty* that we discussed in Chapter 1. But why should we think this also applies to works like *Guernica*?

Rohrbaugh dismisses such objections on the grounds that to take them seriously would be to deny that paintings are physical objects. It would also raise a problem about our ability to perceptually experience works over time. He takes the temporal flexibility of paintings to motivate a similar view of photographs. He hypothesizes a situation in which there is a deterioration of the negative for a photograph, which, he maintains, will count as a change in intrinsic properties of the work (Rohrbaugh 2003, 188). He also argues that we should view musical and literary works as temporally flexible, resisting here the kind of move that we saw Dodd making in such cases. He points to orally transmitted musical and literary works as examples of such works that change over time, then appeals to the virtues of a 'unified account' to extend this to modern works with written texts and scores. We can explain attempts to prevent works from changing against the background idea that all works can in principle change over time.

He connects this to his third claim that both paintings and photographs are *temporal* entities that come into and go out of existence. A painting comes into being when various marks are deliberately made on a surface and passes out of existence when that paint-covered surface does. Similarly, a photograph comes into existence when it is taken, and would go out of existence if there were no longer actual or possible prints. Paintings and photographs, Rohrbaugh maintains, are temporal entities in a similar way. Both are *dependent* entities in the sense that their creation, continued existence, and destruction depend upon how it goes with some other historical items.

However, it can be argued that paintings cannot be identical to physical objects *precisely because* the latter stand in flexible relations to what are usually regarded as not merely intrinsic but essential properties of paintings qua works of art. Some thirty years ago, there was a lively metaphysical debate about whether a statue—say a statue of Goliath which we may term *Goliath*—can be ontologically identical to the lump of clay that sits in the gallery so labelled—we may term the lump of clay 'Lumpl'.[3] Those opposed to such an identification argued that *Goliath* and Lumpl differ in their persistence and existence conditions. In a variation on the famous classical thought experiment concerning Theseus's ship that was repaired one plank at a time, we can imagine that over time the statue *Goliath* is damaged in various small details and that on each occasion the damage is repaired by replacing the lost fragments of clay—each an element in Lumpl—with an identically shaped piece of *the same type of material*—but with pieces that are *not* elements in Lumpl. Arguably, *Goliath* survives this process, but Lumpl does not, since at the end of the process we have a substantially *different* lump of clay. On the other hand, we can imagine an act of iconoclasm in which *Goliath* is placed into a large bowl which is then heated until the clay becomes semi-liquid and forms a shapeless pool at the bottom of the bowl. In this case, arguably Lumpl survives this process—we have the same clay molecules as before—but *Goliath* does not. Thus, while at a given moment in time *Goliath* may be *constituted by* Lumpl, it is not *identical to* Lumpl.

It seems that we could run a similar argument in respect of paintings. While Picasso's *Guernica* may at a given time be *constituted by* a given physical object, it might be argued, it cannot be *identical to* that object because the painting and the object have different persistence and existence conditions. But Rohrbaugh's argument for the modal and temporal flexibility of paintings *does* depend upon the painting being *identical* to the physical object, and, as we have seen, it is to this claimed identity that Rohrbaugh repeatedly appeals in defending his claims about the modal and temporal flexibility of paintings and photographs. Of course, Rohrbaugh might resist the idea—implicit in the preceding reasoning with respect

[3] See, for example, Rudder Baker (1997), Thompson (1998).

to *Goliath* and Lumpl—that Lumpl's continued existence requires that the very same clay molecules exist conjoined in the way they are in making up *Goliath*. Lumpl, he might argue, is a continuant and therefore would survive the replacement of some of its elements over time by others of the same material kind. But he is also committed to saying that such changes in the make-up of Lumpl are also changes in the make-up of *Goliath* even if they involve the loss of what we might regard as intrinsic features of *Goliath*. He is further committed by his argument to saying that the same applies to *Guernica*. This is what will be denied by any theorist who takes the relationship between the work and the physical object 'housing' the work at a given time to be one of 'constitution' rather than 'identity'. For such a theorist, it is an implication of the difference in persistence and identity conditions between the work and its constitutive physical substrate that they differ as to their modal and temporal flexibility. The painting can have its intrinsic appreciable properties essentially, both modally and temporally, while the physical object is modally and temporally flexible in respect of these properties.

Such a view of paintings is defended by David Wiggins in his *Sameness and Substance* (1980). He claims that a painting's intrinsic 'pictorial' properties are essential to it (Wiggins 1980, 125–6). If Wiggins is right, then paintings cannot be identical to physical objects, if the latter are taken to be continuants, but are only contingently realized, fully or partially, in particular physical objects at particular times. Availing ourselves once again of the terminology introduced in Chapter 1, we can say that the intrinsic properties of an artwork include those required in its strict e-instances, and that a given physical object may at one time be a strict e-instance of a painting but, after suffering damage or change, may no longer be a strict e-instance of the work at that later time, even if it is the work's only p-instance. The physical object that realizes a painting at a given time is indeed a continuant that is modally and temporally flexible with respect to those appreciable properties that are arguably essential properties of the painting. But the painting itself, it can be argued, is unchanging. Thus there are strong (to some) intuitions about the temporal and/or modal *in*flexibility of paintings that would, if granted, defeat the proposed identity of paintings with physical objects. And, as noted above, this means that a consideration of paintings provides no unproblematic basis for the claim that multiple artworks like photographs—or indeed musical works—are also modally and temporally flexible. The identification of paintings with physical objects is not, as Rohrbaugh claims, 'relatively uncontroversial'. Thus Rohrbaugh's attempt to show that Platonism cannot account for certain features that our practice ascribes to multiple artworks, whether they be photographs or works of music, fails because it is unclear that these features are indeed so ascribed, let alone *correctly* ascribed.

As noted above, Rohrbaugh's claim that artworks are modally and temporally flexible seems to conflict with the principle AC to which we appealed in challenging Dodd's 'simple view', if we take AC to apply both across possible worlds and

across time in the actual world. AC, applied at a given time, states that if W and W* are works that differ in the properties bearing on their proper appreciation at that time, then they are different works at that time. Modal and temporal flexibility, on the other hand, entail that (a) W and W*, existing in different possible worlds, can be the same work even though they seem to violate AC, and that (b) W and W*, which are entities issuing from the same act of initiation in a world, can be the same work while again apparently violating AC. We can grant that there can be cases in which works can change their appreciable properties over time—orally transmitted songs, cited by Rohrbaugh, might be taken to be an example. But in such cases the genre itself seems to allow for a temporally extended sequence of appreciable properties, so that all of the appreciable properties of the orally unfolding entity are relevant to its appreciation. (This might be seen as a temporally extended form of 'variability'—see below.) In the case of Turner's watercolours, on the other hand, a theoretically uncommitted judgment (correctable in the light of reflection, of course) seems to agree with Magda: our response to the changing aesthetic properties of the objects created by Turner is that we regret that we are no longer able to fully appreciate his works. In other words, while both the original appearance (vibrant colours) and the current appearance (muted colours) are intrinsic features of the exhibited objects—so the *exhibited objects* are indeed temporally flexible in their intrinsic aesthetic properties—it is standardly the intrinsic features of the objects at the time of their initiation that are essential properties of the *works of art.*

6.3 Problems for Platonist Theories of Multiples Initiated via a Production Artefact

However, even if we are unpersuaded by Rohrbaugh's attempts to show the implausibility of a Platonist account of photographic artworks, we should note some highly counter-intuitive implications if we try to extend either Dodd's conception of musical works as eternally existing norm-types, or Levinson's conception of such works as indicated structures, to multiple artworks, such as films and photographs, that are initiated by means of a production artefact. First, each conception, if so extended, would entail that the audiovisual structure of a film and the visual structure of a photograph pre-exists their 'making' and are discovered by their makers. Second, the inclination to see initiation as creation is strongest in the case of multiple artworks whose initiation involves a production artefact. Consider, for example, Rodin's *The Thinker*. Rodin conceived the idea for a sculptural work having certain perceptible properties. He chose to physically realize the work not by working directly on a sculptable material selected as the medium for the piece, but by working first on another kind of physical material which was manipulated to produce a cast. This cast was then employed (in 1902)

to produce a p-instance of the work. A number of other p-instances were cast later. Since the work is p-multiple in that it admits of a plurality of strict p-instances, the sort of reasoning rehearsed by Dodd with respect to music would seem to commit us to thinking of the work as an eternally existing abstract object, a type of which its p-instances are tokens. But, if we reason in this way, then, surprisingly, the decision by Rodin to employ a more indirect physical method for generating instances of his piece entails that, whereas a visually indistinguishable work of carved sculpture would presumably have been his creation,[4] *The Thinker* is his discovery, albeit, as Dodd might insist, one that involved great creativity on his part. Thinking of works of cast sculpture as *indicated* structures would avoid this conclusion only if we can show, contra Dodd, that the latter are creatable.

Counterfactual situations pose further difficulties. Suppose Rodin intended to smash the cast immediately after the first casting, and indeed did so. Because it was still in principle possible for the work to have multiple strict p-instances—someone could have frustrated Rodin's intentions by preserving the cast and casting a second copy of the sculpture—should we say that the work is multiple, and a discovery, even though Rodin merely intended to produce a singular work by a more roundabout causal process? Again, should we say that, once we move from the daguerreotype to the multiply instantiable calotype, photographs are no longer created by their makers but discovered, so that, while Daguerre and Fox Talbot were producing photographic images at the same time—images that in each case can be viewed as instantiating a type of visual manifold—the former was creating his images whereas the latter was discovering his? There is surely something deeply counter-intuitive about this. How could the decision to employ not one kind of causal-mechanical process, which permits only a single strict p-instance of the work, but another equally causal-mechanical process, which permits multiple strict p-instances, carry such consequences for the status of the artist as creator?

6.4 Enigmatic Variations: Variability as an Explanandum

6.4.1 The Problem of Variability Clarified

Of the nine putative explananda for an ontology of multiple artworks listed in the Introduction, we have now looked in some detail at seven and also discussed in

[4] This presupposes that paintings and works of carved sculpture are properly seen as particulars rather than as types. As Dodd notes, it is possible to reject this presupposition. Another alternative would be to view paintings and works of carved sculpture as 'logically proper types' that are capable of having only one token. I am grateful to Juhani Yli-Vakkuri for pointing out this possible option for type-token theorists, albeit an option that Dodd does not take up.

passing an eighth (the possibility of *unexemplified* works). We have not yet said anything about the ninth putative explanandum—the *variability* of some multiple works. In the Introduction, I characterized variability as follows: some multiple works—for example, musical works—admit at a given time of a determinate range of instances that *differ* in those properties that, in bearing on their appreciation, thereby bear upon the appreciation of the work of which they are instances. But the reader might think that we have already dealt with variability so construed indirectly, since it is simply a consequence of the temporal flexibility of works as characterized by Rohrbaugh. This seems to be the view of Anna Pakes (2020) in her recent groundbreaking work on dance ontology. Pakes initially characterizes the problem of variability as the problem of 'accounting for the *variability* of genuine instances of works' (2020, 148), and notes for future discussion that 'both variability and the possibility of works changing (their temporal flexibility) are compromised on the Platonist view'. But the Platonist's problem is then described as the inability to allow for works to change their appreciable properties through time—that is, to account for temporal flexibility. When Pakes returns to these themes in chapter 9, it is again assumed that the problem of variability just is the problem of temporal flexibility. Citing my characterization of the problem of variability as residing in the apparent fact that instances of performable multiple artworks 'can differ from one another in artistically relevant respects', she identifies this, as it applies to dance, with 'the question of whether and how dance works can undergo change while still persisting through time' (2020, 202). Again, perdurantism (see Chapter 8 below) is said to 'resolve the problems of variability and temporal flexibility that beset structuralist ontologies because it answers the question of "what it is about the passage of time which makes it possible for the same object to have apparently incompatible properties"' (2020, 208). And she then takes herself to have shown that 'the ontological problem of variability ... can be generated by deliberate modification on the part of a work's authors or by a gradual process of stylistic evolution, or by a combination of these two, as choreographers accept and creatively develop the changes their works undergo as they adapt to new circumstances' (2020, 218; see also 237).

Temporal flexibility, as we have just seen, is a matter of something's being subject in principle to changes in what we would regard as its intrinsic properties over time. In the case of an artwork, the 'intrinsic' properties will presumably be those properties of a work's artistic vehicle upon which its appreciable properties supervene and the consequent supervening properties. A work is variable *in a broad sense* if its correct instances can vary in the properties that bear upon the work's proper appreciation. One argument for the variability, in this broad sense, of the works in an art form takes as a premiss the temporal flexibility of such works in respect of those properties regarded as instance-determining. If the latter properties change, this entails that there will be a change in the class of things qualifying as correct instances of the work in virtue of possessing such properties.

Since the class of things that qualify as correct instances of W at T1 differs in those properties that bear upon W's proper appreciation from the class of things that qualify as correct instances at T2, we will have variability in the broad sense just distinguished.

But, as I argued in the previous section, temporal flexibility does not seem to pose a serious threat to Platonist theories of performable works, since the Platonist will simply deny that such works are temporally flexible. Indeed, this response follows directly from the Platonist's ontological account, since pure norm-types are individuated precisely in terms of the properties they mandate in correct instances. Thus if we take the problem of variability for a given art form to depend upon the arguments for temporal flexibility, there is no reason to think that *variability* will pose a serious problem for a Platonist either, or that it warrants further attention.

But the *problem* of variability as an explanandum for an ontology of multiple artworks is more specific, and relates to the possibility that *at a given time* and without any change in a work's intrinsic properties, the work's correct instances may differ amongst themselves in those of their properties that bear upon the correct appreciation of the work. Indeed, this possibility seems implicit in the idea, for which I argued in Chapter 1, that multiple artworks should be understood as artworks that allow of a multiplicity of strict p-instances. For this raises the prospect of a work's having strict p-instances that *differ* in those properties that bear upon their appreciation, and upon the appreciation of the work of which they are instances. Performances of a given musical work, for example, may so differ. Indeed, one thing that we may seek in listening to different performances of a musical work is a fuller appreciation of the range of aesthetic properties realizable in correct performances of that work. It is an ear tutored by a muted appreciation of earlier performances of the work that fuels Berthold's rapturous response to tonight's performance of Sibelius's Second Symphony, for example There may also be artistically relevant differences between different prints from the negative of an analogue photograph. What I term the 'problem of variability' is then the problem of accounting for such variation amongst a work's strict p-instances. But why is this a problem? And, if it is a problem, how broad is its scope?

Taking the second of these questions first, the problem of variability clearly cannot arise for singular artworks since they admit of at most one correct p-instance.[5] It also seems clear that where, as in the case of literary works, a multiple artwork is initiated by means of a certified exemplar, there is no room for variation in artistically relevant properties amongst a work's strict p-instances.

[5] Of course, the appearance of the sole p-instance of a work of painting may change over time, but this would normally mean that the p-instance is no longer a strict e-instance. In the case of a work of visual art whose manifest properties are intended to change with time (see the discussion in Chapter 1), the sole correct p-instance of the work is the sole p-instance as it changes over the relevant temporal interval in the relevant respects.

This is because established literary practices require that strict p-instances of a literary work emulate the certified exemplar in all respects that bear upon the artistic appreciation of the work—thus allowing no room for variation in such respects.[6] Two correct instances of *Emma* may differ in typeface or pagination, for example, but they cannot differ in their textual properties and it is upon the latter properties of individual instances that differences in the appreciable properties of such works supervene. Variation in artistically relevant qualities amongst strict p-instances is, however, clearly possible in the case of works initiated by means of prescriptions, as is the case in classical music and (on a standard view of this) theatre. But accounting for such variability might not *seem* to pose an additional problem for the ontology of such works over and above that of accounting for their repeatability. Just as repeatability in respect of strict p-instances can be explained, in such cases, by the fact that a set of instructions allows of being correctly followed, or complied with, by multiple agents, or multiple events, on multiple occasions, so, it might seem, variability, and the *range* of permissible variation, in strict p-instances, can be explained in terms of the space allowed for interpretation within the 'envelope' of prescriptions for right performance set out in a work's score or playscript. (As we shall see shortly, things here are *not* as they might seem!)

The problem of variability is clearly a genuine problem, however, in the case of multiple artworks initiated by means of a production artefact, such as photographic works. A photographic work can have strict p-instances (prints) that differ in such artistically relevant properties as tonal contrast, print medium, and size.[7] As a consequence, there is no single visual array that is common to all of such a work's strict p-instances. Nor do we have prescriptions that might identify a set of visual properties common to all of a work's strict p-instances in terms of which we might delimit the range of acceptable variations. What determines the range of acceptable variations in a photographic work's strict p- and e-instances is, rather, the relation in which an image stands to the relevant production artefact and the conventions in place that determine how that artefact is to be used if a strict p-instance of the work is to result. This determines not only the permissible range of variation in the work's strict p-instances but also the permissible range of variation in its strict e-instances, since the latter range must be determined by the former. It follows that, if we require that an ontology of a given multiple art form explain both the repeatability and the variability, if any, of works belonging to that art form, a photographic work cannot be identified with a

[6] This would not apply to literary works transmitted orally, where variation in a work's multiple strict p-instances might not only be tolerated but encouraged.

[7] One might try to avoid the problem of variability in the case of photographic artworks by treating individual prints as *different works*, and treating the 'photographic work' itself as a grouping of those works in virtue of relevant similarities in their origins. Christy Mag Uidhir (2013) has defended such an account. For a discussion of Mag Uidhir's view, see Chapter 10.

norm-type characterizable independently of the actual photographic practices within which that work was initiated. Whether it can be identified with a norm-type defined *in terms of* those practices is a matter to which we shall return.

6.4.2 Musical Platonism, the Problem of Variability, and the Pragmatic Theory of Norms

In the case of multiple artworks initiated by means of a production artefact, such as photographs, it is difficult to see how one could specify what all strict e-instances must have in common and how they can vary without referring to the conditions under which p-instances are generated. This seems to contrast with multiple works initiated through a set of instructions or prescriptions for right performance. Here, it appears, such instructions allow us to identify the class of strict e-instances without prior reference to the class of strict p-instances, and thus without reference to the context in which a work was initiated and its p-instances generated. Consider, for example, how Dodd's 'simple view' might deal with variability. As we have seen, the simple view states that musical works are norm-types whose tokens are 'datable, locatable patterns of sound, sound-sequence events' (Dodd 2007, 3), and whose identity is determined by the condition something must satisfy to be a correctly formed token (2007, 32). According to the second component of the simple view—timbral sonicism— 'whether a sound-event counts as a properly formed token of W is determined purely by its acoustic qualitative appearance. The properties comprising the set E of properties normative within any work W are all wholly acoustic in character: properties such as *being in 4/4 time, ending with a c-minor chord*, and so on' (2007, 201).

Suppose we try to raise the problem of variability for Dodd's account by asking how a work can be a discovered sound sequence if particular right performances can differ precisely in the way the prescriptions in the work's score are inflected by the performers. Dodd will presumably respond that, while correct performances or soundings of a work may indeed differ in this way, that which they *share*, and that in virtue of which they are correct performances, can be identified purely in terms of their timbral sonic qualities. So, even though there is no one way in which a given piece sounds when correctly performed, there is a condition that all such performances satisfy, and it is this condition that defines the type that is the work. This option is open because of the role that sets of instructions play in initiating a musical work and in thereby establishing those properties that are normative within the work.

But suppose we now ask whether the timbral sonic properties that are required in all correct performances of a musical work—the properties that are 'normative' within the work, on the norm-type theory—can themselves be identified without

reference to the circumstances in which the work was initiated? Or is the identification of *these* properties—the ones required, on the theory, in all strict e-instances of the work—parasitic upon the identification of the properties of the work's strict p-instances, as determined by norms in place in the relevant artistic practices? There are two ways in which this problem might be thought to present itself for the timbral sonicist. First, since the timbral sonicist agrees with the pure sonicist that the melodic, rhythmic, harmonic, articulational, and tempic properties specified in the score for a work are normative within the work, we may ask whether these properties can be identified without reference to contextual norms operative in the generation of p-instances. If we take a score to be the means whereby a composer prescribes certain things, and thereby, for Dodd, makes available to receivers the discovered norm-type that is the work, we need to ask how those prescriptions are themselves to be understood. We saw in Chapter 2 that Nicholas Wolterstorff, defending a view that is a precursor of Dodd's, observes that it is very seldom the case that all matters pertaining to the correct performance of a scored musical work are specified in the score: 'Many [of these matters] are simply presupposed by the composer as part of the style and tradition in which he is working, and others are suggested without ever being specified' (Wolterstorff 1975, 332). In performing a work, a performer acts on her knowledge of the requirements for correct performance, but such knowledge will 'seldom...be gained wholly from specifications which have been expressed [in a score or elsewhere]. And sometimes it may not be gained from these at all' (Wolterstorff 1975, 332). A composer presumably assumes that the markings made in a score will be understood by members of the intended performative community as mandating certain things for correct performance. But the marks themselves do not mandate anything at all. To capture what they prescribe as a property that sets out the conditions for correct performance, therefore, we must be able to incorporate into those conditions the import of the relevant norms for interpreting the score. Can the import of these norms be apprehended independently of the actual practices of a community of performers, however?

Before addressing this question, we should note a related problem that confronts the *timbral* sonicist. As Dodd notes, the only satisfactory way in which a composer can specify the timbral properties normative within a work is by appeal to the use of particular instruments to realize the purely sonic properties normative within the work. Indeed (Dodd 2007, 215), he maintains that the composer's goal in specifying instrumentation is precisely to mandate 'the production of sound-sequences of a certain qualitative character'. The specification of instrumentation, he claims (2007, 218), should be seen as exclusively serving the aim of facilitating the production of sound-sequence events with certain specific timbral features. But, assuming that we *could* make specific the *pure* sonic properties mandated by a score, we must now ask *which* ways of rendering those sonic properties on a given instrument determine what is normative within the work. It

is surely not an option here to take a work to comprise, as correct performances, all sound sequences having the timbral sonic qualities of possible realizations of a work's pure sonic prescriptions on the prescribed instruments. For there are ways of using those instruments that would result in sound sequences that the composer would rightly reject, just as she would reject sound sequences produced on other instruments. For instruments have the capacity, when played in specific ways, to replicate to some extent the tone colour of other instruments.

Indeed, the broader the range of sound sequences that are compatible with the use of given instrumentation to realize a set of pure sonic prescriptions, the less plausible it is to see the specification of instrumental means by itself as a satisfactory way of picking out the distinctive tonal character of the work. To characterize the particular timbral qualities that are normative within a work, as norm-type, and that are prescribed for its correct performance, we must specify not merely prescribed instrumentation but also the manner in which the prescribed instruments would be used by members of the performative community intended or anticipated by the composer. The range of acceptable variations is thus constrained by the norms of the intended performing community. But again, we may ask, can the import of these norms be characterized independently of the actual practices of the relevant community of performers?

The issue here is not whether a correct performance of a musical work can take place on instrumentation other than that specified by the composer if the former is able to duplicate the timbral qualities of the latter. We might grant Dodd's claim (2007, 220) that a composer of a musical work should accept as correct an individual performance of that work on a perfect timbral synthesizer (PTS) as long as it was acoustically indistinguishable from one on the prescribed instrumentation. The point, rather, is that it is the range of acceptable performances possible when the prescribed instrumentation is played in a particular way that determines just *which* performances on a PTS would be so acceptable. Performances on a PTS may indeed be strict e-instances of the work, but it is performances on the prescribed instrumentation that determine the permissible range of variability in the properties required in a work's e-instances. Thus we cannot divorce the identity of the work from both the specified instrumentation and its sanctioned use by members of the intended community of performers.

The two problems just described for the norm-type theorist can also be formulated in terms that relate more directly to the problem of variability as characterized earlier. Our question is whether a problem parallel to the one that arises for photographs might arise for musical works given the need to account for the range of variability in correct performative interpretations of such works. If, as the timbral sonicist maintains, a sound sequence counts as a strict e-instance of a musical work just in case it has a specific timbral sonic character, then the property-associate in terms of which the work, as norm-kind, is defined must furnish necessary *and sufficient* conditions for being a strict e-instance of the

work. It is an understanding of what is prescribed by the work's initiator that supposedly serves to delimit the range of acceptable *interpretations* of the work, and thereby to exclude, as strict instances, interpretations that fail to comply with a proper understanding of those prescriptions. Such interpretations fail to be correct because their rendering of what is explicitly prescribed fails to comply with such an understanding. But, as we have seen, it is through the practices and norms of a performative and receptive community that the proper understanding of the composer's prescriptions is given.

I have suggested that, given certain explicit prescriptions by a composer embodied in a score for a musical work, we would be able to derive a set of determinate prescriptions for correct performance of that work only if we take account of certain norms operative in the intended communities of performers and receivers for the work. These norms relate both to the interpretation of what is explicitly notated in the work's score concerning the work's pure sonic qualities and to the timbral qualities prescribed through the prescription of specific instrumentation for realizing those pure sonic qualities. The question we are currently addressing is whether the properties taken to be normative within the work by the timbral sonicist—the purely acoustic properties required in its strict e-instances—can be characterized independently of the ways in which performances are or would be classified as strict or flawed p-instances within a particular historically situated performative practice. But why should we think that there is a problem here? Why can't we represent the specific norms that are operative in a performative and receptive community, and thus the properties normative within a work, independently of the ways in which members of that community actually apply those norms? Why, in other words, should we think that the very content of those norms depends upon the *actual practices* of those who apply them?

The issues here relate to the nature of the 'norms' to which Dodd appeals in articulating his notion of works as 'norm-types'. Norm-types, we may recall, differ from types *simpliciter* in admitting of both correct ('well-formed') and incorrect tokens. Drawing upon Wolterstorff's original proposal, natural kinds are offered as familiar examples of norm-types. To say that the Grizzly Bear (kind/type) growls is to say that well-formed individual (token) grizzly bears growl, while also allowing for ill-formed ones that don't. But being 'well-formed', here, is a matter of compliance with a natural law or a statistical regularity. It is because the laws that govern the transmission and expression of the genetic material distinctive of the natural kind Grizzly Bear entail that there is a statistically very high probability, ceteris paribus, that a given grizzly bear can growl that we take being able to growl to be a condition of well-formedness in creatures belonging to the kind. In the case of musical works, on the other hand, the correctness of a performance is not a matter of either conformity to a natural law (obviously) or statistical regularity. Even if very few performers of a given musical work are able to rightly execute a particularly virtuosic passage, it will still be the case that a

correct performance is one that does so execute it. Correctness and incorrectness of musical performances is, rather, a matter of satisfying norms having some other kind of basis.

But what is this basis, and how should we characterize the norms that determine the correctness of a performance of a musical work? Norms, in this sense, are like rules. A club, for example, may establish certain rules governing the behaviour of its members, and the rules determine whether its members are behaving correctly, independently of how they actually behave. Such rules are generally made explicit in a set of sentences. If the set of possibilities implicit in a symbol system can be said to pre-exist the realization of those possibilities by its users, then the set of sentences employed in giving explicit expression to a club's rules can be said to pre-exist the establishment of the rules. In this sense, the sentences expressive of the rules are discovered not created. But what about the rules themselves?

There are powerful arguments of a more general philosophical nature for denying that the normative import of rules can ever be made fully explicit in the sentences used to express or interpret them. For, according to a line of reasoning going back at least as far as Wittgenstein's *Philosophical Investigations* (1953), it is impossible to make fully explicit what must be done to comply with a rule. This insight is foundational to Robert Brandom's defence (1994, ch. 1) of a pragmatic theory of norms. Brandom asks how, in general, there can be norms that bind us and to which we can be held accountable. A 'regulist' answer to this question holds that what makes a performance correct or incorrect is always determined by an explicit principle or rule. An individual's grasp of a rule or norm is a grasp of this explicit principle. However, so Wittgenstein argued, this leads to a 'regress' of rules. For any rule admits of both correct and incorrect applications and it is only the *correct* application of the rule that determines whether a given example does or does not accord with that rule. The regulist, who holds that all norms reside in explicit rules or principles, requires a *further* rule R' governing the application of the original rule R. Sooner or later, therefore, we must fall back on a notion of 'rightness' or 'appropriateness' that is a matter of *practice*, not of applying explicit rules. So there must be a way of rightly applying a rule that is implicit in, and exhibited in, actual practice. But how can we have 'right practice' without an independent rule with which such practice conforms?

Brandom argues that the key to understanding how implicit norms are possible is to develop the Kantian insight that what distinguishes us, as normative creatures, is not that we are subject to rules/regularities (our conduct is rule-governed) but that we act according to our conceptions of rules (our conduct can be viewed as rule-guided). Kant attempts to reconcile our being *rational* and our being *free* by holding that our dignity, as rational beings, consists in our being bound by rules we endorse or acknowledge. Our actions issue from our sense of what is required by the rules to which we commit ourselves. Normative compulsion and

normative compliance are thus mediated by our attitude towards rules, and the assessment of what is correct and incorrect according to them. Norms, then, are a product of human activity—they are 'instituted' through that activity. But if I am genuinely bound by the rules I endorse, it cannot be up to me what those rules require. It cannot be, as Wittgenstein puts it, that whatever seems to me to be in accordance with the rule is thereby a correct application of the rule. I determine the force of the rule over me, but not what it requires me to do. Thus the practices in which norms are implicit must be *socially articulated*. This does not involve an appeal to 'the community' as a non-individualistic entity that somehow determines the right application of norms. Rather, it is a matter of the interactions between individuals whereby they adopt normative practical attitudes to one another, *taking or treating* another's (or, indeed, their own) performance as correct or incorrect. The question, then, is how the normative attitude of assessing is somehow implicit in the practice of the assessor. One suggestion, here, is that this is a matter of *sanctioning* behaviours through rewards and punishments. On Brandom's own account, talk of 'sanctions' is replaced by talk of the ways in which the norms operative in a social practice are instituted through the abilities of its members (a) to 'keep score' of changes in the entitlements and commitments of others brought about by 'moves' in that practice, and (b) to modify their treatment of others in light of such 'scores'.

I cite Brandom's account for a number of reasons. First, while this is obviously not something I can defend here, I think his account is the most promising attempt to 'naturalize' norms by grounding them in the world, albeit the human world. Some such naturalization seems necessary if we follow Wittgenstein in rejecting the idea of 'self-interpreting' rules or norms. Second, in abjuring any attempt to ground the objectivity of norms in 'the community' and locating it, rather, in the interactions between individuals, he avoids the kinds of objections levied against what are taken to be 'communitarian' accounts of normativity.[8] Third, and crucially in the present context, Brandom's work challenges philosophers who, like Dodd, wish to appeal to norm-types in their analysis of musical or other multiple artworks to either (a) show how the role they accord to norm-types can be reconciled with Brandom's analysis, or (b) offer and defend an alternative analysis of the normativity of norms, compatible with the role they accord to norm-types, that takes account of Brandom's arguments. While (b) stands as an invitation, let me say why (a) might seem unpromising.

Brandom, following Wittgenstein, maintains that explicit specifications of rules operative in a practice can never do anything more than make partially explicit the norms that reside implicitly in that practice. Applying this to the musical case, it is

[8] The usual target for such objections is the view ascribed (wrongly I have argued—see Davies 1998) to Kripke's Wittgenstein (Kripke 1982). See, for example, Simon Blackburn (1984).

not in scores alone, or in explicit rules for following scores, but also in the practical interactions between composers, performers, and receivers in a particular musical context that the norms determining correct performance of a musical work are located. These interactions give determinate content to the idea of 'shared understandings' as to how scores and other explicit specifications are to be rightly translated into practice. Crucially, the import of these norms cannot be characterized independently of those interactions through which content is given to the idea that particular performances are strict or flawed performances of a work, or fail to be performances of that work at all. It is only by reference to the class of strict p-instances determined through such interactions that we can give content to the idea of a set of properties that are normative within the work in the sense that they delimit the class of strict *e-instances* of the work.

If, then, it makes sense to talk about a norm governing right performance of a work only relative to an interpretive performing community whose practices confer some measure of determinacy upon what is made explicit in a score, we must distinguish between the properties of the notational character used to record a composer's determinations—a character that can plausibly be said to pre-exist the composer's activity—and the norm thereby established for correct performance. The existence of the norm, it seems, *cannot* be divorced from, or somehow characterized independently of, the actual practices of a particular artistic community whose performances are guided, but in no sense determined, by their interpretations of that notational character.

Is this really a problem for a timbral sonicist like Dodd, however? It might be thought not. For suppose it is indeed true that it is only in terms of norms realized in the activities of a particular performative community that we can identity the permissible range of variation in strict instances of a musical work. Nonetheless, the timbral sonicist might argue, these activities still serve to identify, through the class of p-instances that they validate as correct, a set of timbral sonic properties that are necessary and sufficient, given the prescriptions of the composer, for a sound sequence to count as a correct instance of a work. The norm-type to be identified with the musical work, then, prescribes just *these* properties for correct performance. The properties themselves make no reference to either instrumentation used or the context in which the work was initiated. It is the norm-type so conceived that is discovered by the composer, and that exists eternally, even if we can identify it only by reference to the practices of a given artistic community. And, indeed, that very norm-type might also be discovered by other composers working in other musico-historical contexts. The proposed objection to timbral sonicism, it might be claimed, conflates issues about the nature of the musical work with issues about how we can pick out or identify a particular work. A given work, qua prescribed timbral sonic sequence, admits of different identificatory characterizations, formulated in terms of different notational specifications and different norms embodied in distinct artistic practices—different identificatory

characterizations that reflect the different musico-historical contexts in which it might be discovered.

This response by the timbral sonicist seems unsatisfactory, however, for a number of reasons. First, while this would call only for an amendment of timbral sonicism rather than its repudiation, it clearly seems inappropriate in this case to claim that it is the *composer* who discovers the norm-type to be identified with the musical work. Rather, discovery is an affair that essentially involves not just a composer but also the relevant community of performers and receivers. The timbral sonic properties normative within the work depend crucially upon how what the composer prescribes is rightly interpreted by the intended performers, and the composer is unlikely to be able to gauge precisely the range of variations licensed by her act of notational prescription.

Second, we might ask whether the identity of the musical work *can* in fact be understood, in this way, as an abstraction from the practices of members of the performative community for which it is initiated. For we treat musical works as always open to the possibility of new right interpretations that may *expand* our appreciation and understanding of a work by expanding the range of variations possible in its strict instances. Suppose we were to accept the current proposal which abstracts the set of prescribed timbral sonic properties supposedly normative within the work—and thus required in correct performances of it—from the set of performances rightly taken, by members of the relevant artistic community at some time t, to be strict instances of the work. Term this set of prescribed timbral sonic properties TS_t. If we take norms to be grounded in the practices of relevant communities,[9] then the norms relative to which new performances can count as right performances must be the same norms—grounded in the practices of the same communities—as the ones that validate those performances already taken to be right. In other words, claims about a work's openness to new and potentially revelatory right performances seem to be counterfactual claims about how future cases would be rightly assessed within the relevant artistic practice. But, while some things that might be rightly judged within such a practice, at some time $t+1$, to be novel right performances might satisfy the requirements of TS_t, others might not. Rather, they might satisfy the requirements of a norm-type defined in terms of the set of prescribed timbral sonic properties TS_{t+1} that we would have derived had we abstracted our set of properties taken to be normative within the work from the set of performances validated by the practice of members of the relevant artistic community at $t+1$. The proposed timbral sonicist strategy is, then, equivalent to freezing the practices of a performative community

[9] Talk of norms grounded in 'communities' here is shorthand for talk about the interactions between the individuals who participate in a practice. See my earlier discussion of this point in my brief elucidation of Brandom's view of norms.

at a particular point in time.[10] If we wish to make sense of a work's always being open to new, potentially revelatory, right performances of the kind just hypothesized, however, there is no *particular* point at which we can exchange reference to the practices of this community for a particular set of prescribed timbral sonic qualities taken to be constitutive of the work. The only option would be to identify the work with the timbral sonic sequence exemplified by those performances rightly assessed to be strict instances *in the ideal limit of the relevant practice*. But this brings out a third kind of difficulty.

It is undeniable that we can abstract a prescribed timbral sonic sound sequence from the set of performances of a musical work validated through the performative interpretations of a composer's prescriptions by members of an intended performative community and the receptive practice of an intended community of receivers. But, to the extent that this prescribed sequence is accessible only 'after the fact', it cannot plausibly be said to either be *conceived by* the composer or serve as a *guide to* the practice of performers—the latter because it is constituted *through* that practice. It is unclear therefore how such a prescribed timbral sonic sound sequence—a norm-kind—can play any kind of explanatory role in our understanding of the initiation and reception of musical works. By analogy, any given painting embodies a particular visible manifold in a particular medium. The work then possesses the property of embodying just this manifold in just this medium, a property that presumably exists eternally. There is then a type of visual array for which this property is the property-associate, and the type itself exists eternally. Even if a painting is taken to be a physical object, our interest in that physical object, qua painting, is an interest in its embodiment of a particular visual manifold in a particular medium. So, we might say, our interest is in the painting as a token of the eternally existing visual array, the type discovered by the artist. But such an analysis seems to have few merits if we seek to understand the initiation and appreciation of paintings, for the posited type again seems to play no explanatory role in such an understanding. Again, the type comes in 'after the fact'.

What, then, *can* play such an explanatory role in our understanding of musical works, and in particular of the ways in which performances are rightly grouped as strict instances of such works in spite of their variability? What the foregoing discussion brings out, I think, is the central role that originating in, and drawing upon the norms embodied in, a particular artistic practice, plays in the ways in which we group certain entities as strict or flawed *p-instances* of a musical work. This seems to hold in the case of musical works just as much as in the case of

[10] Note that this point follows if we combine the idea that the criteria for a performance of a work *W*'s being correct are fixed by the score, *as interpreted by the performance conventions extant at the time of composition*, with the idea that these conventions get their content through the practice of the relevant performing community whose performances enact those conventions.

photographs and other works initiated by means of a production artefact, as discussed earlier. The multiple nature of such works—their repeatability—is then explicable in terms of this shared history. To be a p-instance of a musical work W is just to have a history H involving a score—at least in the case of scored works—and a performative community that interprets that score in the ways sanctioned by the norms given content by the practices of that community. It is these same norms, whose normative force is to be explained in terms of interactions between members of the community, that classify certain of a work's p-instances as strict p-instances, thereby indirectly determining the conditions that strict e-instances of the work must satisfy.

How we might translate this kind of insight into a positive account of both the repeatability and variability of multiple works in general, including both photographs and musical works, will be our theme in Chapter 9. But, before we move on, there is one loose end that requires attention if the problem of variability is to be a primary reason for rejecting Platonist accounts of multiple artworks.

6.5 A Few Words about Literary Artworks

In Chapter 1 we saw that what distinguishes the p-instances of a work from other elements entering into its provenance is that they are the first (kind of) artefact issuing from the creative activity generative of an artwork that, when completed, bears a sufficient number of the manifest properties required to play the experiential role in the appreciation of the work. In the case of literary works, as we saw in Chapter 2, theorists such as Wolterstorff and Stephen Davies speak of the use of an 'exemplar' in the initiation of the work. It is natural to think of the exemplar as the finished text produced by the author which 'exemplifies' the properties required in strict e-instances of the work and thus the properties required in the work's strict p-instances. But then, it might be thought, the exemplar itself will satisfy the foregoing requirement to count as a p-instance of the work: it will be the first kind of artefact issuing from the artist's creative activity that bears sufficiently many (indeed all!) of the manifest properties required to play the experiential role in the appreciation of the work. Reasoning in this way, one might further conclude that the multiple copies of a literary work through which we gain access to the work are not themselves p-instances, since they stand at one further remove from the initiation of the work: they are, rather, to be thought of as copies, perfect or flawed, of the work's exemplar, where the latter is the work's solitary p-instance. When I first presented the distinction between e-instances and p-instances, I myself suggested this view of literary works (D. Davies 2010, 462). But, as may be clear to the reader, on this view a literary work, like a painting, can have at most one strict p-instance, although unlike a painting as traditionally viewed it can have multiple strict e-instances—most obviously, all correctly

printed copies of the book. So, it seems, literary works turn out *not* to be multiple! Since literary works are generally taken to be a paradigm of multiplicity, something seems to have gone wrong!

The problem lies in the idea that the manuscript issuing directly from an author's activity can itself initiate the work, where the process of initiation serves, given relevant artist practices, to determine the properties required in a strict p-instance of the work. As in the case of multiple works initiated through a production artefact or a prescription, initiation only determines these properties when it is taken to be a process involving not merely the activities of the artist but also the relevant practices and conventions operative in the art form in question. In the case of literary works, the manuscript produced by an author can determine the requirements for a strict p-instance of the work only when 'certified' through the activities of relevant parties. The author's manuscript usually contains infelicities, annotations, omissions, and commissions, and it must be corrected for all of these things if the resulting text is to exemplify the conditions to be met in strict p-instances of the work. It is only through issuing from such a process of what I am calling 'certification' that resultant texts can qualify as p-instances. On rare occasions, the author's manuscript may pass through the process of certification unmodified, in which case it may itself qualify as a (strict) p-instance of the work. But it can acquire this status only retroactively, once the process of certification has taken place, and thus has no privileged status relative to other copies of the certified text. Since the process of initiation through the certification of a text can always in principle issue in multiple strict p-instances of the work, the multiple nature of literary works is upheld.

I have claimed that certification of the author's manuscript is necessary in order to determine which properties are required in strict p-instances of the work. But certification need not be a process vested in institutional agents such as editors or proofreaders for a press. An author or a poet can herself perform this task, but until she has done so no criteria for being a strict instance of the work have been established, and only when we have such criteria can something acquire the status of p-instance of the work. If a literary manuscript has not been subject to a process of certification, however, it must be regarded as unfinished. This mirrors our understanding of works in other art forms that we treat as unfinished. But a work that is 'unfinished' in this sense may be 'certified' by another party—for example, an editor. There are well-known examples of this outside the arts—for example, John McDowell's 'certification' of Gareth Evans's *The Varieties of Reference*.

As we noted in the previous section, the problem of variability *doesn't* arise for textually transmitted literary works. If I want to deepen my understanding of a literary work I have already read, I don't seek out a separate copy but usually reread the one already read. Might the literary Platonist therefore argue that, even if Platonist accounts are flawed for other kinds of artworks, they are still the right kind of account of literary artworks?

Let me suggest a number of reasons why this is not an attractive strategy, and why, even if the argument from variability cannot apply directly to Platonist theories of literary works, the elements mobilized in that argument can be applied indirectly. First, it is unclear, as in the case of musical works, how a Platonic literary type can play an adequate explanatory role, and thus meet the explanatory requirements on ontology for which I argued in the previous chapter. While the finished certified text is obviously a token of a text-type, the type seems to play no role in guiding the activity of the author. What guides that activity is the manipulation of a developing token structure that eventuates, after many revisions, in the finished token that can then be seen to be a token of a given text-type. Analogously, in writing this chapter, there are overarching goals that guide me in my progressive revisions of my text, but no sense of a finished text-type towards which I am striving. As in the musical case, the type only comes in 'after the fact'. Second, as I shall argue in Chapter 9, there are reasons to resist the analogy drawn by Platonists between a class of text-types that pre-exist the author's activity and are discovered in the process of initiating a literary work, and a pre-existing class of possible legal chess games, implicit in the rules of chess, each one of which pre-exists its discovery by players of the game.

Second, there is even less explanatory need for an abstract entity to account for the 'repeatability' of literary works—the generation of subsequent p-instances of a literary work from the certified exemplar—than might be thought to be the case with the repeatability of musical works in correct performances. Here the situation is analogous to that in the case of certain kinds of prints, where the printing process is mechanized. In the literary case, however, the situation is even clearer in that, prior to the invention of the printing press, any duplication of a textual exemplar had to be by manual copying, and the only entities necessary to explain this process are (1) the original text, (2) the copy of the original text, and (3) norms embodied in the practices of the relevant literary community determining in which respects the second has to preserve features of the former.

Finally, we may note that while, as argued earlier, the problem of variability clearly arises for photographic artworks, it does not usually arise for films. Our practice does not admit of variability in the artistically relevant properties of strict p-instances of a film. While different screenings of a film may differ in significant ways, depending upon the nature of the equipment used in a screening and the state of repair of the production artefact, these differences are treated as ways in which some p-instances of a film fail to be strict e-instances. We do not watch different screenings of a film in the hope of better appreciating it as an artwork save in cases where we think that the screenings we have attended have been flawed in some way. There is, of course, an issue of whether there can be different *versions* of the same film, but that is a different matter.

7
The Nine Explananda Revisited

An ontological account of multiple artworks, I have argued, is to be judged by its capacity to make sense of those features of our artistic practices that would be upheld in rational reflection upon those practices. We must allow that differences between kinds of multiples—especially differences in the ways in which they are initiated—might require a pluralist ontology offering different ontological accounts for different kinds of multiples, something canvassed early in the previous chapter. In the preceding chapters, we have critically assessed nine different features of practice that have been or might be proposed as explananda for the ontological account(s) that we seek. We have also seen reasons to think that a Platonist account of multiples will not be able to accommodate at least some of these features, and also reasons to think that some of the latter features are ones that play roles in our practices that seem central to the realization of their goals. This motivates us to look at non-Platonist accounts of multiples that have been defended in the literature and to assess whether their explanatory credentials are stronger than those of Platonism. The principal task in Chapter 8 is to look at four such non-Platonist accounts. Before doing so, however, it will be helpful to remind ourselves of the nine features of practice that have been the focus of our deliberations in previous chapters, and also to reflect on how they might be weighted as putative explananda for an ontology of multiples. As we have already seen, the significance of some putative explananda is open to dispute, their perceived saliency seeming to depend upon a theorist's prior ontological sympathies. In such cases, we might ask as to the pragmatic implications of viewing these explananda as matters whose validity can only be sensibly addressed *after* we have settled the ontological questions. However, if we are to avoid the kinds of methodological sins of which we accused Dodd in Chapter 5, we must ground the decision to set aside a putative explanandum in this way in broader considerations relating to our artistic practices.

7.1 Repeatability

Let me begin with what Dodd terms *repeatability*. While Dodd focusses on the repeatability of musical works through their different performances or soundings,

we should understand the term more generally, in light of our reflections in Chapter 1, as the capacity of a work to have more than one strict instance that stands in the right kind of relation to the initiation of that work to count as one of its p-instances. Furthermore, given our reflections in Chapter 2, there is a sense in which any account of multiple artworks so construed will also be able to account for their repeatability: the latter simply follows from the manner in which multiple artworks are initiated.

Why, then, does Dodd think that the ability to explain repeatability is a principal reason to favour the type-token theory of musical works over other accounts? His reasoning, I take it, is that, even though alternative accounts can ground the possibility of a work's having multiple instances in its manner of initiation, there is no *entity* involved in the process of initiation, on those accounts, that has the properties he feels to be necessary in something that can be *repeated*. It is the intimate relationship that obtains between a type and its tokens that, for Dodd, justifies the idea that *the work itself* is repeatable through its instances: it provides the best answer to the question, what kind of *entity* can have other entities as its occurrences? But the aspects of our practices that we seek to account for in speaking of a work's repeatability do not themselves justify this kind of gloss on what is required for repeatability. As Dodd points out in his own comments on the grounding of a work's 'repeatability' in practice (see Chapter 5 above), what we are seeking to explain is the ways in which we group different events as performances of the same work, and the ways in which our appreciation of the *work* can be furthered by engagements with a plurality of such events. To explain these things, we need to explain, first, how what we take to be the work plays an essential role in such groupings of events as instances, and, second, what justifies ascribing to the work, so conceived, some of the experienced properties of such instances. But the first of these things seems to be entailed by the different kinds of modes of initiation of multiples, as outlined in Chapter 2, and the second requires only that we can justify the predication, of a work instanced, of properties we experience in our engagements with its instances. As we saw in Chapter 3, this can be done either by speaking, with Wolterstorff, of 'analogical predication', or by treating the term that identifies the work as generic, as proposed by Predelli. While, as also noted in Chapter 3, Wolterstorff and Dodd take analogical predication as holding only for types and their tokens, we shall see, in Chapter 9, that this does not depend upon a Platonistic interpretation of types. We can provisionally conclude, therefore, that while repeatability in the general sense identified above is clearly, by definition, a feature of the way in which we treat multiple artworks in our practice, it is not clear that it is a feature that favours Platonism over other accounts.

7.2 The Possibility of Unexemplified Works

A second related putative explanandum to which we made passing reference in an earlier chapter is the possibility of *unexemplified* multiple works, works that as a matter of fact never have *any* strict p-instances, or even no p-instances of any sort. Given the modal nature of p-multiplicity—its being a matter of the *capacity* to have multiple strict p-instances—nothing seems to rule out such unexemplified works. The most obvious examples of this phenomenon are unperformed musical works. If we discover a hitherto unknown score for a third string quartet composed by Vaughan Williams, it is natural to say that we have discovered an unknown work. It would be strange to say that we have only discovered a precondition for a work, a work that can come into existence only when the score is used to guide a performance. It might be argued, however, that, even if this is not what we *would* say, it is what we *should* say. But the burden of proof would be on a person who so argued. Indeed, as we saw in Chapter 3, Dodd himself acknowledges the possibility of unperformed works in his 2000 paper, and it was partly to accommodate this possibility that he changed his earlier account of the existence conditions for properties when writing *Works of Music*. The account in his 2000 paper states that a property exists at a time t iff there is some time t^* at which it is exemplified. The account in *Works of Music*, however, only requires that there be some time t^* at which the property *could have been* exemplified. On the former account, there can be no unexemplified musical works, whereas on the latter account such works do not pose a problem.

The situation is a little less clear in the case of multiple art forms where works are initiated either by means of a certified exemplar or by means of a production artefact. In the case of works of literature initiated by means of a certified exemplar, it would seem that there cannot be any uninstantiated works, since the certified exemplar itself, through which the work is initiated, is itself an instance (indeed, a strict p-instance) of the work. But works of cinematic art whose p-instances are *screenings* of various kinds can surely be uninstantiated if we take such a work to exist once we have examples of the relevant production artefact that can generate a screening of the film. For even if a master encoding or other correct encodings of the film exist, there may never have been a screening generated through the proper use of such production artefacts. While all of the elements comprised by the master encoding of the film may well have been viewed during the production process, there need not have been a consecutive screening of these elements in the order required if one is to 'see the film' in the standard sense, and thus no such screening that might qualify as a p-instance. But in such a case we would presumably again talk of the discovery of a previously unknown cinematic work: we would not say that the work only came into existence once it was screened in the prescribed way.

What of other multiple works that are initiated by means of a production artefact? Suppose we discover some unprinted negatives in a camera used by Cartier-Bresson. Have we stumbled upon hitherto unknown works by Cartier-Bresson, or does a photographic work only come into existence when it has a print? Parallel questions arise for 'works' of cast sculpture or non-photographic print works where no instance has been generated through use of the relevant matrix. These cases are trickier, since, at least in the case of photographic and some other print works, we expect the artist to make important contributions to the artistic content of the work through her manipulation of the production artefact. Lacking these contributions, it is less clear that the works exist. Perhaps the most natural response even in such cases is to say that a previously unknown work has been discovered, but there could be an argument for the contrary view.

7.3 Perceivability

Dodd, we may recall, argues that the type-token view enjoys a default status as an answer to the categorial question because it can explain what he takes to be the two salient explananda for such an answer without the need for philosophical reinterpretation. The first explanandum was repeatability and the second was *audibility*. But, as I argued in Chapter 3, to explain the audibility of a performable musical work, or more generally the perceivability or experienceability of a multiple artwork, Dodd, like proponents of alternative answers to the categorial question, must appeal to Wolterstorff's doctrine of 'analogical predication' or to something like Predelli's account of generic expressions. On Wolterstorff's account, when we predicate 'audibility' of a performable musical work, or 'perceivability' of a photographic artwork, we are attributing to the work a property different from but analogically related to the property that we predicate when we apply the same predicate to a performance of the musical work or a print of the photographic works. To say that the *Fantasia on a Theme by Thomas Tallis* is audible is to predicate of the work the following property: being such that all of its instances (performances) are audible. And to say that *The Steerage* is visually perceivable is to predicate of the work the following property: being such that each of its instances (prints) is visually perceivable. If so, then any theory offering an answer to the categorial question for a kind of multiple artwork will presumably rely on the same kind of explanation for the work's perceivability: (1) a standard account of the perceptual or more generally cognitive mechanisms whereby we are able to experientially engage with *instances* of the work; and (2) the claim that when we predicate perceivability of the *work* we are doing so analogically. In this case, the ability to explain how a given kind of multiple artwork is perceivable cannot be a virtue that favours some answers to the categorial question over the others, contrary to what Dodd claims. A similar conclusion

follows if we analyse predications of audibility of musical works in terms of a semantics for generic expressions, as argued by Predelli.

7.4 Creatability

A fourth putative explanandum is *creatability*. As we saw earlier, Levinson argues that it is a central feature of the way in which we think about and treat classical musical works that they are regarded as entities brought into existence by their composers. Furthermore, so Levinson maintains, a similar claim holds for other art forms. However, we have seen this claim disputed by Kivy and Dodd, inter alia. They insist that the relevant features of our practice can be accounted for equally well on the assumption that musical works are not created but are creatively discovered. Parallels with other fields of human accomplishment—scientific inquiry and geographical exploration, for example—suggest that the esteem accorded to composers does not require that we think of them as creating their works. Even Levinson, as we saw, seems willing to entertain this alternative account. Furthermore, as we also saw, Dodd argues that even on Levinson's own account the creatability condition is not satisfied: 'initiated' types are no more creatable than their intrinsic counterparts. For Rohrbaugh, who, like Levinson, thinks that musical works and other multiples are created temporal entities, this is a further reason to seek a non-Platonist account of such artworks.

As we saw in the previous chapter, however, it is difficult to reconcile the idea of 'creative discovery' with our practices in those multiple art forms where works are initiated by means of a production artefact. In the paradigm cases where we treat what agents do as a matter of 'creative discovery', we are already committed in our conception of their activity to the idea that they are discovering something that exists prior to that activity—regions of the universe that they are exploring that may have previously undiscovered features, or unobservable states of the world that can be brought to light through experimental means, for example. But in the case of those who initiate works of cast sculpture or photography by bringing into existence a production artefact, it seems counter-intuitive to suggest that the resulting works were already there to be discovered. The latter view seems to require further argument, and that argument is usually furnished by an ontological theory held on independent grounds. It is because we are invited to think of musical works as sound structures having some kind of quasi-mathematical description, for example, that we might be attracted to the idea that composers, like mathematicians, are explorers of a realm of already existing potentialities. It is not, I think, accidental that the main impetus behind Platonistic views of multiple works comes from philosophers interested in the performable musical work. It is much less intuitive to think in these terms even about performable works in other

branches of the performing arts. It is true, as Dodd points out, that we could extend the idea of initiation as creative discovery to all of the arts. We might hold that painters discover rather than bring into existence the particular perceptible manifolds exemplified by their paintings. But such a view will, I think, seem attractive only to one already convinced by other arguments for Platonism. Balancing all of these considerations, therefore, it seems that the burden of proof falls on those who wish to deny the creatability of multiples *in general*.

7.5 'Fine Individuation' and Contextualism

Levinson's second requirement for an ontology of musical works is that such works be *finely individuated* not only in terms of their structural properties but also *in terms of the musico-historical contexts in which they are initiated by their composers*. As we saw in Chapter 4, Levinson's defence of a contextualist ontology of musical works is mirrored in other prominent arguments for contextualist ontologies of literary works (e.g. Currie) and works of visual art (e.g. Danto). Contextualists point to central features of our critical and appreciative practices that seem to commit us to the idea that the art-historical contexts in which artworks are initiated are partly constitutive of the identity of those works *as* artworks. As was noted earlier, it is customary to provide those visiting an art gallery with information about the provenance of the works on display, including information about the materials used by the artist, the place of a work in an oeuvre, and the broader artistic context in which an artist was working. Where a gallery departs from this practice, this is usually guided by a philosophical theory that seeks to change that practice. Consider, here, exhibitions such as the 1984 MOMA exhibition, curated by William Rubin, that grouped together with minimal provenential information works by early modernist painters and artefacts taken from collections of traditional African artefacts moved in the early twentieth century from ethnographic museums to the Trocadéro in Paris.[1] Or consider the exhibition of works by painters such as Klee and Dubuffet, on the one hand, and works by 'outsider' artists, on the other, staged at the Whitechapel Gallery in London in 2006, where once again the viewer was denied any easy means of identifying the provenance of such works.[2] The underlying idea in both cases is that works of visual art should be able to 'speak for themselves'. But this idea, perhaps most famously enunciated by Clive Bell (1913) in his defence of aestheticism in the visual arts and echoed in Tom Wolfe's assault (1975) on the artistic claims of late modernist art, is difficult to reconcile with our artistic practice, in spite of the strong aestheticist currents in philosophical thinking about the arts

[1] See Rubin (1984/2006) and the reviews by Danto (1984/2006) and McEvilley (1992).
[2] See Andrada et al.(2006).

since the early nineteenth century. As noted in Chapter 4 above, Danto's famous gallery of perceptually indistinguishable red squares (1981, 1–2), which call, so he argues, for very different kinds of artistic appreciation, reflects Danto's own familiarity with the ways that pictures are regarded in the curatorial and appreciative communities.

There is no reason to think that things are any different in the case of those art forms where works are multiple rather than singular. We may recall Dodd's defence of the 'moderate empiricist' view of what it is to appreciate a work of music '*as music*', a kind of aestheticism about music that echoes Bell's aestheticism about painting. In defending the empiricist model of appreciation, Dodd notes that music critics do seem to take seriously issues relating to the provenance of musical works and the kinds of properties of works that presuppose features of provenance. Dodd's response is to say that music belongs to us all, and that critics are confusing aesthetic and art-historical considerations. But this is to tacitly grant that our musical practice does seem to treat musical works as contextualized entities. So, once again, we seem justified in taking the contextualist idea of the multiple artwork as something partly individuated by its provenance as a feature of our artistic practice that an acceptable ontology of multiples must somehow account for—either by accommodating it or by arguing that our overall artistic practice makes better sense and can be rendered more coherent if contextualism is set aside. As we noted in Chapter 5, it is not an option here to reject contextualism because it does not comport with an ontological theory not itself held rationally accountable to our artistic practice as a whole. The Platonist therefore owes us another kind of argument for rejecting, upon rational reflection, the contextualist dimensions of our artistic practices in respect not only of multiples but also of singular artworks. Lacking such an argument, Platonism in its pure form seems fatally flawed.

7.6 Instrumentalism

Levinson's third desideratum for an ontology of performable musical works is the *instrumentalist* requirement that such works be individuated in part by reference to the performance means specified for the realization of a given sound sequence or sound structure.[3] But, as Levinson himself admits, whether specified performance means are plausibly taken to be partly constitutive of musical works depends upon the norms operative in a given musico-historical community. In some contexts it may be more plausible to assume, as do Kivy and Dodd, that the

[3] As noted in Chapter 4, note 4, while Levinson's explanandum is formulated in terms of musical works, we can generalize this to other art forms by means of something like **Prod**, where it is the means whereby a work's artistic vehicle is generated that is a constitutive feature of the work.

indication of instruments upon which a given sound sequence is to be produced is not rightly understood as mandating that the work be performed on the designated instruments, but is, rather, a way of identifying the timbral sonic values that are to be realized in correct performances of the work. Thus *that performance means are partly constitutive of a musical work* cannot itself be a legitimate explanandum for an ontology of musical works. However, if there are, as Levinson argues, clearly cases where, given the norms in a performing community and/or the intentions of composers, only performances on the specified instruments would be counted as strict p-instances of a work, then it *is* a plausible explanandum for an ontology of musical multiples that it make sense of the idea that performance means *can be* partly constitutive of works, and also explains the kinds of conditions under which they are. *This* condition is arguably one that the Doddian Platonist cannot meet, even if he can argue that in many cases it would not be right to view specifications of performance means as work-constitutive in this way.

7.7 Modal Flexibility

Rohrbaugh, as we saw in Chapter 6, argues that musical artworks share with other kinds of artworks the properties of being *modally* flexible and *temporally* flexible. Let me take these two putative explananda in turn. Modal flexibility is a matter of a work's intrinsic properties in the actual world not being modally necessary—not being properties that the work must possess in any counterfactual situation in which it is taken to exist. A key question here, we noted, is the nature of the 'intrinsic' properties falling within the scope of this claim. Rohrbaugh contrasts intrinsic properties with relational properties: his having a certain ability at golf is intrinsic, while his living north of the equator is extrinsic. But clearly not all of his 'intrinsic' properties can be modally flexible, assuming that at least some of them—for example, having particular parents—are essential for it to be *he* that exists in a counterfactual situation. When Rohrbaugh talks about the modal flexibility of artworks, however, the intrinsic properties in question seem to relate to structural properties of those works—the sound structure of a musical work, the textual properties of a novel, and the distribution of pigment on surface in a painting. Differences in *these* properties will entail differences in the appreciable properties supervenient upon such structural properties, and, by the principle AC advanced in Chapter 5, differences in such appreciable properties entail differences in works. Thus the 'intrinsic' properties of works that are claimed by Rohrbaugh to be modally flexible are arguably *essential* properties of those works. The claim that artworks are modally flexible in these respects, then, is to say the least contentious. Furthermore, the examples offered by Rohrbaugh seem to allow of an alternative description where what we have is very similar, but distinct, modally inflexible works.

Should we perhaps treat modal flexibility in the same way that we have treated Levinson's 'instrumentalist' explanandum, as a matter of artistic practices that can differ across artistic communities, so that the burden on an adequate ontology of multiples is to allow for the *possibility* of modal flexibility? The problem here is that, as just noted, any artistic practice in which works are claimed to be modally flexible might also be described in terms of modally inflexible works whose intrinsic properties are less specific: on this alternative account, the range of flexibility in respect of a given kind of property is built into the characterization of the intrinsic properties themselves. This suggests that, far from being an explanandum for an ontology of multiples, the possible modal flexibility of works is something we might seek to *clarify* on the basis of an ontological theory that best accounts for our other (weighted) explananda. Insofar as the issues relating to modal flexibility rest upon our conflicting modal intuitions, the latter do not seem robust enough to bear the ontological weight given to them by Rohrbaugh.

My suggestion that our modal intuitions about the modal flexibility of artworks cannot bear a significant ontological weight might surprise readers familiar with the argument in chapter 5 of my *Art as Performance*. For, it might be said, surely there I did confer on our modal intuitions a central role in arguing for the 'performance' theory of artworks. Should my suggestion in the present context be taken as a tacit admission that the argument in *Art as Performance* cannot do the job assigned to it, and should this give succour to those who have expressed doubts about that argument (see, e.g., Matheson and Caplan 2008)?

There is in fact no inconsistency here, however. In the 'modal' argument for the idea of artworks as performances, I identified what I termed the 'work-relativity' of our modal intuitions concerning artworks, something that, so I maintained, tracks our sense of what an artist has done in generating the artistic vehicle of an artwork. The 'work-relativity of modality' relates to which of the features of a work's provenance are taken to be constitutive of the work. These features, I argued, are the ones that we assume the work must have in counterfactual situations, as contrasted with other properties that we allow to vary in counterfactual situations in which the work exists. In drawing this contrast, it is assumed, contra Rohrbaugh, that works are modally *inflexible* in Rohrbaugh's sense. The work-relativity of modality relates to *which* properties we take to be intrinsic properties of a work—those which, so I argue, are essential for the work to be the artistic performance that it is—and these properties are the ones that the work must possess in any counterfactual situation in which it figures. My argument, therefore, identifies a particular *pattern* in our modal intuitions about artworks, a pattern that exists even where our intuitions about particular cases differ. Rohrbaugh's defence of modal flexibility, on the other hand, ascribes to our modal intuitions a feature that his philosophical opponents (e.g. Dodd and myself) simply reject, and bases his ascription of this feature on a description of individual cases which his opponents will also reject.

7.8 Temporal Flexibility

Similar considerations apply to Rohrbaugh's second proposed explanandum, *temporal* flexibility. The latter, we will recall, is a matter of a work's intrinsic properties being capable of changing over time in the actual world. This is to be distinguished from the uncontroversial claim that over time a work may cease to have some properties viewed as intrinsic, as with the weather-beaten gargoyle that loses features that originally defined its shape and expression. Once again, for this to be an interesting claim the 'intrinsic' properties in question must include properties taken to bear upon the artistic appreciation of a work. However, as I argued in the previous chapter, it is difficult to anchor Rohrbaugh's claims in features of our artistic practice that could serve as legitimate explananda for an ontological theory. We *could* describe what goes on in those practices in terms of temporal flexibility, but there seem to be equally good ways of describing the practices that make no such commitment. Again, it might be suggested that whether artworks are temporally flexible depends upon the norms embedded in particular artistic practices. For example, whether a painting survives extensive restorative work seems to be a matter upon which equally qualified practitioners might disagree. But, as with modal flexibility, we might take the issue to be *which* intrinsic properties are essential properties of the work, rather than whether such intrinsic properties can change over time.

7.9 Variability

Our ninth and final putative explanandum for an ontology of multiple artworks, discussed in the previous chapter, is *variability*. I take this to be the deeper issue presented by the repeatability of multiples. If multiplicity is a matter of allowing for a plurality of strict p-instances, as argued in Chapter 1, how is something's status either as a p-instance or a strict p-instance itself to be explained? As I argued in the previous chapter, I do not think the variability of those multiple artworks that exhibit this feature can be explained by appealing to anything that transcends our actual artistic practices. In a very real sense, such multiples are themselves creatures of our practices and owe their defining features to the latter. This is why variability presents the most serious challenge to Platonist ontologies and is one reason why we must now consider alternative non-Platonist ontological proposals.

But, as should be clear from the foregoing summary of our reflections thus far on our nine putative explananda, the case against Platonism is broader than this. We have seen, first, that Dodd's argument for the default status of the type-token theory in the ontology of musical works is flawed in two distinct ways: a) the two

explananda supposedly best explained by the type-token theory—repeatability and perceivability—seem to be explicable using resources that are available to any otherwise plausible ontological account—repeatability is a function of the manner in which multiples are initiated, and perceivability is explicable either in terms of analogical predication or in terms of the grammatical features of generic expressions; and b) the choice of these two explananda, to the exclusion of any of the others, as the touchstone of an ontological theory seems to be methodologically flawed, as argued in Chapter 5. Second, while we have downgraded two explananda that would present serious problems for the Platonist—modal and temporal flexibility—we have upheld two other explananda that seem incompatible with Dodd's form of Platonism—the art-historical contextualization of multiples and other artworks and the need to accommodate artistic practices that incorporate instrumentalism or a generalization of the latter (production means) to other art forms. Third, while Platonism can accommodate unperformed works, it cannot accommodate the creatability of multiples initiated by means of a production artefact.

8
Non-Platonist Ontologies of Multiples

8.1 Three Non-Platonist 'Materialist' Ontologies of Multiples

Theorists considering the non-Platonist options available to the ontologist of multiple musical artworks have identified the following general alternatives (see, e.g., Tillman 2011; Kania 2012a):

(1) 'Materialist' theories that commit themselves to the real existence of such works construed as in some sense 'constructions' out of the concrete elements that enter into our practices. Two such theories are musical perdurantism (Caplan and Matheson 2006) and (musical) endurantism (Rohrbaugh 2003). These accounts take musical works to be either *constituted by* or *ontologically dependent upon* such concrete elements.

(2) Eliminativist theories (e.g. Cameron 2008, Mag Uidhir 2013), according to which 'there are only concrete objects, such as performances and the creative actions of composers, and none of these can be identified with musical works: therefore there are no musical works' (Kania 2012a, 208).

(3) 'Fictionalism', as proposed by Kania (2012a), as a kind of 'eliminativism light'. The fictionalist agrees with the eliminativist that there are no entities having the range of properties that something would have to have in order to be a multiple artwork of a given kind, but argues that we should continue to talk as if there were because so doing has various pragmatic benefits.

It has recently been suggested, however, that this taxonomy omits a further non-Platonist realist alternative—one that, once properly understood, outperforms both Platonism and materialism. 'Sophisticated Idealism', as defended by Wesley Cray and Carl Matheson, draws upon a new conception of the nature of ideas in arguing that, at least in the case of classical musical works, the work should be identified with the compositional idea originating in the creative activity of the composer. The claim is that idealism, so modified, evades the traditional objections that have led theorists to dismiss such a view in its more traditional manifestations.

I shall look at eliminativist and fictionalist proposals in Chapter 10. Prior to that, I shall look in this chapter at three realist materialist alternatives to be found

in the literature, and at the claims made for sophisticated idealism. In the next chapter I shall present and defend what I take to be the most promising form of non-Platonist realism about multiple works, arguing that it better serves our purposes than the views considered here. Our question in the final chapter will be whether realism remains a genuine option if we reject the kind of account proposed by the Platonist.

If we reject the Platonist option in the ontology of multiple artworks, the only entities to which we can appeal if we are to offer a realist account of such works must be ones that are nominalistically acceptable—most obviously, concrete particulars or constructions out of such particulars.[1] But this presents some problems that the Platonist does not need to address. We need a principled way of picking out the particulars that enter into the nature of multiple works, and a principled explanation of how those different elements cohere so as to explain the ways in which multiples are treated in our practices. A danger here is that, if we tie the existence of multiples to the existence of a narrow range of particulars, we lose touch with some of the explananda in our practice. If, on the other hand, our non-Platonist conception of multiple artworks embraces a broader range of the particulars that enter into our practices, it becomes less clear that there is something meriting the title of *work* over and above those particulars and those practices.

Consider, as an illustration of the latter problem, the conception of the musical work as a 'multiplicity' of material particulars proposed in a manifesto by the members of MusicExperiment21 based in the Orpheus Institute in Ghent. The multiple materialities entering into our musical practice that are acknowledged in the manifesto are both considerable and diverse, as the following passage makes clear:

> From a materialist ontological perspective, works only exist as elaborated products of a network of relations and interactions between documents. In the place of works... one can look at the innumerable things on top of things that allow for the construction of an 'image of work': sketches, drafts, manuscripts, editions, recordings, transcriptions, treatises, manuals, instruments, depictions, contracts, commissions, letters, postcards, scribbles, diagrams, analytical charts, theoretical essays, articles, books, memories, etc. Brought together in specific combinations (historically and geographically situated), these things make up those reified generalities that we used to call musical works. From this materialistic perspective works emerge as '*multiplicities*' as highly complex, historically constructed

[1] This is compatible with an idealist view, even if mental particulars are not physically realized. In fact, as we shall see in the following section, Cray and Matheson's 'sophisticated idealism' takes ideas to be systems of particulars that are physically realized in the brain.

conglomerates of things that define and take part in an ever-expanding 'manifold'. (MusicExperiment21, 2015)

Talk here of 'reified generalities that we used to call musical works' suggests that, rather than reconceive the performable musical artwork in nominalistically acceptable terms, the proposal is that we should view such works as a result of mistaken attempts to impose upon the multifarious aspects of our performance practices a unifying notion of work, the traditional role of which has in fact been to constrain performative freedom. This reading is reinforced in another document from MusicExperiment21 which talks of the exciting possibilities for performance once we liberate ourselves from the idea of performing a 'work' in the standard sense:

> The main goal of MusicExperiment21 is to propose and generate new modes of performance and exposition of research. Integrating material that goes beyond the score (such as sketches, texts, concepts, images, videos) into performances, this project offers a broader contextualisation of the works within a transdisciplinary horizon.... Combining theoretical investigations with the concrete practice of music, this project presents a case for change in the field of musical performance, proposing alternatives to traditional understandings of 'interpretation'. Whereas traditional models are based on static conceptions of the score, this project proposes a dynamic conception, in which innumerable layers of notational practices and editions of musical works throughout time generate an intricate multi-layered set of inscriptions. If the source text is seen as dynamic, rather than fixed, and if the performative moment is—in its essential nature—also dynamic and ever-changing, it follows that every performance is more of an 'event' than a reiteration of the given 'form' of a piece.
> (MusicExperiment21, 2013)

For MusicExperiment21, the traditional conception of a performable musical work that stands apart from and imposes constraints on musical performance originates in the idea that we need to regiment musical practice by prioritizing the authority of the composer and limiting the freedom of performers. The multiple materialities entering into musical practice are to be subordinated to the work so conceived. But there is no suggestion that MusicalExperiment21 want to fashion a new conception of the performable work as a construction out of these materialities. Rather, the fruits of the composer's activity is just one element available to performers as they seek novel and rewarding forms of performance. Understood in these terms, MusicExperiment21's proposal is analogous to James Hamilton's suggestion that we think of theatrical performance practice in terms of an 'ingredients' model. Hamilton (2007, 31) affirms that 'the texts used in theatrical performances [are] just so many *ingredients*, sources of works and other ideas

for theatrical performances, alongside other ingredients that are available from a variety of other sources. Works of dramatic literature, in particular, are not regarded as especially or intrinsically fitting ingredients for performances. As ingredients they are but one kind among many possible sources of words for a theatrical performance.' But Hamilton is not merely affirming a possibility for theatrical performance. He maintains, in a spirit that anticipates that of MusicExperiment21 (2015), that 'a [theatrical] performance is...never a performance *of* some other work nor is it ever a performance *of* a text or *of* anything initiated in a text; so no faithfulness standard—of any kind—is required for determining what work a performance is of'.

A nominalist *realism* about multiple artworks, or about some kinds of multiple artworks, must offer a principled way of selecting from the range of particulars that enter into our artistic practices some elements that can plausibly be taken to play the roles ascribed to works in such practices. These roles are the ones we have tried to capture in our talk of the explananda to which an ontology of multiples is accountable. The nominalist realist must also explain how the work, and its existence and persistence conditions, is related to the chosen range of particulars. As Chris Tillman makes clear in his comprehensive critical overview of materialist options in the ontology of music (Tillman 2011), how the realist responds to this second challenge will determine whether she is open to the traditional Platonist charge that materialism violates fundamental logical principles by identifying the one—the musical work—with the many—the potentially distinct particulars that materialize the work.

Three forms of materialist realism merit consideration here: (1) Nelson Goodman's nominalist conception of musical works as classes of performances; (2) the idea, defended by Ben Caplan and Carl Matheson, of musical works as perdurants; and (3) Rohrbaugh's idea, sketched in the previous chapter, of artworks in general as continuants, essentially historical individuals that endure through time.

8.1.1 Goodmanian Nominalism about Musical Works

In *Languages of Art* Nelson Goodman proposes and defends a nominalist account of musical and theatrical works. In each case, a work is 'the class of performances compliant with a character' in a symbol system. Taken at face value, such a view faces the kinds of problems, identified by Wollheim and others, that we discussed in Chapter 2. We think of performable works as only contingently having the number of performances that they do: this seems to be built into our conception of such works as repeatable. We also seem committed to the possibility of unperformed works. If one tries to meet these objections by defining works in terms of classes of performances that include *possible* performances compliant with a score,

this seems nominalistically problematic. How are possible particulars (performances) any better, ontologically speaking, than abstracta, unless we are realists about other possible worlds. This view also falls foul of the problem of variability. Goodman defines a musical work as a class of performances that complies with a score, but, as we have seen, which performances so comply depends upon the norms in a given musical community. The Goodmanian view of musical and theatrical works has found few adherents, and, given the methodological approach for which I have argued in this book, it does not seem to offer much promise.

8.1.2 Musical Works as Perdurants—Caplan and Matheson

Ben Caplan and Carl Matheson, in a number of articles (2004, 2006, 2008), have set out and defended the claim that performable musical works are persisting entities—entities that exist at more than one time—that are constituted by their temporal parts, the latter being concrete entities or events. They reject the idea that musical works are abstract entities on the grounds that this makes it difficult to see how such works can enter into our practices either as the referents of our terms or as the subjects of our appreciative experiences. Rather, they maintain, musical works *perdure*—they 'hav[e] different temporal parts at every time at which they exist'. The temporal parts that make up a perduring entity E themselves exist only at particular times, are parts of E, and overlap at those times everything that is a part of E. Perdurantism about musical works may construe the temporal parts constitutive of such works more or less broadly, as including, for example, not only performances but also the composition of the score and other events of the sort spelled out in the MusicExperiment21 manifesto cited above. On Caplan and Matheson's considered version of their theory (2006), however, such works are fusions of performances. Since the temporal parts or 'stages' of which a musical work consists are each themselves concreta, the perdurantist view faces none of the difficulties faced by the Platonist in explaining how we are able to causally interact with and experientially engage with such works. They further argue that perdurants are entities with which we are already familiar in other contexts. Many philosophers hold that people, for example, are best understood as perduring entities made up of those person-stages that occur sequentially between the birth and the death of an individual person.

It is immediately apparent that the perdurantist view of musical works so understood faces some of the same difficulties as the Goodmanian view in satisfying the weighted explananda spelled out in the previous chapter. First, if a musical work is constituted by temporal stages that are performances, the perdurantist must hold that there *cannot* in fact be unperformed musical works, but such a claim seems difficult to sustain given the methodological assumptions for which I argued in Chapter 5 and the further reflections in Chapter 7. For closely related

reasons, on such a perdurantist account musical works are not created by their composers, since the elements that make up the work qua perduring entity are created by those who perform it (see Cray and Matheson 2017). Even if the composer gives the first performance of a work she composes, this performance has no special status in relation to the creation of the work unless it is the composition's only performance. But this would entail that a composer is the single creator of a work only if no one else ever performs it! The perdurantist might respond to both of these problems by broadening the range of concreta that can be constitutive of a musical work to include things that are not performances. In fact, an earlier version of perdurantism proposed and defended by Caplan and Matheson (2004) included the act of composition as one of a work's temporal stages. This allows for there to be unperformed works, but, pace Cray and Matheson (2017), does not seem to make musical compositions creatable in the normal sense—as the sole creations of their composers. We might achieve the latter if we incorporate into the perdurantist account a requirement that the temporal stages be historically and causally related in a specific way: the composer's act, it might be said, initiates and provides conditions—in terms of content and origin—that other temporal stages have to meet. But once we do this, it seems that musical works are no longer properly described as fusions of their temporal stages, but as something more historically grounded and structured. We shall see proposals as to how such entities might be understood in Rohrbaugh's account, in Cray and Matheson's 'sophisticated idealism', and in the account of 'Wollheimian types' to be developed in Chapter 9.

A second related problem is to explain why, as seems to be the case for the perdurantist, it is not merely contingent but *necessary* that a musical work have the particular performances that it does. In defending their position against such a charge, Caplan and Matheson grant that it would indeed be unacceptable to make it a necessary feature of a musical work that it has just *these* performances. They suggest a number of ways in which the perdurantist might accommodate this requirement. The issue is that, if musical works are fusions of performances and if, as is widely believed, fusions are modally constant—if, that is, they have their parts essentially—then they have the performances constitutive of them essentially. One option for the perdurantist would be to adopt a counterpart theoretic account of de re modality in the style of David Lewis (1968). On such an account, it is the properties that something's counterparts in other possible worlds can have in those worlds that determine its modal properties. The modal properties of a musical work would depend upon the non-modal properties of its counterparts. It might then be claimed that *different* counterpart relations will be relevant according to whether we are considering modally a work W or the 'fusion of performances' with which it is identical in the actual world. This allows for the work to have had a different number of performances in counterfactual situations, even though the fusion of performances with which it is contingently identical

could not. Caplan and Matheson also consider two other possibilities. A 'hyperperdurantist' might hold that musical works are fusions of performances in the actual world and performances of their counterparts in other possible worlds. Or, appealing to classical mereology, the musical perdurantist might reject the idea that fusions are modally constant, appealing here to a distinction between 'thick' and 'thin' fusions, where only thick fusions are modally constant. Such moves, they suggest, have parallels in the case of perdurantism about persons. How convincing one finds each of these options will depend upon one's assessment of the more general metaphysical strategies upon which they draw. But, as they acknowledge, the tenability of musical perdurantism requires that at least one of these options (or some other solution) can be made to work.

Caplan and Matheson also respond to some other objections to perdurantism about musical works raised by Dodd (see again Tillmann 2011 on how perdurantists can deal with these kinds of traditional Platonist objections to musical materialism). The first of these, which they term the 'objection from perception', is that perdurantism entails that we cannot hear the whole of a musical work in listening to a performance of it. This is because what we hear, in listening to a performance, is only one of the temporal stages that constitutes the work. Caplan and Matheson canvass, as one response, simply biting the bullet. When we say that we heard the whole of a work in attending a performance of it, what we mean is that we heard a whole performance of it. This would contrast with hearing a performance of only one of the movements of a string quartet, for example. Dodd dismisses such a response (2007, 157–60), but this is not obviously a problem for those multiples, like musical works, that exhibit the kind of variability discussed in Chapter 6. Variability, as we saw, consists in the fact that a work's strict p-instances can vary in those of their properties that bear upon the appreciation of the work instanced. With multiple artworks where this is not the case—literary works, for example—it might well be absurd to say that someone who read a copy of a book had only read part of the work, since all of the experienceable qualities bearing on the appreciation of the work are present to the reader in a single act of reading. But, where a multiple work exhibits variability, this is not the case. Only some of the properties that bear on the proper appreciation of a musical work will be appreciable in listening to a single performance that is a strict p-instance of the work. Other such properties will be appreciable in listening to other performances that interpret the work differently. So if we equate listening to the whole of a *work*—rather than the whole of a *performance* of a work—with having a perceptual experience in which all of the work's perceptually appreciable qualities are made manifest, it is indeed the case that one who listens to a particular performance does not hear the whole of *the work*.

In any case, Caplan and Matheson do not entertain this kind of response to Dodd's challenge, but offer another strategy. Citing Dodd's claim, discussed in Chapter 3 above, that a musical work is audible through 'deferred perception'

when we listen to one of its instances, they suggest that the perdurantist can say the same kind of thing. One response to this suggestion is that it violates what Caplan and Matheson term the *presence principle* according to which one can perceive all of X at t in virtue of perceiving P at t only if X is wholly present at t (Caplan and Matheson 2006, 63). But they question why a perdurantist should accept the presence principle. They also claim that the situation for the musical perdurantist is no worse than it is for a perdurantist about persons. When I meet someone for a coffee, for example, I would not say that I only meet part of them, even though, if perdurantism about persons is correct, it is only one of the temporal stages constitutive of the person that is 'present' to me in such an encounter. Dodd (2007, ch. 6) argues that the cases are not analogous, since in the case of people we are justified in saying they are present in any encounter with one of their temporal stages, whereas this is not correct when we are talking about an object of perception. But this distinction may strike one as obscure, especially if one finds convincing the above considerations about the variability of musical works.

A fourth objection against perdurantism concerning musical works is what Caplan and Matheson (2006) term the argument from spatially scattered temporal parts, which claims that the perdurantist offends against certain standard principles in mereology. Dodd (2004) argues that, since two performances of a given musical work W can occur simultaneously, a given temporal part of W can be spatially scattered. If so, then some performances of W are not in fact temporal parts of W, but proper parts of a spatially scattered temporal part of W. Caplan and Matheson deny that this renders the perdurantist account obscure, since there exist continuity relations between a work's temporal parts. Nor are they concerned by Dodd's charge that musical works will have *different kinds* of parts. They take this to be fine, given general principles of mereology, as long as we also distinguish between the temporal parts of a work and the musical-work stages, where the latter are identified with its performances. More than one stage can make up a temporal part of a work, but this is not taken to be problematic.

Dodd also raises a more general worry (2007, 154–6) that bears upon the ability of a perdurantist account to speak to one of our other ontological explananda, repeatability. Our standard examples of continuants that exist through time— trees, stones, and persons—do not have temporal stages that are occurrences of those continuants, he argues, so musical works would be a different kind of continuant. It is difficult to gauge the force of this objection. Since, by construction, the things that are the 'stages' constitutive of a musical work are *performances*, the problem of repeatability as it needs to be understood, given the discussion earlier in this chapter, seems clearly to be addressed by the perdurantist. The real problem here, as I also suggested earlier, resides not in explaining how musical works can have their performances as occurrences, but in explaining how it is that certain events count as instances, and as strict instances, of those

works and thereby qualify as their performances. This problem is an aspect of the problem of variability, but, insofar as it takes the status of certain events as performances of a musical work as given, perdurantism will have nothing to say on this count. As we shall see in Chapter 10, the perdurantist might appeal to some kind of causal-historical relation between those things that count as performances: Caterina Moruzzi's eliminativist variation of perdurantism adopts such a strategy. But this raises the earlier worries about the ontologically kosher nature of what results when we build more and more materialities into our putative 'work'. This, coupled with our earlier concern about how the perdurantist can account for unperformed works, raises doubts about how well the kind of account proposed by Caplan and Matheson can satisfy our explanatory requirements for an ontology of multiples. It is this, rather than the supposedly 'disabling' objections cited by Dodd, that should lead the nominalist realist to seek an alternative account.

8.1.3 Musical Works as Endurants—Rohrbaugh

In Chapter 6 I briefly sketched Guy Rohrbaugh's proposal that multiple artworks in general, and performable musical works in particular, are 'continuants', historical individuals that depend for their existence on those concrete entities that are their 'embodiments'. Some of these embodiments are *occurrences*. These are distinguished from other embodiments in that they '[display] the qualities of the work of art and are relevant to appreciation and criticism'. This allows for the existence of unexemplified works, since the latter will still have embodiments that are not occurrences, and it also allows for the contingency of a work's actual performances. Rohrbaugh's characterization of 'occurrences' in terms of the role they play in appreciation suggests that they are a work's e-instances, or perhaps a work's strict e-instances, but the role that they are intended to play as embodiments that enter into the dependence-base of works understood to be *historical individuals* suggests that they must stand in an appropriate historical relation to a work's initiation, in which case they must also be p-instances.

On the perdurantist view considered above, musical works are *perduring* entities made up of their temporal parts, which, in the case of musical works, will include at least their performances. Embodiment here is *constitution*. On Rohrbaugh's alternative account, continuants are *enduring* entities, '"higher level" objects' that depend on but are not constituted by those physical or spatial things that are their embodiments. As we have seen, continuants so construed, according to Rohrbaugh, possess three qualities that artworks also possess and that Platonic entities do not: (1) continuants are modally flexible—the same continuant might have existed with different intrinsic properties from the ones it actually possesses; (2) continuants are temporally flexible—their intrinsic properties might differ over time; and (3) continuants can come into and go out of existence.

A particular house might be an example of a continuant. This house in which I am writing, it might be claimed, could have had a slightly different design, may undergo various alterations in its intrinsic properties during its lifetime, and comes into and goes out of existence—the first when it comes to have, and the second when it ceases to have, an embodiment. The existence of a house depends upon only some of the elements entering into the story of its being a particular continuant. For example, a house usually stands in a relation of causal dependence on an architect's plan, but the plan is not one of its existence-constituting embodiments.

Rohrbaugh claims that a musical work is a continuant having the aforementioned kinds of properties, and that such a work can exist without performances as long as it has other embodiments. As noted in Chapter 6, Dodd raises concerns about the metaphysical obscurity of Rohrbaugh's notion of a continuant, and the relationship of 'dependence' in which it stands to its embodiments. There are, however, a number of other problems with Rohrbaugh's account, given the way in which we have defined our task. First, to take internal difficulties, even if it be agreed that continuants are modally and temporally flexible, the claim that musical works are continuants doesn't sit well with the work-concept as standardly understood. As we saw in Chapter 6, there are reasons to doubt whether performable works are modally flexible, in the sense that something having different formal requirements for its strict instances could have been the same work. The same doubts arise about other kinds of multiples. And there are also reasons to doubt whether multiple artworks are temporally flexible, admitting of change in their intrinsic properties through time. Rohrbaugh, as we saw in Chapter 6, draws an analogy with paintings which, so he claims, are endurants with these properties. But others have argued to the contrary that while the physical objects that 'house' paintings are indeed continuants, paintings themselves are not but are modally and temporally inflexible. This is one reason why, for some philosophers, works of sculpture are constituted by but not identical with the physical masses that serve as their vehicles: the statue and the lump of clay have different persistence and existence conditions.

Equally germane in the present context, Rohrbaugh's account doesn't seem to provide an answer to two central challenges for an ontological account of traditional classical musical works—the challenges of accounting for both the repeatability and the variability of such works. It might seem that the continuant account can explain repeatability in terms of a musical work's capacity to have multiple occurrences among its embodiments. But we have defined the problem of repeatability in terms of a work's capacity for multiple p-instances that are *strict* e-instances. We therefore require an account of how the latter are to be picked out, which requires, in turn, a solution to the problem of variability. But it isn't clear that, as it stands, Rohrbaugh's account has any way of addressing the latter problem. In dealing with the musical work in terms of embodiments and occurrences, it fails to address how status as an occurrence and as a strict occurrence is

established through our musical practices, as argued in my discussion of Platonist theories. If Rohrbaugh were to argue that, given that continuants are historical individuals, a musical work's occurrences must be p-instances, then he might avail himself of an independent account of how a work's p-instances, and indeed those of a work's p-instances that are strict e-instances, are determined. In the following section, and in Chapter 9, we shall consider the possibility of augmenting an ontological account of multiples by building into it those aspects of our artistic practices that, so I have argued, account for variability. Such a strategy might be an option for Rohrbaugh, especially given the ways in which he has appealed to features of our practices in more recent work (2020). But such an augmented account of works as continuants would be open to the kinds of challenge to be spelled out in Chapter 9.

8.2 'Sophisticated Idealism'

We briefly encountered idealism as an option in the ontology of art at the beginning of Chapter 2, where I sketched the reasoning leading Wollheim to the conclusion that multiple artworks should be viewed as types. Wollheim, it may be recalled, presents for consideration the 'Physical Object' hypothesis according to which artworks are physical objects. He notes and dismisses two other kinds of global hypotheses about the ontological standing of artworks: (a) the 'presentational' view according to which artworks are congeries of perceptible properties that physical objects and events make available to us in our experiential engagement with them; and (b) the 'ideal view' according to which artworks are 'ideas' or 'expressions' in the mind of the artist that are only contingently externalized. Citing Croce and Collingwood as supposed advocates of the latter view,[2] Wollheim offers the following summary of its central claims:

> First, that the work of art consists in an inner state or condition of the artist, called an intuition or an expression: secondly, that this state is not immediate or given, but is the product of a process, which is peculiar to the artist, and which involves articulation, organization, and unification: thirdly, that the intuition so developed may be externalized in a public form, in which case we have the artifact which is often but wrongly taken to be the work of art, but equally it need not be. (1980, 36–7)

Few have questioned Wollheim's peremptory dismissal of the Ideal View so understood. Critics point to various ways in which it fails to comport with our

[2] For criticism of this reading of Collingwood, see Davies (2008).

understanding of our artistic practices. For example, if a musical work is an essentially private experience in the head of its composer, then it is not itself either performable or publicly audible. Even if the composer herself provides an externalization of her idea, we have no way of knowing whether the inner experience thereby produced in us mirrors the inner experience of the composer, so works are only accidentally and unknowably shareable. Indeed, if the inner experience identified with the work is viewed as an expressive *process* whereby the composer arrives at the expressive form of the work, then an externalization gives at most an idea of the *terminus* of this process.

In their paper 'A return to musical idealism', Wesley Cray and Carl Matheson (2017) freely acknowledge these infirmities of what they term 'simple idealism': 'If compositions are ideas and ideas are private, unplayable, and inaudible, then compositions are private, unplayable, and inaudible. In so far as our ontology should, as much as is possible, preserve common thought and talk about compositions, this is a bad result' (2017, 704). They further maintain, however, that the source of this 'bad result' is not the identification of musical compositions with ideas, but the identification of ideas with something private, unplayable, and inaudible. Drawing on independent work by Cray and others, they propose that ideas be understood as 'systems of appropriately related token mental states. By appropriately related, we mean that the token mental states are (i) tokens of the same type, with the relevant types individuated by the content of their tokens, and (ii) sufficiently causally and historically related. When we speak of an idea's content, we take that content to be inherited from the idea's component tokens: if the tokens in the system have content C, the idea has content C.' (2017, 705). Since the tokens can be *inscriptions* that share their content with other mental tokens, the 'Systems Account' makes ideas in principle public and shareable, rather than private, entities.

Given this understanding of what ideas are, Cray and Matheson propose (2017, 707) that musical compositions be identified with *completed ideas for musical manifestation*. 'Manifestations' are 'artifacts—such as performances or recordings—that are intended to realize, and are sufficiently successful in realizing, the idea in some perceivable form by satisfying the conditions imposed by the content of the idea' (2017, 707). They add that 'an idea is an idea *for* some kind of thing K (or action A) when its originator intends for that idea to be, in principle, able to serve as the basis for the generation of a K (or for the act of A-ing). An idea serves as the basis for such when its content is intended to prescribe an outcome, and perhaps a means for realizing that outcome' (2017, 708). Finally, drawing on work by Trogdon and Livingston (2014), they take a completed idea to be one that the composer has no (active) disposition to change. Unlike simple idealism, they maintain, the 'sophisticated idealist' conception of ideas as 'systems' and of musical compositions as completed ideas for musical manifestation make musical compositions 'public, shareable, audible, and playable'. As just noted,

compositions are public and shareable in virtue of being ideas as understood on the systems account. They are audible because, like types on the Platonist account, they can be heard indirectly through hearing their manifestations. And they are playable because the idea, in virtue of its content and causal history, imposes constraints on the performance of a given composition.

Cray and Matheson also claim that sophisticated idealism performs at least as well as competing accounts of musical compositions in accommodating central features of our musical practices. They take the principal competitors to be:

(a) the Type theory, in either its 'pure' or 'indicated' form, according to which 'compositions are some variety of abstract sound structure', and

(b) a sophisticated materialism, according to which 'compositions are either composed of, or coincident with, their concrete manifestations', and that allows for a composition to have concrete manifestations over and above its performances. (Cray and Matheson 2017, 709)

One desideratum here is to render musical compositions creatable, something that both sophisticated idealism and sophisticated materialism are able to do but that, as we have seen, seems incompatible with pure type-theories. Cray and Matheson reject the suggestion (by Kivy and Dodd) that we should be happy to think of musical compositions as 'creative discoveries'. This, they claim, would entail that, contrary to our intuitions, particular musical works would have existed even if no intelligent life forms had evolved in the universe. They also reject Levinson's claims about the creatability of *indicated* structures on the grounds that the latter are 'metaphysically obscure'.

Apart from creatability, Cray and Matheson identify three other general features of musical compositions for which an ontology of the latter should account (2017, 713):

a) 'Contentfulness'—'Compositions... specify, in some manner and to some degree, that which a manifestation should manifest';
b) 'Concreteness'—'Compositions are entities sufficiently related to the concrete world in that they are creatable, spatio-temporally locatable, and able to interact causally with concrete objects (performers, performances, etc.)'; and
c) 'Of-ness'—'manifestations are... literally of compositions'.

A sophisticated idealist account of musical compositions, it is claimed, accommodates for all three of these features, whereas Type-theories fail to respect the concreteness of compositions, and materialist theories, in making manifestations *parts of* compositions, fail to respect of-ness.

At the beginning of their paper, Cray and Matheson are careful to distinguish between their concern—to defend an ontological conception of musical *compositions*—and the project that preoccupies most of their collocutors—to defend an ontological conception of musical *works of art*. Their reason for focussing on compositions rather than works is that while we can give a univocal ontological account of musical compositions—they are ideas, so they claim—there is unlikely to be a univocal ontological account of musical works of art. They follow Kania (2006) and others in taking the works of art in a given art form to be the principal foci of critical and appreciative attention in that art form. While, they maintain, this focus in the case of standard works of classical music is indeed the musical composition, in the case of other musical art forms it is best understood to be something else—the recorded 'track' in the case of rock music, and the performance in the case of jazz. However, they argue, in these different musical genres we can still identify something composed, and this something is best understood in idealist terms.

These structuring assumptions of their article help to explain some lacunae in their account. They do not discuss Rohrbaugh's endurantist account, for example, noting that the latter might be viewed either as a form of sophisticated materialism or as a form of sophisticated idealism depending upon whether the musical work, as historical individual, is taken to be initiated through a process of ideation in the composer's head or through an inscription on a score. But, even if Rohrbaugh's 'historical individuals' may incorporate an idea in Cray and Matheson's sense—since they may incorporate a system of tokens sharing both content with, and historical grounding in, the initiating idea of the composer—the historical individual itself, and thus (for Rohrbaugh) the work of classical music, will not be identical to this system (and thus not identical to the composition in Cray and Matheson's sense), since it will also incorporate those embodiments that are not occurrences (and thus not manifestations) of the work.

This also bears upon another acknowledged lacuna in the defence of sophisticated musical idealism—the failure to consider the views of those, like Currie and myself, who have identified works in general, and therefore musical works, with action-types or action-tokens Here again, proponents of such views may freely grant that the action-type or -token identified with the musical work will involve creative ideation on the part of the composer, but will insist that it is the compositional act—involving what Currie termed a 'heuristic path'—rather than the idea issuing from that act—the 'musical composition'—that is to be identified with the musical work of art. Thus, even in the case of Cray and Matheson's favoured musical genre where the composition and the work of art are taken to most obviously coincide, it seems contentious to identify the work of art with the composition qua idea. Furthermore, as I argued in Chapter 6, one significant explanandum for the ontology of multiple artworks initiated through a prescription is the extent to which a work's strict p-instances can vary in their artistically

salient properties. But if, as I have argued, the norms manifest in such variability have to be grounded in the actual performative practices of the relevant artistic community, they seem to come in 'after the fact' relative to the composer's creation of the musical composition.

Cray and Matheson might dispute this latter claim, however, on the grounds that it rests upon a failure to properly attend to the requirement, on the 'Systems Account' of ideas, that the tokens making up an idea are not only of the 'same type' measured in terms of their content but also 'appropriately related' to one another causally and historically. This requirement, as applied to musical compositions as ideas, functions in part to incorporate into 'sophisticated idealism' resources sufficient to accommodate what Levinson terms the 'fine individuation' of musical works. For Levinson, as we saw in Chapter 4, those properties of a musical work that depend upon the musico-historical context in which a composer was working are to be explained in terms of the composer's act of 'indicating' a given type of implicit structure in that context. As we noted above, Cray and Matheson find the notion of indicated structure 'metaphysically obscure'. They think that they can accomplish what Levinson was seeking without 'obscurity' by (a) building into their conception of musical compositions as *completed ideas for musical manifestation* a key role for the historically situated compositional activity of the composer, and (b) further stipulating that subsequent instances of a composition must be appropriately historically related to the initial token in the mind of the composer and, in virtue of this, inherit content from the initial token. But, Cray and Matheson might claim, given these resources that are implicit in the requirement that the tokens making up a system be 'appropriately related' historically and causally, couldn't the same resources be deployed to solve the problem of variability? For we might take the norms implicit in the practices of a historically situated *performative* community to be a further constraint operative in the 'appropriate relation' that must hold between a composer's originary tokening of a musical idea and subsequent putative instantiations of that idea if the latter are to count as genuine tokens of the composition. (In Chapter 9 we shall consider a similar modification of Levinson's 'indicated structure' account to address the problem of variability.)

One issue with this proposal is that it is not clear how making an art-practical context a constraint on the relationship between tokenings of the composition qua idea will also impose such constraints on the correct *manifestations* of that idea, as is required for a solution to the problem of variability. But we might also wonder whether the resulting 'sophisticated idealist' account would itself evade charges of metaphysical obscurity if the elements that the compositional 'systems' comprise are taken to be 'ideas'. Sophisticated idealism so modified seems to incorporate all of the elements required in an account of multiple artworks, given our explananda, but to also postulate 'ideas' as the entities that bring these elements together. In the modified sophisticated idealist model, we have various elements in place—a

creative act by a composer that is located in a specific musico-historical context and a given performative-historical context, and that stands in relationships to 'manifestations' of the work in virtue of contextualized actions on the part of the relevant parties. But, while the sharing of content between the manifestations and the originating impulse supports the use of the term 'idea' in characterizing the sophisticated idealist composition, the roles played within the system by concrete actions, practices, and contexts make these 'ideas' idiosyncratic at best. It is tempting to respond to 'ideas' so conceived in the way that Dodd responded to the elements built into Levinson's 'indicated structures': the temporality built into these 'ideas' seems more fitting to an action or process than to an entity. In the following chapter, I shall suggest that, while Dodd's intention was dismissive, we should explore precisely this idea as the best way of describing something that combines the elements we have been exploring.

Prior to that, however, I want to note another difficulty with the sophisticated idealist account that suggests it can only contribute to our understanding of artistic practices if it is an element in a more comprehensive account. It identifies something that is possible in a narrow range of cases, but this itself is something that needs to be explained in broader terms. I take it to be crucial to the *idealist* status of sophisticated idealism that (a) it preserves the simple idealist tenet that musical compositions exist primarily in the minds of composers and of others who mentally entertain an idea with the same content that stands in the right kind of historical and causal relation to the composer's idea, and that (b) it also preserves the idea that compositions are only contingently externalized. The claim is that, given the systems account, sophisticated idealism can uphold these tenets without incurring the consequences that make simple idealism untenable. But, they acknowledge, this raises an obvious question: 'What should we say about contents too complex to hold the entirety of them in our minds at once?' (Cray and Matheson 2017, 707). How can such works have purely mental tokens? They respond as follows: 'We think that we can have mental states with very complex contents without being able to simultaneously attend to every aspect of those contents, just as we can see physical objects without simultaneously seeing every part of those objects' (2017, n. 10).

But this seems to conflate two distinct questions the critic might be asking. Cray and Matheson take the critic to be concerned about our inability to focus at the same time on all of the elements that make up a complex manifold. If this is indeed the worry, their response is appropriate. Suppose, for example, that I claim to know Coleridge's *Kubla Khan* by heart, and thus to have the complete poem as the content of a mental representation in my mind. This means that I can run through the entire poem, either silently or out loud. What I can't do is attend to the whole poem at any one time, but that is an issue about selective focus, not about my lacking a mental representation of the poem. However, the critic's worry might be a different one. The concern might be that, in the case of some complex musical or

literary manifolds, we lack the ability to internalize all parts of the manifold *without some external aid*. For example, when Dickens wrote *Bleak House*, it is very implausible to think that, when he arrived at a 'completed' version of the novel, that version existed in its entirety as a mental token. The problem is not that he would not be able to focus on all of the elements at once, but that the elements would not exist as an idea in his mind that could be a subject of selective focus. Rather, the process of composition in such a case surely relied essentially on a process of externalization, and it is by working with and revising such externalized fragments of text that the process of composition works itself out. This suggests that, were the sophisticated idealist to propose an account of *literary* compositions paralleling the proposed account of musical compositions, it could reasonably be objected that such an account of literature could apply only to simpler works (like *Kubla Khan*, if we believe Coleridge's account of the process of composition) that *are* capable of existing in toto as mental representations. More complex works in the same art form, however, cannot be so entertained, or at least are not plausibly thought of as being so entertained by authors engaged in the compositional process (maybe they could be so entertained by an idiot savant, once composed).

A related objection seems possible to the sophisticated idealist account of *musical* compositions—this is the point the aforementioned objector *should* have been making. The capacity required by the sophisticated idealist account of musical compositions—the capacity to entertain the entire composition as a mental token at the conclusion of the compositional process—seems to be one that individual composers may possess to different degrees. Even if we credit Mozart with the ability to retain in his mind the entirety of the improvisation that we now know as the 'musical gift', it would surely be unreasonable to deny the status of composer to other less talented individuals who lack the ability to generate and preserve a musical structure 'entirely in the head' and who have to rely on material registrations of the different parts of that structure. Nor would it seem reasonable to deny what they produce the status of 'musical composition'. Indeed, it is unlikely that even Mozart could perform this feat for a complicated orchestral piece, and even if he could, this would not explain how less talented individuals could be the composers of actual works, rather than the originators of what would have been compositions if they had originated in the mind of Mozart. So, it might be claimed, sophisticated idealism cannot be an adequate account of musical composition in general.

Cray and Matheson restrict the scope of sophisticated idealism to musical composition, with a gesture towards a similar view of literature. But it should be clear from the foregoing reflections that it will provide no illumination of those art forms where the creative ideas of the artist can initiate a work only through prolonged engagement with a recalcitrant material medium of some sort. While a painter or film director may indeed have an idea for pictorial or cinematic manifestation, and that idea may be operative in the development of the work, the

idea is at best an essential element in the generation of a work and not something that could play the central role in our artistic interest in the art form that musical compositions might be thought to play in classical music. As we just saw, even a literary composition, perhaps the most favourable case for extending the scope of sophisticated idealism, will only contingently be initiated or preserved through an idea in the mind of the author. Perhaps we may believe that the entire text of an extended *Kubla Khan* existed in Coleridge's head when he awoke from his 'dream' and that the 'fragment' we have was simply transcribed until the ill-timed arrival of the person from Porlock. But authors more generally work in the way that I am working now, with material embodiments of their thoughts to which they return many times to make minor or major adjustments. A 'system' of historically related tokens sharing content is initiated only when this process of manipulation of exteriorized texts is completed.

9
Multiple Artworks as Wollheimian Types

9.1 Introduction

Our inquiries in the last couple of chapters have made increasingly apparent the significance and the implications of our clarification, in Chapter 1, of the nature of artwork multiplicity. I argued that an artwork is multiple in the sense of interest to ontologists of art *not* in virtue of allowing for a multiplicity of strict *e-instances* capable of playing the experiential role in its appreciation—not in virtue of being e-multiple—but in virtue of allowing for a multiplicity of strict *p-instances*—in being p-multiple—in virtue of its manner of initiation. While there are perhaps some works that are e-singular, the class of e-multiple artworks arguably includes many works, such as paintings, that have been taken in the literature to be paradigms of singularity. In defining the relevant notion of multiplicity in terms of the possibility that a work has a plurality of strict p-instances, we followed the lead of Wollheim. We also followed his lead, and that of other more recent writers, in holding that what makes it possible, in the case of some kinds of artworks, for there to be a plurality of strict p-instances of those works is the manner in which such works are 'initiated', brought into existence as objects of possible appreciation. When works are initiated by means of a certified exemplar, a production artefact, or a set of instructions for performers, this thereby establishes the means whereby a multiplicity of strict instances standing in the right kind of historical-intentional relation to this act of initiation can be generated.

As I suggested in Chapter 7, if we understand what it is for something to be a multiple artwork in these terms, there is a sense in which the repeatability of such works requires no further philosophical explanation: they are repeatable precisely in virtue of what makes them multiple in the first place—there being established and intended means for generating multiple strict p-instances of the work in virtue of how it has been initiated. The salient question, then, is to explain how something so generated *qualifies* as a *strict* p-instance, and how in many cases entities that so qualify can vary in those of their properties that bear upon the proper appreciation of the initiated work. According to the Platonist, to answer these questions we need to understand the work itself as something that stands apart from our actual artistic practices and provides norms to which they are accountable—this is the role that Dodd accords to norm-types. But, as I argued in

Chapter 6, the norms operative in determining which acts of generation produce p-instances, and which produce strict p-instances, of a multiple artwork cannot be divorced from the actual practices of the artistic community in which the work is initiated. Even if, as some post-structuralist theorists have suggested, we deny that artworks are anchored in this way in the art-historical context of their initiation, we will still need to appeal to the norms embedded in the actual practices of some other artistic community—perhaps the norms embedded in the interpretive practices of a critic's own community. Thus the Platonist idea of a multiple artwork as an abstract entity standing outside of our actual practices cannot speak to some of the principal questions that we need to answer, once we conceive multiple artworks in the terms described above. And, as I argued at the end of Chapter 6, neither is there an explanatory role for multiple works as abstracta in the case of those multiple art forms that do not face the problem of variability—most obviously literature and cinema. For both the status of certain things as strict p-instances of such works and the reasons why they are not subject to the variability of other multiples are explicable in terms of the same kinds of norms embedded in artistic practices that apply where variability is an issue.

But, as we saw in the last chapter, locating multiple artworks in our practices themselves, rather than positing them as things that transcend those practices, is itself no simple matter. On the one hand, attempts to identify the work with its instances taken collectively generate problems in accommodating some of our central explananda. On the other hand, attempts to provide the work with a broader materialistic grounding strain our sense that we are talking about works at all in any sense that would provide succour to the realist about multiples. Nor, as we have just seen, does transposing our analysis into an idealist key serve us any better. At this point, a non-realist account of multiples—some kind of eliminativism or fictionalism, for example—begins to look more attractive, something that we shall consider in the next chapter. Before that, however, I want to canvass an alternative approach, one that has its roots in the Wollheimian reflections in which our present inquiries had their beginning in Chapter 2, and that is already implicit in the discussion of the problem of variability in Chapter 6. A merit of the approach to be developed in the rest of this chapter is that, as we shall see, it speaks to and can accommodate all of the weighted explananda in those respects that were endorsed in Chapter 7. A possible demerit, however, is that one might wonder, as we wondered about some of the materialistic accounts canvassed in the last chapter, whether this approach can pass realist muster. This will be a further issue to be addressed in the next chapter.

9.2 The Nature of Wollheimian Types

I have thus far left unchallenged Dodd's construal of (norm-)types as abstract objects that are individuated in terms of those features required in (well-formed)

tokens of the type. As we have seen, Dodd argues that, if musical works are types so construed—we may speak here of 'D-types'—then they must be discovered rather than created by their composers. A similar conclusion will follow for other kinds of multiple works if they are D-types having the properties outlined in Chapter 2. As we also saw in Chapter 2, Dodd's account of musical works as norm-types is indebted to Wolterstorff's idea that multiples are norm-kinds, but is intended to correct what Dodd takes to be some mistaken conceptions on Wolterstorff's part as to the existence and individuation conditions of such entities. Wolterstorff's own account of multiples as norm-kinds, in turn, is intended as a corrective to Wollheim's claim, in *Art and its Objects*, that multiple artworks are simple types that share properties with their tokens. We looked at this claim in Chapter 2 in developing the idea that multiple artworks are to be distinguished from singular artworks by reference to whether their modes of initiation allow, or do not allow, for p-multiplicity.

But, we may now note, Dodd's conception of types, of which genus norm-types are a species, seems to contrast strikingly with Wollheim's own conception. What is noteworthy in the present context is Wollheim's claim, cited in Chapter 2, that what distinguishes types from other kinds of generic entities is that they are usually postulated when we wish to correlate a group of particulars with a piece of human invention. This suggests that 'Wollheimian types', as we may call them, are very different kinds of beasts from D-types. Indeed, I shall argue, multiple artworks construed as Wollheimian types, unlike multiples construed as D-types, can have exactly the kinds of properties that were argued, in Chapter 7, to be the salient explananda for an ontology of multiples.

Wollheim (1980, 34–5) introduces the idea of multiple artworks as types in addressing what he terms the 'logical' question, 'Are works of art physical *objects*?' This asks about the logical category to which works of art belong, and thus the kind of criteria of identity and individuation applicable to them. To answer the logical question positively is to say that works are particulars, rather than being non-particulars such as universals, or classes, and are therefore to be identified and individuated in the way that particulars are. Wollheim contrasts the logical question with the 'metaphysical' question, 'Are works of art *physical* objects?' Here we assume that artworks are particulars, and ask what kinds of particulars they are. Alternative answers to the metaphysical question might be that works are indeed physical objects, or that they are non-physical particulars standing in some kind of relation to physical objects. As we have seen, Wollheim considers two theories of the latter sort: artworks might be 'Ideal' objects, existing in the minds of artists or receivers and only contingently externalized in physical objects, or they might be 'presentational' objects, purely phenomenal entities comprising sets of sensible properties which are contingently realized in physical objects.

Wollheim introduces the idea of multiple artworks as types as one possible negative answer to the logical question. This seems to carry with it the assumption

that such works are not objects or particulars of any kind, and thus not abstract objects or particulars of any kind. Indeed, it is notable that, in his discussion of multiple artworks as types, Wollheim nowhere mentions abstracta. This isn't to say that types might not be abstract *entities*, but it is to say that this is not relevant to answering the logical question as Wollheim conceives it. Rather, as noted in Chapter 2, he classifies types alongside classes and universals as kinds of *generic* entities. The latter are ways of grouping elements that in some sense 'fall under them', and they differ in *how* they group the elements falling under them and in the logical relationships in which they stand to these elements. Classes, for Wollheim, are simply constructs out of the particulars that are their members. Universals are more intimately related to their instances, being present in them. Types, however, are even more intimately related to their tokens. They not only are present in them but are treated much of the time as if they enjoy equal status with them. According to Wollheim, this is to be explained in terms of the way in which properties are transmitted between types and their tokens. He holds that we can rightly predicate of a type all those properties—other than those only possible in particulars—that a token must have in order to be a token of that type. Thus, for example, the Red Flag is rightly taken to be red because all tokens of the Red Flag must be red. Although we treat types like their tokens in this way, Wollheim does not take this as indicating that types are *themselves* particulars of some kind standing apart from their tokens in the way that works stand apart from their physical manifestations on the 'Ideal' and 'Presentational' theories. What positively distinguishes types from classes and universals, he claims, is that we characteristically postulate a type 'where we can correlate a class of particulars with a piece of human invention; these particulars may then be regarded as tokens of a certain type' (Wollheim 1980, 78).

This claim, Wollheim stresses, is an answer to an 'entirely conceptual [question] about the structure of our language'. (Compare this with the Peircean 'semantic' notions of 'type' and 'token' discussed by Rohrbaugh, as cited in Chapter 6.) Furthermore, crucially, questions about the identity of types, and about their individuation, are essentially questions about the generative relationships in which particular groupings of tokens stand to such pieces of human invention. Wollheim speaks of the problem of 'how the type is identified or (which is much the same thing) how the tokens of a given type are generated' (1980, 79), and of 'the variety of ways in which the different types can be identified, or (to put it another way) in which the tokens can be generated from the initial piece of invention' (1980, 80). Types so construed differ in the ways in which they can be initiated. Again, as we saw in Chapter 2, it is Wollheim who first distinguishes between the different ways in which a multiple artwork or more generally a multiple artefact can be initiated such that a plurality of strict p-instances is possible.

Tokens of a Wollheimian type, therefore, are grouped not in terms of shared manifest properties per se, but in terms of a shared relational property—their

having the manifest properties that they do in virtue of a causal history that relates them to a particular act of human invention. This accords with what we have already seen regarding the role that a particular causal history plays in grouping certain entities as p-instances of a multiple artwork. The multiple nature of works of photography, film, and cast sculpture, for example, is explicable in terms of this shared causal history. To be a p-instance of such a multiple work W is just to have a causal history C involving the work's production artefact in a way sanctioned within the relevant practice. To be a strict p-instance of W is just to have certain specific manifest properties in virtue of C. The precise nature of those properties—the ones required in order to fully qualify to play the experiential role in the appreciation of a work—is, as we saw in Chapter 6, determined by the norms operative in a given artistic practice. Screenings of *Citizen Kane*, for example, are the end products of a particular process of making mediated by a particular production artefact, and a properly formed screening has certain specific manifest properties, qua visual-acoustic sequence, in virtue of that causal history. All such screenings, proper or flawed, are thereby p-instances of *Citizen Kane*. What is required in a correct screening, in turn, depends upon norms embedded in the relevant artistic practices. Similar analyses can be given in the case of multiple artworks initiated either by means of a certified exemplar or by means of prescriptions for performances.

While Wollheim offers a logical account of types, and of works as types, that ties their identity and individuation to the different ways in which we group particulars, this is not to embrace a simple nominalism about types of the sort criticized by Dodd (2007, 38–41). Wollheim's claim is not that statements that use type-expressions are 'translatable' into statements about those particulars that are tokens of the type—the view criticized by Dodd. Rather, for Wollheim, to postulate a type is to postulate a particular kind of *principled way of grouping* particulars that relates them to an act of human invention taking place within a practice, and that provides both a locus for predication and a focus for appreciation. This enables us to clarify the 'of' locution whereby we describe the relation that obtains between a multiple work and its p-instances. Claims such as 'this is a screening *of Citizen Kane*' are to be compared with other locutions describing how we group particulars by reference to the causal-intentional relations in which they stand to acts of human invention. Consider, for example, the locution 'copy of this Sunday's *Observer*'. What I am reading is correctly so described because it has certain textual properties as a result of being produced by a causal process using a production artefact that is itself the result of a collective act of human creation. Those things correctly described as copies of this Sunday's *Observer* are grouped under this label not merely in virtue of their manifest properties but also in terms of the histories of making whereby they came to have those properties.[1]

[1] Note that if I were to photocopy my copy of this Sunday's *Observer*, the result would be properly described as a copy of a copy of the newspaper, not a copy of the newspaper.

It might seem, however, that we have simply postponed the ontological question about multiple artworks. If *Citizen Kane*, as a Wollheimian type, is indeed something postulated in respect of the way in which we group particular screenings by reference to their standing in a causal-intentional relation to a particular piece of human invention, what kind of thing is it, ontologically speaking, that we postulate? It is here that we see the temptation to reify types through the kind of analysis furnished by Dodd. Wollheimian types, it might seem, must be entities that somehow stand apart from their tokens, and that explain *why* those tokens are rightly grouped together. It is instructive, here, to review how Wollheim's logical conception of types mutated into the ontological conceptions offered by Wolterstorff and Dodd. As we saw in Chapter 2, Wolterstorff introduces norm-kinds, as a corrective to Wollheim's talk of 'types', by analogy with natural kinds such as 'The Polar Bear'. Natural kinds, he assumes, are associated with a set of manifest properties possessed by well-formed, but not necessarily all, members of the kind. This funds the idea that it is through possessing certain properties, rather than through standing in a particular causal-intentional relation to a piece of invention, that something qualifies as a token of a norm-type that is a work. This then further funds Dodd's idea that musical works, as norm-types, are individuated in terms of property-associates that specify the manifest properties required in well-formed tokens. This allows Dodd to defend the 'timbral sonicist' view that musical works are individuated solely in terms of how their well-formed instances sound. This divorces status as a well-formed instance—a strict instance, in our terminology—from provenance (Dodd 2007, 2).

A preliminary Wollheimian response to Dodd would be that, if we postulate types when we group things relative to a piece of human invention, then D-types whose property-associates specify only the *manifest* properties required in well-formed tokens cannot explain the groupings we make precisely because such D-types prescind from provenance. In the kinds of examples offered by Levinson in support of the fine individuation of musical works, for example, performances of the musical doppelgängers will be grouped together by Dodd as instances of the same D-type in spite of the fact that they originate in distinct pieces of human invention. It might then seem attractive to say that what we are postulating when we speak of *Citizen Kane* as a Wollheimian type is a not a pure D-type as proposed by Dodd but a Levinsonian initiated type whose property-associate incorporates not only intrinsic but also relational properties of its correct tokens, such as having manifest features X in virtue of standing in relation R to a given act of human 'invention' A.[2] Such a view might seem attractive because (1) unlike Dodd's ontological account of musical works, it integrates the role of

[2] However, as may be apparent, and as we shall see in the following paragraphs, this characterization of a Levinsonian type as what is postulated in the case of a Wollheimian type is inaccurate or unclear in two crucial respects: (1) as was argued in Chapter 6, the 'manifest features X' required in (strict)

human invention into its conception of the multiple artwork, while (2) it also speaks, like Dodd's account, to deeper motivations for including D-types in an account of multiple artworks.

These motivations are apparent in Levinson's distinction between 'implicit' and 'initiated' types. Implicit types, as we saw in Chapter 3, are D-types that pre-exist their 'discovery' and exist through belonging to—being implicit in—a certain framework of possibilities. In chess, for example, all possible sequential combinations of legal moves exist as implicit types given the rules of the game. When a player tries to discover the best way to continue from a given game situation, this way of continuing is open to discovery by multiple players on multiple occasions. Here it seems right to say that particular games or particular sequences of moves exist prior to their discovery, and to treat each such discovery as a tokening of a pre-existing type. Levinson takes given combinations of sound sequences and instruments used to produce those sound sequences to be implicit types in this sense. Thus a composer discovers rather than invents one such combination. But, as noted earlier, Levinson maintains that the work itself is not the implicit type but, rather, an initiated type—the implicit type as 'indicated' by an individual at a time, or as 'indicated' in a given musico-historical context. Thus two composers who discover the same implicit type in different musico-historical contexts bring into existence works that have different properties consequent upon that difference in context, and thus different works. Musical works, then, as initiated types, 'begin to exist only when they are initiated by an intentional human act of some kind' (Levinson 1980, 81).

Levinson, like Wollheim, wants to accommodate the creatability and fine individuation of multiple musical artworks by tying their identity and existence-conditions to particular historically situated human actions.[3] But, by taking musical works to be initiated types that incorporate acts of discovering implicit types, Levinson lays himself open to the objection, noted in Chapter 3, that an initiated type whose existence is tied to the existence of its property-associate is no more creatable than an implicit type. And, by incorporating the historical details of particular situated actions into initiated types he also courts the charge of metaphysical obscurity that critics such as Dodd, and Cray and Matheson, are quick to bring. Assuming that both implicit and initiated types are D-types, it is difficult to see how Levinson can counter these charges without giving up on the idea of indicated structures as *types*—an option he entertains in a 2012 paper that I discuss below. But, we might ask, why does an account whose primary

instances of a work are partly determined by actual performative and interpretive practice; and (2) the 'given act' A will not be one of human invention, but one of human *creative discovery* of an implicit type.
 [3] For Wollheim's commitment to 'fine individuation', see his 'Criticism as Retrieval' in his 1980.

explanatory targets are creatability, fine individuation, and instrumental means need to traffic in D-types at all, whether implicit or initiated?

Consider first Levinson's commitment to implicit types. As we have seen, this seems to be funded by the analogy between musical composition and playing chess. The idea is that the sound/performance means structures distinctive of musical works are discovered rather than created by their composers, just in the way that combinations of chess moves are discovered by players. In problematizing this analogy, however, we might contrast the essentially inventive nature of the process whereby artists initiate both singular and multiple artworks with the creative activities of chess players. To think of writers and composers as discovering pre-existing structures implicit in a framework fails to take account of the ways in which artists themselves are often responsible, through their creative activities, for establishing the very framework of possibilities that their works explore. This is most obvious in literature in the works of writers like Joyce (*Finnegans Wake*), Burgess (*A Clockwork Orange*), and Hoban (*Riddley Walker*) who invented substantial parts of the very language in which their works were written. But the possibility for such invention is always present in artistic activity, even for artists who work within the kinds of constraints characteristic of classical French drama, for example. In some arts, as in painting, the framework of possibilities can be altered by seizing upon new technological resources—for example, in painting, the possibilities for 'staining' canvases made available with the development of acrylics. The artist's ability to exhibit what Kirk Varnedoe (1989) termed a 'fine disregard' for the existing conventions within an art form and still produce something that belongs to that art form undermines the idea of artists as discoverers of what is pre-existent in a general framework of possibilities.[4] But this is precisely what is not open to the chess player. However creative a given player's performance in a game of chess may be, the field of possible games will be unchanged—all that the creative chess player can do is reveal to later players one of the hitherto undiscovered strategies implicit in the rules of the game.

If we eschew implicit types in our account of what goes on in acts of musical composition, we remove what I take to have been at least one of Levinson's reasons for describing the works that result from such compositional acts as initiated *types*, although another reason might have been the assumption, critically addressed in earlier chapters, that only a D-type can have performances as instances. But the comparison sometimes drawn between classical musical composition and mathematical reasoning may make the reader reluctant to give up the

[4] Varnedoe takes such a 'fine disregard' to be a mark of modernism, although it surely also applies to much premodern art. Even if there are cultures of artistic production that are usefully thought of on the 'chess' analogy—perhaps French neoclassical drama—they cannot furnish a general model for thinking about how artworks are initiated. Varnedoe quotes the term 'a fine disregard' from the memorial to William Webb Ellis at Rugby school. Ellis's own 'fine disregard' was of the rules of football, when he picked up the ball and ran with it, thereby inventing rugby football.

'chess' analogy for musical composition, even if its applicability to other art forms is moot. I shall now suggest, however, that even if we retain the idea of composition as the discovery of implicit types, there are compelling reasons to resist the idea that the resulting works are themselves D-types.

Given the general methodological principles governing our inquiry, suppose we ask whether we gain explanatory purchase on, or enhanced understanding of, multiple artworks by taking postulated Wollheimian types to be initiated Levinsonian types, types whose property-associate incorporates properties that relate a perceptual manifold to a piece of human discovery or invention: the property-associate will presumably have the form 'being correct if instantiating sound/performance means structure Z in virtue of standing in an appropriate historical relation to act of indication A'. We may grant that such D-types exist, since their corresponding property-associates exist, and, given suitable care in formulating the relevant property-associate, they will presumably comprise all and only the strict p-instances of a multiple artwork. But the need for care in formulating the relevant property-associate gives the game away. Unlike implicit D-types that exist independently of their possible tokens, that can thus be thought of as discovered by composers, and that can explain our grouping of certain things as strict instances of works if Dodd's proposed ontology is accepted, the types we are currently considering can only be characterized 'after the fact', as it were. This is because the things that are rightly grouped as p-instances, or as strict p-instances, of a multiple work—the tokens (or strict tokens) of the Wollheimian type—depend not merely upon what the artist does but also upon the relevant conventions in place in the artistic community that determine what must be done in order to generate an instance (or a strict instance) of a work—for example, how we must manipulate a production artefact if a p-instance (or a strict p-instance) of the work is to result. This is one of the lessons we drew from our reflections upon the problem of variability in Chapter 6. Thus initiated Levinsonian types cannot explain our groupings of things as tokens of a work, and do not add to our understanding of the picture already in place in the Wollheimian account. The problem is not the absence of the relevant type, but its failure to bear on the questions to which we seek answers in our attempts to understand multiple artworks.

Even though a standard Levinsonian account of performable works as indicated structures—entities whose constituents are both an implicit type and an arthistorical context in which that type is indicated—cannot account for the variability of such works, recent work that draws upon the Levinsonian model suggests how the latter might be modified to remedy this lacuna. In *Choreography Invisible,* Anna Pakes (2020) proposes an ontology of dance works modelled on Levinson's account of musical works as indicated structures. She claims that repeatable dance works are best understood as 'structures of action-types indicated by choreographers within a given historico-artistic context'

(2020, 181). In chapter 9, however, she asks how such a view can accommodate the 'variability' of dance works. As we have seen, Levinson's 'indicated structures' do not comprise the actual *performative* practices in a musical work's art-historical context of origin. But there seems to be no reason why we could not modify the Levinsonian account so as to include such practices in the context of indication. This is precisely what Pakes incorporates into her Levinsonian ontology of dance. Her claim is that, if there are performable dance works, they are structures of action types indicated in specific art-historical *and performance-practical* contexts. If we thereby build into the work the very norm-embodying practices that determine the range of variability of individual dance works, then we *do* seem to solve the problem of variability, and thereby overcome a major obstacle to any traditional type-theory of multiple artworks in the performing arts. If so, presumably we could modify Levinson's account of performable *musical* artworks in a parallel way.

As Pakes is aware, however, even such a fortified 'indicated structure' theory of dance works will face some of the problems raised by Dodd and others for Levinson's account of musical works. If indicated structures of action-types are themselves D-types, then, Dodd will insist, they must still exist eternally and be uncreatable, because their identity and existence conditions are determined by the property-associate defining the type, and all properties exist eternally if at all. As noted earlier, Levinson, in a more recent paper (2012, 56–7), considers giving up on the claim that indicated structures are themselves D-types. Citing Dodd's claim that types are eternal and uncreatable, he responds that 'that is precisely the opposite of what indicated structures and initiated types are supposed to be, and so insisting that they are types would undermine one of the main motivations for introducing them'. But his brief discussion of *what else* indicated structures might be if not types is puzzling. He rejects the idea that they are 'qua-objects' such as 'Obama-as-President' on the grounds that such things are 'too insubstantial, too aspectual' to be things we create in any robust sense by doing something to a pre-existing sound structure. His only positive suggestion is that indicated structures must be 'what Wollheim called generic entities, that is, things that can have instances'. But, as we know, it is standardly assumed that the only things that can be generic in this sense are precisely abstract entities such as types! Absent the proposed clarification of the Wollheimian notion of type earlier in this chapter, to say that indicated structures are not types but are Wollheimian generic entities seems self-contradictory. Furthermore, we need to understand how a structure-as-indicated-in-a-given-art-historical-context could indeed be a 'generic entity' capable of having instances falling under it. I suggest below how this might be understood if we identify the musical work not with an *indicated* structure but with an *indicating* of a structure.

A further worry with Pakes's proposal might be that the actual performative practices in place in a given dance-historical context are not the kinds of things

that could be partly constitutive of an abstract entity, which is what an indicated structure of action-types purports to be. But, it might be responded, Pakes's modified indicated structures are no *more* problematic metaphysically speaking than the Levinsonian originals. For the latter are partly constituted by 'the whole of musical development up to [the time of composition]' and 'musical activities of [the composer's] contemporaries' at that time. If we have no problem incorporating actual episodes in the history of art into the property-associates of our abstracta, we should presumably be equally untroubled by incorporating into them actual performative practices!

The modified version of the indicated structure theory just considered may remind us of the modified version of sophisticated idealism canvassed at the end of Chapter 8. In each case, the claim is that a proposed ontology of musical artworks can explain the variability of such works by building into its model as an additional element those aspects of our performance practices necessary to capture the norms that determine the range of variation in a work's strict p-instances. For the sophisticated idealist, these practices can be built into the historical and causal links that structure the elements making up the 'system' identified with the composition, qua completed idea for musical manifestation. For the indicated structure theorist, as we have just seen, the practices can complement the art-historical factors taken to be constitutive of the context in which a given implicit structure is indicated. I also suggested in Chapter 8 that a similar modification might be made to the materialist theories advanced by Rohrbaugh or by Caplan and Matheson. One response to these kinds of proposals, again canvassed at the end of the previous chapter, is to worry about whether the posited entities are metaphysically kosher. But a more salient question, I think, is whether the entities are metaphysically *necessary* once we have in place all of the elements that they comprise. Do the posited entities do any essential work that cannot be done by the very elements built into them?

Taking Pakes's proposal as an example, let us suppose that we are metaphysically unphased by the idea of a 'pure' structure of action-types that is selected by a choreographer who initiates a given dance work, where the selection takes place in a given dance-historical (DH) and dance-practical (DP) context. Why do we need to suppose that this results in (or realizes) a new existent—a structure-of-action-types-as-selected-in-DHContext1-and-DPContext2? What explanatory role does such an entity play that is not already covered by what we have in our account of what the choreographer has done and the context in which she has done it? What work does this posited entity do? The canonical answer, which frames the current discussion, is that we need this entity to be the thing of which performances can be classified as correct instances. The assumption is that if the correct instances are grouped as tokens, then we need a type—conceived as an abstractum—of which they are tokens. But why does any account of our practice of grouping certain performances together as being 'of-a-work' require a type so conceived? The range

of correct performances of a given dance work is not settled by reference to such a type, but issues from the ongoing interaction of the elements taken by Pakes to be constitutive of that type.

Here, I suggest, we should return to Wollheim's original suggestion that multiple artworks are only types in the logical sense of not being particulars but being things we posit when we want to correlate a group of particulars with a piece of human invention. What we posit in positing a dance work qua Wollheimian type is a contextualized *indicating* of a structure of action-types which leads to the grouping in question—something done by a choreographer involving a particular structure of action-types (if we follow Pakes on this)—and a given dance-historical and dance-practical context in which this is done. This explains everything that needs to be explained without also assuming some new abstract entity thereby brought into existence.[5]

How, then, if not in terms of independently existing abstracta, implicit or initiated, might we understand what is postulated when, in identifying a work, we postulate a Wollheimian type? The answer, generalizing from the dance example, is that we illuminate what is postulated by attending to the *precise combination* of human invention and an enabling practice that legitimates, and thereby explains, both the groupings of certain things as p-instances of a work and the identification of some of those things as strict p-instances. To postulate a work, qua Wollheimian type, is to postulate a piece of human invention, 'initiating' the work that is embedded in a set of practices that issue in the very groupings of tokens that we seek to understand. To appreciate such works as Wollheimian types is just to appreciate what was done in two senses—what manifest properties are possessed by right tokens having the relevant causal history, and what was done in establishing the preconditions (for example, the generation of a production artefact) for that causal history to take place. On such a view, the things that play the particular kind of logical role described by Wollheim might be viewed as forms of what I have elsewhere (D. Davies 2004) termed 'performances', contextualized actions.

It might be objected, however, that the proposed elucidation of Wollheimian types, whatever its independent merits as an ontological account of multiples, is *not* compatible with the earlier claims about what Wollheim was doing when he proposed that we think of multiple artworks as types. For, it will be recalled, types were presented by Wollheim as a *negative* response to the 'logical' question as to

[5] This also bears upon our understanding of dance work appreciation. The dance-historical context in which a choreographer works and the performative practices in place in that context bear upon the appreciation of the work she creates in virtue of their bearing on what the choreographer *did* in selecting a particular type of implicit structure: it is in virtue of what the composer was doing in selecting that implicit structure that such things have any bearing on the work. In other words, it is as features of an indicating of a structure that such features confer content on that structure. It is then correct performances of the dance work as certified by the performative norms that have certain properties in virtue of the fact that a given structure of action types was selected by the choreographer in a given dance-historical context.

whether multiple artworks are particulars. But, it might be argued, 'performances', as glossed above, while they are not objects, are surely particulars. They are not 'generic entities', whereas Wollheim's claim is that types, like classes and universals, *are* generic entities.

To respond to this concern, we need to recall that, when Wollheim draws his distinction between the 'logical' question and the 'metaphysical' question, he phrases the first question in terms of whether multiple artworks are *objects*, and then offers the idea that they are generic entities as an alternative to this. The problem with the idea that multiple artworks are objects is that this fails to explain the manner in which they are generic *in the sense that they can have other entities falling under them*. We noted in Chapter 1 that, while copies of a painting are treated as being 'extrinsic' to the work, instances of a multiple artwork are taken to be 'of' the work intrinsically. But Wollheimian types, as I am understanding them, *are* generic entities of a singular kind. While all 'generic entities' in Wollheim's sense are principled ways of grouping particulars, *types* group particulars in virtue of their standing in a particular kind of contextually mediated relation to a piece of human invention. And, as noted earlier, types are individuated, for Wollheim, precisely in terms of how that contextually mediated relation is to be understood. It is a particular kind of mediated relationship, embedded in a practice, between a piece of human invention and a class of particulars—the 'tokens' of a given type—that furnishes us, in such cases, with the principle of grouping definitive of a given work, qua generic entity. That this principle of grouping is realized in a contextualized performance, rather than in an abstract entity, does not call into question the generic nature of the work so understood. While objects are simply particulars that cannot have other entities 'falling under them' generically, certain kinds of contextualized actions which are in one sense particulars do function as principles for grouping other particulars and are therefore, when considered as so functioning, generic entities.

I have argued for the performance theory at length elsewhere, and obviously cannot repeat those arguments here. My present claim, defended below, is that multiple works, viewed as contextualized performances, can play precisely the role for which Wollheimian types are postulated, and can, unlike D-types, accommodate the repeatability, the variability, and the creatability of multiple works. But before defending this claim, the reader is entitled to at least a brief overview of what the performance theory says and why it might speak to our concerns, in the current context, with the nature of multiple artworks.

9.3 Artworks as Performances—a Brief Overview

It will be helpful here to recapitulate some terminology introduced at various places earlier in this book and to complement this with a few further helpful terms

and distinctions. Artworks, we might say, come into existence because something is done in a context where this doing counts as doing something else. For example, an individual applies oil paint to a canvas, and this counts as the production of a painting to which various representational, expressive, and formal properties can be ascribed by receivers. Suppose we term the first doing 'manipulating a vehicular medium', and the product of this activity 'the artistic vehicle'. And suppose we term the second doing 'articulating an artistic content', where 'artistic content' is a catch-all term for the broadly 'meaningful' properties that we ascribe to products of artistic activity in our critical engagement with those products. These properties include being a kind of representation, having a particular expressive value, and making manifest some formal property or property of the vehicular medium, plus all of the higher order meanings that we ascribe to the vehicle in virtue of these basic meanings. Manipulating a vehicular medium counts as the articulation of an *artistic* content because the context in which the former doing takes place, or the context in which the product of the former doing is received, provides interpretive norms or shared understandings that license so taking it. We can term these shared understandings an 'artistic medium'. Then the product of an artistic act of making for the purposes of appreciation—what we may term the 'focus of appreciation'—is an artistic content articulated by an artistic vehicle in virtue of an artistic medium.

As we saw in Chapter 4, a number of philosophers have argued, against empiricist views of artistic appreciation such as Dodd's, that we can properly grasp a work's focus of appreciation only if we locate the manifest product—the artistic vehicle—in the context of its history of making.[6] Indeed, this may be necessary even to identify the artistic vehicle—as is the case with much late modern visual art.[7] Suppose that this is right and that, as a result, we must reject the empiricist model of appreciation and replace it with some kind of contextualist model. Given the pragmatic constraint, which holds ontology of art accountable to our reflective critical and appreciative practice, what should we conclude about the nature of artworks?

The standard answer is some form of *ontological* contextualism. Ontological contextualists, as we have seen, view a work as the *contextualized product* of an act of artistic making, as a focus of appreciation the grasp of whose relevant properties requires knowledge of certain aspects of that act and whose identity, as a work, incorporates that history of making in some way. For the ontological contextualist, a work, qua focus of appreciation, is an artistic vehicle as generated in a particular art-historical context. Levinson, as we have seen, claims that musical works are not, as the common-sense view might maintain, pure sound (or sound and

[6] See, for example, Danto (1981), Levinson (1980); Dutton (1979), Currie (1989, ch. 2), and D. Davies (2004, chs. 2 and 3).

[7] See here D. Davies (2007).

instrumentation) structures but such structures as 'indicated' in such a context. And Arthur Danto proposes a contextualist theory of visual artworks in line with an assumed contextualist theory of literary works.

The performance theory, however, argues (D. Davies 2004) for an alternative and more radical response to the perceived demise of the empiricist view of appreciation. Recognizing the significance of the history of making of its artistic vehicle for the appreciation of an artwork, the performance theorist proposes that we identify artworks of all kinds not with the contextualized products of the generative activities of artists but with those generative activities themselves as completed by those products. According to the performance theory, an artwork is a particular generative performance consisting in the motivated manipulations of a vehicular medium whereby a particular focus of appreciation is specified. The work, for the performance theorist, is a particular contextualized event—the doing of certain things by one or more individuals in a given art-historical context. It is not a *type* of generative event that can in principle be multiply instantiated, as was suggested by Gregory Currie (1989) in chapter 3 of his *An Ontology of Art*. For Currie, an artwork is a type of event consisting in the discovery of a particular structure-type through the execution of a particular kind of strategy or 'heuristic'. As a type of event, the Curriean work itself admits at least in principle of multiple occurrences. The performance theorist, by contrast, maintains that we should treat works as historically situated individuals, as token events or 'doings'. While some works—musical and literary works, for example—admit of multiple *vehicles* whereby their artistic contents are articulated for our appreciation, the work itself is singular, like all particular actions that we perform.

If the performance theory is to be taken seriously as an alternative to ontological contextualism, two questions need to be addressed. First, what arguments can be given for preferring the performance theory to some form of contextualism? Given the pragmatic constraint that ties what is rightly said in the ontology of art reflectively to our artistic practices, why should we think of artworks as generative performances rather than as the products of such performances? Second, how exactly are we to understand the 'performances' with which the performance theory proposes to identify artworks? While the initially counterintuitive idea of artworks as performances might be made to sound more plausible by pointing out problems with ontological contextualism, the devil will surely be in the details. With what 'performances' could artworks plausibly be identified?

Let me briefly sketch some considerations that I have offered in support of the idea that artworks are generative performances rather than the contextualized products of those performances. Because of the intimate relations that exist between the properties of any product and the properties of the process whereby it was produced, it is difficult to come up with knock-down arguments in the contest between ontological contextualism and the performance theory. The argument for the latter must therefore be 'cumulative' in the sense that individual

considerations acquire more weight as it becomes clear how they fit into an overarching theoretical framework for thinking about artistic practice and our discourse about art.

The analysis of the 'fine structure' of the focus of appreciation is a crucial first step in developing this kind of argument. In arguing against empiricism, the epistemic contextualist points to the complex manner in which the different contentful elements in the focus of appreciation are related both to one another and to the context of agency in which the focus is specified. This undermines the familiar appeal, by empiricists, to a distinction between artistic properties and art-historical properties. But it also leads us to ask *which* features of the history of making of an artwork—which 'provenential properties' as we might call them—are 'artistically relevant' in the sense that they bear upon the proper appreciation of that work? Ontological contextualists who rely upon arguments for a contextualist epistemology certainly ascribe artistic relevance to those provenential properties that determine aspects of the work-focus—either the nature of the artistic vehicle or aspects of the artistic content articulated through that vehicle. We may describe such provenential properties as 'focus-determining'. For example, where the representational content of a painting depends in part upon features of the art-historical context in which it was painted, as with certain represented gestures in Renaissance paintings, those features will be 'focus-determining'.

But many of the provenential properties to which we refer in our critical and appreciative discourse about works do not in any obvious way play such a focus-determining role. Examples would include: overpainting visible only through X-ray technology; being generated through the use of devices such as the *camera obscura*; being prefigured in early drafts or sketches whose design elements are superseded in the finished vehicle; being a product of failed or unrealized semantic intentions on the part of the artist, or of experiments with the medium upon which an artist drew in her manipulations of that medium in a given work; and standing in relation to broadly biographical facts about how the artist acquired various skills, dispositions, or interests bearing upon those manipulations. The challenge for the ontological contextualist is to deal in a principled way with our interest in those aspects of an artist's generative performance just cited that usually leave no lasting mark on the resulting focus. For the performance theorist, on the other hand, such provenential properties are artistically relevant to the extent that they bear upon the appreciation of the generative artistic performance that is the artwork.

A related advantage of the performance theory is that, in distinguishing between the work, as performance, and its focus of appreciation, it allows us to reconcile two apparently inconsistent intuitions that we may have concerning the relevance of the artist's semantic intentions—her intentions as to the artistic content of her work—upon the work's proper appreciation. On the one hand, it seems to matter that an artist intended her work to articulate a particular content,

but, on the other hand, we may wish to resist the idea that merely intending that a work have a particular content can make this the case. It is the tension between these two intuitions about the significance of artistic semantic intentions that funds the long-standing dispute between 'actual intentionalists' and 'hypothetical intentionalists'.[8] The performance theorist can accommodate both of these intuitions by maintaining that artistic intentions about content do not generally determine the content actually articulated by a work's artistic vehicle, but are always relevant to the work's appreciation because they are among the things motivating those manipulations of the vehicular medium that constitute the work.

A further argument that complements the foregoing considerations provides an independent reason to question the adequacy of ontological contextualism. This argument appeals to structural features of our *modal* intuitions about artworks—that is, our intuitions as to how a given work might have been different from the way it actually is.[9] Contextualism has difficulty accounting for the fact that aspects of provenance bear upon our modal judgments with a *variable* force that reflects *our overall sense of what is to be appreciated* in a given work. In some cases—for example, in the case of Andy Warhol's *Brillo Boxes*—it is difficult to see how one could have the same work in a different art-historical context. In other cases—for example, the work of a 'naive' painter—we have no such reasons to modally constrain the work. Nor can this be explained purely in terms of the kind of *artistic content* that a work has if, as already suggested, non-focus-determining features of a work's provenance can bear upon its proper appreciation. In fact, it can be argued, our modal intuitions about works track our modal intuitions about the particular performances whereby focuses are specified. We ask, 'Could this have been *done* under those circumstances?', where 'this' refers not merely to the product of the artist's activity but to that activity itself, the doing qua performance. A natural way to account for this is to identify the work, about which we have such intuitions, with the specificatory performance in question. To do so is to endorse the performance theory.

The performance theory identifies artworks with performances generative of focuses of artistic appreciation. But, it might be asked, is there a principled way of picking out the generative performance, or 'doing', with which the performance theorist proposes to identify an artwork? After all, it may take a considerable time—even years in some cases—for an artist to execute a particular work. Surely we do not want to count everything that the artist does during that period of time as an element in the work. Even at those times when the artist is at work on a particular piece, surely many of the things she does—ordering a pizza, for

[8] See, for example, the papers collected in Iseminger (1992). For a sophisticated presentation of the case for a kind of actual intentionalism, see Livingston (2005).
[9] See the discussion in Chapter 7 of how this relates to Rohrbaugh's claims about the modal flexibility of artworks.

example, to sustain her during an all-night session on a painting—plays no role in the identity of the work. A natural proposal here might be as follows. An artwork, qua performance, is a sequence of motivated manipulations of a vehicular medium through which a particular focus of appreciation is specified. These motivations are to be characterized in terms of their articulatory goals and the cognitive and physical resources upon which they draw. The doing identified with a work W will comprise those motivated manipulations we take to be instrumental in the articulation of artistic content c through artistic vehicle v, and will incorporate both features of provenance that are directly focus-determining and manipulations that, while elements in the process generative of v, do not leave enduring marks thereupon. It will also incorporate those features of the social, cultural, and historical situation implicated in what we judge to be a perspicuous representation of those motivated manipulations. The 'motives' that are partly constitutive of the work, qua doing, are ones that pertain directly to the manipulation of the vehicular medium in order to articulate a particular artistic content. Other broader motives of the artist, and other actions she performs in the process of generating the work-focus, will not enter into the *identity* of the work, though they may well bear on how we explain or value what was done.

The proposal above is that we understand Wollheimian types as contextualized actions in something like this sense. A multiple artwork is a contextualized action initiated by one or more individuals that provides the necessary primary input into an established practice for producing multiple strict p-instances. The contextualization of the action includes both art-historical and practice-historical elements. The action provides such primary input by certifying an exemplar, manufacturing a production artefact, or prescribing certain things for performances, and by doing so in a context of established practices for producing p-instances, for determining something's status as a p-instance, and for determining status as a strict p-instance, of the work. In one sense this is simply an application of the performance theory to our current concerns. But in another sense, it is a further argument for thinking of at least some artworks—multiple artworks—as situated performances. For, as we shall now see, thinking of multiple artworks as Wollheimian types so construed seems to provide us with the best explanation of those weighted explananda that bear upon the viability of an ontology of multiples.

9.4 Multiple Artworks as Wollheimian Types and the Explananda for an Ontology of Multiples

That the theory of multiple artworks as Wollheimian types can address the problem of variability should not surprise us. For in effect the theory incorporates into the multiple artwork the very elements that were offered in Chapter 6 as the

means whereby the problem of variability can be answered. The range of acceptable variations in the artistic qualities of a given work's strict p-instances, it was argued, is determined by the norms realized in the actual artistic practices in the relevant artistic community in which the work was initiated. The work's identity as a work—tied to the distinctive artistic properties that bear upon its proper appreciation—is inseparable from the performance of an act of initiation in a given art-historical and art-practical context. In an important sense, it is not merely that practice constrains the ontology of multiple artworks (and indeed of singular artworks—consider the persistence conditions of paintings) by enabling us to clarify the nature of the specific roles played by the works whose ontological status we are trying to determine. It is also the case that such works are *creatures of practice*, owing their very existence as multiples, and not merely their specific appreciable properties, to the practices that confer those properties on them.

The proposed identification of multiple artworks with Wollheimian types can also accommodate the other salient explananda identified in Chapter 7, and can arguably do so better than any of the other ontological accounts that we have considered. Repeatability comes immediately for any theory of multiples, I have argued, if they are identified with works admitting of a plurality of strict p-instances in virtue of the means whereby they are initiated. Works as Wollheimian types wear this very fact on their sleeves. They are defined as actions of invention performed in a context which provides the means both to generate and to license such multiple strict p-instances. Dodd takes the challenge posed by repeatability to be to identify a kind of metaphysically respectable entity that is capable of having other things as its instances. If, as I have suggested, Wollheimian types would explain how multiples are repeatable in this way, the only remaining question is whether they are metaphysically respectable. This is a central question for the next chapter.

Unlike 'simple' perdurantism and Dodd's original version of the type-token theory, the Wollheimian theory has no problem accounting for the possibility of unexemplified multiples. The work's initiation sets up the *conditions* for multiple instances, and the work exists in virtue of the performance of such an initiating act in an artistic context that embodies in its actual practices the norms that would identify the strict p-instances of the work. Given that p-multiplicity is defined modally—in terms of the capacity to have multiple strict p-instances—multiple works, as Wollheimian types, exist as long as the conditions for generating multiple strict p-instances exist, and it is these conditions that are brought into existence by the initiating activity of the artist. But the existence of the work does not require that any p-instances, strict or otherwise, are actually generated.

The creatability of at least some multiple artworks, we have seen, is clearly an explanandum for an adequate theory of multiples. A theory that denied that multiples whose p-instances are produced by means of a production artefact are created would face a serious burden of proof, and we have also problematized the

'chess' analogy offered in support of a 'creative discovery' model of the initiation of multiple works in literature and the performing arts, both in its Doddian and in its Levinsonian varieties (where, in the latter, the work is identified not with the discovered 'implicit type' but with that type as so discovered—the initiated type). As we saw in Chapter 3, there are issues here about whether creatability (as opposed to creative discovery), were it to be a genuine desideratum for a theory of multiples, is achievable even for initiated structure theorists like Levinson. Rohrbaugh's endurantism can obviously allow for creatability, and so, as just illustrated, can the Wollheimian account. An individual can bring a multiple artwork into existence through performing an act of human invention in a context that provides the conditions for licensing a plurality of strict p-instances. This model applies whatever the manner of initiation of the multiple—it makes sense of multiplicity whether the manner of generating strict p-instances involves a certified exemplar, a production artefact, or a set of instructions.

In our discussion of Rohrbaugh's contention that all artworks, multiples included, are modally and temporally flexible, we concluded that whether artworks in general, or multiple artworks in particular, possess such properties seems to depend upon what is counted as a change in a work's intrinsic properties, and this in turn seems to depend upon the norms in place in the particular artistic communities in which works are produced and consumed. As Amie Thomasson has argued (2005), it seems very implausible to think that either metaphysics or indeed conceptual analysis can furnish us with a principled answer to questions about the persistence conditions of paintings. Even in comparatively standard cases such as the restoration of a painting, the operative norms seem to be ones that obtain in the relevant art-historical context. A metaphysician's insistence that what we are looking at can no longer be identified with Damien Hirst's *The Physical Impossibility of Death in the Mind of Someone Living* because the original tiger shark has suffered such deterioration that it has had to be replaced with another such beast would cut little ice in the face of the general acceptance of the work's continued existence in the artistic communities in question. The issue here, as I suggested earlier, concerns the non-artistic properties of the artistic vehicle that we take to play an essential role in the articulation of the work's artistic content.[10]

If, as Wollheimian types, multiple artworks are contextualized acts of initiation, then there is no problem meeting the Levinsonian requirement of fine individuation. Works, so construed, can clearly have properties bearing on their artistic value in virtue of various aspects of the contexts in which those acts of initiation are performed—this pertains both to 'achievement value' and to value that resides in properties the work is experienced as possessing when viewed in the context of its initiation. That works can have such values does not in itself follow from the

[10] For insightful and empirically rich discussion of the ways in which such matters are negotiated in our artistic practices, see Sherri Irvin's work on what she terms the 'artist's sanction' (Irvin 2005).

Wollheimian theory, but if it is a desideratum for a theory of multiples that it explain the contextualized nature of such works, the Wollheimian theory, unlike the Doddian account, can satisfy this desideratum.

In assessing Levinson's arguments in defence of instrumentalism concerning musical works, we concluded that, while, as Levinson granted, instrumentalist requirements seem to vary between musico-historical communities, it is a requirement in an ontological account of musical multiples that it allow for those communities in which instrumentalism is upheld. The Wollheimian account, unlike pure structuralism, meets this requirement without any difficulty. If instrumentalism depends upon the individuative practices of a given musical community, the Wollheimian account, which builds into our conception of the nature of a musical work (or more generally a multiple or even singular artwork) a reference to the norms of a given receptive artistic community, will explain why this is the case.

Finally, a performance-theoretical account of multiple artworks as Wollheimian types can avail itself of the strategy proposed at the beginning of Chapter 7 to explain how multiple artworks can be perceivable. It can be argued that, even if multiple artworks themselves are not perceivable in the sense that their instances are, 'perceivability' can be truly predicated of them *analogically*, and this arguably holds for all accounts of multiples, including continuant theorists. Whether works are constituted by their temporal stages or are somehow ontologically dependent upon their embodiments, it is their instances that are literally perceivable: what the work possesses is the analogically related property of being such that all of its instances are perceivable. Additionally, if it be argued (see Chapter 3 above) that analogical predication is a distinctive feature of types and their tokens, the Wollheimian theory—unlike other non-Platonist theories—can grant this point without prejudice; indeed, we will recall, it was with respect to Wollheimian types that Wollheim first advanced the idea of 'transmission' between types and their tokens, and it was this that led Wolterstorff to introduce the idea of analogical predication. Alternatively, the Wollheimian theorist can appeal to Predelli's account of the semantics of generic expressions (see Chapter 3).

10
Can Non-Platonists Be Realists about Multiple Artworks?

10.1 Introduction

In the last two chapters I have explored a number of accounts of the nature of multiple artworks that reject Platonism in its various forms but that seek to preserve a realist stance towards such works. Proponents of such accounts recognize the force of the widely accepted arguments sketched in Chapter 1 against any identification of multiple artworks with their instances taken individually or collectively, and also reject the identification of such works with abstracta that stand apart from those entities that instantiate a work or enter into our artistic practices. They propose instead that we identify multiple artworks with something that is either constituted by or dependent upon these entities construed as ordered in some way.

But some have questioned the ontological credentials of such 'constructions'. We have already encountered this kind of concern when we considered the plethora of materialities entering into the pluralistic reconception of the musical 'work' proposed by MusicExperiment21. In this chapter we shall examine three kinds of arguments that have been, or might be, offered in support of the claim that, if we reject Platonist accounts of multiple artworks understood in the way spelled out in Chapters 1 and 2, then we should also reject any kind of *realism* about such works. There is, it is claimed, no construction out of the physical elements entering into our practices in those art forms taken to be multiple that merits a place in our ontology. Given the argument of the last two chapters, a particular concern will be whether the account of multiple works as Wollheimian types elaborated in Chapter 9 is open to these kinds of objections. I shall focus upon the following three arguments while also addressing related arguments offered by other theorists:

1) In his book *Art and Art-Attempts* (2013), Christy Mag Uidhir has argued that, once we reject Platonism, what we standardly regard as separate instances of a single multiple artwork should instead be viewed as separate *singular works* that stand to one another in relations of 'relevant similarity'. Related arguments have been offered by Allan Hazlett and Caterina Moruzzi.

2) Andrew Kania (2012a) has claimed that any kind of non-Platonist realism concerning at least musical works is untenable, but that we should preserve our talk of multiple musical artworks in a spirit of useful pretence—we should, that is, adopt a fictionalist stance towards such talk.
3) Jody Azzouni has argued that fictionalist stances more generally may fail to satisfy what he terms an 'external discourse constraint' on the discourses in question, but that we can still treat such discourses as truth-apt even though there are none of the entities to which such discourses, taken at face value, would commit us.

10.2 Mag Uidhir, Hazlett, and Moruzzi: 'Multiples' as 'Relevantly Similar' Concreta

Christy Mag Uidhir (2013) maintains that, whatever one's more general views about Platonism, no *artworks* can be abstract entities. He argues for this conclusion on the basis of a more general claim about the conditions under which something can be an artwork. He begins with the generally accepted idea that artworks are substantively 'intention-dependent' in being the products of intentional agency on the parts of those to whom they are ascribed. He then maintains that, if we are to take seriously the intention-dependence of artworks, we must see them as the products of *art-attempts*. An art-attempt is an action that has success conditions that, if satisfied, entail the satisfaction of the conditions for being an artwork, whatever those may be. Intentions direct the relevant attempts of which something's being art is the product. Mag Uidhir takes it to be a corollary that, where we are concerned with some X that is a product of intentional action, the substantive intention-dependence of X's is to be captured in terms of X's being the result of X-attempts that can at least in principle result in *failed*-X's. Thus, if *artworks* are substantively intention-dependent products of intentional action, then any adequate theory of art must allow for failed-art, 'non-art things for which being non-art is non-trivially informative about those things – being the right sorts of things, and having the right sorts of history required to be art, only to be non-art by having failure where being art requires success' (Mag Uidhir 2013, 16).

Taking intention-dependence seriously, then, entails that the minimal structure for any theory of art must be as follows: '*w* is art iff *w* is the product of a successful X-attempt, where this requires that *w* is the product of an X-attempt and that w possesses X in the manner intended as the result of the x-attempt'. What 'X' is will depend upon the theory of art in question. If, for example, we take all and only those artefacts upon which their makers have conferred significant form to be artworks, then an X-attempt will be an attempt whose success conditions require that the product of one's action has significant form. This allows for both simple and complex kinds of *failed-art*. In the simple case, the attempt does not result in

something with X (significant form), and in the complex case it does so result but not in the manner intended.

Mag Uidhir then connects his 'minimal' analysis of arthood to a minimal account of what it is to be the author of a 'work', broadly construed to include both artistic and non-artistic artefacts, and of what it is to be an artist. The 'minimal' account of authorship, for 'works' broadly construed, takes this to be a three-part relationship: A is an author of a work w as an F iff A is directly responsible, at least in part, for the way in which w falls under the sortal F. I am in this sense an author of this string of words as a critical exposition of Mag Uidhir just in case I am directly responsible, at least in part, for these words meeting the requirements for being such a critical exposition. Being 'directly responsible', in this sense, requires that it is my intentions that direct the activities constitutive of the (I hope!) successful critical-exposition-attempt of which this string of words qua critical exposition is the result. This yields a minimal account of what it is to be an artist: an author of a work w as an F-work is an *artist* just in case w is an artwork in virtue of the way in which it is an F-work. (Mag Uidhir 2013, 84) It follows from the minimal account of arthood, then, that to be the artist of a particular work is to be 'the source of the intentions directing the actions constitutive of the successful art-attempt of which that particular artwork is the product'. The minimal account of arthood thus entails that an artwork, as the product of a successful art-attempt, must have an artist (2013, 45).

In chapter 4 of his book, Mag Uidhir brings this minimal conception of arthood to bear upon the distinction between 'singular' and 'multiple' art forms. He understands multiple artworks such as literary and musical works, films, and works of cast sculpture as 'repeatables' which are standardly taken to be 'types', abstract entities of some sort, rather than concreta. Mag Uidhir argues that it follows from taking the intention-dependence of art seriously that no artworks can be abstract entities. No abstractum can stand in the relation to an art-attempt required for arthood, since no one can be the author or artist directly responsible for an abstractum qualifying as an F, for some art-relevant sortal F. If a given abstractum indeed qualifies as such an F, the properties in virtue of which it does so cannot be credited to the activity of an artist, since, as Dodd argues and Mag Uidhir agrees, we cannot bring about or alter the properties of abstract entities: all we can do is *creatively discover* an abstractum that has such properties independently of our activities.

Given the conclusion of chapter 4 that 'if there are such things as artworks, then artworks must be concrete things', Mag Uidhir proposes in chapter 5 not that we should become anti-realists about 'repeatable' artworks but, rather, that we should adopt 'the more productive view of repeatability as tracking a relation between concreta, specifically that which I call *relevant similarity*' (2013, 164). Responding to the charge that 'placing a nominalist constraint on the ontology of art threatens the very foundations of the institutions, practices, and conventions surrounding

putatively repeatable art' (2013, 170), Mag Uidhir develops his 'relevant similarity' account of repeatability by taking printmaking practices as his model. What is ontologically distinctive of printmaking, he maintains, is that the different impressions drawn from a given matrix or template 'are themselves individual and distinct original artworks', each standardly identified by a label such as *Barcelona Day* 20/40. What this work shares with other works having the same name but a different numbering—e.g. *Barcelona Day* 29/40—is 'relevant similarity' understood as follows: 'Two prints are relevantly similar to one another just in case they share all constitutive appreciable print features in common in virtue of sharing a production history' (2013, 176). This maps onto Mag Uidhir's more general thesis about the substantive intention-dependence of artworks in that two prints are relevantly similar just in case they are products of the same successful print-attempt, each satisfying the conditions for being a print in the same manner. This gives us a sense in which a work can be repeatable not in virtue of being a multiply instantiable abstractum but in virtue of being 'a concrete, individual, and distinct artwork to which multiple other concrete, individual, and distinct artworks may be relevantly similar' (2013, 179).

Mag Uidhir then argues that this notion of repeatability—what he terms RS-Repeatability—captures the sense in which literary works are repeatable, and plausibly applies to other kinds of artworks traditionally viewed as multiple. Poems, for example, are properly viewed as individual inscriptions (or utterances?) identified, like individual prints, by a name and a number, that stand in a relevant similarity relation to other poems, themselves inscriptions identified by the same name but a different number. He argues that this proposal should be seen as plausible and intuitive, and as less revisionary than the 'instantiable abstractum' view that requires that we reconceive our ordinary talk of hearing musical works and reading novels.[1] He also argues that a claim such as 'I've read every novel written by Virginia Woolf' is properly ('non-trivially', as he puts it!) read as the claim that, for every unique successful novel-attempt by Virginia Woolf, I have read at least one of the novels that is the product of that attempt. Other claims that might seem false on the 'relevant similarity' view of repeatability are to be parsed in similar ways.

As may be apparent, Mag Uidhir's notion of 'relevant similarity' bears a strong structural resemblance to the notion, central to the account defended in the previous chapter, of a principled grouping of entities whose 'relevantly similar' appreciable properties obtain in virtue of the shared relationships in which they stand to an act of artistic initiation. The Wollheimian account differs from Mag

[1] I shall not comment here on Mag Uidhir's dismissal, as 'wholly inadequate', of the attempt by those who hold multiple works to be abstracta to explain our ability to hear or read works in terms of our relations to their concrete instances. But, given the widely voiced claim that this is just one instance of the broader linguistic phenomenon that Wolterstorff terms 'analogical predication', it would be helpful to have some explanation as to why appeal to the latter is 'wholly inadequate'.

Uidhir in stressing the crucial mediating role played by established practices in validating the range of instances, strict or otherwise. The more crucial difference, however, is that, on the Wollheimian account, 'relevant similarity' groups those things that are instances of a given multiple artwork, whereas on Mag Uidhir's account it links a multiplicity of different artworks with no single multiple artwork of which they are instances.

There are, I think, two related problems with Mag Uidhir's proposal. The first is a problem with the proposal itself: it is considerably more revisionary of basic features of our thought and practice concerning artworks than Mag Uidhir suggests. The second is a problem with the reasons offered in its support: it is not true that—as he claims—his proposed account in terms of *relevant similarity* is the *only* way (2013, 196) in which we can preserve the idea of repeatable artworks if artworks cannot be abstracta. Let me spell out each of these points in more detail.

Here are a few revisionary implications of Mag Uidhir's proposal.

First, consider the claim that 'I've seen every work by Feininger and read every work by Henry James'. If Mag Uidhir is right, the first claim is true at face value but the second requires parsing in the proposed manner as talk about at least one of the works that is a product of every successful novel-attempt by James. On Mag Uidhir's account, no one could ever read all of the works by any established author—indeed, as long as the work is still being printed, new works by the author are yet to come into existence.

Second, and relatedly, when he wrote *The Waste Land*, Eliot surely took himself to be successfully authoring one poem of which he hoped there would be many copies, not as authoring many distinct (albeit 'relevantly similar') poems.

Third, and more significant, we standardly assume that distinct works differ from one another in the properties that bear upon their proper appreciation. This is part of the point of the 'indistinguishable counterparts' cases offered by authors such as Danto, Levinson, and Currie, where it is differences in non-manifest or relational properties that explain why we indeed have distinct works. But Mag Uidhir's proposal commits us to a preponderance of cases—especially in literature—where we have an indefinitely large number of distinct works that share all of their constitutive appreciable properties. They are, it would seem, not merely 'relevantly similar' but 'relevantly identical' as *works* since they have all of their artistically relevant properties in common. Of course, it might be objected that, while a difference in appreciable properties between *W1* and *W2* is *sufficient* for their being distinct works (recall AC in Chapter 5), it is not *necessary*. But Mag Uidhir's claim that relevantly similar 'instances' in art forms other than printing are in fact *distinct works* rather than different instances of a common work seems motivated only by the needs of the RS account of repeatability.

Fourth, there is a related problem when we consider multiple artworks that exhibit variability in their p-instances. Here there is indeed a good case for

thinking that at least some of these instances—some interpretive performances—are rightly viewed as artworks in their own right (see chapter 7 of my *Philosophy of the Performing Arts*). But we also assume that the differences between these 'relevantly similar' performances illuminate the richness of something that is not itself a performance—namely what we would normally think of as 'the performed work'. Finally, Mag Uidhir's account seems incapable of accommodating the existence of unexemplified multiple artworks, since in such cases there are no entities capable of standing in the relationship of relevant similarity, and thus no works.

These problems reflect, I think, a deeper one, and this leads to my second observation. Consider the kinds of errors that can enter into the printing process, whereby, for example, my copy of *The Waste Land* may begin with the words 'April is the cruellest moth', while your copy begins with the words 'April is the cruellest month'. It would surely be unacceptable to accord these copies equal status as distinct works—distinct works with *different* artistically relevant properties—both of which are works by Eliot. Mag Uidhir, I assume, will protest that only *correct* copies stand in the required relation of relevant similarity, because only they have all of the constitutive appreciative properties of the 'relevantly similar' works in virtue of issuing from Eliot's successful poem-attempt. But what makes some copies correct and others flawed, given that poets may themselves make mistakes—corrected in the editing process—in their autographs? The 'abstractum' theorist appeals here to a type discovered by the author that allows us to distinguish between correct and incorrect tokens, but no such determining role can be accorded to an abstractum on Mag Uidhir's account. Rather, what presumably sorts correct from incorrect instances issuing from a successful art-attempt, for a nominalist, are the kinds of artistic practices in place to which we alluded in addressing the problem of variability in Chapter 6, practices that embody the norms that ground such distinctions. This is more obviously the case if we move from literary works to other kinds of multiple works and ask, for example, which performances stand in the relation of 'relevant similarity' to one another relative to a successful art-attempt by a composer, or which prints of a photograph stand in the relation of 'relevant similarity' relative to a successful art-attempt by a photographer. Mag Uidhir's answer, I take it, is again that this is determined by the 'constitutive appreciable features' of the work, but how are *they* determined?

Any adequate nominalist answer to this question must, I think, embed the norms that distinguish correct from incorrect instances, and instances, correct or incorrect, from non-instances, in artistic practice. (Indeed, as was argued in Chapter 6, this is a requirement for all ontologies of p-multiple works, and the failure to satisfy this requirement is a crucial failing in Platonist theories such as Dodd's.) But, once we ascribe these sorts of sorting roles to artistic practice, we seem to have a way of accounting for repeatability in nominalist terms that doesn't require multiplying works beyond necessity. Multiple works, I have argued,

should be thought of as Wollheimian types, ways in which things are grouped in relation to a piece of human invention in virtue of practices in place. For Wollheim, as we saw, we standardly posit a type when 'we can correlate a class of particulars with a piece of human invention'. In this respect they are no more ontologically mysterious than today's newspaper or even grade-A eggs. This allows us to retain the idea that each copy of a book, and each performance of a musical work, is an instance of a work that is multiply instantiable in virtue of the concrete practices that group individuals together. And, armed with the general considerations marshalled above against the idea of multiple distinct artworks sharing all of their constitutive appreciable properties, we might wonder whether even those cases that Mag Uidhir takes as his model—numbered impressions deriving from a single successful print-attempt—are really exemplars for clear thinking about multiple artworks, or might rather be artefacts of the kinds of economic interests motivating contemporary printmaking and print-collecting practice. But that is a matter for further discussion![2]

Allan Hazlett (2012) arrives at the same conclusion as Mag Uidhir—that we can explain the relevant features of our artistic practices without including repeatable artworks (in the standard sense of 'repeatable') in our ontology—but does so by a different route. Hazlett agrees with Rohrbaugh that multiple artworks are modally and temporally flexible, whereas abstract objects are inflexible, but, unlike Rohrbaugh, he takes this to fund 'the best argument against repeatable artworks: repeatable artworks are abstract objects, abstract objects have all their intrinsic properties essentially, but artworks don't have all their intrinsic properties essentially' (Hazlett 2012, 161). He draws a different conclusion to that of Rohrbaugh from the modal inflexibility of abstract objects because he also holds (1) that a repeatable artwork is repeatable in virtue of having—at least in principle—multiple 'instances', and (2) that 'no concrete object has instances.... Things with instances are unambiguously and determinately abstract' (2012, 163). In so claiming, Hazlett seems to be agreeing with Dodd (see Chapter 2 above) that something that can have instances must be an 'instantiable' in the metaphysical sense, where only abstracta can be instantiables. As we saw in Chapter 1, however, to understand the repeatability of multiple artworks in this way is to conflate those features of our artistic practice in respect of multiples that need an ontological explanation with the ontological explanation for which they call. Nothing in the relevant features of our practice bearing upon the distinction between singular and multiple artworks commits us to the idea that multiple artworks must be instantiables in the metaphysical sense. Our talk, in Chapter 1, of differences evident in our practice pertaining to works with multiple or singular 'instances' in need of explanation explicitly prescinded from such a metaphysical reading of 'instance'.

[2] For the beginnings of such discussion, see my 'Varying impressions' (D. Davies 2015).

Of interest to us here, however, is how Hazlett thinks that we can account for the relevant features of our artistic practice *without* committing ourselves to repeatable artworks. He begins (2012, 173) by conceding the possibility of a reductionist account of multiples whereby they are identified with some set of non-abstract objects. But he proposes instead that we accept one of two antirealist strategies in thinking about multiples, strategies he terms 'profligate' and 'austere' eliminativism. Profligate eliminativism is essentially Mag Uidhir's position: 'would-be instances of would-be repeatable artworks are each distinct works of art, united only by intrinsic similarity and a common origin' (2012, 173). Austere eliminativism, on the other hand takes would-be instances of would-be repeatable artworks to be 'copies of some original artwork'. The latter is capable of being copied but not of being repeated (2012, 174). Hazlett suggests that the antirealist might adopt different strategies for different kinds of artwork. Taking an 'austere' approach to literature, for example, might seem attractive. We can take a literary work to be the original token manuscript written by an author, and the things with which we normally engage in reading the work to be token copies of that manuscript. In the case of theatrical works, on the other hand, we might take a 'profligate' approach, taking each performance to be a distinct work of art and taking 'the play' to be a literary work, to be understood austerely. In the case of a performing art like music, Hazlett tentatively endorses an austere approach as long as we view copying as something that can involve both skill and creativity. How we should proceed in offering an eliminativist account of artworks belonging to particular artwork kinds will depend upon the relevant conventions operative in the art form in question.

Hazlett's approach is clearly preferable to that of Mag Uidhir in that it allows us to avoid a highly counter-intuitive profligate approach to literary works. But it is still counter-intuitive in many respects. If we identify a literary work with the original manuscript, then the work itself is lost if the manuscript is destroyed, and all we have left are 'copies'—this would make the existence and persistence properties of literary works analogous to those of paintings. And it is also not clear how musical works can exist unperformed on either the profligate or the austere approaches: on the profligate approach there are no works, and on the austere approach there is no 'original' to be copied. If, as Hazlett notes, there are reductivist realist approaches available that don't present these issues and that are otherwise tenable, they would better meet our explanatory needs. We therefore need to consider challenges to the tenability of such approaches before resigning ourselves to one of the two forms of eliminativism canvassed.

Caterina Moruzzi's 'Musical Stage Theory' (MST) proposes a view similar to Mag Uidhir's with respect to musical works, albeit on the basis of arguments that appeal to features of our musical practices rather than to the more abstract considerations that motivate Mag Uidhir. According to MST, 'the musical work is a single performance/stage which is connected by a privileged relationship to

other appropriate stages/performances' (Moruzzi 2018, 342). With explicit acknowledgement of Mag Uidhir's notion of 'relevant similarity' (2018, 350, n. 5), she describes this relationship—which she terms the 'Repeatability-relation' or 'R-relation'—as 'a privileged "horizontal" relation between different entities [which] explains what is commonly understood as repeatability, that is, as a "vertical" relation between a work-type and its exemplars'. It includes:

> 1) a causal relation which links the works-as-performances together and/or which connects the works-as-performances to the relevant act of composition,
>
> 2) the performers' intentions to play precisely that performance, and
>
> 3) a sufficient degree of similarity between the works-as-performances. (2018, 344)

She does not deny that our talk about musical works often seems to abstract from particular performances, but she maintains that such talk is to be understood as talk of what she terms the 'work-as-construct', talk which is actually about different performances related in the appropriate way:

> When someone says 'I enjoyed Chopin's Sonata in C minor yesterday night,' she refers to a performance-stage, that is, according to MST, to what strictly is the work. Yet, in other cases she adopts a 'timeless perspective' and asserts that 'Chopin's Sonata in C minor was performed many times in the late nineteenth century in Paris.' In this case, what is at issue is a talk directed toward a collection of R-related stages: suitable stages/performances of it took place in Paris. So, while in the first example the person refers to the work-as-performance, that is, strictly speaking, the work, in the second example she is referring to what one might call the work-as-construct. (2018, 345)

As Moruzzi is aware, the work-as-construct understood in this way is a perduring entity of the sort that, as we saw in Chapter 8, Caplan and Matheson identify with the musical work proper.

Moruzzi's Repeatability-relation incorporates many of those things that, for the Wollheimian type-theorist, are elements in the work, as contextualized performance. By denying that there is any 'real' work over and above the R-related stages, however, she, like Mag Uidhir and Hazlett, cannot allow for unperformed musical works, but she happily embraces this consequence of her view. Considering a hypothetical unperformed work, *Blue Carpet* composed by a composer named Bob, she writes:

> *Blue Carpet* according to MST, is not a work of music. It is, nevertheless, a 'would-be work.' In particular, many among those with an access to Bob's score would understand the shape 'it' (that is, a performance that follows that score)

would take. Although not a work, *Blue Carpet* bears all the characteristic features of something that provides the conditions for the existence of a particular work—that is, for the realization of a performance. (2018, 346)[3]

While this is admirably consistent, we saw in Chapter 7 that the onus in such cases is on the one who wishes to deny the existence of unperformed works. Moruzzi appeals here to the virtues of her account over those she takes to be its competitors—the type-token theory and musical perdurantism. The principal virtue of MST, which distinguishes it from all other accounts, is that 'by identifying works with performances, that is, with sound events uncontroversially accessible by the senses, MST accounts for the commonsensical commitment to the idea that we should be able to have direct epistemological grasp of musical works' (2018, 342). We can hear musical works because they are just performances, individual sonic events. As we have seen, alternative accounts might appeal to our ability to 'derivatively' or 'analogically' hear the work when we hear their performances, but for MST works are directly heard.[4] It is worth noting, however, that in the case of our talk of the audibility of Moruzzi's 'work-as-construct', we must first identify the latter with those performances linked by the 'Repeatability-relation' and then take those performances to themselves be directly perceivable. The crucial difference, of course, is that for the MST the 'work-as-construct' is not itself the work. But the need to gloss much of our talk of works in this way indicates that the MST will be highly revisionary of our ordinary talk. This is not in itself an insuperable problem, but it should lead us to favour a theory that does not have these consequences. Here, as with Mag Uidhir's and Hazlett's accounts, the Wollheimian-type account seems to preserve many of MST's assets without incurring its liabilities. As noted above, the Wollheimian-type theory accommodates in the work, as contextualized performance, all of those features of our musical practices upon which Moruzzi insists. But, in preserving the existence of the musical work independently of its performances, it avoids the counter-intuitive implications of the eliminativist position.

10.3 Kania: Fictionalism about Multiples

As noted in Chapter 8, Andrew Kania identifies three non-Platonist options in the ontology of music: materialism, eliminativism, and fictionalism. He further claims

[3] For a more comprehensive critical response to Moruzzi's treatment of unexemplified musical works, and to her defence of musical stage theory more generally, see Letts (2022). See also the earlier exchange in Letts (2020) and Moruzzi (2020). Letts (2022) provides very helpful background on the work in metaphysics upon which Moruzzi's 'musical stage theory' draws.

[4] On Predelli's 'generics' analysis of sentences that ascribe perceptible properties to multiple artworks, we are also predicating such properties of well-formed individual performances.

that both materialist and eliminativist accounts entail that there are no musical works of the kind assumed in our ordinary musical practices, since, for reasons to be examined below, he takes those practices to commit us to Platonism. The issue here, as he sees it, is whether it is better to adopt a nominalist materialism that identifies musical works with concreta or to deny that there are musical works. He takes the argument for eliminativism over materialism to be that 'it would do less violence to musical practice to deny the existence of musical works altogether than to identify them with the concreta the materialist believes them to be' (Kania 2012a, 210). He takes the dispute between the materialist and the eliminativist to be 'doubly pragmatic' (2012a, 210): (1) it is pragmatic in the sense that the materialist and eliminativist agree about what kinds of things exist, but not about whether to call one kind of thing a musical work; and (2) it is also pragmatic in the sense that, in the spirit of the 'pragmatic constraint', it takes the optimal solution to the dispute to be the one that makes best sense of our musical practices. The question a nominalist faces when choosing between materialism and eliminativism is whether giving up talk of musical works altogether or transforming it into talk of, say, fusions of performances is closer to, or more coherent with, existing musical practices.

Kania claims that such pragmatic grounds should lead us to prefer fictionalism over either materialism or eliminativism. The fictionalist about musical works claims that, while there are actually no such things, shared musical-work-representations play valuable roles in our musical practice. This justifies continuing to talk as if there are musical works even if the world contains no such things. The kinds of properties we have been assuming that musical works must have—Kania cites creatability and repeatability, in particular—play an important part in sustaining different elements in our musical practice. But, Kania maintains, it is doubtful whether anything can actually have both of these features. However, in order to preserve the various useful parts of musical discourse centred on the concept of the musical work, we should make-believe that there are such things.

In presenting his case for fictionalism, Kania also maintains that non-Platonist realism is not in fact an option. 'Realism about musical works', he writes, 'stands or falls with Platonism about musical works. That's because ... a theory according to which musical works are concrete objects of some sort is not a realist theory of *musical works*, properly understood' (2012a, 197). As he later makes clear, he takes this view to be common to otherwise diverse nominalist understandings of musical works: 'According to both kinds of nominalist theory I have considered here—materialism and eliminativism—there are no musical works of the kind implied by our musical practices, since those practices imply that musical works are abstract' (2012a, 209). And, describing a materialist ontology of music as one that 'transforms' our talk of musical works, he links this talk of 'transformation' to his claim that 'materialism about musical works is not realism about musical works' (2012a, 210).

But why should we think that our musical practices imply a Platonist understanding of musical works? On perhaps the most obvious reading of this claim, as a claim about the meaning of speakers' utterances, it seems clearly mistaken. For, we might ask, *whose* utterances are in question here? If this is a matter of how *those aware of issues in musical ontology* talk about musical works, it seems just false to say that such speakers use the term 'musical work' as synonymous with 'musical work as abstract object'. When Dodd, for example, claims that musical works are Platonic entities, he is certainly not endorsing a semantic claim about the literal meaning of the term 'musical work'. Rather, he is quite clear that he is offering what he believes to be the best explanation of specific features of our musical practice—the purported repeatability and audibility of musical works. And when Rohrbaugh denies that musical works are abstract entities, he is not, presumably, contradicting himself, which he would be doing if being an abstractum was part of the literal meaning of the term 'musical work'.

But we fare no better if we take the claim to be about what 'the folk' are doing when they engage in such utterances. For we might wonder whether the folk even have an idea as to what an abstract object is. They are interested in talking about specific *musical works* without being concerned about what such things 'are' ontologically speaking. Furthermore, as argued in Chapter 5 above, what the folk say about musical works, and about those activities our engagement in which is described in terms of musical works, is the *input* to the activity of ontologists of music: it identifies the very things that an ontology of musical works seeks to make sense of, to explain—repeatability, variability, creatability, 'sameness' of work across performances, etc. The idea of musical works as abstracta is offered as an *answer* to such ontological questions.

Kania's claim must therefore be about what is implicit in our actual musical practices, rather than what is implicit in the language we use to talk about those practices. Indeed, later remarks indicate that the claim that 'our musical practices...imply that musical works are abstract' is in fact a claim about what, *as philosophers* bound by the pragmatic constraint, we must take musical works to be if they exist.

> It seems implausible (to me) that in ordinary musical discourse people are not committed to the existence of musical works as distinct entities, that they are already speaking about them fictionally. Application of the pragmatic constraint gives us our best theory of the kind of thing people are referring to (or attempting to refer to) in such discourse.... (Kania 2012a, 212)

> The ontological theory of musical works as abstract objects is already the theoretical philosophical result of a process of reflective equilibrium—an abstraction, if you will. If the pragmatic constraint is correct, then, *as philosophers* we ought to think of musical works, if there are any, as a certain kind of abstractum.

Similarly, if it turns out there are no such things, it is only *as philosophers* that we must choose between the nominalist alternatives. (2012a, 216)

This is a puzzling argument. The premiss seems to be that the ontological theory that makes best sense of our practice is a Platonist one, so as philosophers we must conclude, if Platonism is wrong, that there are no musical works. But if, as philosophers, we think Platonism is wrong because it cannot account for such things as the creatability or the variability of musical works, surely that suggests that it may *not* be the best account of our practices. One who offers a 'materialist' ontology of musical works will then argue that this is a *better* account of our practices. To claim, as Kania does, that this would be changing the subject is, then, to beg the question against the materialist. Furthermore, Kania's other reason for favouring a fictionalist account is that supposedly no realist account can accommodate both of those central features of our musical practice that fictionalism allows us to preserve—creatability and repeatability. But, as argued at the end of Chapter 9, the Wollheimian-type theory *does* preserve both of these features and also accommodates those other things reasonably taken to be explananda for an ontology of multiples, musical and otherwise.

10.4 Azzouni: Multiples and the 'External Discourse Demand'

Let me return briefly to Kania's argument *for* fictionalism. He assumes that *if* only Platonism can satisfy our ordinary conception of musical works, and *if* we reject Platonism, then, in concluding that there are no musical works, we can preserve a role for a discourse in which we 'talk about' musical works only if we view our engagement in that discourse as a pretence. Such a pretence is a useful way of keeping track of the various things we want to say about what composers and musicians do, but it will preserve neither the idea that there *really are* musical works nor the idea that our statements 'about' musical works in musical discourse are 'truth-apt' in the sense that there are linguistic contexts in which they have determinate truth-values. The same will apply to eliminativism, which, it is assumed, preserves no role for such discourse.

Fictionalism, however, is not the only available strategy for preserving our ordinary talk of musical works if we assume that the non-existence of the latter is entailed by the rejection of Platonism. This becomes apparent if we consider Jody Azzouni's defence (2010), in his *Talking About Nothing*, of a nominalist account of talk about such ontologically puzzling entities as numbers, hallucinations, and fictional characters that preserves our sense that such discourses are truth-apt without committing us to the existence of the entities they purport to be about. As we shall see, the trick, for Azzouni, is to allow the truth-aptness of such discourses to be grounded not in a correspondence between substantive

expressions in a discourse and their referents, but in the indispensability of that discourse for 'our assertoric practices in ordinary life and our sciences', something he terms the 'external discourse demand' for such discourses. Unlike standard appeals to indispensability arguments for the *existence* of the entities to which nominalistically problematic discourses seem to commit us (see, e.g., Quine 1976, Putnam 1979), this preserves the truth-aptness of such indispensable discourses while denying that there are entities corresponding to their putatively referring expressions. In the case of discourse about multiple artworks, then, it might be argued that such discourse is subject to an external discourse demand, and that the nominalist must find some way to render the discourse truth-apt. The standard nominalist strategy in the literature that might speak to these issues is to argue that multiple artworks exist, but do so in a nominalistically acceptable way. But Azzouni's strategy suggests another possibility: (1) discourse about multiples might be rendered truth-apt in virtue of the explanatory role that talk about multiple artworks plays in our ordinary talk about artistic practices, while (2) we can agree with the Platonists that the *existence* of multiple artworks requires a commitment to abstracta and that, if we reject Platonism, then there are in fact no multiple artworks.

In *Talking About Nothing*, Azzouni first considers the debates between Platonists and Meinongians, on the one hand, and fictionalists, on the other, concerning certain discourses that seem, if taken at face value, to commit us to the existence of things that fit uneasily into a nominalist's ontology. The nominalistically problematic discourses (henceforth NPDs) discussed by Azzouni are those that seem to be 'about' numbers, hallucinated objects, and fictional characters. He maintains (Azzouni 2010, 36–7) that the dynamic in such debates between Platonists and Meinongians, and in arguments for fictionalism, reflects a commitment to the following claims about the relationship between truth-aptness and reference, the second claim being the contrapositive of the first:

(1) The truth-aptness of x-discourse requires that x-terms genuinely refer: more formally, [TA(x-discourse) -> x-terms genuinely refer], and

(2) If x-terms do not genuinely refer, then x-discourse cannot be truth-apt: more formally, [-(x-terms genuinely refer) -> -(TA(x-discourse))].

The 'truth-aptness' of a sentence is its capacity, in appropriate circumstances and with its present meaning, to express a proposition with a determinate truth-value. This will exclude sentences which serve to ask questions or issue commands, and will (or may) also exclude sentences that have the grammatical form of assertions but that arguably play an expressive or prescriptive, rather than an assertoric, role: consider, for example, 'it is wrong to break your promises', or 'smoked anchovies are tasty', on non-cognitivist readings of these kinds of claims.

It is (1) that motivates Meinongian treatments of NPDs. Our engagement in such discourses seems to require 'object-directed thinking', or 'singular thought', and it is assumed that to sustain such discourses and render them truth-apt we need to supply objects for that thinking. But, unwilling to commit themselves to the *existence* of numbers or Sherlock Holmes, Meinongians ascribe to such purported entities *being* (or 'subsistence') but not existence. This allows them to be the referents of the singular terms in an NPD, thereby rendering sentences in the NPD truth-apt. It is (2), on the other hand, that motivates fictionalism. The fictionalist is convinced—usually on nominalist grounds—that no kind of existence or being can be ascribed to the purported referents of singular terms occurring in NPDs: there is no sense in which there are numbers or hallucinated objects or fictional characters. Given (2), it is concluded that the discourses cannot be truth-apt, but, unlike the eliminativist, the fictionalist sees good reason to continue to use them because they are 'useful fictions'.

Azzouni argues that we should reject (1) and (2), thereby making possible an alternative to the ontologically unattractive options of Platonism and Meinongianism, on the one hand, and the epistemically unattractive option of fictionalism, on the other. We can do this by holding that the 'truth-aptness' of a discourse requires not truth-makers—states of affairs into which the referents of the singular terms in the discourse enter—but what he terms 'truth-value inducers', which may, but need not be, truth-makers. Truth-value inducers are

> those aspects of the world (entities and relations among those entities) that, coupled with our truth-assertion practices, force a truth-value on a sentence. Where at least some of the terms in a sentence are non-vacuous, included among the truth-value inducers are the relata of those nonvacuous terms and the relations among them. These may be called the truth-makers of the sentence. However, when all the terms of a sentence are vacuous, it has no truth-makers, only truth-value inducers. (Azzouni 2010, 47)

But, it might be thought, this makes truth-aptness too easy. After all, certain sentences inscribed on the pages of copies of the novels of Conan Doyle, together with what might seem to be our truth-assertion practices, seem to be truth-value inducers for sentences such as 'Sherlock Holmes lives on Baker Street'—which gets the value 'true'—and 'Sherlock Holmes lives in the White House'—which gets the value 'false'. Azzouni is aware of this, and maintains that, if we are to take the truth-aptness of a discourse-practice seriously, we require not only truth-value inducers in this broad sense but also a certain kind of indispensability of the discourse captured by what he terms an 'external discourse demand' (EDD). Such a demand exists in virtue of the fact that the discourse-practice 'has an evidential and implicational role with respect to thought and statement outside the context of that practice' (2010, 70).

Azzouni explains how this might work in the case of discourse 'about' fictional characters. He first draws a distinction between 'fiction-internal' statements, such as 'Sherlock Holmes lives on Baker Street', and 'fictional-external' statements, such as 'Emma Woodhouse was created by Jane Austen', or 'Hamlet appears in *Rosencrantz and Guildenstern Are Dead*'. While the former are not truth-apt, the latter are (2010, 149) because they are subject to the EDD: they

> state facts that empirically confirm statements that aren't about fictions in any sense. That is, fiction-external statements, when coupled with other statements that aren't about fictions, will imply (for example) biographical and psychological facts about the creators of those fictions. The popularity (or unpopularity) of such fictional objects, how depictions of them evolve over time, what other uses they are put to by subsequent writers and readers, and so on, will empirically confirm sociological generalizations of various sorts. These statements, the ones that are empirically confirmed and that aren't about fictions – are truths and falsities simpliciter, both in the sense that such statements are ordinarily asserted as statements we believe, and in the sense that they, in turn, are used both in further inferences to and as confirming (or disconfirming) evidence for still other statements. (2010, 118)

As Azzouni puts this later, 'what's crucial to the external-discourse demand, as it applies to fiction-external statements, is the tracing of the influences on and sociological effects of literary characters and using statements about them in turn as evidence for sociological and historical facts' (2010, 146).

If a discourse is accountable to the EDD then it must be truth-apt, Azzouni maintains, and this rules out a fictionalist construal of the discourse. But, he further maintains, thinking of truth-aptness in terms of truth-values that are conferred on statements by our overall linguistic practice also counsels against a realist construal of a discourse when our practice only confers truth-values on some of its statements, leaving other questions unanswered and perhaps only answerable on pragmatic grounds. This applies in the case of discourse about fictional characters. The realist is committed to there being a fact of the matter as to how fictional characters are rightly individuated transtextually: for example, a fact of the matter as to whether the character called 'Sherlock Holmes' in the film *The Seven-Per-Cent Solution* is the same fictional character as the character so named in the stories by Conan Doyle. For the nominalist non-realist, on the other hand, there are no such facts but only the greater convenience for our practice of treating certain characters as existing in different texts. Fictional nominalists

> are only concerned with making identity and difference talk consistent with the evidential and deductive burdens that external-fiction discourse shoulders. How essential, they ask, is transtextual identity and difference talk to the evidential and

deductive role that fiction-external discourse has? Fictional realists and fictional Meinongians, however, are concerned with metaphysics, with the in-principle identity conditions that govern fictional objects. (Azzouni 2010, 137)

It might be thought that the very reasons that Kania offers for being a fictionalist would by themselves make the case for thinking that discourse about musical works is subject to an EDD. Kania's fictionalist claims that, while there are actually no such things as musical works, we have shared ways of representing such things in our musical practice. These shared representations play a valuable part in that practice, and this justifies continuing to talk as if there were such works even if the world contains no such things. The kinds of properties we have been assuming that musical works must have—creatability and repeatability, in particular—play an important part in sustaining different elements in our musical practice. But the tangled philosophical disagreements over the nature of musical works suggest to the fictionalist that there may in fact be no entities that correspond to our conceptions.

But Kania's defence of fictionalism over eliminativism stresses the role of musical-work-discourse *internal* to our musical practice and explicitly denies that it should be viewed as truth-apt. He draws an analogy with Georges Rey's argument for the 'intentional inexistence' of standard linguistic entities such as sentences:

> We discover the kinds of properties musical works must have (creatability, and so on) by investigating musical practice, just as we discover what properties sentences must have by investigating linguistic practice. While the claim that there are no musical works with these properties is not as well established as the parallel linguistic claim, the ongoing and seemingly intractable disputes about the fundamental metaphysical nature of musical works seems akin to the linguists' evidence that there are no sentences with the requisite structure.
> (Kania 2008, 440)

We should, he argues, be 'revolutionary fictionalists'[5] about musical-work discourse:

> What is the value of musical discourse about works that justifies retaining it despite its falsehood? It is the value of those musical practices that are enmeshed with that discourse—practices (apparently) involving musical works—whatever that value is.... The fictionalism I have recommended is 'revolutionary' in that it recommends moving from a musical-works discourse aimed at truth to a musical-works discourse aimed at whatever the value is of practices involving

[5] For the distinction between 'revolutionary' and 'hermeneutic' fictionalism, see the Introduction to Kalderon (2005).

such discourse. So though the practice, including the discourse, may look the same on the surface, it will be operating in a different way. What would in the past have been assertions about musical works, for instance, ought really, according to the fictionalist, to be put forward as make-believe.

(Kania 2012a, 212, 215)

However, if we turn to Azzouni's reasons, cited earlier, for thinking that the EDD applies to fictional-external statements, it seems clear that parallel reasons can be given for thinking that it applies to statements about musical works. As cited above, what is crucial here for Azzouni 'is the tracing of the influences on and sociological effects of literary characters and using statements about them in turn as evidence for sociological and historical facts' (2010, 146):

Fiction-external statements, when coupled with other statements that aren't about fictions, will imply (for example) biographical and psychological facts about the creators of those fictions. The popularity (or unpopularity) of such fictional objects, how depictions of them evolve over time, what other uses they are put to by subsequent writers and readers, and so on, will empirically confirm sociological generalizations of various sorts. These statements, the ones that are empirically confirmed and that aren't about fictions - are truths and falsities simpliciter. (2010, 118)

Analogously, the relevant 'external' claims about *musical works* will relate to, for example, which works are performed most frequently and where, which draw the highest attendances when performed, and which are liked by people in specific demographic categories. They will also include facts about composer's creative trajectories—the kinds of works composed at different times in their creative careers—(again) the popularity of musical works, the ways in which performances of particular works change over time, and how the compositional activity of one composer has influenced the compositional activity of other composers. Nothing in this account seems to prevent us from formulating parallel arguments with respect to other kinds of multiple artworks. Our talk about such works, it might be claimed, is subject to an EDD, and thus such talk must be truth-apt—so fictionalism is not an option. But we can uphold the truth-aptness of such talk while denying that there are actually entities that correspond to the work-referring expressions in such discourses.

10.5 Nominalist Realism about Multiples: a Provisional Defence

If there is indeed an EDD applicable to our discourse about multiple artworks, and if fictionalism about such works cannot satisfy that EDD, then we have two live

non-Platonist approaches to such discourse: (a) some kind of nominalist realism, and (b) Azzouni's nominalist non-realism. Each of these renders such discourse truth-apt, but only one of them admits multiple artworks into its ontology. Of course, what we would thereby be admitting will depend upon the form of nominalist realism in question. Scepticism about a form of nominalist realism, as we have seen, usually casts doubt on the ontological credentials of the kind of thing to which the nominalist is committed—we encountered such scepticism in the charges of metaphysical obscurity levelled at Levinson's indicated structures.

One strategy open to the defender of a form of nominalist realism is to offer a 'companions in guilt' argument posed either positively—we already unproblematically admit x's into our ontology, and x's involve the same kind of ontological commitment as multiple artworks on a given account—or negatively—if our ontology refuses to countenance multiple artworks construed in a given way, we would also have to deny reality to x's, which is a very unattractive consequence. But some kinds of nominalist realism are less conducive to this strategy than others. Consider, for example, Caplan and Matheson's perdurantism, and its capacity to satisfy 'Concreteness', one of Cray and Matheson's three desiderata in an account of musical compositions. Cray and Matheson describe Concreteness as follows: 'Compositions are entities sufficiently related to the concrete world in that they are creatable, spatiotemporally locatable, and able to interact causally with concrete objects (performers, performances, etc.)' (2017, 713). They take it to be a virtue of materialist theories that they satisfy this desideratum by taking works to be either constituted by, or dependent on, such eminently concrete things as performances and copies of scores. But, on the perdurantist account, the existence of these concrete things does not entail the existence of the work qua fusion of its performances. Thus we do not have to deny the existence of any of the concrete things entering into our musical practices if we deny existence to the perdurantist work. If the price of denying existence to perdurantist musical works, qua fusions of their temporal stages, were just that we might have to exclude mereological sums more generally from our ontology, then a 'companions in guilt' argument does not seem compelling and an eliminativist stance might seem the better option. There is, however, a further cost for the eliminativist, who needs to make some sense of our ways of talking about musical works. But we saw earlier, in looking at Moruzzi's eliminativist variation on Caplan and Matheson's 'stage' model of the musical work, that one can be a realist about work-stages and give constructive sense to talk about works while denying the reality of the latter.

Indicated structures, even if distinguished from types as Levinson has more recently proposed, also seem ontologically expendable without great consequence. As critics have pointed out, their ontological standing depends upon their being more than qua-objects—'objects' such as 'this computer as used by me' or 'the Eiffel Tower as pointed at by Louise'. If, as Levinson has attempted to do (2012), we seek to locate indicated structures in a middle ground between types, as

abstracta, and qua-objects by stressing the creative nature of indication, we seem to move from works as indicated structures to works as indicatings of structures. The latter, of course, is essentially a form of the Wollheimian type theory defended in Chapter 9.

One advantage of the Wollheimian-type theory as I have interpreted it, on the other hand, is that contextualized performances have powerful companions in guilt. Any presentation of a paper denying ontological status to contextualized performances would itself be a contextualized performance! Nominalist realism for the Wollheimian type theorist comes at a significantly lower ontological cost than it does for the other forms of materialist realism under consideration. It involves a commitment only to things that are already comfortably installed in the Lebenswelt, along with paintings, baseballs, and philosophy lectures. Indeed, the very performances of musical works that are elements in the perdurantist's fusions and the supervenience base for the endurantist's historical individuals are themselves contextualized in various ways.

But locating multiple artworks in the Lebenswelt does not make them immune from metaphysical scepticism. One prominent strand in analytic metaphysics questions the reality, in a metaphysically strict sense, of the Lebenswelt itself. For such philosophers, while the physical elements that at a given time constitute a material artefact like a baseball exist, the baseball itself does not (see, e.g., Merricks 2001). If so, then neither musical works nor paintings will get onto the ontological map. On the other hand, if we follow Amie Thomasson (2007) in thinking that there are no good reasons to exclude 'ordinary objects' from our ontology, then we might argue that musical works, as contextualized performances, are no less 'real' than paintings, works of sculpture, and baseballs. This is obviously contested ground, and we cannot hope to resolve such metaphysical questions here. What we can do, however, is consider a further 'companions in guilt' argument whose conclusion would be that anyone who wishes to apply Azzouni's line of reasoning on fictional characters to multiple artworks, and to insist upon a non-realist understanding of discourse about the latter, will *also* have to take a non-realist line on things whose reality might seem dearer to our hearts—for example, works of visual art. I shall ask therefore whether Azzouni himself provides us with guidance as to how we should proceed on these issues, and how he might view the nominalist pretensions of the materialistic theories of multiple works on offer.

In *Talking About Nothing*, Azzouni does not argue in detail for a view about when entities of a certain kind exist, but he does present the following existence-condition: 'For something to exist is for the attribution of properties to it to be independent of our very property-attribution practices themselves, in short, for our property-attribution practices to be open to a kind of failure because they don't match the properties that such objects actually have. Truth-apt fictional discourse lacks the required independence' (2010, 149). What kinds of property-attributions to objects would meet this condition, and what kinds would fail? In

discussing truth-apt fictional discourse, we may recall, the claim was that the realist is committed to there being a practice-independent fact about the transtextual individuation of fictional characters.[6] However, Azzouni maintains, such individuation seems to be determined pragmatically: it depends upon our interests in those other discourses that stand in evidential relations to external fictional-character discourse and thereby make the latter subject to an EDD.

I assume that the properties whose independence of our property-attribution practices bears upon the existence of an entity are *intrinsic* properties. Being created by Shakespeare, for example, is a relational and not an intrinsic property of the Fool, and we can therefore view the claim that Shakespeare created this character as potentially unknowable. *King Lear* might have been written by someone other than Shakespeare, or the character of the Fool might have been borrowed from a lost text. It is such talk about the authoring activities of artists that contributes to the EDD on fictional-character discourse, but this is compatible with a non-realist stance on fictional characters themselves. But the attribution-dependent property of fictional characters to which Azzouni points—how a character is individuated transfictionally—is clearly an intrinsic property of the character. It is only if an entity's intrinsic properties are attribution-dependent that its claim to genuine existence is compromised.

But in this case Azzouni's existence-condition does seem to present a problem for a realist stance with respect to multiple artworks. Consider, for example, the following analogue to the property whose dependence on property-attribution practices seems to be a reason for denying reality to fictional characters. Composers frequently return to a score after having deemed it complete and make further (usually small) changes. Do we have here two distinct musical works, or one musical work finished later than we had thought, or one musical work with two different 'versions'? Philosophers of music debate these questions, but it isn't clear that the reasons for favouring one solution over another are anything other than pragmatic (or dependent upon broader theoretical choices that are themselves pragmatic). This is simply one consequence of the fact that multiple artworks are 'creatures of practice', as I have argued. But this suggests that, if we shouldn't be realists about fictional characters for the reasons offered by Azzouni, we shouldn't be realists about musical works either. In that case, none of the forms of musical materialism canvassed earlier would be nominalistically acceptable for Azzouni. But a parallel argument will count against ascribing reality to paintings. The question whether we have the same painting after we carry out restoration to repair some damage to the original canvas seems to be 'pragmatic' for the same reasons as the aforementioned decision about the individuation of musical works.

[6] For another example of this kind of reasoning, see Anthony Everett's argument against the existence of fictional characters in his 2005. For critical discussion of this argument, see Ross Cameron (2013).

Once we recognize that singular artworks such as paintings and works of sculpture arguably have different individuation and persistence conditions from the entities that at given times are their material supports (see the discussion of this in Chapter 6), it seems that any lines of argument that might lead one to resist a nominalist realist view of musical works would also count against such a view of singular artworks such as paintings. In this sense, all artworks are 'creatures of practice'.

Perhaps the latter consequence is one that Azzouni would accept. Certainly, in the literature on social ontology this is something that many are happy to embrace. As noted above, it is sometimes claimed that there are really no ordinary objects such as baseballs, but only the elementary particles of which such things are composed: possessing at a given time the property of being a 'baseball' is essentially a matter of our social practices of reification and individuation. If we read Azzouni's test in *this* way, there will be no musical works because musical works are entities that owe their identity, and individuation and persistence conditions, to our social practices and to the distinctions made in those practices. This would not, of course, prevent discourse about musical works from being truth-apt if we buy into the line of reasoning spelled out in Section 10.2 above. But it would count against any kind of nominalistically respectable realism. In the spirit of a tradition familiar from Quine's *Word and Object*, we might try to make this austere view more acceptable by distinguishing between what is acceptable in ordinary discourse and what is acceptable in the discourse in which we attempt to 'limn...the true and ultimate structure of reality'. One finds such a strategy adopted by Ross Cameron in 'There Are No Things that Are Musical Works' (2008). Cameron agrees that it is perfectly correct to say in ordinary talk that there are musical works, but that such a claim would be false if we were speaking 'ontologese', the language appropriate for doing metaphysics.

The conclusion I wish to draw from these reflections is that the considerations raised by Azzouni and Cameron against adopting a realist view of a given discourse will prescribe non-realism not only about musical works but also about other 'cultural objects' such as paintings and works of sculpture. Whether we side in these debates with writers like Thomasson or with writers of a more austere ontological persuasion, there is no reason to think that realist nominalists about multiple works, conceived as contextualized performances, are any worse off than realist nominalists about singular artworks. This, I believe, is a conclusion that the defender of a Wollheimian account of multiple artworks can live with.

Bibliography

Andrada, Felix, Eimear Martin, and Anthony Spira (eds.) (2006): *Inner Worlds Outside* (London: Whitechapel).
Azzouni, Jody (2010): *Talking About Nothing* (Oxford: Oxford University Press).
Bartel, Christopher (2017): 'Rock as a three-value tradition', *Journal of Aesthetics and Art Criticism* 75.2, 143–54.
Beardsley, Monroe C. (1958): *Aesthetics: Problems in the Philosophy of Criticism* (New York: Harcourt, Brace, and World).
Bell, Clive (1913): *Art* (London: Chatto & Windus).
Blackburn, Simon (1984): 'The Individual Strikes Back', *Synthese* 58, 281–301.
Borges, Jorge Luis (1970): 'Pierre Menard, Author of the *Quixote*', in J. E. Irby, tr., *Labyrinths* (Harmondsworth: Penguin), 62–71.
Brandom, Robert (1994): *Making It Explicit: Reasoning, Representing, and Discursive Commitment* (Cambridge, MA: Harvard University Press).
Brown, L. B. (2011): 'Do higher-order music ontologies rest on a mistake?' *British Journal of Aesthetics* 51.2, 169–84.
Brown, L. B. (2012): 'Further doubts about higher-order ontology: reply to Andrew Kania', *British Journal of Aesthetics* 52.1, 103–6.
Bruno, Franklin (2013): 'A case for song: against an (exclusively) recording centred ontology of rock', *Journal of Aesthetics and Art Criticism* 71.1, 65–74.
Burkett, Daniel (2015): 'One song, many works: a pluralist ontology of rock', *Contemporary Aesthetics* 13, n.p.
Cameron, Ross P (2008): 'There Are No Things That Are Musical Works', *British Journal of Aesthetics* 48.3, 295–313.
Cameron, Ross (2012: 'How to be a Nominalist and a Fictional Realist', in Christy Mag Uidhir, ed., *Art and Abstract Objects* (Oxford: Oxford University Press), 179–96.
Caplan, Ben, and Carl Matheson (2004): 'Can a Musical Work Be Created?', *British Journal of Aesthetics* 44.2, 113–34.
Caplan, Ben, and Carl Matheson (2006): 'Defending Musical Perdurantism', *British Journal of Aesthetics* 46.1, 59–69.
Caplan, Ben, and Carl Matheson (2008): 'Defending "Defending Musical Perdurantism"', *British Journal of Aesthetics* 48.1, 80–5.
Carroll, Noël (1998): *A Philosophy of Mass Art* (Oxford: Clarendon Press), 219–22.
Cray, Wesley, and Carl Matheson (2017): 'A return to musical idealism', *Australasian Journal of Aesthetics* 95.4, 702–15.
Currie, Gregory (1989): *An Ontology of Art* (New York: St. Martin's Press).
Currie, Gregory (1991): 'Work and Text', *Mind* 100, 325–40.
Danto, Arthur (1964): 'The Artworld', *Journal of Philosophy* 61, 571–84.
Danto, Arthur (1981): *Transfiguration of the Commonplace: A Philosophy of Art* (Cambridge, MA: Harvard University Press).
Danto, Arthur (1984/2006): 'Defective Affinities: "Primitivism" in 20th century art', in Howard Morphy and Morgan Perkins, eds., *The Anthropology of Art: A Reader* (Oxford: Blackwell), 147–9.

Davies, David (1991): 'Works, texts, and contexts', *Canadian Journal of Philosophy* 21.3, 331–46.
Davies, David (1998): 'How sceptical is Kripke's "sceptical solution"?', *Philosophia* 26, 119–40.
Davies, David (2004): *Art as Performance* (Oxford: Blackwell).
Davies, David (2007): 'Telling Pictures: The Place of Narrative in Late-modern Visual Art', in Peter Goldie and Elisabeth Schellekens, eds., *Philosophy and Conceptual Art* (Oxford: Clarendon Press), 138–56.
Davies, David (2008): 'Collingwood's "performance" theory of art', *British Journal of Aesthetics* 48.2, 162–74.
Davies, David (2009): 'The primacy of practice in the ontology of art', *Journal of Aesthetics and Art Criticism* 67.2 (Spring 2009), 159–71.
Davies, David (2010): 'Multiple Instances and Multiple "Instances"', *British Journal of Aesthetics* 50.4, 411–26.
Davies, David (2011): *Philosophy of the Performing Arts* (Oxford: Wiley-Blackwell).
Davies, David (2012): 'Enigmatic Variations', *The Monist* 95.4, 643–62.
Davies, David (2012): 'What Type of "Type" is a Film?', in Christy Mag Uidhir, ed., *Art and Abstract Objects* (Oxford: Oxford University Press), 263–83.
Davies, David (2015): 'Varying impressions', *Journal of Aesthetics and Art Criticism* 73.1, 81–92.
Davies, David (2017): 'Descriptivism and its discontents', *Journal of Aesthetics and Art Criticism* 75.2, 117–29.
Davies, David (2019): 'Dance seen and dance-screened', *Midwest Studies in Philosophy* 43, 117–32.
Davies, Stephen (2001): *Musical Works and Performances: A Philosophical Exploration*, (Oxford: Oxford University Press).
Davies, Stephen (2003): 'Ontology of Art', in Jerrold Levinson, ed., *Oxford Companion to Aesthetics* (Oxford: Oxford University Press), 155–80.
Davies, Stephen (2007): 'Balinese aesthetics', *Journal of Aesthetics and Art Criticism* 65.1, 21–9.
Devitt, Michael, and Kim Sterelny (1999): *Language and Reality: An Introduction to the Philosophy of Language*, 2nd edition (Cambridge, MA: MIT Press).
Dodd, Julian (2000): 'Musical works as eternal types', *British Journal of Aesthetics* 40.4, 424–40.
Dodd, Julian (2004): 'Types, Continuants, and the Ontology of Music', *British Journal of Aesthetics*, 44.4, 342–60.
Dodd, Julian (2007): *Works of Music: An Essay in Ontology* (Oxford: Oxford University Press).
Dodd, Julian (2012): 'Defending the Discovery Model in the Ontology of Art: A Reply to Amie Thomasson on the Qua Problem', *British Journal of Aesthetics* 52, 75–95.
Dodd, Julian (2013): 'Adventures in the Meta-ontology of Art: Local Descriptivism, Artefacts, and Dreamcatchers', *Philosophical Studies* 165, 1047–68.
Dutton, Denis (1979): 'Artistic crimes: the problem of forgery in the arts', *British Journal of Aesthetics* 19.4, 304–14.
Evans, Gareth (1982): *The Varieties of Reference*, ed. John McDowell (Oxford: Clarendon Press.
Everett, Anthony (2005): 'Against fictional realism', *Journal of Philosophy* 102, 624–49.
Goehr, Lydia (2007): *The Imaginary Museum of Musical Works: An Essay in the Philosophy of Music*, rev. ed. (Oxford: Oxford University Press).

Goodman, Nelson (1976): *Languages of Art*, 2nd edition (Indianapolis: Hackett).
Goodman, Nelson, and Catherine Z. Elgin (1988): *Reconceptions in Philosophy & Other Arts & Sciences* (London: Routledge).
Gracyk, Theodore (1996): *Rhythm and Noise: An Aesthetics of Rock* (Durham, NC: Duke University Press).
Hamilton, James (2007): *The Art of Theatre* (Oxford: Wiley-Blackwell).
Hazlett, Allan (2012): 'Against Repeatable Artworks', in Christy Mag Uidhir, ed., *Art and Abstract Objects* (Oxford: Oxford University Press), 161-78.
Irvin, Sherri (2005): 'The artist's sanction in contemporary art', *Journal of Aesthetics and Art Criticism* 63.4, 315-26.
Iseminger, Gary, ed. (1992): *Intention and Interpretation* (Philadelphia: Temple University Press).
Kalderon, Mark Eli (ed.) (2005): *Fictionalism in Metaphysics* (Oxford: Oxford University Press).
Kania, Andrew (2006): 'Making Tracks: The Ontology of Rock Music', *Journal of Aesthetics and Art Criticism* 64, 401-14.
Kania, Andrew (2008): 'The Methodology of Musical Ontology: Descriptivism and Its Implications', *British Journal of Aesthetics* 48.4, 426-45.
Kania, Andrew (2012a): 'Platonism vs. Nominalism in Contemporary Musical Ontology', in Christy Mag Uidhir, ed., *Art and Abstract Objects* (Oxford: Oxford University Press), 197-219.
Kania, Andrew (2012b): 'In defence of higher-order musical ontology: a reply to Lee Brown', *British Journal of Aesthetics* 52.1, 97-102.
Kivy, Peter (1983): 'Platonism in Music: A Kind of Defense', *Grazer Philosophische Studien* 19.1, 109-29.
Kivy, Peter (1987): 'Platonism in Music: Another Kind of Defense', *American Philosophical Quarterly* 24, 245-52.
Kivy, Peter (1988): 'Orchestrating Platonism', in T. Anderberg, T. Nilstun, and I. Persson, eds., *Aesthetic Distinction* (Lund: Lund University Press), 42-55.
Kripke, Saul A. (1980): *Naming and Necessity*, 2nd rev. edition, (Cambridge, MA: Harvard University Press).
Kripke, Saul A. (1982): *Wittgenstein on Rules and Private Language* (Cambridge, MA: Harvard University Press).
Lessing, Alfred (1965): 'What is wrong with a forgery?', *Journal of Aesthetics and Art Criticism* 23, 461-71.
Letts, Philip (2020): 'Is Moruzzi's Musical Stage Theory Advantaged?' *Journal of Aesthetics and Art Criticism* 78, 357-61.
Letts, Philip (2022): 'Musical Exdurantism', *Journal of Aesthetics and Art Criticism* 80, 477-93.
Levinson, Jerrold (1980): 'What a Musical Work Is', *Journal of Philosophy* 77.1, 5-28. Repr. in *Music, Art, and Metaphysics* (Ithaca, NY: Cornell University Press), 63-88.
Levinson, Jerrold (1990a): 'What a Musical Work Is Again', in *Music, Art, and Metaphysics* (Ithaca, NY: Cornell University Press), 215-63.
Levinson, Jerrold (1990b): 'Authentic Performance and Performance Means', in *Music, Art, and Metaphysics* (Ithaca, NY: Cornell University Press), 393-408.
Levinson, Jerrold (1996): *The Pleasures of Aesthetics* (Ithaca, NY: Cornell University Press).
Lewis, David (1968): 'Counterpart Theory and Quantified Modal Logic', *Journal of Philosophy* 65, 113-26.
Livingston, Paisley (2005): *Art and Intention* (Oxford: Oxford University Press).

McEvilley, Thomas (1992): 'Doctor, Lawyer, Indian Chief', in *Art and Otherness: Crisis in Cultural Identity* (Kingston, NY: McPherson & Co.), 27–56.

Mag Uidhir, Christy, ed. (2012): *Art and Abstract Objects* (Oxford: Oxford University Press).

Mag Uidhir, Christy (2013): *Art and Art-Attempts* (Oxford: Oxford University Press).

Matheson, Carl, and Ben Caplan (2008): 'Modality, individuation, and the ontology of art', *Canadian Journal of Philosophy* 38.4, 491–517.

Merricks, Trenton (2001): *Objects and Persons* (Oxford: Oxford University Press).

Moruzzi, Caterina (2018): 'Every Performance Is a Stage: Musical Stage Theory as a Novel Account for the Ontology of Musical Works', *Journal of Aesthetics and Art Criticism* 76.3, 341–51.

Moruzzi, Caterina (2020): 'The Assumptions behind Musical Stage Theory: A Reply to Letts', *Journal of Aesthetics and Art Criticism* 78, 362–5.

MusicExperiment21 (2013): 'Experimentation versus Interpretation: Exploring New Paths in Music Performance in the 21st Century', in Mick Wilson and Schelte van Ruiten, eds., *SHARE: Handbook for Artistic Research Education* (Amsterdam: ELIA European League of Institutes of the Arts), 100–3.

MusicExperiment21 (2015): 'From Musical Works to Multiplicities: A New Image of Work', *MusicExperiment21* (2 October 2015), https://musicexperiment21.eu/2015/10/02/frommusical-works-to-multiplicities-a-newimage-of-work/" https://musicexperiment21.eu/2015/10/02/frommusical-works-to-multiplicities-a-newimage-of-work/ (accessed 21 December 2017).

Pakes, Anna (2020): *Choreography Invisible* (Oxford: Oxford University Press).

Peirce, Charles S. (1933): 'Apology for Pragmatism', in *Collected Papers of C. S. Peirce*, vol. 4 (Cambridge, MA: Harvard University Press).

Predelli, Stefano (1995): 'Against musical Platonism', *British Journal of Aesthetics* 35.4, 338–50.

Predelli, Stefano (2011): 'Talk about Music: From Wolterstorffian Ambiguity to Generics', *Journal of Aesthetics and Art Criticism* 69.3, 273–83.

Putnam, Hilary (1975): 'The Meaning of "Meaning"', in *Mind, Language, and Reality*, (Cambridge: Cambridge University Press), 215–71.

Putnam, Hilary (1979): 'What Is Mathematical Truth', in *Mathematics Matter and Method: Philosophical Papers, Vol. 1*, 2nd edition, (Cambridge: Cambridge University Press), 60–78.

Quine, Willard V. (1960): *Word and Object* (Cambridge, MA: MIT Press).

Quine, Willard V. (1969): 'Ontological relativity', in *Ontological Relativity and Other Essays* (New York: Columbia University Press), 26–68.

Quine, Willard V. (1976): 'Carnap and Logical Truth', repr. in *The Ways of Paradox and Other Essays*, rev. edition (Cambridge, MA: Harvard University Press), 107–32.

Rohrbaugh, Guy (2003): 'Artworks as Historical Individuals', *European Journal of Philosophy* 11 (2), 177–205.

Rohrbaugh, Guy (2005): 'I could have done that', *British Journal of Aesthetics* 45.3, 209–28.

Rohrbaugh, Guy (2020): 'Why Play the Notes? Indirect Aesthetic Normativity in Performance', *Australasian Journal of Philosophy* 98.1, 78–91.

Rubin, William (1984/2006): 'Modernist Primitivism: An Introduction', in Howard Morphy and Morgan Perkins, eds., *The Anthropology of Art: A Reader* (Oxford: Blackwell 2006), 129–46. Originally published in William Rubin (ed.), *'Primitivism' in 20th Century Art: Affinity of the Tribal and the Modern*, Vols I and II (Boston, MA: Little, Brown and Co., 1984).

Rudder Baker, Lynn (1997): 'Why constitution is not identity', *Journal of Philosophy* 94, 599–621.
Shields, Christopher (1995): 'Critical Notice of Currie, *An Ontology of Art*', in *Australasian Journal of Philosophy* 73, 293–300.
Steadman, Philip (2001): *Vermeer's Camera* (Oxford: Oxford University Press).
Stecker, Robert (2003): *Interpretation and Construction: Art, Speech, and the Law* (Oxford: Blackwell).
Strawson, Peter (1974): 'Aesthetic Appraisal and Works of Art', in *Freedom and Resentment and Other Essays* (London: Methuen), 178–88.
Thomasson, Amie (1999): *Fiction and Metaphysics* (Cambridge: Cambridge University Press).
Thomasson, Amie (2005): 'The Ontology of Art and Knowledge in Aesthetics', *Journal of Aesthetics and Art Criticism* 63: 221–9.
Thomasson, Amie (2007): *Ordinary Objects* (Oxford: Oxford University Press).
Thomasson, Amie (2020): 'A pragmatic method for normative conceptual work', in Alexis Burgess, Herman Cappelen, and David Plunkett, eds., *Conceptual Engineering and Conceptual Ethics* (Oxford: Oxford University Press).
Thomasson, Amie (2021): 'Conceptual engineering: when do we need it? How can we do it?', *Inquiry*, DOI: 10.1080/0020174X.2021.2000118.
Thompson, Judith (1998): 'The Statue and the Clay', *Philosophical Perspectives* 32, 149–73.
Tillman, Chris (2011): 'Musical Materialism', *British Journal of Aesthetics* 51.1, 13–29.
Trogdon, Kelly, and Paisley Livingston (2014): 'The complete work', *Journal of Aesthetics and Art Criticism* 72.3, 225–33.
Varnedoe, Kirk (1989): *A Fine Disregard* (London: Thames & Hudson).
Wiggins, David (1980): *Sameness and Substance* (Oxford: Basil Blackwell).
Wittgenstein, Ludwig (1953): *Philosophical Investigations*, ed. G. E. M. Anscombe and R. Rhees, tr. G. E. M. Anscombe (Oxford: Blackwell).
Wolfe, Tom (1976): *The Painted Word* (New York: Bantam).
Wollheim, Richard (1980): *Art and its Objects*, 2nd edition, with 6 supplementary essays (Cambridge: Cambridge University Press). 1st edition 1968.
Wolterstorff, Nicholas (1975): 'Toward an Ontology of Art Works', *Noûs* 9.2, 115–42.
Wolterstorff, Nicholas (1980): *Works and Worlds of Art* (Oxford: Clarendon Press).
Zemack, Eddy (1970): 'Four ontologies', *Journal of Philosophy* 67, 231–47.

Index

For the benefit of digital users, indexed terms that span two pages (e.g., 52–53) may, on occasion, appear on only one of those pages.

Acconci, V. 30 n. 20
analogical predication 39–41, 52–3, 55, 59–60, 192
appreciation constraint (AC) 99, 101–4, 121–2, 125–6
Austen, J. 17–18, 20–1, 73–5
Azzouni, J. 194, 205–14

Bartel, C. 113 n. 7
Beethoven, L., *Hammerklavier Sonata* 99–102
Bell, C. 148–9
Blackburn, S. 136 n. 8
Borges, J. L. 17–18, 72–3
Brandom, R. 135–7, 138 n. 9
Brown, L. 113 n. 7
Bruno, F. 113 n. 7
Burgess, A., *A Clockwork Orange* 179
Burkett, D. 113 n. 7

Cameron, R. 154, 213 n. 6, 214
Caplan, B., and Matheson, C. 154, 158–62, 182, 201, 211
Carroll, N., on Currie's 'instance multiplicity hypothesis' 25, 27–30
carved sculpture 124
cast sculpture, as multiple 126–7, 147–8
causal-historical theories of reference-fixing 108–9
Chadwick, H. 29
Coleridge, S. T., *Kubla Khan* 169–71
Collingwood, R. 164
contextualism, epistemic, characterised 70–5
contextualism, ontological 148–9
 characterised 70–5
 criticized 82–90
 defended 74–8
Cray, W., and Matheson, C. 10, 154, 155 n. 1, 158–9, 165–71, 178–9, 211
creatability of multiple artworks 8, 43–4, 62–9, 147–8, 190–1
Currie, G. 77, 185 n. 6, 186, 197
 action-type hypothesis 6–7, 92–3, 167–8
 instance multiplicity hypothesis (IMH) 18–32
 'Jane Austen' thought-experiment 17–18, 20–1, 73–5, 102–3

Daguerre, L. 127
dance, as multiple 180–2
Danto, A. 71, 148–9, 185 n. 6, 197
Davies, D., *Art as Performance* 93, 151, 184–9
Davies, S. 112–13, 113 n. 7
 Currie's 'instance multiplicity hypothesis' criticized 19–20
descriptivism, local 103–6
descriptivist theories of reference in the philosophy of science 108
Devitt, M., and Sterelny, K. 5
Dickens, C., *Bleak House* 169–70
Dodd, J. 118–19, 121–2, 137–8, 143–5, 160–2, 176, 178–9, 204
 audibility of musical works 52–9, 146–7
 contextualism and instrumentalism, criticized 82–90, 133
 creatability of musical works criticized 65–9, 147–8
 'discovery model' in ontology 3, 106–8, 110–12, 115
 meta-ontological argument for the 'simple theory' 103–6
 methodological strategy in *Works of Music*, challenged 91–102, 113–14
 moderate musical empiricism, defended, 84–6, 88–9, 94, 96
 'simple view' 9–10, 44–6, 65 n. 5, 126–7, 131–3, 152–3
 timbral sonicism 83–6
 types, nature of 46–50, 53–4, 173–4, 177–8
D-types, introduced 173–4
Dutton, D. 185 n. 6

e-multiplicity, defined 15–16
eliminativism about multiples 154, 194–202
endurantism about multiples 120, 162–4
epistemic empiricism 70–1, 94–6
Everett, A. 213 n. 6
experiential role in appreciation 2

Fatal Attraction 116–17
fictionalism about multiples 154, 202–6
film, as multiple 142, 145
Fox-Talbot, H. 127
fine individuation 9, 148–9, 191–2
 defended 74–8
 disputed 82–90

generic entities, Wollheim on 34–5, 174–5, 183–4
generic terms 60–1
Goehr, L. 113 n. 7
Goodman, N. 14, 24–5, 42–3, 71–2, 157–8
Goodman, N. and Elgin, C. Z. 71–2, 72 n. 1
Gracyk, T. 113 n. 7

Hamilton, J. 156–7
Hazlett, A. 193, 199–202
Hoban, R., *Riddley Walker* 179
Hopkins, R. 29 n. 18
Hurst, D., *The Physical Impossibility of Death in the Mind of Someone Living* 191

idealism about multiples 154, 164–71
'initiation' of multiple works, methods 36–7, 118
instances of works
 e(pistemic)-instances defined 12–14, 24, 37–8
 p(rovenential)-instances defined 14–15, 24, 37–8
 strict instances defined 13–14
instrumentalism, *see* 'performance means'
Irvin, S. 191 n. 10
Iseminger, G. 188 n. 8

Jarrett, K. *Koln Concert* 30–1
Joyce, J., *Finnegan's Wake* 179

Kalderon, M. 209 n. 5
Kania, A. 113 n. 7, 154, 167
 fictionalism, defended 10–11, 194, 202–6, 209–10
Kivy, P. 45–6, 50–1, 62–3, 65–6, 80–1, 83
Kripke, S. 4, 108–9, 136 n. 8

Lessing, A. 77–8
Letts, P. 202 n. 3
Levinson, J. 10, 50–1, 92–3, 98, 98 n. 1, 185–6, 185 n. 6, 197, 211–12
 creatability of musical works, defended 62–6, 147
 Currie's 'instance multiplicity hypothesis', criticized 22–3, 25–7
 'fine individuation' and contextualism, defended 74–8, 81–2, 89–90, 102–3, 148–9

musical works as indicated structures 63–5, 81–2, 93, 126–7, 166, 168, 177–82
performance means and instrumentalism, defendec 79–81, 149–50
Lewis, D. 159–60
literature, as multiple 129–30, 140–2, 145, 196, 200
Livingston, P. 188 n. 8

Mag Uidhir, C. 130 n. 7, 154, 193–202
Matheson, C., and Caplan, B. 151
Merricks, T. 212
modal flexibility of works 9, 48, 120–3, 125–6, 150–1, 191
monotypes 16–17
Moruzzi, C. 59 n. 2, 161–2, 193, 200–2, 211
Mozart, W. A. 170
musical stage theory 200–2
MusicExperiment21 155–7, 193

nine explananda
 introduced 7–9
 reassessed 143–53
 Wollheimian types and 189–90
norms, nature of 134–7
norm-kinds/norm-types, Wolterstorff on 41–4, 134–5

Pakes, A. 127–8, 180–2
Peirce, C. S. 175
perceivability of multiple artworks 8, 46, 52–61, 146–7, 192
perdurantism about musical works 154, 158–63
performance means 9, 79–81, 149–50, 192
photography, as multiple 118–20, 126–7, 130–1, 146–8
Picasso, P., *Les Demoiselles d'Avignon* 116–17
Piero della Francesca 28
p-multiplicity, defined 15–17
pragmatic constraint (PC) 2–3, 91–5, 98, 102–4, 110–14, 204–5
Predelli, S. 53–4, 144, 202 n. 4
 generic terms, semantics of 59–61, 146–7, 192
print-making, as multiple 195–6, 198–9
property-existence 67–9
Putnam, H. 4, 108–9, 205–6

Quine, W. V. 53, 205–6, 214

Radcliffe, A. 17–18, 20–1, 73–5
repeatability of multiple artworks 8, 46, 58, 143–4, 172–3, 190
relevant similarity and 195–201

Rodin, A., *The Thinker* 126–7
Rohrbaugh, G. 10, 48, 82 n. 5, 116–17, 147, 175, 182, 199, 204
 modal flexibility of works, defended 121–6, 150–1
 multiple works as continuants/historical individuals 120–1, 154, 162–4, 167
 temporal flexibility of works, defended 121, 123–6, 152
Rubin, W. 148–9
Rudder-Baker, L. 124 n. 3

Smithson, R., *Spiral Jetty* 29–30
Steadman, P. 79 n. 4
Stecker, R. 64 n. 4
Stieglitz, A., *The Steerage* 118–20

temporal flexibility of works 9, 48, 120, 123, 125–9, 152, 191
Tétreault, Y. 102 n. 2
Thomasson, A. 3–7, 109 n. 3, 111, 115, 191, 212, 214
Thompson, J. 124 n. 3
Tillman, C. 154, 157, 160
topic-specific constraint on applied ontology 107–11

Trogdon, K., and Livingston, P. 165–6
Turner, J. M. W. 28, 117

unexemplified works 8, 67, 145–6, 190, 197–8, 201–2

variability of works 9, 127–40, 152–3, 160, 189–90
Varnedoe, K. 179, 179 n. 4

Welles, H. G., *Citizen Kane* 175–6
Wiggins, D. 125
Wittgenstein, L. 135–7
Wolfe, T. 148–9
Wollheim, R. 113 n. 6, 164–5
 multiple works as types 33–8, 172–84
Wollheimian types 11, 174–84, 189, 198–9
Wolterstorff, N. 16–17, 22, 64–5, 144
 analogical predication 39–41, 60–1, 146–7, 192
 creatability 43–5
 multiple works as norm-kinds 38–44, 131–2, 177
 norm-kinds, defined 41–4, 173–4

Zemach, E. 47